THE FLETCHER JONES FOUNDATION

HUMANITIES IMPRINT

The Fletcher Jones Foundation has endowed this imprint to foster innovative and enduring scholarship in the humanities.

The publisher gratefully acknowledges the generous contribution to this book provided by the Fletcher Jones Foundation Humanities Endowment Fund of the University of California Press Foundation.

OUR DISTANCE FROM GOD

OUR DISTANCE FROM GOD

STUDIES OF THE DIVINE AND THE MUNDANE IN WESTERN ART AND MUSIC

JAMES D. HERBERT

UNIVERSITY OF CALIFORNIA PRESS BERKELEY LOS ANGELES LONDON

University of California Press, one of the most distinguished university presses in
the United States, enriches lives around the world by advancing scholarship in the
humanities, social sciences, and natural sciences. Its activities are supported by the
UC Press Foundation and by philanthropic contributions from individuals and
institutions. For more information, visit www.ucpress.edu.

University of California Press
Berkeley and Los Angeles, California

University of California Press, Ltd.
London, England

Library of Congress Cataloging-in-Publication Data

Herbert, James D., 1959–
 Our distance from God : studies of the divine and the mundane in western art
and music / James D. Herbert.
 p. cm.
 Includes bibliographical references and index.
 ISBN 978-0-520-25213-4 (cloth : alk. paper)
 1. Spirituality in art—Case studies. 2. Spirituality in music—Case studies.
I. Title.
 N8248.S77H47 2008
 701'.1—dc22 2007000246

Manufactured in the United States of America

17 16 15 14 13 12 11 10 09 08
10 9 8 7 6 5 4 3 2 1

The paper used in this publication meets the minimum requirements of ANSI/NISO
z39.48–1992 (R 1997) (*Permanence of Paper*).

CONTENTS

ILLUSTRATIONS

ILLUSTRATIONS

ACKNOWLEDGMENTS

The opening paragraphs of Chapter 1, and a few others later on, served to introduce my essay "Crossroads of the King: The Unity of the Disciplines under the Absolute Monarch," in *The Interdisciplinary Century: Tensions and Convergences in 18th-Century Art, History, and Literature,* edited by Julia Douthwaite and Mary Vidal (Oxford: Voltaire Foundation, 2005), 23–40. After shared beginnings, that essay and Chapter 1 of this book take completely different paths. Chapter 2 appeared in nearly identical form as "The Debts of Divine Music in Wagner's *Ring des Nibelungen," Critical Inquiry* 28 (Spring 2002): 677–708. The first half of Chapter 4 replicates the beginning of "Bad Faith at Coventry: Spence's Cathedral and Britten's *War Requiem," Critical Inquiry* 25 (Spring 1999): 535–65; the second half of the essay as it appears in this book, however, moves in an entirely different direction from the earlier version, turning the former conclusions nearly on their head.

My home institution, the University of California, Irvine, has supported this project over the years of its development with research funds, travel grants, and a publication subvention from the Humanities Center. *Our Distance from God* really took form, however, during a magical research year I spent in Williamstown, Massachusetts, in 2002–3 as a recipient of fellowships from the American Council of Learned Societies and the Clark Art Institute. At the Clark and in the surrounding community, I learned much from conversations with many fine scholars and other friends; I have particularly fond memories of exchanges with Caroline Bruzelius, Sam Edgerton, Peter Elvin, Darby English, Peter Erickson, Tamar Garb, Marc Gotlieb, Werner Gundesheimer, Mark Haxthausen, Guy Hedreen, Michael Ann Holly, Ben Kilborne, Liz McGowan, Karen Merrill, Nick Mirzoeff, Keith Moxey, Carol Ockman, John Onians, Mark Phillips, Ruth Phillips, Richard Rand, Adrian Randolph, Angela Rosenthal, Fronia Simpson, Marc Simpson, Ellen Todd, Martha Umphrey, and Kathleen Wilson.

Many people have contributed to the writing of this book. Their assistance ranges from providing crucial bits of information in response to my queries all the way to reading and commenting on full chapters. For these contributions I am grateful to George and Linda Bauer, Martin Donougho, Steve Felder, Tim Getz, Dan Herbert, Robert Herbert, Julia Lup-

ton, Steve Mailloux, Margie Miles, Mark Poster, Ken Reinhard, Nancy Troy, Jay Twomey, Mary Vidal, Sarah Whiting, and Lori Wike. Margaret Murata was extraordinarily generous with her time and expertise in applying her full musicological rigor to my analysis of Britten's *War Requiem*. Monique Whiting continues in her indispensable role as my consultant for French translation.

The Reverend Canon Justin Welby spontaneously offered a thorough tour of Coventry Cathedral. At the Robert Wilson Archives, Jason Loeffler, Allison Roach, and Carsten Siebert were remarkably generous with their time and resources. Louise Campbell, Brigette Maria Meyer, Lesley Leslie-Spinks, and Richard Sadler all provided photographs from their personal collections, at times under challenging circumstances. Maura Coughlin captured a brilliant detail from Monet's Orangerie. Dan Herbert kindly picked up his architectural pencil again on my behalf. Others have gone out of their way to assist in my acquisition of photographs or rights: Merry Armata, Lei-Lei Fu, Bridget Hanson, Jo Hibbard, Claudia Ponton, David Savage, Ignaz Schön, Anna Shepherd, and Shirley Willis.

At the University of California Press, Stephanie Fay had the tenacity to believe in this project from beginning to end; her occasional copyediting improved the text. Eric Schmidt, and before him, Sigi Nacson, coordinated the production of the book with efficiency and good humor throughout the long process. Lois R. Crum was the sort of copyeditor that authors truly appreciate: meticulous with the details yet respectful of the text. Proofreading with Fronia Simpson was a delight. Jessica Braun designed a handsome volume, while Nicole Hayward fielded frequent questions about photographs and design. Alexander Trotter prepared the index. James Elkins and Whitney Davis identified themselves as external readers of the manuscript, making it possible for me to thank them heartily for their exceptionally rigorous and insightful assessments of the text. The introduction, in particular, benefited from their attention, as each helped me perceive broader themes and relevant contexts that draw the chapters together.

I am grateful to Nicole and Pauline for the divine spark of youth they bring into my life. Above all, I owe enormous and unflagging gratitude to Cécile Whiting: wife and friend, fellow voyager, companion to many a museum and concert, intellectual and spiritual interlocutor, editor of first and last resort. In seeing me through the book, she has seen me through much more than these pages can ever properly acknowledge.

Introduction

It is as if the residence of the king had usurped the proper place of God's own house. A view of the Versailles Palace, engraved by P. Menant during the last years of the reign of Louis XIV, records a shift in the principal object of attention at this public site, accomplished over decades by the grand monarch's massive building campaign (Fig. 1). In medieval ecclesiastical towns (Vézelay, for example), a pilgrim would have traveled down narrow streets bustling with commerce to approach church or cathedral, normatively to the east. At Versailles following Louis's architectural transformations, the visitor approaching the palace advanced up-hill to the west, to encounter not a sanctuary but the king's private rooms, situated at the center of the symmetrical facade. Where was the church? Until the final years of the pious king's reign, a series of provisional chapels were tucked into inconspicuous locations, off in one wing or another.[1] The completion of the permanent chapel in 1710, visible in Menant's print as the tall structure to the right, constituted the only significant addition to the palace during Louis's final decades as monarch. Yet this building, erected well off the palace's main axis, did less to reassert the importance of the Roman Church than to confirm the redirection of devotion toward the French king. God had been shunted to the side. The chapel's altar, which faced back toward the monarch ensconced at the heart of the palace, seems to have been awaiting his attention when he could afford to divert it from the secular realm, whose expanse he perused from the central apartments. In the middle ground of Menant's print, the soldiers and vassals who muster along the sight lines of the centralized monarch view him viewing them more as Frenchmen than as Christians.

Yet religion could not be so easily pushed to the periphery at this birthplace of the modern nation-state. Certainly the artistic program and the rituals venerating the king borrowed heavily from the devotional habits of Christianity. "There is . . . something religious in the respect one gives to the prince," declared Bishop Jacques-Benigne Bossuet, the famed theological apologist for Louis's absolutism. "The service of God and respect for kings are inseparable things."[2] More important, the deity reappears not as a visible entity, but as one that bears indispensable witness. In Menant's view, for whom is the centrality of the king

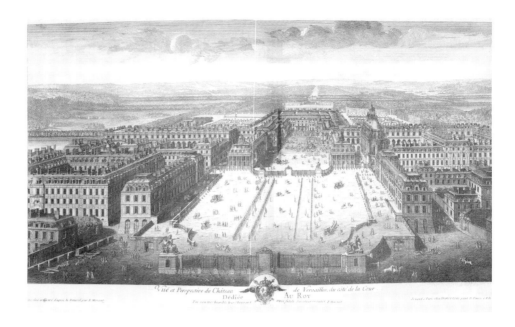

1. P. Menant, *Perspective View of Versailles Palace from the Side of the Court*, 1714–15. Engraving. From *Les Plans, Profils, et Elevations des ville et château de Versailles, avec les bosquests et fontaines, tels quils sont a present; Levez sur les lieux, dessinez et gravez en 1714 et 1715* (Paris: Chez Demortain, [c. 1715]). Collection and photo: University of Delaware, Newark.

performed? For his subjects, to be sure (and we will note their crucial role as spectators of his power), but such a motley of mere mortals had no standing to recognize and endorse the monarch's transcendent oversight of the realm. That called for a higher being—and the engraving obliges. Our vantage lifts high above the earth, which slopes gradually downhill from the palace, to look divinely downward onto the roofs of the edifice. Our slanting perspective little resembles the view of humans who raise their eyes from the streets of Versailles toward the palace. Rather, as in Charles de la Fosse's depiction, its angle replicates the overview of Christ ascending, who gazes down from the chapel's cul-de-four to bless the king worshipping below (Fig. 2). (Indeed, much as Menant's prospect of the palace suspends itself between heaven and earth, that exterior view also shifts somewhat to the right off the main axis, as if seeking a lateral compromise between the position of the grounded humans approaching the facade from straight on and that of the elevated Christ looking down from the displaced sanctuary.) In the ceiling of the chapel, a west-facing God the Father, painted by Antoine Coypel, similarly sanctifies the monarch. To complete the Trinity's consecration of the king, a dove of the Holy Spirit (not visible in Fig. 2), depicted by Jean Jouvenet, seems to descend not just on Mary and the Apostles in the image but also on Louis, standing during holy offices on the royal tribune directly below the picture (in Fig. 2, we see the divinities portrayed by de la Fosse and Coypel from this same platform). With both the westward

prospect of the palace's exterior and the eastward view of the chapel's interior, the king obtains his authority as monarch only if he inherits his excellence from some antecedently glorious being. Such a bequest requires the reintroduction of that eternal benefactor, implicitly or explicitly, into the secular scene.

Our Distance from God explores the repeated emergence of Christian figures, including God the Father and Jesus the Son, and of Christianity's key concepts, such as omniscience and incarnation, in Western art and music from Louis's day to our own. Religious issues arise even in seemingly secular works where we might not expect them, because Christian mysticism and metaphysics thoroughly permeate the rhetoric and sensibility of Western cultural production. According to the philosopher Gianni Vattimo: "Not only the capitalist economy (as shown by Weber), but all the principal traits of western civilization as well are structured by their relation to Judaeo-Christian Scripture, the text upon which this civilization is based. While our civilization no longer explicitly professes itself Christian but rather considers itself by and large a dechristianized, post-Christian, lay civilization, it is nevertheless profoundly shaped by that heritage at its source."[3] Whatever our own religious (or irreligious) tendencies, and irrespective of the manifest content of the artworks we encounter, we look at images, listen to music, and proceed through ritualized space with that sacred legacy forcefully molding our experiences. Our own preferences have no greater effect on the ubiquity of Christian ideas and habits in Western art and music than did Thomas's doubts, or the other disciples' certainty, on the presence of a resurrected Christ behind locked doors (John 20:19–29). Unlike Thomas, however, we will not spend much time looking at Christ, let alone probe his wounds. The argument of this book seldom involves examining the figural representation of deities.[4] In *Our Distance from God,* the divine emerges more often as the subject of sight and sound than as their object. In the case studies that follow, art and music address audiences presupposed to possess characteristics such as omnipresence, linguistic transparency, and ethical certainty that are attributable only to entities greater than humans. Such qualities in the Western cultural heritage are associated most often with the first or second "persons" of the Trinity. Because the works also engage human viewers and auditors, they inevitably posit relations between the two audiences. The crux of this study rests on the relative positioning of celestial and terrestrial audiences. To what degree can humans lay claim to divine attributes? To what extent are they drawn together as humans by their shared exclusion from the places of God? Since we are dealing with two species of subject, however, we explore only half the dynamic if we investigate only mortals. We need to ask with equal analytic rigor: How much does God invest himself in the human realm? How far does he hold himself apart?

We can examine the character and qualities of those human and divine actions, I contend, without presupposing the actual existence of the actors. Louis XIV need not have been present behind the central windows of the palace, during his time or since, for his posited centrality to structure the space in front of it. Claims that deal with divinity are more contentious. And here I ask readers to join me in what might at first appear to be a dodge. I

2. *Perspective View of the Chapel of the Royal Palace of Versailles*, 1714–15. Engraving. From *Les Plans, Profils, et Elevations des ville et château de Versailles, avec les bosquests et fontaines, tels quils sont a present; Levez sur les lieux, dessinez et gravez en 1714 et 1715* (Paris: Chez Demortain, [c. 1715]). In cul-de-four: Charles de la Fosse, *Resurrection of Christ*, 1708–10. In clerestory: Antoine Coypel, *God the Father in Glory*, 1708–10. Collection and photo: University of Delaware, Newark.

hope that the questions I pose about "address" and "relations" can sidestep the persistent ontological conundrum of God's existence. Even as it recognizes that religious presuppositions shape perceptions, this book neither assumes nor excludes a readership of believers. We need not contend that God actually descends to analyze how his presence might be felt in art and music; neither need we assert that such feeling must be nothing more than a human sentiment, with no possible bearing on the divine. I hold the ontological question in abeyance not out of theological diffidence—though, as a nontheologian, I admit to a healthy measure of that sentiment—or to avoid dividing readers into two antagonistic camps, those who share faith with the author in whatever doctrines he may profess and those who reject them. (As my argument develops, however, preventing such divisiveness will prove to be of substantive, not just rhetorical, importance.) Rather, I set aside the question of the existence of God because I regard that suspension to be a precondition for this study to proceed meaningfully.

The philosopher Jean-Luc Marion has built a compelling case, "written at the border between philosophy and theology," for refraining from ontological claims about God.[5] Marion has often been paired with Jacques Derrida in the literature that describes the poststructuralist engagement with religion. The two are considered to represent significant challenges to "onto-theology," the term coined by Martin Heidegger for the philosophical error of claiming God, or any other transcendent entity, as the ground for all being. Marion and Derrida, each in his way, invoke the heritage of apophaticism, or negative theology, which maintains that we can ascertain only what God is not, naming things that lie within the realm of human comprehension, not what he is, which transcends any such limited understanding. Apophatic thought stands as an alternative to the excessive claims of onto-theology (although Derrida suggests that much negative theology actually forwards onto-theological propositions).[6]

Marion writes in the preface to the English edition of his book *God without Being:*

> I am attempting to bring out the absolute freedom of God with regard to all determinations, including, first of all, the basic condition that renders all other conditions possible and even necessary—for us, humans—the fact of Being. Because, *for us,* as for all the beings of the world, it is first necessary "to be" in order, indissolubly, "to live and to move" (Acts 17:28), and thus eventually also to love. But *for God,* if at least we resist the temptation to reduce him immediately to our own measure, does the same still apply? Or, on the contrary, are not all the determinations that are necessary for the finite reversed for Him, and for Him alone? (xx)

Marion's rhetorical questions telegraph his answers. Being (capitalization registers Marion's working of Heideggerian categories) enters human cognition only as a concept. In that form it imposes our mortal limits on whatever it contains. That is to say, Being taints that to which it is ascribed with our inherent finitude, with our incapacity to envisage endless expanse or absolute purity. A God who *is*—which is to say, a God to whom we attribute our idea of

existence—is a God who fails to surpass human measure and thus is no God at all, but only our idea of him. Marion explains:

> The concept consigns to a sign what at first the mind grasps with it (*concipere, capere*); but such a grasp is measured not so much by the amplitude of the divine as by the scope of a *capacitas,* which can fix the divine in a specific concept only at the moment when a conception of the divine fills it, hence appeases, stops, and freezes it. When a philosophical thought expresses a concept of what it then names "God," this concept functions exactly as an idol. . . . The idolatrous concept of "God" appears, where, more than God, thought judges itself. (16)

Granting God existence does not bring him forth for us to consider but rather occludes him behind our own opaque concept. Denying him has precisely the same effect: The negation idolatrously assigns to him the humanly defined attribute of not-Being.

Marion proposes instead that we receive God—God's giving himself to humanity not as Being but as an overwhelming, excessive, undeserved gift of love *[agapē]*—through our recognition of our distance from him. Distance, paradoxically, both removes him from us and draws him near. "Between [the] gaze [of God] and the world, distance is established, a gap that unites as much as it separates, a gap whose first term cannot but comprehend the incomprehensibility of the second, a gap, therefore, that offers itself less to be conceived or reduced than to be traversed and inhabited" (129). Suppose we let go of the delusion that God can be captured within any idol of our own making. If we do, we open ourselves to the possibility (though hardly the certainty) of discerning the miraculous expansiveness, necessarily greater than either our being or our concepts, that the gift both unfurls without limit and traverses back to us. As Marion declares in his earlier book *The Idol and Distance:* "God withdraws in the distance, unthinkable, unconditioned, and therefore infinitely closer."[7]

If the idol is Marion's figure for the doomed effort to collapse distance to render God present in the object, the icon is his means of confronting the expanse always held open between fathomable humanity and a depthless deity. In *The Idol and Distance,* Marion describes Christ (rather than any image of him) as the perfect instance of the icon:

> [The icon] is the figure not of a God who in that figure would lose its invisibility in order to become known to us to the point of familiarity, but of a Father who radiates with a definitive and irreducible transcendence all the more insofar as he unreservedly gives that transcendence to be seen in his Son. The depth of the visible face of the Son delivers to the gaze the invisibility of the Father as such. The icon manifests neither the human face nor the divine nature that no one could envisage but, as the theologians of the icon said, the relation of the one to the other in the hypostasis, the person. The icon conceals and reveals that upon which it rests: the separation in it between the divine and its face. Visibility of the invisible, a visibility where the invisible gives itself to be seen as such, the icon reinforces the one through the other. The separation that joins them in their very irreducibility finally constitutes the ground of the icon. *Distance,* which it is above all no longer a question of

abolishing, but of recognizing, becomes the motif of vision. . . . The icon [offers] a sort of negative theophany [appearance of God]: the figure remains authentically insurpassable (norm, self-reference) only in that it opens in its depth upon an invisibility whose distance it does not abolish but reveals. (8–9)

The icon, rather than representing an essence, presents a relation.

Our Distance from God ventures into the strange expanse between God and humanity rid of the metaphysical miasma of presupposed Being or non-Being. It does so through the felicitous means provided by a set of cultural artifacts: works of art and music produced in Europe and America over the past three and a half centuries, each preserving a tension between near and far in the manner of Marion's icon. The book is an exercise in what might be called a theology of art, similar to what we have grown accustomed to speaking of as the social history of art. The social history of art recognizes how certain privileged objects— paintings, say, or symphonies—engage and elucidate the social conditions of their day; an understanding of social conditions, in turn, reveals unexpected facets of the works of art. Likewise, works of art may throw light on particular theological debates, and theological issues may draw attention to aspects of the art not otherwise noticeable.

I attempt to demonstrate here that works in the visual arts enable exploration of issues raised by distance of this theological sort. To be sure, pictures, with the tension they are able to sustain between their own proximate surfaces and manifold illusions of depth, have long declaimed effectively about mundane distance, space as we encounter it in this world. They do so, moreover, often without fussing over ontological claims. Because we accept that the depiction of remote space may legitimately range from straight transcription to pure fiction, we can analyze the structure and quality of perceived depth without first needing to ascertain its existence.

Art history as a discipline attends closely to the hold of images on space, actual or imagined. Recently David Summers, in his magisterially ambitious *Real Spaces: World Art History and the Rise of Western Modernism,* has traced an evolution through three major stages of spatial presentation. First, "planar" images, such as bas-reliefs depicting frontal, static figures, posit only the shallowest of spaces, if they offer any intimation of spatial recession at all. Second, "virtual" images—which, despite the strong connotations of the digital age currently carried by the term, Summers associates instead with the paradigm of Renaissance perspective—create compelling illusions of great distances extending into depth, each prospect to be witnessed from an individuated viewpoint that is itself a certain specified distance from the picture plane. Third, the modern regime of "metaopticality" abstracts any such singular viewpoint to suggest instead "an infinite, isometric matrix" of the three-dimensional coordinate grid expanding without limit in all directions and thus "independent of a viewer."[8] In Summers's account, metaopticality, "the universal metric space of modern Western physics and technology," is decidedly secular; the sacred manifests itself much

more in his early chapters on centered places (21). Art historians preceding Summers have often conflated the abstract grid of metaopticality with the rigorous geometries of linear perspective—Summers's "virtuality." Certainly Renaissance perspective constitutes an epochal transformation in the capacity of images to posit vast distances across such open spaces as urban plazas paved in regular patterns and surrounded by rectilinear buildings, and over the decades art historians have developed highly sophisticated accounts of its mechanisms and importance.[9]

Yet the secular depths proffered by linear perspective contain unexpected miracles of their own, replete with intimations of the divine. No one has captured that paradox more eloquently than Erwin Panofsky, whose *Perspective as Symbolic Form,* first published in 1927, has emerged as a foundational text for all subsequent discussions of perspective. Owing to the invention of the vanishing point as the "infinitely distant point of all orthogonals" and the sense that "*imagined* space now reaches out in all directions beyond *represented* space," Panofsky argued, "the finiteness of the picture makes perceptible the infiniteness and continuity of space."[10] Consequently, in perspectival paintings of the Renaissance, "the world . . . outgrew divine omnipotence, with an almost religious sublimity of its own" (66). Yet, where to locate that infinity? "Perspective creates distance between human beings and things," Panofsky continued, "but then in turn it abolishes this distance by, in a sense, drawing this world of things, an autonomous world confronting the individual, into the eye. . . . [with its] subjective 'point of view'" (67). The result has theological implications for the beholder. "Perspective, in transforming *ousia* (reality) into *phainomenon* (appearance), seems to reduce the divine to a mere subject matter for human consciousness; but for that very reason, conversely, it expands human consciousness into a vessel for the divine" (72). The mind might attempt to contain the sacred in its concepts in the manner of Marion's idol, but the sacred responds by radically enlarging the mind, exploding its human limits.

Perspective is hardly the only means of conceiving distance and space that aches to break beyond the mundane. Karsten Harries has argued that modern scientific space—in other words, Summers's metaopticality—owes its infinite character directly to the heritage of premodern theological beliefs about the unlimited expanse of God. Thus, according to a line of thought recounted by Harries, humans manifest divine pretensions when they accede to such perspectiveless perception:

Descartes drew his psychology from the angelology of St. Thomas. . . . There is indeed something angelic about the point of view claimed by the new science, a point of view that really is no longer such, for it claims to have left behind the perspectival distortions characteristic of points of view. . . . The idea of objectivity . . . is tied to the idea of a knowing that is free from perspectival distortion, an angelic, divine, or ideal knowing. It is thus linked to the idea of a knower not imprisoned in the body and not bound by the senses, a pure subject. . . . Heidegger, in *Being and Time,* claims that in appealing to an idealized subject, to a pure ego, or to an ideal observer, we illegitimately read the traditional understanding of God into the human subject.[11]

Regardless of the legitimacy of the human epistemic aspirations involved (a question Marion might address), it should be evident that the divine is never much further away than the images and sights arising before our mundane eyes.

In *Our Distance from God* I explore just this opening up of the depiction of mundane distance onto the proximity of the divine. Through a variety of technical devices, of which the perspectival plunge in Menant's engraving of Versailles Palace is only the most obvious example, Western images juxtapose the obdurate reality of their flat surfaces with the illusion of space yawning, even infinitely, elsewhere. Actual spaces shaped by architecture, landscape design, and sculpture, when passed through, can also intimate divine distance and proximity. As it considers such matters, this book might be seen as, among other things, an extension of the existing literature on pictorial space. My analysis supplements existing accounts of how images and places engage secular space by examining the reach of visual artifacts toward the divine, a reach that acknowledges that realm's irrevocable distance from us but also draws it impossibly near.

It could be objected that to read theological significance into pictorial or actual space is to conflate literal distance with a figurative reading of it and that such a confusion deludes us into imagining a leap from the prosaic to the profound. But the point is precisely that pictures and places, by activating that miraculous uncertainty, may provide a rare and fantastic way to think of distance as something more than its mundane self. We can also invert the formulation: The only expanse that really matters is the literal infinity that separates us from, and unites us with, God; against it the spaces we actually experience, in life as in art, are but finite figurations of the awesome possibility of the gift's traversal across the limitless gap. Whatever the direction the speculative extension takes—from mundane to divine, or from divine to mundane—the spatial dispositions of visual art call forth, and simultaneously are called forth by, the remove that separates and unites humanity and God, without distance thereby either acceding to Being or fading into chimera.

To pit the literal against the figurative evokes a second type of distance: between a representation, as actual cultural artifact present before us, and what it represents, absented by that very act of representation. In the business of cultural analysis we have grown savvy—perhaps unto weariness—about the inevitable gap between signifier and signified, which can be bridged only provisionally through the endless deferral of such difference. Because the semiotic remove imposed by Derridian *différance* closely resembles the chasm across which religious faith must leap, an analogy between deconstruction and negative theology can easily be drawn. Yet we may deny ourselves a form of expansiveness if we resign ourselves too quickly, with too much certainty, to the immobility imposed by the looming abyss of language. Marion, again, proposes an alternative:

Christ calls himself the Word. He does not speak words inspired by Gᴑd concerning Gᴑd ["let us cross out Gᴑd with a cross, provisionally of St. Andrew, which demonstrates the limit of the temptation, conscious or naïve, to blaspheme the unthinkable in an idol"], but he abolishes in

himself the gap between the speaker who states (prophet or scribe) and the sign (speech or text); he abolishes this first gap only in abolishing a second, more fundamental gap, in us, men: the gap between the sign and the referent. In short, Christ does not say the word, he says *himself* the Word. He says *himself*—the Word! Word, because he is said and proffered through and through. As in him coincide—or rather commune—the sign, the locutor, and the referent that elsewhere the human experience of language irremediably dissociates, he merits, contrary to our shattered, inspiring or devalued words, to be said, with a capital, the Word.[12]

We cannot say that the literal, historical Jesus functions merely as a figure (Word as merely words) for the divine, transcendent God—or rather, we cannot say so without exercising the sort of metaphysical partitioning against which Marion warns us, which cuts off theological inquiry before it even starts. Nor can we say that our experience or description of Jesus makes the divine fully present (mere words as Word), for that would treat Christ as an idol rather than an icon and claim divine linguistic capacities as our own. Instead, Jesus, as Word, is literally what he figures, and he figures what he literally is. Here the ambiguous phrase "as Word" itself stands neither as given fact nor as rhetorical device, but as a suspension of the difference between them. Likewise, in reading Marion, each of us faces the choice of reading his description of the Word either literally or as a massive figuration for the lack of figuration. The power of each formulation depends on keeping that choice open, so that the words function iconically to activate the relation between near and far. The Incarnation is but one of many forms of an idea we will encounter in this book: that the language of God makes present exactly what it represents, with no gap for him between selfsame signifier and signified.[13] We, in contrast, remain uncertain of our distance from such linguistic immediacy. Sometimes we feel closer to it; at other times, further away.

If the visual arts allow us to reflect on the theological implications of distance as physical remove, music proves an apt medium for considering the possible diminution or obviation of the chasm between sign and referent—though the visual arts also sometimes attempt to bridge that gap. Aside from the occasional chirping of a bird or the rumble of artillery (we will have occasion to hear both), music tends not to mimic the sounds produced elsewhere in the world. For the most part, each tone enters the air as nothing other than itself. A fiddle or flute playing middle C does not represent that note, as if the real tone existed elsewhere. It manifests it here, in the present. Similarly, auditors do not hear a representation of a musical passage. They hear that passage itself. We need not be seduced by these qualities into believing that music literally abolishes the human semantic abyss to become a divine language— although, as we shall see, Schopenhauer, and through him Wagner and the young Nietzsche, appear to have been drawn toward that siren song. All we need do is recognize that music's self-presence, when combined with whatever meaning it evokes (and thus also holds at a distance), renders the art form a perfect vehicle for investigating the expansive territory that may lie between the endless turns of human rhetoric and the ostensible immediacy of di-

vine language. Whether literally or figuratively, music plays celestial literalism and terrestrial figuration in counterpoint.

In *Our Distance from God* I focus on specific works of art and music that I consider propitious for studying the dynamics of divine distance. Other religions may raise similar issues about the separation and union of humans and gods, but this book draws almost exclusively from Christian texts and doctrine. On several occasions in the early chapters, cultural artifacts rely on defunct religions—classical myths, Teutonic and Nordic legends—to thematize divine qualities attributed in actual religious practice to the Christian Father or Son. For the purposes of this book, Louis XIV's Olympian gods are thoroughly Christianized, as are Wagner's source texts in Old Norse and Middle High German. I focus on Christianity in part because of its historical appropriateness: all the works of art and music I examine here were created in a modern Euro-American context thoroughly steeped in the Christian legacy, either overtly or in its secularized forms. Equally important, the way Christianity deals with divine distance and the traversal of it facilitates its application to the analysis of human cultural artifacts. If the works I select are well suited to the elucidation of Christian doctrine, then Christian doctrine also casts much light on these particular works. The circularity engendered by historical context enables rather than compromises the study.

First, the Christian doctrine of kenosis—whereby Jesus, though "in the form of God . . . [in] equality with God," nonetheless "emptied himself" to be "born in human likeness" and thus "humbled himself" to all corporeal indignities including death—implies a choice on the part of the Godhead to enter freely into the mundane (Philippians 2:6–8).[14] The Incarnation, in Vattimo's words, represents "God's renunciation of his own sovereign transcendence." Vattimo cautions that we need to "be suspicious of an excessive emphasis on the transcendence of God, as mystery, radical alterity, and paradox" if we are to attend to the possibility of his continuing engagement in our secular affairs: "Kenosis, having begun with the incarnation of Christ, but even before that with the covenant between God and 'his' people, continues to realize itself more and more clearly by furthering the education of mankind concerning the overcoming of originary violence essential to the sacred and to social life itself."[15] Against Vattimo's optimism we might pit an alternative Christian thematic, recounted by Richard Elliott Friedman, that has God increasingly distancing himself from the terrestrial realm following a very busy first week and his later direct dialogue with the early tribes.[16] For the purposes of this book, we need not determine whether God is coming or going. What matters is that this age-old debate demonstrates how Christian theology itself formulates a problematic of passage between the divine and the mundane, opening up the same ambiguous territory explored here.

Second, the divine conflation of text and referent does not reside solely in the Incarnation; Christian doctrine repeatedly engages the possibility of an essence embodied directly in its sign. The sacrament of the Eucharist emerges often in the chapters of this book as a theological model—used by historical actors, and perhaps by us—for imagining the mirac-

ulous manifestation of the inaccessible within what lies close at hand. Yet Christianity also carries in it a deep suspicion (Marion is hardly the first to express it) of any such claim to divine presence in the object: "You shall not make for yourself an idol, whether in the form of anything that is in heaven above, or that is on the earth beneath" (Exodus 20:4). Indeed, we can regard the Crucifixion itself as the initial, and ultimate, expression of this icono-clastic impulse if we consider it not as a political act (Pilate eliminating "the King of the Jews," a potential rival to Rome's authority) but as internecine Jewish rage to destroy that which presents itself as divine embodiment ("The Jews answered [Pilate], 'We have a law, and according to that law he ought to die because he has claimed to be the Son of God'" [John 19:7]).[17] As in disagreements over the Godhead's kenotic extension into our world, the potency of the Christian precedent for my analysis of representation lies not in settled doctrine but in unresolved debate: How much of the absent essence can be made present in the sign?

Third, Christianity offers an intriguing vision of community that suggests a different species of distance in this book's case studies: not the expanse that separates and unites hu-manity and God or the sign and its referent, but the gaps—spatial, temporal, social, ideologi-cal, temperamental—that differentiate one set of human viewers or auditors from another. For whom did Christ die? Ever since the church's first textual manifestations in the Epistles of Paul, Christianity has worried that question, perhaps more than any other. Historically, Jesus was one in a line of apocalyptic prophets preaching in the context of Palestinian Ju-daism; and Daniel Boyarin maintains that even Saint Paul "lived and died convinced that he was a Jew living out Judaism."[18] In a society of the first century characterized by sharp ethnic and cultural divisions, both Jesus and Paul might well have seemed destined to speak only to Jews descended from Abraham, the people purportedly chosen by God. Paul, how-ever, took the astounding initiative of bringing the teachings of Christ to the Gentiles, pro-pounding a radical message of pan-ethnic universalism: "In Christ Jesus you are all children of God through faith. . . . There is no longer Jew or Greek, there is no longer slave or free, there is no longer male and female; for all of you are one in Christ Jesus" (Galatians 3:26, 28).

History offers ample evidence that this fantastic proposal for boundless human unity is not without its difficulties. Boyarin's study of Paul, an excellent examination of the tension in the Epistles between Jewish particularity and Christian universalism, points us toward two troubling issues. First, tolerance of diversity risks indifference toward distinctiveness, so that physical or cultural attributes cherished by an individual or group lose their salience when superseded by an all-encompassing spirit. Second, the granting of a name—"Jesus Christ" or any other—to the entity that purports to embody communion necessarily ex-cludes from unity anyone who refuses that name. As Boyarin writes: "Tolerance . . . deprives difference of the right to be different, dissolving all others into a single essence in which mat-ters of cultural practice are irrelevant and only faith in Christ is significant" (8). The predica-ments are both debilitating and inexorable, yet we can no more avoid them by foreswearing

universalism than by embracing it. Boyarin continues: "Paul's gospel *was* one of tolerance . . . [but] tolerance itself is flawed—in Paul, as it is today. Its opposite—by which I do not mean intolerance but insistence on the special value of particularity—is equally flawed. . . . The claims of difference and the desire for universality are both—contradictorily—necessary; both are also equally problematic. . . . [Neither] can be ignored or dismissed because of the reactionary uses to which it can and has been put" (10). In human practice, universality can never shed its cultural specificity; particularity always summarily excludes. We live daily with both dilemmas.

Nonetheless, Marion's concepts of idol and icon may offer new hope for Paul's declaration of unlimited inclusiveness. Let us imagine, without making any claim for its Being, that universality freed from all cultural specificity resides properly in the realm of the divine. (Where else could we posit it?) The error would then lie in the attempt to "fix," in any human manifestation of it, "distant and diffuse [universality] and assure us of its presence, of its power, of its availability" (here and in the next few sentences, I am interpolating the Pauline terms into the place of "divinity" or "divine" in Marion's descriptions of the idol and the icon).[19] In that case, universality is fixed in the idol "on the basis of the experience of the [universal] that is had by man," which means it is always particular to a certain place and time (5). Even Paul—the human, which is to say, the Greek Jew, the citizen of Rome, and so forth—cannot avoid such idolatry when he finds universality in the figure of *his* encounter with God, namely, in Jesus Christ. "The idol reflects back to us, in the face of a god, our own experience of the [universal]" (6).

What if, however, we approach universality by regarding it instead as an icon? Then each particularized striving toward it within human affairs becomes the "visible face" that "delivers to the gaze the invisibility" of boundless, divine universality (8). "The icon manifests neither the . . . face [of human practice] nor the [boundless universal] that no one could envisage, but . . . the relation of the one to the other. The icon conceals and reveals that upon which it rests: the separation in it between the [universal] and its [manifestations]" (8). By these lights, the key term in Paul's statement is not "Christ Jesus," a particularized name susceptible to idolatry, but the prepositional phrase "through faith": faith not as belief—a modern notion of intellectual assent, full of onto-theological implications, probably absent from Paul's Greek—but rather faith as trust. Faith then stands as a relation, in place of Christ as an essence, because that in which we must trust is the unverifiable proposition that, "through the separation that joins them," our good-faith effort toward communion in practice bears some indiscernible resemblance to an absolute universality, whose character we can never know (8). This approach addresses, without ever solving, both of the difficulties Boyarin identifies in Paul's formulation. Divine universality remains untainted by human cultural specificity owing to the distance it maintains from it (just as God, through distance, remains untainted by the human concept of Being); and human particularities, rather than needing to be effaced in order to make way for a hegemonic sameness, can be valued precisely because they stand in unassimilable relation to divine universality. In Galatians 3, a key text in

the Christian heritage, great potency flows from this opening up of the expanse between the mundane and the divine, across which new forms of communion might be imagined. The chapters that follow repeatedly describe instances of human viewers drawn closer to each other, provisionally overcoming the potential isolation of their particularities, less because of their common subscription to a given doctrine than because of their shared distance from God. That miracle, as improbable as kenosis and incarnation, depends on locating in the realm of the divine the principle of unity beyond all cultural particularities.

I can now confess: I would like the first-person possessive pronoun in the title *Our Distance from God* to activate precisely this tension. It should chafe a bit in its seeming presumption that readers share with this author any relation—even one based on distance—to this particular divinity, God. In the slight discomfort to which the attachment of that sentiment to a scholarly book might give rise, we can recognize the constraints and exclusions activated by any appeal to shared acceptance or rejection (actions equally onto-theological) of any transcendent entity. Yet the pronoun should also hint at the astounding possibility of union achieved through our exploration of that relation together, despite our inevitable differences. Through the separation that joins, "our" should emerge not as an idol of theological or scholarly cultishness but as an icon of the expanse where distinctiveness and community might join.

Community involves more than establishing a circle of identification, however particular or universal. It also necessitates some degree of acceptance that standards of behavior cannot be solely of one's own making. "Ethics," Rowan Williams, the current archbishop of Canterbury, has written, "is nothing if not a discipline for evaluating and judging local or individual claims to know the good in light of accounts of the good that are not purely local or individual."[20] The problem, as Williams recognizes, lies in the fact that no horizon of inclusivity envisaged by humans, however expansive it may be imagined, can ensure that the particularities of local interest have been overcome; the locality just gets defined at an ever larger scale. I argue that disinterested ethics, like nonparticularized universality, can exist only at a divine remove, which is also to say, in miraculous proximity. Ethics requires a certainty that transcends human bias, as if it were divine. We can aspire to that standard, be it projected or real, yet we should never presume to be certain of it, because we are human.

Our Distance from God offers five case studies of art and music, ranging over three and a half centuries and two continents, that systematically explore these three axes of distance and traversal: the positional, the semiotic, and the ethical. I intend for each study to both shed light on the particular artifacts and contexts involved and build on the other studies, evoking historical and thematic patterns greater than the individual cases. To counter the still distressingly prevalent historiographical tendency to regard modernization as a steady move away from the church, the chapters progress from instances in which religion remains implicit toward ones with explicit Christian concerns. Yet, I argue, overt piety may at times curb the human arrogation of divine attributes, as viewers and auditors confront directly the ineluctable difference between their encounters with either artwork or world, on the one

hand, and perceptions practiced by or proffered to a deity, or precepts held by God, on the other. The chapters systematically introduce cases in which human attempts to claim divine qualities inevitably fail, followed by instances in which humility in face of the divine may, paradoxically, allow a miraculous expansion beyond the mortal self.

Chapter 1, on Louis XIV's Versailles, examines royal claims to divine omnipresence, omniscience, and omnipotence. Building on a juxtaposition of a painting of the panoramic view from the king's bedroom (the inverse of the image that opens this Introduction) and a map of the town and the royal grounds commissioned by the monarch, my analysis engages architecture, sculpture, and portraits of the king. As the personification of ubiquity in a single mortal body, Louis could not help placing himself in an impossible dynamic whereby the very centeredness of his power and knowledge demanded simultaneously a dispersal of his presence into the furthest corners of his realm.

Chapter 2, an analysis of Wagner's *Ring of the Nibelung,* explores how the composer could imagine that his musical leitmotifs might communicate in a transparent, tropeless manner akin to the pure language of God. Wagner strove first to realize such expression free of the distortions of rhetoric, and then to pass that capacity on to his human audience at Bayreuth, a gift of the divine. I argue that the very mechanisms that transfer his ambitious bequest may have dragged music back into the realm of human linguistic exchange.

Chapter 3 looks at Claude Monet's enormous valedictory paintings of water lilies, installed permanently in the Orangerie in the Tuileries Gardens at the heart of Paris. The floor plan of the building resembles that of a small church, and the visitors' passage through the spaces takes on a familiar liturgical character. I demonstrate how the deployment of pond scenes posits a position of omniscient perception at the center of each of the two main rooms of the installation. Yet the special character of these rooms lies in their capacity to prod visitors away from those impossibly divine central spots and toward the human periphery. Once there, viewers encounter the painted surfaces of Monet's canvas according to a logic inherited from the Eucharist: as a presence of some spiritual essence not manifest in "accidental" physical characteristics of paint. In short, the Orangerie in Chapter 3 emerges as my foil to both the Versailles of Chapter 1 and the *Ring* cycle of Chapter 2: visitors there accept both human situatedness (with an inkling of omniscience elsewhere) and human representation (with intimations of presence even in the vacated sign).

Chapter 4 treats Basil Spence's cathedral at Coventry, consecrated in 1962 as a replacement for the structure destroyed during the German bombardment, and Benjamin Britten's *War Requiem,* commissioned for that consecration. Examining the resulting dialogue between architecture and music—and internally in both edifice and requiem, the interplays between past and present, mundane and divine, and good and evil—I uncover complex moral dilemmas raised by the simultaneous imperatives to assign war guilt and to forgive the atrocities of combat. The interchanges between and within cathedral and musical piece, I argue, demand both the benchmark of divinely sanctioned ethics and an acknowledgment that humans dare not claim that benchmark as securely their own. In other words, as the first three

chapters in combination explore the divine and mundane aspects of location and language, Chapter 4 investigates the two sides of ethics.

Robert Wilson's work *14 Stations,* the subject of Chapter 5, tips the balance decidedly toward a recognition of human limitations in all three regards: location, language, and ethics. This complex sight-and-sound installation, first mounted as a feature to supplement the Oberammergau Passion play in 2000 and moved to the Massachusetts Museum of Contemporary Art in 2001, presents the visitor—whether Passion-play pilgrim or art-museum habitué—with the choice of identifying with Jesus as he walks down the *Via Crucis,* the Way of the Cross. A double uncertainty marks any such empathetic response: how much is a contemporary viewer willing and able to identify with Jesus; and to what degree can Christ be considered, in the words of the Definition of the Council of Chalcedon of 451, "of one substance . . . with the Father as regards his Godhead, and at the same time of one substance with us as regards his manhood"?[21] I will argue that the mystery of the Incarnation proposes a route to the divine distinct from the fruitless attempt to arrogate godly attributes directly. Only through the full embrace of the imperfections of humanity does the human open itself to the expansiveness of divine grace.

If we are to sound out the elusive relation between humans and God, ultimately we must strive for such humility. Louis XIV, by all indications, possessed no great measure of that attribute. Irrespective of the oxymoronic character of embodied omnipresence, Versailles had the monarch float atop the contradiction as if it did not exist rather than plunge into the heart of it. Wagner similarly cherished godly aspirations for himself and his human audience, and—in the manner of the good entrepreneur that he was—attempted to bargain his way out of the dilemma. Only when we move to Monet's Orangerie do we encounter a place that realizes the limitations, and the liberations, that letting go of divine hubris entails. At Coventry, ethics becomes possible only when its human practitioners recognize the necessity of terrestrial distance from a celestial moral standard—though they need not abandon the possibility that such a standard exists. With *14 Stations,* paradoxically, we only really begin to approach the transcendent when we embrace our humble earthly existence. We only intuit the possibility of expanding beyond our human shell when we surrender ourselves to the reality of that imperfect, transient casing. That surrender is a choice that I would ask you to consider making with me as you read this book. We can recognize that the argument need not and cannot master the large spiritual issues at hand but can only live within the spaces that they open. We might grant the artifacts we study the freedom to break beyond any human attempt to make sense of them, including our own. Perhaps then we may glimpse that which will always exceed us and acknowledge our fellowship with all those who before us have aspired to such impossible, miraculous insight.

Louis XIV's Versailles

1. A MAN AT THE WINDOW AND THE EYE OF GOD

Jean-Baptiste Martin's view facing east from the center of the facade of Versailles Palace, painted well into the reign of Louis XIV after most of the construction on the complex had been completed, proffers much: courtiers poised for court and soldiers earnest at drill, coaches arriving from destinations afar (Plate 1). And down what impressive roads the carriages travel! The all-important Avenue de Paris claims the axis, even though the highway will need to veer left beyond this picture's horizon to arrive at the capital. The avenues of Saint-Cloud and of Sceaux enter the broad plaza from either side just beyond the farther of the two gilt barriers. These two roads, somewhat disguised because they parallel the slopes of the Mansart roofs of the nearby Royal Court, also re-emerge beyond the middle-ground Ministers' Wings (those familiar with the town plan's compelling geometry would know to look for them, and they can be seen clearly in Figs. 3 and 4). Between these roads opens up the wide expanse that fills the background of the picture. The three avenues form the three prongs of an acute arrow pointing toward the vantage this image posits. The semicircular courts of the stables to the left and right of the Avenue de Paris, with trains of horsemen flowing across them, further focus attention on this spot. Martin's painting declares the king's private apartments at the center of the palace's facade the proper place for the monarch to oversee his domain. Since 1668 the room at the exact center had been known as the Grand Salon. Before the completion of the Hall of Mirrors in 1679, it served as a principal reception room; afterward it became the king's changing room. In 1701 the room assumed its current configuration as the king's bedroom, with the monarch's bed placed perfectly on the axis defined by the Avenue de Paris that points directly at these windows.[1]

The picture has yet higher aspirations for Louis. The viewpoint rises out of his rooms to above the cornices of the facade, visible along the wings. Other images executed for the court lift the vantage further: to a bird's-eye perspective, in Israël Silvestre's drawing of the palace from around 1690; to the view from straight above, in a map engraved by Pierre Le Pautre

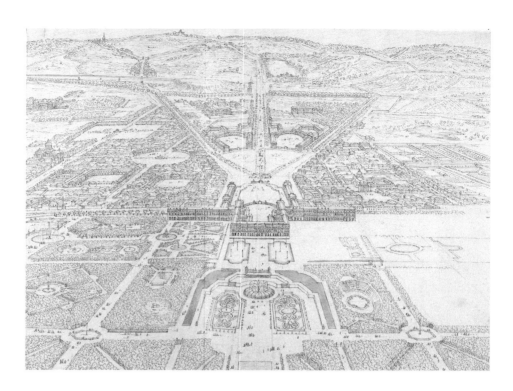

3. Israël Silvestre, *Perspective above Versailles*, c. 1690. Drawing. Musée du Louvre, Paris. Photo: Réunion des Musées Nationaux, Paris / Art Resource, New York.

during the final years of the monarch's reign (Figs. 3 and 4).[2] This plan, beyond showing how the three avenues target the palace's central facade, proposes an eye capable of ascending beyond such terrestrial traffic to behold the full extent of the palace and its grounds. A painting in perspective and a map: these two artifacts exemplify the two poles of vision made available to the monarch. In the play between them will appear competing claims for the humanity and the divinity of the king.[3]

Allen S. Weiss, discussing the ideas of René Descartes in relation to formal gardens of the day, remarks: "Every viewpoint can be deduced from the universal position of God, for whom all viewpoints are instantaneously accessible. Such is the basis of the Cartesian model of spatiality, where depth is but a result of the very incapacity of perception. . . . Depth exists because man is not God."[4] The actual Louis looking out the front window, or the elevated monarch posited a bit higher by Martin's painting, sees a single perspective. Depth exists for him—lots of it. The three avenues, radiating out to cover an ever wider expanse of land, promise to grasp as between fingers the accumulating riches of the vast realm. Nonetheless, in the Cartesian terms described by Weiss, the king claims his kingdom only in a limited way. To the extent that he has it in depth he has it only as a human, not with the omniscience and omnipresence of God.

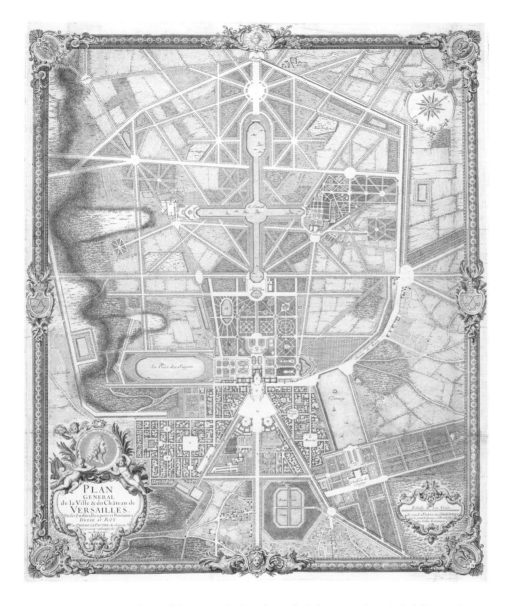

4. Pierre Le Pautre, *General Map of the Town and Palace of Versailles* (side text panels not included), 1717. Engraving. Cartes et Plans [Ge C 9183], Bibliothèque Nationale de France, Paris. Photo: Bibliothèque Nationale de France, Paris.

How different the view offered by Le Pautre's map! Devoid of perspective, the map renders each place in the landscape as though from directly above. If the territory can be said to seen by an eye, then it must be one like God's that can be many places at the same time. The heavy border engraved along the edges of the map, although it hems in vision, also represents an arbitrary imposition, for the cartographer, at the whim and command of the

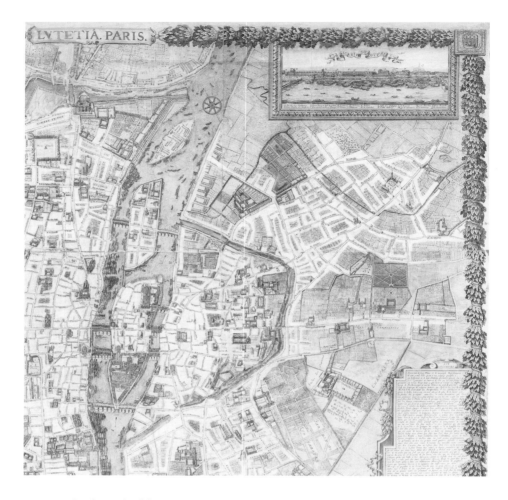

5. Jacques Gomboust, detail from *Lutetia, Paris*, 1652. Engraving. Cartes et Plans [Ge AA 573 Rés], Bibliothèque Nationale de France, Paris. Photo: Bibliothèque Nationale de France, Paris.

monarch, could move farther north, south, east, or west. The map lacks depth, perspectival or any other sort: it encounters the earth's surface as an impenetrable limit. True, it suggests distance, a remove above the soil on which men tread (or more precisely, a double detachment, which I will discuss later: eye from page and page from land), but the viewer can choose the degree of distance. Holding the map nearer to the eye produces the semblance of a closer approach, where proximity is limited not by the logic of the pictorial form but only by the precision of the engraver's burin. Compare that effect with actual physical movement into perspectival space, where the configuration of things is always changing and depth always extends farther, the vanishing point always infinitely distant. In the cartographer's art, nothing resides in depth; everything is as close as one wants to make it be.

6. Pierre Le Pautre, *General Map of the Town and Palace of Versailles*, 1717. Detail of Fig. 4. Photo: Bibliothèque Nationale de France, Paris.

To whom does Le Pautre's map grant such proximate omniscience? To all its viewers, in a sense, but in the first instance to the monarch. Louis Marin argues that the logic of rational comprehensiveness characterizing the map of Paris produced by Jacques Gomboust in 1652 for Louis when he was a boy depends on the absolute oversight of the king (Fig. 5). "The order of the enterprise, the order of its rational method, and the political order of the absolute monarchy conspire to the same rhythm in the map. . . . The glory and liberality of the king, as well as his wisdom and omniscience according to political truth, have for effect a faithful and exact representation that is absolute because absolutely *subjugated,* in each of its points and in each of its lines, to its principle, which is the prince."[5] Beyond such general cartographic logic, Le Pautre's map specifies Louis as its first observer—regardless of whether he actually saw it. The words in the escutcheon at the left dedicate the plan to him (Fig. 6). His portrait in bust profile surmounts this shield to peruse the royal seat—from the side in this case—in a manner that designates the king the most privileged of viewers. Dedication and portrait ratify the presumed attribution to the king of the principal orientation from above. The map grants to Louis the power to peruse his domain through God's eye.

All this is not to say that the map, as a set of inked lines on a piece of paper, succeeds in rendering God's vision. It recognizes its human limits: it covers nothing beyond its inscribed frame, it reaches its threshold of precision, and it offers views of the kingdom only from directly above rather than from the infinite angles of divine sight imagined by Descartes. Additionally, even as the map attributes hovering omniscience to the royal eye, it also twice locates Louis on the surface: as a presumed corporeal presence in the rooms at the center of

the palace, and in the inscribed portrait, whose dramatically long, curly hair makes it unconvincing as a depiction of sculpture. Rhetorically, Le Pautre's map gestures toward the mundane situation and containment of the king.

Inversely, Martin's painting seems to aim at achieving a measure of the map's divine omnipresence through its elevation of the king's position. The emphasis on roads, moreover, hints at mobility across the plane for the royal person and eye. The king might circulate through his realm in a carriage like the one at lower right. He would enter into the painting's space and thus obviate its depths—even if, as a moving body, he could do so only provisionally because each new prospect would necessarily distance him from all preceding ones.

Cartography and painting grant predominance to opposing tendencies of royal vision while each manifests both. On the one hand, they render sight as embodied in the precisely located human form of the monarch as he, for example, peers out upon the forecourt of the palace. On the other, they posit a disembodied optic that soars and roams freely, at whatever distance it chooses, over the realm.

2. HUMAN BODY AND DIVINE MAJESTY

On Gomboust's map of Paris from 1652, Marin discerns seamless coordination between the main geometric overview and the set of perspectival vignettes positioned along the image's borders (Fig. 5). "Perfect and total reflexivity of representation, without excess or default, reason of state [Louis in his palace] and state of reason [the map's "totalizing gaze"], here is the map in its product (the map itself) and its production (the oriented pathways [implied by the vignettes along the border])" (176). Yet the juxtaposition of Le Pautre's map and Martin's painting suggests something other than perfect complementarity, without excess, between the two modes of vision. The geographic ubiquity of the map's omniscient oversight, coupled with its power of proximity at will, appear to be ideal means to assess the expanse of the realm, then acquisitively draw it near. In comparison with that plenteous plan, Martin's canvas—despite the obvious territorial continuity from close to far—seems the depiction of sheer, yawning distance. The first layer of nobles in the foreground (to whom I will return) are the exception that proves the rule: everything above them, even the other figures milling this side of the nearest gate, recedes with vertiginous rapidity. The minute size of these subjects emphasizes the space separating them from their sovereign even more than it reveals their exposure to his remote vision. Why insist so on distance?

In order to find an answer, let us reverse direction from Martin's view and look out the back of the palace.[6] We can imagine Louis, on some limpid morning, standing in the Hall of Mirrors, the ceremonial space just one doorway away from the more intimate space from which (or just above which) Martin's painting affords its view. Assuming the spot at the window on the axis (Fig. 7), Louis would see in the distance the most prominent sculptural group

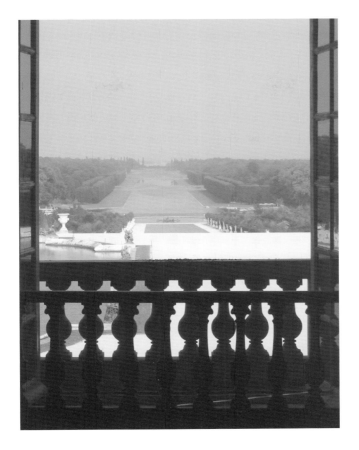

7. View from the Hall of Mirrors, Versailles Palace. Photo: author.

in the extensive gardens: Jean-Baptiste Tuby's *Apollo Fountain* of 1668–70 (Fig. 8).[7] The char-
ioted god of the sun drives his horses forward, while muscular Tritons blow their conch shells
to announce the beginning of the day. The rays of the actual sun would be shining over the
palace, from behind Louis, causing the gilded group to glisten like the solar orb itself. The
Sun King watches the sun god rise.

Yet the actual geographic orientation breaks the symmetry. The sculpted Apollo rises in
the west, not the east. For the sake of maintaining proper address to the monarch (or is it
to the morning sun? or is it to both, as identical entities?), the sculpture turns around to face
the palace. Such a turning, such an ability to be troped (etymologically, to be "turned"),
marks Tuby's Apollo as not a god but only the mundane representation of a deity, one bit
of figuration in the complex rhetorical performance of the court. The real sun rises in the
east. Louis rises in the east. Looking at Tuby's fountain, then, Louis perceives two things.
First, he sees, as if in a reflection, a representation of what he is: the sun, the being at the di-

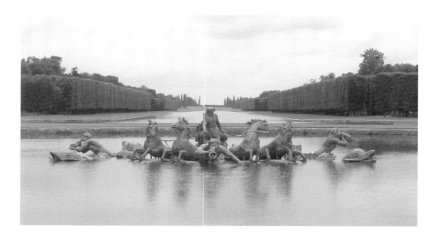

8. Jean-Baptiste Tuby, *Apollo Fountain*, 1668–70. Sculpture. Versailles. Photo: author.

vine center of things (centeredness, a characteristic that distinguishes the Olympian deity from the omnipresent Christian God). Second, he sees a representation of what he is not: a representation.

He is what he is—what this configuration would have him be—and unlike the sculpture, he cannot be figured otherwise. Jacqueline Lichtenstein astutely writes, regarding the incomparability of the king's "image," which in her analysis is the king himself: "The king's image . . . resists any attempt at integration with the imaginary, mimetic, and thus analogical universe of representation. Absolutely singular, it is beyond all comparison and as such is the image of the absolute, the only image whose definition coincides with that of reality. The king can be compared only to himself, represented only by himself; no historical or mythological hero can serve as an exemplary figure to represent his image."[8] In essence, the relation of the sculpture of Apollo to the king at the palace window reverses the operation of the icon as Jean-Luc Marion describes it, for it allows the king to look across the gap of distance between the god and his representation, yet to do so ostensibly from the celestial side.[9] Tuby's figure of a deity provides only a "visible face" for Louis's divinity, but it can resemble neither his centrality (again, an attribute of the Olympian rather than the Christian divinity) nor his imperviousness to the turns of rhetoric. These are seminal characteristics of the monarch that must remain "invisible" in the peripheral garden, a vast field of figuration. As a form of "negative theophany," the sculpture, in Marion's words, "opens in its depth upon an invisibility whose distance it does not abolish but reveals." The remarkable political twist at Versailles is that the distance between figure and essence disclosed by Tuby's sculpture projects the difference of divine invisibility back onto that very viewpoint to which the artwork presents its own visible form. The king becomes divine (in an Olympian manner)

not because he is represented as such but because he is distanced from the place from which representation distances itself from the divine. Tuby's *Apollo Fountain* distances distance.

From what, then, does Martin's picture distance the king? The lower half of the picture displays a teeming population of subjects occupying a great stretch of landscape. We might be tempted to say: The king sees the nation, France, as this collection of innumerable people and boundless territory, man-made structures, and natural features. Yet the modern nation-state during this era of its historical emergence may have obtained a precocious coherence only by modeling itself on the monarch's corporeality. The body of the king, centered at the palace, becomes the essence of France. Individuals, with their disparate wills and trajectories, whom Martin captured in his picture as they fall fitfully into military regimentation before breaking ranks again, coalesce into a unified entity only by imitating the intact identity of the person of the king. To be sure, Louis accrued attributes when regarding Martin's scene, as he did when eying the sculptural group in the garden: the manifest riches of the realm were proffered as his. Whereas Tuby enabled the sun to view the sun, Martin gives us France looking at France. Yet just as the position of the *Apollo Fountain* distanced the iconic sculpture from the authentic solar monarch, Martin's depiction of the expanse and the crowd safeguards the coherence of France with Louis, at a remove from the variegated realm, which remains inchoate save for its emulation of him.

"In France, the nation does not constitute a body; it resides entirely in the person of the king." This grand pronouncement, ascribed to Louis, would confirm the king as the corporeal model for France, except that historians have cast serious doubt on its authenticity—like that of the even more famous declaration "L'état, c'est moi."[10] A statement of more certain attribution, in Louis's *Memoirs for the Year 1661,* intended for the instruction of the dauphin, might appear more equivocal but actually provides greater insight into this doctrine of national incorporation: "So finally, my son, we must give much greater consideration to the good of our subjects than to our own. It seems they make up a part of ourselves, since we are the head of a body of which they are the members."[11] In one sense, the formulation distinguishes king from crowd: as the head, the monarch is the seat of mind and the source of will that directs the actions of obedient but unthinking limbs. In another sense, it affirms the corporeal unity of sovereign and subjects, for the populace, members of the body whose head is the monarch, becomes "part of" the sovereign. We might thus detect in Martin's view a different valence: its tension between continuous extension and vertiginous expanse might capture the simultaneous connection to and alienation from one's own body that Lei-Lei Fu's self-portrait from 2001 concisely expresses, as the corporeal form, manifestly the artist's own, drops precipitously away into giddying depth (Fig. 9).

Louis was by no means a deep thinker on the subject of political philosophy and deserves no credit for inventing this particular corporeal analogy. The argument about heads and bodies from the *Memoirs* traces its roots back through medieval political theology to the earliest days of Christianity.[12] In the Epistles, Paul maintained that members of the Christian community must combine their individual "gifts" for the purpose of "building up the body

9. Lei-Lei Fu, *Self-Portrait*, 2001. Oil on unstretched canvas. Private collection. Photo: author.

of Christ, until all of us come to the unity of the faith and of the knowledge of the Son of God, to maturity, to the measure of the full stature of Christ" (Ephesians 4:11–13). Paul cast the Son as a totality that envelops all the faithful within his transcendent corporeal form. Yet he positioned the pious away from the Son's brow, among the sinews: "We must grow up in every way into him who is the head, into Christ, from whom the whole body [is] joined and knit together by every ligament" (Ephesians 4:15–16). In his most lapidary version of the enabling ambiguity, Paul wrote: "For just as the body is one and has many members, and all the members of the body, though many, are one body, so it is with Christ. . . . Now you are the body of Christ and individually members of it" (1 Corinthians 12:12, 27). One and many, body and members: to be adherents, to be in the church, is to suspend the difference between the two possible meanings of belonging to Christ.

Frenchmen were Frenchmen owing to their relation to Louis precisely as Christians were Christians owing to their relation to Christ. We may rely on the authoritative words of Bishop Bossuet, who, because of his scholarly erudition, political savvy, and skills as a homilist and panegyrist, ascended rapidly through the ranks of the clergy to emerge at Louis's court as chief theological apologist for the absolute monarchy. In *Politics Drawn from the Very Words of Holy Scripture,* the bishop declared: "The title of 'Christ' is given to kings; and everywhere one sees them called Christs or the Lord's anointed."[13] Thus, we could say that the territorial half of Martin's painting presents an icon—again, in Marion's sense of the term—of the nation. It renders visible the distance between the disparate territory and that divine entity which, were the gap miraculously to be traversed, would bestow upon the realm's variegated nature an encompassing unity it lacks on its own. In the picture, France possesses all its cumulative attributes (just as Tuby's Apollo possessed radiance and other such virtues) with the exception of its identity and coherence (just as the represented Olympian god lacked reality and centrality). For those absent qualities, the milling populace needed to turn back toward the central viewpoint to behold the body of the king, autonomous and whole, and await his beneficent extension of himself into them, his members. Martin's picture, in a sense, looks out on the kingdom through the eyes of a Louis poised as Christ.

If in Martin's scene Louis looks out toward a collectivity that looks in turn to him, the painting raises the question: What precisely do territory and subjects see in the king? If they make visible to the monarch the diversity that so enriches the kingdom, how does he make visible to them the expansive coherence that they lack? (The question had posed no difficulty in the case of Tuby's Apollo, an entity that witnessed Louis's own manifest centrality.) Doctrinally, Christ was simultaneously both God and man; the Definition of the Council of Chalcedon of 451 states that he was "of one substance with the Father as regards his Godhead, and at the same time of one substance with us as regards his manhood."[14] Corporeal coherence clearly derived from the mortal aspect of Christ: the actual physical architecture of living flesh provided the analogy of head and members. Accordingly, Louis's human body needed to stand forth right there, fully visible in the ceremonial rooms of Versailles. The view that Martin delivers, with its symmetrical wings and its avenues pointing back toward the windows from which Louis himself might daily peer, with its hierarchy of courtyards culminating in the king's exclusive apartments, dramatically situates the living monarch at the heart of the palace, apart from the realm that unfolds before him across vast distance into the periphery. Whereas Tuby's fountain centered the classical god, Martin's picture centers the body of the man.

Yet this nodal, corporeal king alone would not suffice for establishing a nation. The king's physical specificity, however requisite as a model of coherence, precluded the ubiquity that would allow the compass of France to extend beyond palace and fief. And indeed, Bishop Bossuet's *Politics Drawn from the Very Words of Holy Scripture* returns repeatedly to the image of a king who, in spirit and in surrogate, covers and comprehends the kingdom:

Under an able and well-informed prince, no one dares to do evil. One believes him always present, and even the diviner of thoughts. . . . News flies to him from every quarter; he knows how to discriminate between those items, and nothing escapes his knowledge. (123–24)

The prince is himself a sentinel established to guard the state: he must watch more than all the others. (134)

God is infinite, God is all. The prince, in his quality of prince, is not considered as an individual; he is a public personage, all the state is comprised in him; the will of all the people is included in his own. Just as all virtue and excellence are united in God, so the strength of every individual is comprehended in the person of the prince. What greatness this is, for one man to contain so much! . . .

Consider the prince in his cabinet. From thence flow the commands which coordinate the efforts of magistrates and captains, of citizens and soldiers of provinces and armies, by land and by sea. It is the image of God, who directs all nature from his throne in the highest heaven. (160)

God enables the prince to discover the most deep-laid plots. His eyes and hands are everywhere. . . . The birds of the air bring him news of what happens. He even receives from God, in the course of handling affairs, a degree of penetration akin to the power of divination. Once he has penetrated intrigue, his long arms seek out his enemies at the ends of the earth and uncover them in the deepest abysses. (161–62)

Just as Martin's picture depicts human and geographic variegation in want of coherence, it also grants to its royal audience intimations of such an omniscient prospect. We have already seen how lifting the viewpoint above the cornices launches Louis toward the perspective of the avian agents that Bossuet enlists; other images we have seen raise him yet higher, even affording him winged mobility away from the palace (Figs. 1, 3, 4). More important, the sweep of the symmetrical panorama—with its radiating avenues doubling as depthless sight lines, with its bands of uniformly hued paving and roofs and fields and forests culminating in an endless purple ribbon at the horizon—situates each of the persons and objects that populate the kingdom precisely at its own specific place within the isotropic space (space in the singular!) that constitutes the king's field of commanding perception. Even the cloudy sky that fills nearly half of this vertical canvas seems to convey to the monarch a sense of the limitless range of his personal extent. We need not evoke God's heavenly throne mentioned by Bossuet or rely on some anachronistically Romantic notion of the sublime powers of nature in order to recognize how the depicted cumuli suspend spatial recession and allow near to confound with far. How large and distant are those clouds, or how small and close? How vertical and how deep should we read the large curve beginning in the upper left corner? Witness how easily the puffs of smoke that rise from the palace buildings at the right edge bleed into the far-off cirri, pulling them forward. Indifferent to distance in its amorphous expanse, the sky covers the realm like an omnipresent deity.

Martin's painting presents its regal viewer with both components of the kingdom he brings into being: variegated things (including subjects) that resemble the monarch in their materiality yet differ from him in their disaggregation, and the transcendent force that obviates

that incoherence by incorporating all parts of the realm into his whole. The picture, as it centers the king's body in the palace, also registers the effects of his "royal power," which, in Bossuet's words, "holds the whole kingdom in position just as God holds the whole world" (160).

It was not enough for Louis to stand sentinel over his realm and know it thoroughly, or even for his power to be "felt in a moment from one end of the [kingdom] to the other," like the might of God in the world (160). According to Bossuet, the divine aspect of the king, along with his corporeal coherence, should be seen.

> The divine, . . . for the good of human affairs, has lent some of its brilliance to kings. (61)
>
> If the power of God extends everywhere, magnificence accompanies it. Nowhere in the universe is there a lack of striking marks of his goodness. You see order, justice, and peace throughout the realm. These are the natural effects of the authority of the prince. (161)
>
> You have seen a great nation united under one man: you have seen his sacred power, paternal and absolute: you have seen that secret reason which directs the body politic, enclosed in one head: you have seen the image of God in kings, and you will have the idea of majesty of kingship. . . .
>
> An undefinable element of divinity is possessed by the prince, and inspires fear in his subjects. . . .
> You possess in your authority, you bear on your forehead, the stamp of the divine (162).

The nation formed in emulation of the king's physical body was not to take his divine extension on faith. Like his coherence, it had to be rendered visible, given as an image. In a word, the bishop declared, "Majesty is the image of the greatness of God in a prince" (160).

At Versailles, the extravagant disposition of architecture and accoutrements enveloping the king, from the penumbrae of the grounds and the palace to the velvet and ermine caressing his flesh, strove to display divine magnificence, greater than the body of mortal man. Consider Hyacinthe Rigaud's canonical portrait of Louis XIV from 1701 (Plate 2). We need not belabor its specific symbolic details—scepter and crown, robes and column—to recognize how it attributed to Louis a glory that transcended his human nature.[15] The "most important attributes" of "this body in its portrait," Marin summarizes in his essay on Rigaud's painting, "communicated to the spectator with the aim of bringing about recognition and admiration. Thus the spectator will be inclined, not only to say 'That is Louis,' or 'That is the King,' but also 'That is the Monarch in all of his Majesty.'"[16] Let us concede that the impressive cultural panoply could indeed have induced many contemporaries to believe in the divinity of Louis, with at least part of their minds. Let us grant that the attributed quality seemed to sink into his body itself, so that his partially nude physique in Jean Nocret's group portrait of 1670 of the royal family as the gods of Olympus could inspire genuine veneration: Ludovicus, rather than (as it appears to our eyes) ludicrous (Fig. 10). Let us stipulate that the divine expanse of nation could come to reside so easily in Louis's body that when it was depicted in *Franche-Comté Conquered for the Second Time* of 1678–84, one of Charles Le Brun's ceiling decorations for the Hall of Mirrors, Louis himself could person-

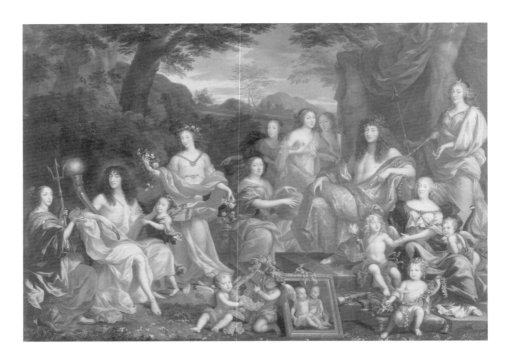

10. Jean Nocret, *The Family of Louis XIV Dressed up as Mythological Figures*, 1670. Oil on canvas. Musée des Châteaux de Versailles et de Trianon, Versailles. Photo: Réunion des Musées Nationaux, Paris / Art Resource, New York.

ify France, whereas Spain needed to rely on the allegorical lion and Germany on the eagle (Fig. 11).[17] Beyond a doubt, Versailles aspired to make of Louis more than a human being.

"Majesty," however, implied something greater than national compass or even Olympian godliness. The king's divinity could come from one source alone. Despite his own claims about the Christic character of kings, Bossuet, in extolling the king's grandeur, shifted emphasis within the Godhead from the Son to the Father. Much more than Christ, the figure of God dominates the bishop's argument in *Politics Drawn from the Very Words of Holy Scripture*. "Brilliance" and "magnificence," as signs of the divine that Bossuet saw reflected in the monarch, are hardly apt terms for the mendicant preacher described in the Gospels, who eschewed terrestrial authority, saying "My kingdom is not from this world" (John 18:36), and who accepted that his divinity could well go unrecognized: "Father, forgive them; for they know not what they do" (Luke 23:34 RSV). Such divine qualities were precisely those of which Jesus "emptied himself " in the kenosis of the Incarnation. The French monarch could ill afford such a sacrifice. To garner fealty to his expansive capacities, Louis needed somehow to render visible God's own magnificence.

The problem is that no earthly thing—no pose struck or ritual performed at Versailles, no artifact of human manufacture created or displayed there, no palace and garden however vast, nothing capable of depiction in Rigaud's or Nocret's or Le Brun's paintings—could

11. Charles Le Brun, *Franche-Comté Conquered for the Second Time*, 1678–84. Ceiling painting in the Hall of Mirrors. Musée des Châteaux de Versailles et de Trianon, Versailles. Photo: Lauros / Giraudon / The Bridgeman Art Library.

ever achieve divine stature comparable to God's. In actual practice, no visual artifact at Versailles even dared compare Louis directly with Jehovah or, for that matter, Christ. Overt Christian iconography virtually disappears outside the chapel, and even in the sanctuary the Father and the Son are presented to the king rather than equated with him (Fig. 2). Figures who did play leading roles in the iconographic program of the palace and the gardens—Apollo and Alexander led the many others—possessed the advantage of being demotable into the field of representation. When juxtaposed with Louis, the mythological or historical figures seemed, in the manner of Tuby's fountain, to emulate or represent the true model provided by the living king. Moreover, they were not God. If evocations of Olympus or depictions of Macedonian heroics declared the monarch's glory, they also acknowledged that Louis, however great or even divine, could never quite be the Father. Had Nocret recast the Bourbon king as the Christian God in heaven surrounded by his progeny as the seraphim, the portrait would have crossed the line into blasphemy.

It is an inescapable paradox: Majesty, to appear in full force, had to be Jehovian, but for majesty to be Jehovian, it could not appear. Contemporaries were hardly blind to the dilemma. Immediately before declaring, "Majesty is the image of the greatness of God in a prince," Bishop Bossuet qualified the claim: "I do not call majesty that pomp which surrounds kings, or that external show which dazzles the vulgar. That is the reflection of majesty, but not its

true self" (160). We can imagine ostentatious ermine and gold, even poised human flesh, falling away from the Louis shown in Rigaud's portrait, to leave a certain "undefinable" quality that none of these earthly items, or the painter's depiction of them, could ever possess on their own. Perhaps, then, the key term in Bossuet's lapidary formulation (again, "Majesty is the image of the greatness of God in a prince") is "image." Louis gives a true rendition of God's majesty—guaranteed with the direct impress of a "stamp," with the unmediated fidelity of a "reflection"; freed from the contingency of any cultural practice of merely human agency or any turns of human rhetoric—without usurping God himself.

If the king sees in the disparate crowd depicted in Martin's painting an icon representing its distance from his own Christic coherence, the crowd sees in Louis an idol of God, whom he closely resembles. Marion, whose account of the idol is as nuanced as his explanation of the icon, argues that the worshipper need not mistake the idol for the deity—as Bossuet so obviously was careful not to do—in order to believe that the god shows its face there (or the version of it that falls within human experience): "The idol . . . does not deceive the worshipper who does not see the god in person in it. . . . What, then, does the worshipper worship in the idol? The face that the god, or rather the divine, wants to find in it. . . . The idol does not resemble us, but it resembles the divinity that we experience, and it gathers it in a god in order that we might see it."[18] There is gain here, but also loss: gain, in that the idol makes present the divine, in the sense of presenting it in a face; loss, in that that face is not the divine itself, but only the mundane image of it. According to Marion: "What the idol works to reabsorb is, precisely, the distance and the withdrawal of the divine: but by establishing such an availability of the divine within the fixed, if not frozen, face of the god, does one not deceitfully but radically eliminate the lofty irruption and the undeniable alterity that properly attest the divine? Compensating for the absence of the divine, the idol makes the divine available, secures it, and in the end distorts it. Its culmination mortally finishes the divine" (7, translation slightly altered). Whereas the icon represents the distance between the mundane and the divine in such a manner as to allow its miraculous traversal, the idol draws the divine so close that it retreats to an impossible remove.

Far from holding contradictory beliefs—claiming that Louis is divine and claiming that he is not—the shrewd Bossuet is executing precisely this trade-off proffered by the idol. For the sake of mustering the appearance of Jehovian omnipresence to the terrestrial political purpose of allowing Louis's reign to expand across the realm, the theologian is willing to allow God himself to withhold full conferral of his majesty on its current human legatee.

So great is this majesty that its source cannot be found to reside in the prince: it is borrowed from God, who entrusts it to the prince for the good of his people, to which end it is well that it be restrained by a higher power. . . .

You [princes] are children of the most High: it is he who has established your power for the good of the human race. But, O gods of flesh and blood, of mud and dust, you will die like other men, you will fall like the greatest. Greatness divides men for awhile; a common fall levels all in the end.

O kings, be bold therefore in the exercise of your power: for it is divine and beneficial to the human race; but wield it with humility. It is conferred on you from without. In the end it leaves you weak, it leaves you mortal, it leaves you still sinners. (162)

It might seem that Bossuet is attempting to finesse a potential embarrassment that could compromise royal majesty: the mortality of the monarch. The opposite is the case. Underlying the bishop's formulation—indeed, the entire political system of which he and Louis were a part—is the recognition that the inevitable corruption of the king safeguards the divine character of majesty elsewhere, with God. Consider the extraordinary attention paid at Versailles to all the base human characteristics of the monarch: his need to sleep and to sleep around, what he ate and what he defecated, his inescapable aging and his debilitating gout. Versailles needed the king's body twice over: once cataphatically, as the affirmation of real Christic coherence upon whose model France could be fashioned in the image of a nation; and again apophatically, as the carrier of the image of majesty against which, through negation, God emerged as real.

Attempting to reconcile the competing demands for embodiment and ubiquity placed on the king, Marin, in *The Portrait of the King,* proposes the figure not of Christ but of his "real presence" in the Eucharist:

"The state is me"—thus does the absolute monarch pose himself: the monarch, or power in its singularity; and the absolute, or power in its universality. We discover, then, the paradox of the proposition where some sentences about the young Louis are summarized: if "me" is the proper name of him who says here and now, "The state is me," then he who utters it localized himself as a singular body in time and space. But the proposition, in the same verbal gesture, identifies him with the state, that is, with universal power in all places and at all times, everywhere present. In other words, the body present here of him who speaks now is none other than one body everywhere and always. Now a body at once local and translocal is precisely what the sacramental host realizes for Jesus Christ in the universal community of the church. (10)

The result, Marin argues in his own version of the Triune One, is a "sole body [which] unifies three, a physical historical body, a juridico-political body, and a semiotic sacramental body, the sacramental body, the 'portrait,' operating the exchange *without remainder* (or attempting to eliminate all remainder) between the historical and political bodies" (14). Accordingly, Marin is able to propose that Louis himself and his portrait by Rigaud are perfectly interchangeable, each being a copy of the other: "The King only imitates his portrait just as the portrait imitates the king. . . . The king and his king and his royal representation reciprocally subordinate themselves to each other. . . . They belong to or appropriate each other in a manner that is perfectly reversible."[19]

This is exactly wrong. Louis at Versailles, or Rigaud's portrait of him, or the view Martin proffered before the king, did not abolish the excess of the king's body. Rather, they depended on the interminable mismatch and play between that human corporeal entity and the omni-

presence of God. Louis's physical presence mattered at the center of the palace, in a way in which the "accidental" attributes of bread and wine never do to the "real presence" of Christ in the Eucharist.[20] Far from resolving embodiment and expanse in the figure of Christ, Versailles effectively annuls the Council of Chalcedon in relation to the king, affirming his "one substance with us as regards his manhood" by casting his own majesty as merely a reflected image of God's. Reciprocally, majesty appears as a quality of God precisely because it is not fully embodied in the king. Both human substance and divine image emerge as "remainders" in relation to each other.[21]

Louis could not extend his "long arm" into the peripheries of the realm unless he was first embodied by actual human flesh at its center. God's majesty cannot sanction that terrestrial extension unless it resides first on high.

3. VIGILANCE AND DISPERSAL

Because of his assimilative powers derived from God, the king was always present throughout the realm, and he or his forebears always had been. Nonetheless, the borrowed character of his extension implied the possibility of some form of corporeality loose within the realm, if not temporally, then conceptually, antecedent to his own. Once again, in the space behind the palace in the protected precincts of the garden, a sculptural group exposes the dynamic with greater clarity than the prospects out in front or from above.

The *Latona Fountain* by Gaspard and Balthasar Marsy of 1668–70 (modified 1687–91), placed directly on the main axis, is the major sculptural group closest to the palace (Fig. 12). Yet owing to a dip in the terrain before the greensward leading to the *Apollo Fountain,* the work cannot actually be seen from Louis's standpoint in the Hall of Mirrors. It is as if the fountain was the garden's troubling little secret, the king's Achilles' heel, the accidental truth that should not be yet cannot help being revealed. As a mere mortal, one must venture to the lip of the first parterre, or descend a staircase left or right, to gain a view of it (Fig. 13).

This sculptural group tells a tale from Ovid's *Metamorphoses.* The goddess Latona, mistress of Jupiter and mother, by him, of Diana and Apollo, is fleeing from the god's jealous wife, Juno. With her children, a parched Latona arrives at the shore of a pond. Here the miserly peasants of Lycia deny her succor and instead mock the divine single-parent family. Latona, protecting her son with one arm and raising the other in supplication, calls vengeance down on the Lycian mob for their ill treatment. Her petition is granted, and the unruly mortals are transformed into frogs. Ovid does not specify the agent of this metamorphosis, but the caption to a contemporary print of the fountain interpolates Jupiter into that role.[22] The Marsy brothers can pull out all the stops with such rich thematic material: amphibious heads atop human bodies, hands becoming webbed, anguished mouths jetting water; and, rising above it all, gesticulations of motherly love in distress (with no sign of Latona's anger described by Ovid).

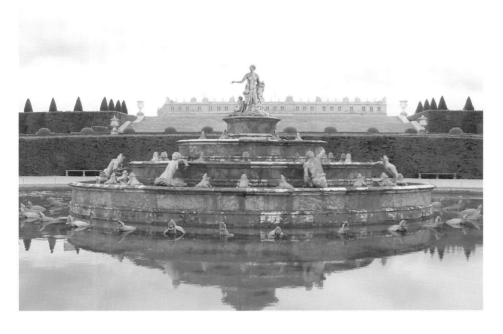

12. Gaspard and Balthasar Marsy, *Latona Fountain*, 1668–70 (modified 1687–91). Sculpture. Versailles. Photo: author.

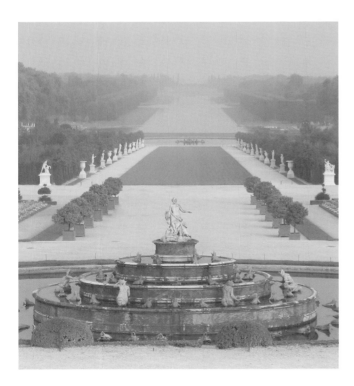

13. View from behind the *Latona Fountain* toward the *Apollo Fountain*. Versailles. Photo: author.

The allegorical meaning seems obvious enough. A divine force ruling the heavens and earth will use absolute powers to crush all insubordination. The inclusion of Apollo as a boy, some interpreters propose, may evoke the period of the Fronde, dating from the early stages of Louis's reign, when nobles and the Parisian Parlement unsuccessfully attempted to wrest power from a monarchy seemingly weakened by having a child as its king.[23] In the sculpture's first installation, Latona, on a lower pedestal, faced toward the palace: her entreaties appear directed toward the now mature Louis (Fig. 14). In a proleptic trick that elides the aid of others—whether Ovid's unnamed godly force or the caption's Jupiter or the youthful king's prime minister Cardinal Mazarin—the Sun King protects himself in his own radiant youth. He does so twice, in fact. First, as the adult Apollo positioned to hear Latona's plea, he turns the peasants into frogs. Second, as the king, Louis transforms the unruly figures into stone. In the first instance, he exiles the peasants from humanity; in the second, he incorporates them directly into the pageant of his own court. By punishing those that would harm his child self, Louis both demonstrates his capacity for violent and effective enforcement and affirms the basis of his identity and power. Two interpretations offer themselves simultaneously. When one regards the group as a sculpture, the king stands as real in contrast to the peripheral representation as he did with Tuby's *Apollo Fountain.* And when one reads the *Latona Fountain* for its content, the sun god in the palace safeguards the sun god in the garden, thereby allowing himself to grow into full and glorious being.

Fine and good. Yet, if identity and power stem from embodiment, then the king may be caught here in something of a predicament. Apollo, compositionally not much more than a column supporting his mother, is not the most interesting body in the Latona group. The peasants of Lycia are far more dramatic: panicked, writhing, divided in their very corporeal being between fiend and frog. Forget the huddled family of gods distanced at the center of the composition; the more proximate metamorphosing mortals must have elicited attention from the members of the court, perhaps even gained their empathy were the courtiers to identify with these other subjects of the king who had already experienced his wrath. Power has shifted. Defiance of the monarch will be punished; that is certain; another century will pass before an uprising against the French monarch succeeds. Yet the force of the nation has been applied and expended here. It has left the body of the Louis figure to register, first, in the altered, tortured bodies of these peasants, and second, in the freezing of their plight into stone. Victims of both Apollo's vengeance and Louis's sculptural program, they now record the displacement of royal might. They now embody it. Viewers, then as now, can well imagine what it must feel like proprioceptively to have such painful bodily distortion imposed upon themselves—imposed twice: humans into frogs and frogs into art. And when that empathy arises, the power that should reside in Louis disperses, incorporated into the subjects of the realm.

With the lesson of the *Latona Fountain* in mind, let us return to Martin's view. I have argued that, thematically, the embodied king perceives in the lower half of the picture a collection of subjects placed at a great remove from him. We can now see that that yawning

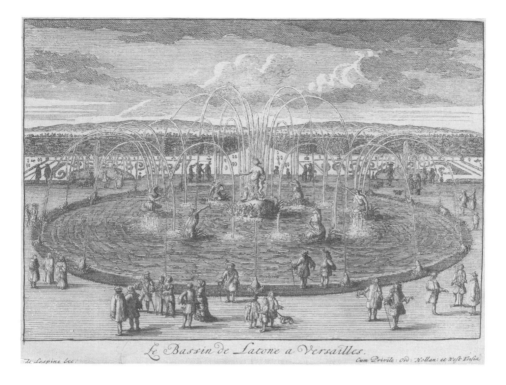

Le Bassin de Latone a Versailles.

14. Willem Swidde [eng. Lespine], *The Latona Basin at Versailles* [1st installation], 1686. Engraving. From *Veues de Versailles: Grauees sur les dessins au naturel par Guillaume Swidde* ([Amsterdam?]: De Lespine ex., 1686). Collection and photo: Research Library [90-B16333], The Getty Research Institute, Los Angeles.

distance allows space for the emergence of a potential threat. Perhaps these figures, like the peasants of Lycia, have bodies and wills of their own. Perhaps they have come into being during that conceptually antecedent moment that anticipates the extension of the king's majesty. The threat, in turn, creates a twofold political imperative, both to make the realm known to the king and to make it part of his greater being. We have heard Bossuet on both aspects: "God enables the prince to discover the most deep-laid plots"; and "The will of all the people is included in his own." Yet the first formulation belies the second, for how can plots be uncovered without first being hatched by wills not included in the king's? Even within the majestic body of the nation, things may grow that are part of the king but also, like a cancer, not part of him. The monarch must remain ever vigilant to protect his national being, modeled on his human body and extended by God's majesty, from such internal infirmities. What is this gathering of courtiers in the forecourt (Fig. 15)? Loyal subjects or a cabal? Benign tissue or a malignant polyp? Can we tolerate this telos that registers, or not, the royal telos? Can it be confirmed as an innocuous inner part of the nation, or need it be extirpated for the general good of Louis that is France?

If Martin's picture raises the specter of deviance from the king's will, it also activates the

15. Jean-Baptiste Martin, *Perspective View from Versailles Palace of the Place d'Armes and the Stables*, 1688. Detail of Plate 1. Photo: Réunion des Musées Nationaux, Paris / Art Resource, New York.

powers of scrutiny and assimilation. As if its vision were farsighted, the painting holds the king's subjects at more than arm's length, the better to capture the revealing details of their comportment: each pose struck, each gesture flourished, and toward whom. Stylistically, Martin eschews any temptation to parrot aristocratic gesticulations with a painterly swish of his brush, instead serving the royal viewer with a meticulous report. The picture aspires to render intent visible and then stands ready to integrate the wills thus revealed into the panoramic vision that belongs to the king. Each gathering becomes a cluster in its proper place, situated within the isotropic space of the realm presented here to Louis as his own assimilative mode. Moreover, the medium of painting permits the pictorial device of collapsing far and near, as performed compositionally by the clouds in the upper half of the picture, to descend like a curtain from above onto the lower half of the scene, with its pronounced thematic depth. If the depiction of vast distance hurls each person and item far away into the fictive expanse, their careful rendition in paint pulls them abruptly near again, no farther

away from the monarch's scrutiny than the surface of this canvas upon which he gazes. Whereas the Marsy brothers turned the Lycian peasants into stone, Martin transforms the king's contemporary subjects into flat paint. Inviting the king's artistic eye to dart like Bossuet's birds, Martin's medium and flat support ensure that Louis's attention travels everywhere across the depicted kingdom, with the surface of the picture serving as a figure for the comprehensiveness and proximity of the king's faultless awareness.

The surface as a figure of royal knowledge: therein, precisely, lies the limitation of this representation of the monarch's capacity to draw his realm arbitrarily near through artistic means. When the painting gives the kingdom to Louis as an image, the material substance of its variegated contents disappears behind this flat, opaque screen. The picture occludes the place. While we are dealing here with wholly terrestrial relations, we have encountered this dynamic before. In essence, Martin's painting functions as an idol for the absent realm: it offers a "face" that resembles the kingdom as we—and as Louis, as a living human— experience it rather than the kingdom itself. Much as (according to Marion) onto-theology reduces God to a concept and (by Bossuet's lights) royal accoutrements risk reducing majesty to a courtly performance, landscape painting reduces the realm to an image, so "that we might see it," to repeat Marion's words.[24] Like the idol in relation to God, the artifice of the picture "mortally finishes" the possibility that the actual kingdom can be made present. Instead, representation represents itself as such, as just a surface, allowing the kingdom to escape, in "undeniable alterity," into the real and the profound. Louis in front of the picture would then be left with nothing but illusion, hemmed in by the surfaces—Martin's painting in particular, and more generally the acres of canvas covered by his court artists—that encase him like a prisoner in a gilded cell, fundamentally isolated and alienated from the kingdom over which he was meant to rule.

Such abject epistemic failure would condemn Martin's picture, except that the painting is redeemed by its iconic nature—in Marion's sense, which concerns relation across distance rather than resemblance. To be sure, Martin's renditions do resemble the scattered subjects. The details are meant to establish correspondence between paint patches and the appearance of the things; otherwise, scrutiny would fail. Nonetheless, the great gap of space in the lower half, as opposed to the collection of objects that that space contains, grants to the king a powerful kind of distance. That distance both sunders his human self from his realm and allows his divine majesty miraculously to traverse back over it. To paraphrase Marion's assessment of the icon: "the [landscape] conceals and reveals that upon which it rests: the separation in it between the [realm] and its face." The forms of difference and distance that characterize the contents of the kingdom as presented by Martin's painting—geographic remove, material autonomy, physical variety, potentially alien intent, and so on—constitute a "visibility of the invisible, a visibility where the invisible gives itself to be seen as such." Thus they stand both as the initial rationale and as the final culmination of Louis's divine omniscience. They both create the imperative for the human king to borrow majestic expanse from God and enable the efficacy of that borrowing by vouchsafing the pseudoinde-

pendent existence of the wide world that omniscience intends to assimilate. The world is only pseudoindependent, rather than fully autonomous and thus inassimilable, because it is separate from the king only in that conceptually anterior moment that his royal majesty has always already traversed and yet is also always traversing anew with each viewing of the painting or each gaze out the window. Much as the presentation of Louis's expansive majesty to the realm in portrait and ritual depended on the constant transcendence of his base corporeal being, for the realm to appear to Louis as a nation depended on the king's both having already overcome its difference and distance from him, and overcoming that difference and distance again now.

Majesty depends on the distance it must traverse. To the extent that depth in Martin's painting succeeds in conveying a sense of that requirement, Le Pautre's map, with its omnipresence and willed proximity, appears comparatively hamstrung (Fig. 4). Cartographic vision seems unable to evoke the excess of alterity, which is endangering and enabling at one and the same moment. Viewed from the prospect of God, a map in its ultimate and perfected rendition achieves identity with the country it no longer represents but becomes. Jorge Luis Borges, in his short story "On Exactitude in Science," which is as compact as the map it describes is expansive, captures well the possibilities and impossibilities of such a fully completed map. The tale begins: ". . . In that Empire, the Art of Cartography attained such Perfection that the map of a single Province occupied the entirety of a City, and the map of the Empire, the entirety of a Province. In time, those Unconscionable Maps no longer satisfied, and the Cartographers Guilds struck a Map of the Empire whose size was that of the Empire, and which coincided point for point with it."[25] The flawlessly accurate map becomes indistinguishable, in features and in location, from the territory over which it perfectly lies and with which it necessarily fuses in complete identity—because anything less would constitute a basis for discerning difference and thus inaccuracy. The consciousness presented with such a complete map (but "presentation" is out of the question; instead "presence" is the operative term) would, in grasping its full content, in like manner need to occupy its entire surface without spatial remove. We return to Descartes's God who is not man, who is omnipresent in the world he created, who is that world that he perceives fully, from every angle, without distance (the lack of distance, in fact, rendering the question of angle moot). A divine Louis, occupying the full extent of the fully extended map and thus the territory that that map does not represent but has become, achieves identity with the realm by being coextensive with it.

Though fulfilled by and fulfilling for a god, such a complete map would have no worth for humans. Borges continues: "The following Generations, who were not so fond of the Study of Cartography as their Forebears had been, saw that that vast Map was Useless, and not without some Pitilessness was it, that they delivered it up to the Inclemencies of Sun and Winters. In the Deserts of the West, still today, there are Tattered Ruins of that Map, inhabited by Animals and Beggars; in all the Land there is no other Relic of the Disciplines of Geography." The map resurfaces as material artifact only when, destroyed, it peels away from the topography with which it was once identical.

Le Pautre's map, once we stop thinking about it abstractly as the ideal of the divine king, need not perform any such pulling away. As a piece of paper, its own internal frame engraved, its geographic coverage and material size both limited, the map necessarily has distance from the terrain it depicts. Had he ever held it, Louis would have encountered this map as a material thing. We can imagine him picking it up, unfolding it, orienting it to his own body, holding it up or laying it flat. In holding such a map away from his head, or perhaps even letting go entirely once the sheet was properly situated on a table, his human eyes would need to distance themselves from the cartographic rendition—not too close, not too far—in order to take in information with the degree of specificity required by that particular viewing. In establishing the proper distances, moreover, the king necessarily would view the paper improperly, from the two-point vantage of human binocular perspective rather than from the omnipresent vision of God (for which proximity becomes embeddedness) that the logic of the map itself calls forth. And when the king's human head pulls back from the paper map, the map—constrained in size and lacking depth, accurate only to the degree that human precision allows—lifts itself away from the kingdom, revealing the great gap separating the two. It resembles the realm but also presents itself as just an image, thereby allowing the territory to emerge as expansive excess. The map, like the landscape, provides the distance necessary for majesty to exert itself.

Yet with that launching of the power of assimilation always—hand in glove—arises the threat of disruptive difference. Just as Lycian peasants can refuse succor and gesticulating subjects can plot, items portrayed by the map, once granted provisional autonomy from their image, can threaten to become unruly. Earlier I argued that the layout of roads and garden paths in Le Pautre's map directs attention to Louis at the heart of the palace. Yet the map itself is actually centered on something else: the *Apollo Fountain* (Fig. 8). To be sure, the framing results in large part from the stubborn fact that the huge gardens spread outward from the palace in only one direction. Thus when mapping the estate, Le Pautre faced the practical necessity of shifting his frame westward, which is to say upward. He pushed the palace as close to the middle of the image as he could, leaving some meaningless countryside along the bottom, eastward edge. Still, the fountain is the map's hub. Indeed, a number of avenues in the garden, those radiating outward like spokes from the nearer head of the cross-shaped Grand Canal, seem to point less toward the Apollo in the palace than to the one rising reverse-wise from the pond. The Tritons and the horses, moreover, spread out from the chariot toward the west, much as do the avenues from the monarch's apartments.

Louis creates a garden to complement his royal residence, a garden that should give back to him his own sense of reality in contrast to its playful representations. Nonetheless, in addition to being a sculpted Apollo revealed as mere figuration by being westerly troped, Tuby's main figure may emerge a god that turns on the king. He faces off against Louis XIV, who is looking down at the sculpture from the Hall of Mirrors (Fig. 16). As if in recognition of this shift, Latona, when she was reinstalled atop a higher pedestal by the architect Jules Hardouin-Mansart around 1690 (a decade and a half after her creation), was turned to direct

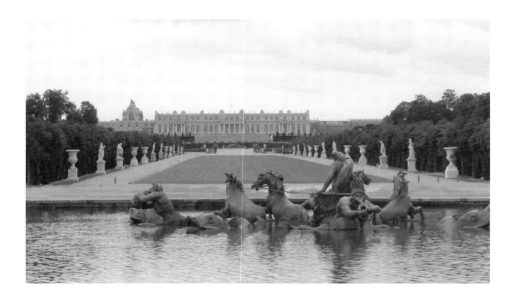

16. View from behind the *Apollo Fountain* toward the palace. Versailles. Photo: author.

her supplication toward this other Apollo (Fig. 13). In place of the man in the Hall of Mirrors, the sculpture of the god in the chariot rising from the waters becomes the mature Apollo that, proleptically and self-sufficiently, intervenes to save his own youthful self.

The threat to the king has more than doubled because, unlike miserly peasants or plotting subjects who exploit the terrestrial space allowed them by distance, the Apollo in the basin appears to be repossessing nothing less than the king's capacity to know and enforce, which is to say, his majesty on loan from God. The sculpture can do so because Louis—by necessity, in order to have a kingdom to incorporate and a majesty to extend over it—has had to allow both realm and God to exist as something other than himself.

4. NEITHER HERE NOR THERE

What is a king to do? In an obvious sense, the threat is not genuine. The figure is only Apollo, a defunct god; and, like the Lycian peasants, he is only a sculptural representation, serving as a foil to the real king. The prospect may nonetheless have prompted concern because it raises the possibility that the king's powers, not just that upon which he exercises them, might depart the palace. If we are to accept the testimony of a painting by Pierre-Denis Martin (probably the nephew of Jean-Baptiste), one of the ways in which Louis responds is to travel out from the center, across distance, to reclaim whatever has been allowed to take up residence afar (Fig. 17). Mounted on a wee chariot of his own (probably utilized because of some

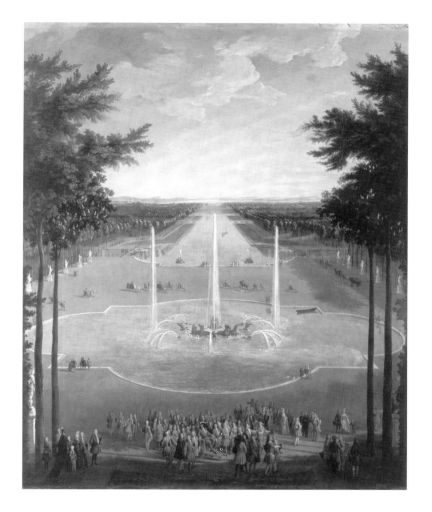

17. Pierre-Denis Martin, *View of the Apollo Basin in the Gardens of Versailles*, c. 1713. Oil on canvas. Musée des Châteaux de Versailles et de Trianon, Versailles. Photo: Réunion des Musées Nationaux, Paris / Art Resource, New York.

infirmity of age), the portrayed Louis faces not toward the fountain but in the same direction as the Apollo in the basin.

But then the question arises, at whom or what is Louis looking; the Louis, that is, depicted in Pierre-Denis Martin's painting? And who or what is looking at him? Whose gaze does the painting, and the depicted king's attention, solicit? Latona's, perhaps, to allow the monarch to recoup his displaced task of Olympian autopaternal intervention. Yet from the perspective of the *Apollo Fountain,* Latona is all but lost in her topographic dip (Fig. 16). So instead Louis looks back principally on the palace. He looks up to himself in the Hall of Mirrors— a place proper to the king even when his physical body is not occupying it—looking down on himself in front of the *Apollo Fountain.* A second backs each Louis, either the Apollo ris-

ing in his chariot or the actual morning sun. It matters not, then, whether the king looks from here to there or from there to here. Both center and periphery allow the king to witness his own prowess, from the perspective of his own prowess.

The endless reflexivity of such gazing between the centered and peripatetic kings may even become the object of Louis's own meta-attentiveness. Placing him back in the Hall of Mirrors, we can imagine him focusing on that small spot directly ahead that is the Apollo group in the distance (Fig. 7) and then extrapolating from Apollo's directed attention—which Louis himself has exercised during his excursions into the garden—the view back toward Latona, who stares beseechingly at the god in the chariot (Fig. 16). Whereas in my earlier account the king directed his attention to the charioted god alone, now I have him also discerning the proleptic salvation by Apollo of Apollo being enacted by sculptural groups visible and not visible before him. Accordingly, the reversal of Latona during the reinstallation is not some terrible misjudgment by Hardouin-Mansart but actually becomes a representation within the garden of the sun god's proleptic salvation of himself, against which his own autonomous self-generation in the palace stands, reflected in its difference, as real.

It is a loftier stance, which might seem to recenter the monarch, except that even this meta-attentiveness becomes displaced from the center back again into the field. Imagine a courtier standing behind the *Apollo Fountain,* squinting back toward the palace on the off chance of spying Louis at the opened central window; the courtier imagines the monarch witnessing the face-off between sculptural groups. Imagine Louis witnessing that subject, who is both of the king and potentially not of him, witnessing the monarch, and so on. It should be clear how it goes: back and forth, alternating between center and the expanse of the realm, in unending layers of meta-attentiveness.

So it is not just embodiment that necessarily disperses across the realm. Royal vision, with its capacity for scrutiny and assimilation, its aptitude for discernment and discipline, also leaves the palace to spread out across the kingdom. Moreover, not only bodies as the vessels of power could come to reside with others out in the realm; in the same way others too—sculptured gods or squinting courtiers—could claim to see through the king's eyes. Neither the center nor the monarch's own body located there can keep a firm hold on the king's roving oversight.

But such has been the case all along with the images we have been examining in this chapter. Up to now I have been treating Jean-Baptiste Martin's canvas as if the painting's outlook, like the prospect from the bedroom itself, belonged exclusively to the king. Actually, even the window was not solely the king's: courtiers and even servants undoubtedly also peered out. Martin's picture likewise attracted the passing glances and studied attention of many members of the court other than the monarch. The view in its painted rendition, moreover, traveled away from the center. Martin's canvas was commissioned for placement in the Grand Trianon, the monarch's retreat erected in the gardens well to the northwest of the *Apollo Fountain,* where Louis could be reminded of his omniscience centered in the main palace and, in addition, courtiers could examine the picture. Probably as many people regarded the king's view in Jean-Baptiste Martin's picture as looked upon the king in Pierre-Denis Mar-

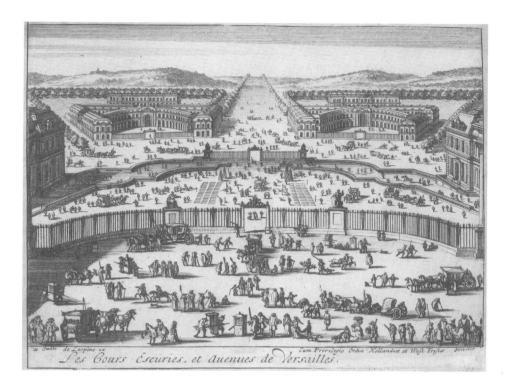

Les Cours Escuries, et auenues de Versailles.

18. Willem Swidde [eng. Lespine], *The Courtyards, Stables, and Avenues of Versailles*, 1686. Engraving. From *Veues de Versailles: Grauees sur les dessins au naturel par Guillaume Swidde* ([Amsterdam?]: De Lespine ex., 1686). Collection and photo: Research Library [90-B16333], The Getty Research Institute, Los Angeles.

tin's painting, which hung in the neighboring room in the Grand Trianon.[26] Paintings are like that: they tend to call for an audience of at least dozens, if not hundreds and (over time) thousands. Consider, further, a drawing by Willem Swidde engraved by Lespine in 1686, an image predating the elder Martin's work and showing much the same scene as the painting (Fig. 18). A print, issued in multiple copies meant for dissemination, hardly presupposes the king as its exclusive audience, or even its principal one. It may be issued under royal auspices, but it demands a great many viewers, indeed many owners. As Gérard Sabatier has written of such images: "Volumes and illustrations were distributed by the hundred—as many as 1,700 could be printed at once—to the royal family, dukes, ministers, archbishops, and *présidents* of the *parlements* and other courts, but above all to ambassadors who gave them as gifts when they were received at foreign courts. . . . Colbert set prices himself, at very low levels so that even the most modest of amateurs could have access to royal treasures."[27] The process did not end in the seventeenth century, for the prints have continued to circulate to this day, reaching the far corners of the globe.[28] In the end, the range of places that have hosted engravings such as Swidde's and the number of viewers solicited by them far exceed the acreage and the crowd depicted in the image itself.

So, many have seen the print, as we see it now. But what are we seeing? It is possible that real or hypothetical viewers might attempt to claim the commanding view as their own. That was the threat represented by the *Apollo Fountain,* to which Louis responded by transporting himself to the chariot's vantage. Were it not for that danger, permanently present and permanently overcome, the king would have lacked part of his mandate for extending his oversight. Nonetheless, the potential for such appropriation cannot be regarded as the principal approach proffered by this image. We, the collectivity of people (past, present, and future) into whose hands the print or secondary reproductions of it have fallen, are not looking at the actual view from the center. It is not our bedroom; for almost all of us it is not even our epoch. Rather, we are looking at the king's act of looking. Perhaps the mild elevation in both Jean-Baptiste Martin's painting and Swidde's image hint at this nuance: only Louis has the majestic stature to see thus from on high. The king's overview in the form of its pictorial representation enters into the territory he surveys, and those in that territory witness his power to view the kingdom.

And what a sight to see! In both Jean-Baptiste Martin's painting and Swidde's view, we witness a realm filled with variety and difference, *and* the capacity of the king to impose coherence over that heterogeneity, converting disparate specificities into the general isotropy, *and* the assurance that the uniformity thus imposed, rather than consisting of only the flat representation placed before the monarch, actually extends out into the kingdom. (Similar things are seen in Le Pautre's map, though it emphasizes the homogenizing effects of the king's rationality more than the kingdom's material variety.) In a sense, the stages replicate those we discovered in Rigaud's portrait, where we saw a Christic body that modeled coherence, *and* an idol of Jehovian majesty, *and* the assurance, in the form of a fully mortal body, that majesty is something other than its terrestrial appearance. But the landscapes have an advantage. The portrait can manifest majesty only as an idol of human scale, or as that "undefinable element" that remains when all earthly appearances of the idol are stripped away. In contrast, the landscapes demonstrate—in the iconic form of "a visibility where the invisible gives itself to be seen as such" (again Marion's words)—majesty in the process of realizing itself on earth, through the exertion of Louis's assimilative oversight. When seen as actual countryside, the painting and the print show only space and the stuff that occupies spots within it. When regarded instead as Louis's view of the countryside, they depict the nation, made replete by the omnipresence of the glorious king. More even than Rigaud's picture, the landscapes in this manner portray France: Christic corporeal coherence presented not through its human model but in its expanded form, encompassing land and all those living upon it.

To be sure, God's majesty could no more be captured by Martin's and Swidde's depictions of countryside than it could by Rigaud's portrayal of king and accoutrements. Nonetheless, the landscape views provided an excellent means for rendering visible Louis's borrowing of that majesty for terrestrial purposes. In showing France, moreover, such images also gave themselves to be seen by France itself. The diverse individuals toward whom paintings and

prints traveled cohere as a nation precisely by seeing themselves incorporated into the king's vision of them. Nation can be seen only in this form, in the viewer's faith that some ineffable coherence has descended on the land and its people, like grace. Occupants of the territory here regard themselves as French because they see the king seeing them that way, as a majestic extension of his own human body. Analogically, other nations to whose ambassadors prints were given could see, in addition to Louis viewing France and the French viewing Louis viewing them as French, their own status as nations recognized by a France that, modeled on its king's body, modeled coherence.

In one sense, the king enters here on a dangerous form of dependence on the people of the realm. France that is modeled on Louis needs to ratify that the Louis who is France embodies and oversees it. Otherwise, the king is just a man at the window, bereft of majesty. Just as the peasants of Lycia out in the garden need to embody, as victims, the power of the king to inflict his power from the center, so too the distanced viewers of the king's viewing serve the indispensable role of registering out there in the kingdom, and beyond, Louis's capacity to see all from Versailles. Yet in another sense, the dispersal of the king's vision, by giving to everyone far and wide the message that the overview resides in the king's nodal prospect, returns power directly to the embodied eye in the palace. The center travels to the periphery, while the periphery reaffirms the center. The king and his vision must be witnessed by the kingdom, while the kingdom must be witnessed by the king, who in turn must be witnessed by the kingdom, and so on without end. Louis's embodiment of royal identity and power becomes possible only if both his august person and his capacity to see take the risk of extending, dispersing themselves into the realm. They do so with the hope, yet without the assurance, of a proper return, whether through the initial investment or through its manifold derivatives. The monarchy, less than absolute, turns on that ceaseless, uncertain speculation.

Wagner's *Ring of the Nibelung*

1. MOTIFS AND THE MUSICAL TRUTH

The charge bites, with the instant veracity of his best aphorisms: "All of Wagner's heroines, without exception," Friedrich Nietzsche quipped in his late and vicious essay of 1888, *The Case of Wagner,* "as soon as they are stripped of their heroic skin, become almost indistinguishable from Madame Bovary!" Yes, of course! The goddess Fricka, without her armored breastplate, shrinks down to a petty housewife, worried into fits about her philandering husband and their mismanaged household. Gods fare no better than goddesses. Wotan himself becomes hopelessly enmeshed in binding contracts and ill-conceived bargains, the standard legal vehicles of the small-time businessman, as he attends to the entirely bourgeois matters of preserving his uncertain corner of power and extending his questionable legacy. Nietzsche's wit cuts to the marrow of the matter: "Transposing them into hugeness, Wagner does not seem to have been interested in any problems except those that now preoccupy the little decadents of Paris. . . . All of them entirely modern, entirely *metropolitan* problems."[1]

Yet the philosopher, perhaps owing to the rhetorical demands of his polemical tone, failed to voice the logical converse of his own insight. If Wagner's Nordic gods found themselves disturbingly close to Flaubert's slight heroine, then the middle ranks who made up the bulk of Wagner's first audiences could not have been all that distant from the ethereal precincts of Walhalla, the gods' fortress in the sky. If deities shared bourgeois concerns, then presumably good German burghers could partake of divine essence. Wagnerian opera, in short, could strive to grant godliness to a certain class, comprising those present for the premiere in 1876 of the four operas of Wagner's *Ring of the Nibelung* at the Festspielhaus, the theater Wagner built in the small northern Bavarian town of Bayreuth expressly for the performance of his operas.

How could Wagner accomplish such an anointment of these auditors? In one sense, he could not. Just as Versailles could never elevate Louis XIV to the full majesty of God, the mortal Wagner necessarily lacked the means to actually deliver divinity to his audience at

Bayreuth. Nonetheless, much as the royal court strove to lend divine majesty to the French king, Wagner could aspire to give to humans, through the performance at Bayreuth, one particular godlike attribute: language that means precisely what it says. To the extent that it differed from a libretto tainted by the rhetorical feints and distortions of human speech, music in the *Ring* emerges as such a language seemingly freed from figuration, selfsame with the referents that it realizes rather than represents.[2]

While the *Ring* peopled the stage of the Festspielhaus with gods lifted from defunct Teutonic and Nordic myths, the ideal of a true and transparent language had deep roots in the prelapsarian myth of the Judeo-Christian tradition. Much as Apollo could serve as a partial surrogate for the Christian God at Versailles, the music of Wotan and his kin embodies the possibility of unalienated Edenic language within the *Ring*. *Parsifal,* Wagner's final opera, may be his most explicitly Christian (or perhaps anti-Christian) work, yet the cosmological ambition of the *Ring* cycle, spanning time from the dawn of existence through the era of the gods to the advent of the age of humanity, makes it promising territory for seeking out the origins of language. In the music of the *Ring* Wagner strove toward divine expression without the tropes of rhetoric, and at Bayreuth he attempted to bequeath that legacy to his human auditors.

Music begins it all, and with music we begin.

The new world at its moment of origin—the only point where Wagner could properly commence his monumentally ambitious *Ring* cycle—is a unitary entity, founded in unprecedented depths. A single note, sustained for 136 bars and lasting more than four minutes, opens *The Rhinegold,* the first installment of the *Ring* tetralogy. It is a rumbling E-flat, barely audible, executed by half the string basses in one octave and the other half an octave lower. Bassoons soon add to the restrained drone with B-flat in two octaves, the lower note at the extreme limit of the instrument's range. This accretion of a second pitch is less a development from the initial tone offered by the basses than a recognition of the essential nature of their E-flat: B-flat, a perfect fifth above E-flat, is the first overtone (following the octave) of that lower note. As the prelude proceeds, quiet horns contribute the deliberate movement of arpeggiated chords that remain within the harmonic ambit of E-flat major by adding to the existing pitches only the mediant of G. Then strings—in turn, cellos, violas, and violins—pick up the pace and double it again, gliding up and down that same basic major triad. The curtains part. We are on the bed of the Rhine, in the realm of elemental nature, with the waters of the river flowing over bedrock much as the high strings glissade over their low counterparts. As flowing waters constitute a moving manifestation of nature rather than a progression away from it, those consonant high strings perform rather than transform the fundamental harmonic implications of the basses' primordial E-flat.

Change, marked by the cessation of the basses' deep rumble, strikes abruptly. It arrives with the advent of character, with the entrance of the human voice. "Weia! Waga!" nonsensically cries Woglinde, the first of three Rhinemaidens who frolic in the waters. Semantic meaning surfaces briefly—"Woge, du Welle! Walle zur Wiege" ["Surge, you wave! Rock

our cradle!"]—before submerging again beneath the wash of alliteration: "Wagalaweia! Wallala weiala weia!"[3] Although the music remains in the key of E-flat (the Rhinemaidens are creatures of nature, swimming in its ambient key), Woglinde and Wellgunde, the second Rhinemaiden to sing, abandon the major triad to cavort along a pentatonic scale, as free of harmonic tension as the triad but different in feeling.

Welcome to the world of the Wagnerian motif, in which each element of the emerging musical drama—"Nature," say, or "Rhinemaidens"—has its own musical signature, a distinctive phrase that, with each recurrence, marks the deployment of a specific character, concept, or action in the *Ring* cycle. The motifs—somewhere between 100 and 150 can be identified in the tetralogy, from two notes to several bars long—constitute the building blocks of Wagner's compositional technique. Simplifying somewhat, we could say that musical exposition in the *Ring* cycle proceeds principally by sequencing and juxtaposing motifs.[4] For instance, "Rhinemaidens" swim in the "Rhine." And toward the end of *The Rhinegold*, "Erda" foretells the "Twilight of the Gods."

Owing to their denotative constancy and relatively fixed musical form (I discuss exceptions a bit later), the motifs tend to maintain both discrete identities and syntactic disjunction. Phrased differently, variations in the rendition of motifs—transposition in key or a change in tempo, even the truncation of the musical phrase—have no effect on their signifying capacity, on their assignment to a clear place in the system of motifs. In this regard, motifs function the way words do. The "Spear" motif, which finishes with a descending diatonic scale, is the "Spear" motif whether brass or strings play it, and even when the last several notes are omitted, just as the name Wotan refers to the patriarch of the gods whether it is spoken by a male or a female voice or is pronounced "Vote-on" or "Woe-tan." Indeed, analyses of Wagner's compositional practice (including this one) often refer to motifs by using verbal tags, names given to them not by the composer but by musicologists over the years, who have demonstrated remarkable perseverance and ingenuity in breaking down the *Ring* cycle into its atomic parts. The term "Sword," a certain brass fanfare, and a weapon wielded first by Siegmund and later by Siegfried, appear at specific moments in the opera cycle and in discussions of those moments.

Like words, and yet not like words. The musical motifs, once formed, prove more resistant than words to grammatical inflection. In most verbal languages, nouns and verbs alter their forms so as to change the syntax, and thus the meaning, of a statement. "Dog bites man" is not the equivalent of "dog bit man" or "dog is bitten by man." The musical motifs, in contrast, tend toward the nominative case. They are simple declarations of presence or relevance in the drama, whatever they denote. A plunging minor sixth followed by the rise of a half tone expresses "Plotting," not "to plot," and no alteration of its form can make the musical phrase indicate the time of that treacherous act or the nature and relationship of its subject and the object. A rendition of "Plotting" close to the motifs for "Hagen" and "Gunther" or when Hagen and Gunther are onstage cannot tell us when the nefarious plot was, or is, or will be launched or who is plotting against whom.

In the context of the *Ring* cycle, however, this limitation emerges not as a loss in signifying capacity but as a gain in expressive clarity. The twisting and turning of words, full of nuance and feints, inevitably yield deceptions, and those skilled in the manipulation of verbal language—Alberich, Mime, and, above all, Hagen—are morally suspect. Wotan, too, performs tricks with words. He attempts to weasel out of his contract with the giants in scene 2 of *The Rhinegold* and engages in an archetypal riddle game with the dwarf Mime in act 1, scene 2, of *Siegfried,* the third opera of the cycle. Yet during precisely such acts of verbal duplicity, Wotan reveals his fatal flaws, demonstrating his oft-remarked parallels to the evil Alberich. Meanwhile, the motifs just say what they have to say.[5] If "Plotting" sounds, then "plotting" there is. And if the ethos of the opera holds sway, you should know that in the pit of your stomach. Whereas "Nature" and the "Rhinemaidens" accord with the harmonious order of rising overtones, for instance, the perturbation of "Plotting" takes the form of descending dyads that sound the dissonant intervals of a tritone and of a half step beyond the octave.

In some sense, the verbally rendered narrative—with its wild turns and famous inconsistencies, its conflicts between principals and its withholdings of truth—will take care of itself. It plots itself into knots, inconsequentially. More important in the *Ring* cycle are the visceral verities underlying the narrative convolutions, manifested in the strictly nominative declarations of the motifs. In no passage is this tendency better exemplified than in act 1 of *The Valkyrie,* the second opera, where the motifs repeatedly reveal significant truths to the audience—Siegmund and Sieglinde's identity as Wotan's twin offspring, Hunding's earlier participation in the gang that pursued Siegmund, the waiting presence of the concealed sword—while the characters onstage flounder in ignorance. Again and again, the motifs in the *Ring* cycle line up and render their uninflected, undistorted sense. They have no syntax, really. They lack that vehicle of perfidy. Or alternatively, their lack of that vehicle represents, in the musico-linguistic dynamic of the tetralogy, the ineluctable truth-telling of the motifs.

Although the motifs have no inflection, the *Ring* cycle does offer instances (the exceptions I mentioned above) when the alteration of musical form modifies meaning. Invert the upward-rising "Nature" motif (growth, life), and you get the descending motif of the "Twilight of the Gods" (decrepitude, death). The first highlighted instance of such a transformation, during the passage between scene 1 and scene 2 of *The Rhinegold,* contrasts starkly with the discrete presentation of motifs in scene 1. The horns intone the "Ring" motif—Alberich has just absconded with the gold from which he will fashion that implement of immeasurable power. Immediately after, a brass choir repeats much the same musical pattern but alters the motif's harmony and rhythm just enough to make it into a motif of its own, "Walhalla," named for the newly constructed Olympian stronghold of the gods. Ultimately, a number of motifs emerge similarly from others. Deryck Cooke has constructed a particularly ornate genealogical tree, grouping the motifs into families and tracing virtually all the important ones (some are unrelated misfits) to about ten origins.[6] Again, we seem to be imagining the mo-

tifs as mimicking the behavior of words: "Ring" becomes "Walhalla" much as the name Wotan, by means of arbitrary alterations, becomes the word "wanton," say, or "photon."

In the logic of the motif system, however, such musical modifications are anything but arbitrary. Here, a similarity between signifiers necessarily implies a similarity between signifieds. The ring and Walhalla are both manifestations of absolute power—indeed, Wotan intends at one point to pay for Walhalla by handing over the ring. Similarly, the "Rhine" flows out of "Nature," the "Woodbird" and the "Rhinemaidens" alike sing nature's message to man, and so forth. Words do not operate this way: the patriarch of the gods may be wanton at times, but he bears no relation to a quantum of light. Often, in fact, the motifs themselves—like that relatively rare linguistic phenomenon onomatopoeia—resemble their referent. "Nature" grows upward; the "Twilight of the Gods" descends. The musical phrase "Spear" breaks into fragments when the weapon is shattered in act 3, scene 2 of *Siegfried* (a scene to which we will return); "Siegfried's Horn Call" in *Siegfried,* act 2, scene 2, sounds like nothing so much as the call of Siegfried's horn. Part of the sense that music tells the truth in the tetralogy stems from the fact that the motifs carry within them the essential characteristics of that to which they refer. The motifs, in short, are motivated.

The connection between motif and referent is closer still. In the *Ring* cycle Wagner more or less constructed his own world. True, he derived many of the characters and events from ancient Nordic and Teutonic myths. Yet despite a widespread but cursory interest on the part of the German public during this period of searching for national roots, detailed knowledge of such hoary tales remained the purview of dusty antiquarians, and Wagner could easily alter the narrative without causing his audience to fret that he had gotten it wrong. If in *Twilight of the Gods,* the final opera, Wagner had the hand of the dead Siegfried rise to threaten Hagen, whereas the source text, *Song of the Nibelung,* had a bleeding wound do the trick, then as far as the audience in Bayreuth was concerned, that hand did properly rise.[7] It helped that no one in Wagner's day actually believed in the pantheon of pagan gods and the phalanx of mythic heroes introduced in the *Ring* cycle. Had he attempted an opera about Jesus Christ (a project he envisioned earlier in his career but wisely abandoned), Wagner inevitably would have profaned the material in the eyes of the many believers, who knew well the story of Jesus's life. The Christian Father and Son could no more readily appear in Wagner's operas than outside the chapel at Versailles without disrupting the logic and autonomy of the presentation. In contrast, the characters and events of Wagner's saga did not really exist outside the *Ring* cycle. The playing of a motif during the tetralogy in essence called it into being. No plotting without "Plotting"; no weapon without the "Sword." (Well, yes, the text refers to a sword, and a sword appears as a prop, but these entities are mere epiphenomena in relation to the truth of the sword rendered by the underlying musical motif.) The motif did not, like words, represent its referent. It *was* that referent. Neither idol nor icon (both categories of representation), the motif involves identity. The relationship between Siegfried and Brünnhilde might thus accurately be paraphrased—or, rather, realized in its actuality,

without the representational distance from the referent engendered by the presence of a verbal phrase—by the musical rendition of the idea: behind every successful brass fanfare there stands a clarinet in the lower register.

2. GODS DO NOT TROPE

So far, I have worked to deduce the nature and function of the motifs through an examination of the *Ring* cycle itself. But I have arrived at a point not far from Wagner's own claims about words and music, claims we might now understand with greater clarity in light of their realization in his operas. The composer wrote in 1860:

> The speech of man evolved along a more and more abstract line; so that at last there remained nothing but a conventional meaning, depriving the feeling of any share in understanding the words, just as their syntax was made entirely dependent on rules to be acquired by learning. . . .
>
> As the modern European languages—divided into different stocks, moreover—have followed their conventional drift with a more and more obvious tendency, music, in contrast, has been developing a power of expression unknown to the world before. It is as though the purely human feeling, intensified by the pressure of a conventional civilization, had been seeking an outlet for the operation of its own peculiar laws of speech; an outlet through which, unfettered by the laws of logical thought, it might express itself intelligibly to itself. . . . However unintelligible [music's] tongue when judged by the laws of logic, she must possess a more persuasive title to our comprehension than anything contained within those laws.[8]

Wagner's argument bears the unmistakable imprint of the ideas of the philosopher Arthur Schopenhauer, whose book *The World as Will and Representation* of 1818 Wagner had discovered and read with rapt attention many times, beginning in 1854. Schopenhauer's ideas about music held equal sway over the young Nietzsche, and it is no exaggeration to say that Schopenhauer's book engineered the close acquaintanceship—too sycophantic to qualify as friendship—between older composer and youthful philosopher, before their dramatic falling-out in 1876. In *The Birth of Tragedy* of 1872, a work dedicated to Wagner and concluding with a panegyric of him, Nietzsche quoted at length the relevant passage from Schopenhauer:

> We may regard the phenomenal world, or nature, and music as two different expressions of the same thing [the "will"], which is therefore itself the only medium of their analogy, so that a knowledge of it is demanded in order to understand that analogy. Music, therefore, if regarded as an expression of the world, is in the highest degree a universal language, which is related indeed to the universality of concepts, much as they are related to the particular things. Its universality, however, is by no means that empty universality of abstraction, but quite of a different kind, and is united with thorough and distinct definiteness. . . . All possible efforts, excitements, and manifestations of will, all that goes on in the heart of man and that reason includes in the wide, nega-

tive concept of feeling, may be expressed by the infinite number of possible melodies, but always in the universal, in the mere form, without the material, always according to the thing-in-itself, not the phenomenon, the inmost soul, as it were, of the phenomenon, without the body. This [is the] deep relation which music has to the true nature of all things. . . . Music is distinguished from all the other arts by the fact that it is not a copy of the phenomenon, or, more accurately, of the adequate objectivity of the will, but is the direct copy of the will itself, and therefore exhibits itself as the metaphysical to everything physical in the world, and as the thing-in-itself to every phenomenon. We might, therefore, just as well call the world embodied music as embodied will. . . . Music . . . gives the inmost kernel which precedes all forms, or the heart of things.[9]

The passage may require exegesis.[10] For the Kantian Schopenhauer—and by extension, for Wagner and for Nietzsche at this early point in his career—the empirical world experienced by our human senses is only a derivative "representation." It consists only of the phenomenal traces given to us by a fundamentally imperceptible yet ontologically secure world of noumena. That realm of noumena Schopenhauer designated the "will," by which he meant not the intents and desires of any individual but rather the general impetus driving onward the hidden world of essence. (The individual will is related to this force only by analogy and can no more manifest it fully than, according to Marion, the human concept of Being is able to contain God.) Verbal language, with its abstractions and arbitrary conventions, can do no better than mimic the phenomenal world, with greater or lesser success. It is an imperfect representation of an imperfect representation. In Schopenhauer's formulation, music at first seems the sibling rather than the progeny of phenomena and is thus presumably subject to the same inadequacies as that other form of representation. Yet as the argument progresses, music does better. Having shunned the arbitrary conventions of the human arts, music in its universality emerges in Schopenhauer's account as a *perfect* copy of the "will." And perfect copies cannot be distinguished from what they represent—otherwise, they would not be perfect (recall Borges's map). In the end, music is identical to the "will." As Nietzsche summarized Schopenhauer: "We understand music as the immediate language of the will"; or as Wagner digested him: "Music speak[s] a language immediately intelligible by everyone, since it needs no whit of intermediation through abstract concepts."[11]

This was a remarkable position for the young Nietzsche to adopt, given his otherwise unremitting skepticism about all claims to unmediated representation. In his unpublished essay "On Truth and Lying in an Extra-Moral Sense" from 1873, he declared:

When we speak of trees, colors, snow, and flowers, we believe we know something about the things themselves, although what we have are just metaphors of things, which do not correspond at all to the original entities. . . .

What is truth? A mobile army of metaphors, metonyms, anthropomorphisms, in short, a sum of human relations which were poetically and rhetorically heightened, transferred, and adorned, and after long use seem solid, canonical, and binding to a nation. Truths are illusions about which it has been forgotten that they *are* illusions, worn-out metaphors without sensory impact. . . .

> To be truthful [means] to use the customary metaphors, or in moral terms, . . . to lie according to an established convention, to lie collectively in a style that is mandatory for everyone.[12]

Nietzsche's is a stunning indictment of the whole human pretense to truth. All human thought and all of its illusory claims to grasping the world through the use of concepts and language remain subject to the incessant turning of tropes, not against the actual world but against each other. All human knowledge, in short, is rhetorical.

This insistence on the rhetorical nature of all thought, along with the concomitant implication that no rhetorical formulation has greater purchase than any other on absolute truth, placed Nietzsche squarely against antirhetorical conceptions of knowledge that dominated the era. For instance, Alexander von Humboldt's plan for the University of Berlin of 1809 imagined the principal purpose of the institution to be the pursuit and teaching of modern "science" (in the broader German sense of *Wissenschaft*) rather than instruction in the classical skills of rhetoric. John Bender and David Wellbery encapsulate the trend:

> In Germany, the Enlightenment ideal of linguistic transparency, of a purely neutral representational medium, emerged in Leibnitz's project of an *ars characteristica,* a philosophical calculus that would leave the deflections of human language behind in order to reproduce the language of things themselves. This dream, which in a variety of forms obsessed the entire eighteenth century, perhaps most fully exemplifies the removal of discourse from . . . the rhetorical fray. . . .
>
> What the Enlightenment accomplished in the domains of theoretical and practical discourse, Romanticism achieved in the aesthetic domain. . . .
>
> Romanticism represents the final destruction of the classical rhetorical tradition.[13]

Seen from this antirhetorical stance, the goal of knowledge was to strip away the cluster of metaphors that encumbered perception in order to approach the truth ever closer. From Nietzsche's rhetorical position, knowledge was nothing but a cluster of metaphors, truth (of the conventional sort) was illusion, and no proposition could meaningfully claim greater proximity than any other to a form of truth that lay beyond the twists and turns of rhetoric.

Yet despite their obvious differences, both the rhetorical and the antirhetorical positions recognized that no one could ever actually achieve (as opposed to approach) a pure and natural language entirely freed from figuration. "As Leibniz and later Herder well understood," Bender and Wellbery point out, "such a perfected sign system would coincide exactly with the absolutely nonpositional mind of God" (14). Once upon a time, perhaps, man had access to such a direct language. And I do mean "man," a single individual of the male sex, namely, Adam. "So out of the ground the Lord God formed every beast of the field and every bird of the air," recounts Genesis, "and brought them to the man to see what he would call them; and whatever the man called every living creature, that was its name" (Genesis 2:19). At that prelapsarian moment, Adam could see the thing and give it its name (not man's name for it). All words functioned as proper nouns, properly assigned.[14] (Proper nouns in the tetralogy, acting improperly, flail about in abandon. Wotan is also The Wanderer, Wolfe,

Wälse, and Licht-Alberich. Siegmund in the course of act 1 of *The Valkyrie* puts on and takes off sobriquets—Wehwalt, Friedmund, Frohwalt, Wölfing—as if they were so many fig leaves concealing his true identity, which manifests itself only in the constant musical motif.) After the Fall, and certainly after Babel, when God "confused the language of all the earth," words lost their unmediated connection with things (Genesis 11:9). Humanity since then can no more empty its language of figuration than it can rid the world of sin. The human race—to speak figuratively, or rather to activate the prefiguration—bears its cross of rhetoric.

Within this harsh philosophical and theological environment, it is truly extraordinary that Schopenhauer's thesis concerning the unmediated character of music could survive and even prosper, attaining new life in the claims made implicitly by the young Nietzsche and explicitly by Wagner for the composer's musical language of motifs. How fitting, then, that the *Ring* cycle is set during the epoch of gods predating the advent of human history, which can only commence after the events recounted in *Twilight of the Gods*. Wagner's is not the biblical story of Genesis, but it is an obvious correlate myth of origins. In regard to the motifs, Wagner assumes the position of Adam. As each new significant element of the tale arises, the composer gives it its proper name in music, a name entirely sufficient to evoke that element since the two are, for all purposes, identical. Neither Adam nor Wagner can misspeak, because they speak in the language of things themselves. For Wotan and his divine clan, this is the proper tongue, and Wotan abandons it only when he chooses to speak in the verbal language of humans.

The tetralogy, moreover, provides formal warrant for the authenticity of its musical motifs. The words of the libretto have an identity and a function outside the operas in the seemingly infinite realm of common usage, and despite Wagner's patent attempts at archaism, the verbal language can never become his own. Any given word in the operas can be twisted into a new meaning to the extent that Wagner's use of it differs somewhat from its ordinary use and meaning. Indeed, the libretto's words cannot help but trope their conventional meanings since their application within the *Ring* cycle differs from common usage precisely owing to their specificity. I am only reiterating Nietzsche's idea that verbal language is always rhetorical, or—to expand only a bit—that every trope engenders an improper use of the verbal term.[15]

The motifs, in contrast, exist only within the compass of the tetralogy: there is no ground of conventional usage beyond the operas against which to measure the figure of the motif. To be sure, the basic rules of Occidental diatonic music under which Wagner operated constitute a convention. Yet the composer's codification of musical ideas into relatively rigid motifs has the effect of freezing those underlying rules in place and lifting signifying activity onto the level of the musical phrase. Once a downward-leaping fifth establishes itself as "Hagen," the listener experiences it as the Gibichung evil half-brother rather than as a musical interval. Something very similar happens with verbal language. Although phonemic variation creates differences between words, once a word solidifies into accepted meanings, its users can disregard the phonemes. A dictionary tells us that a "cat" is a domestic feline,

not that it differs from "hat" or "bat." Once words are formed, they enter into the infinite realm of actual and potential human application. In contrast, the tetralogy, though vast to a virtually sublime degree, is still finite. The cycle lasts some fifteen hours (Wagner abbreviated nothing; his operas, the polar opposite of Nietzsche's lapidary aphorisms, never perform the trope of ellipsis), during which each motif can be played only a certain number of times. While the whole may be difficult to hold in a human mind (practically all musicologists who catalogue the motifs at some point declare their efforts less than comprehensive), the various applications of any given motif certainly lie within the range of human comprehension. And thus analysts, and perhaps even repeat auditors, can grasp the entire range of potential and actual applications of a particular motif. (In this finite world, "potential" and "actual" are selfsame, since no new operas will be written using this set of motifs and thus no further "potential" uses will ever be made "actual.") Definition exactly corresponds to usage; *langue* precisely matches *parole*.[16]

Consider, at something approaching an extreme instance, the seemingly contradictory motif of "Love's Renunciation."[17] It receives its first clear rendition near the end of scene 1 of *The Rhinegold;* the orchestra slows down markedly and arrests extraneous movement to emphasize this passage as the motif's signature rendition. Alberich, having been told that domination of the world awaits him who renounces love and thereby obtains the ability to forge a ring from the Rhine's golden hoard, sings to the notes of the motif (a mere moment before seizing the treasure): "So verfluch ich die Liebe!" ["Thus I curse love!"]. It might then seem incongruous for this motif—similarly highlighted by the cessation of excessive orchestral activity—to reappear toward the conclusion of act 1, scene 3, of *The Valkyrie,* when Siegmund prepares to withdraw the sword from the World Ash Tree (earlier placed there for him by Wotan), singing: "Heiligster Minne, höchste Not; sehnender Liebe, sehrende Not" ["Holiest love, highest need; yearning love, injurious need"]. After he frees the weapon and names it Notung, he will present it to Sieglinde, declaring to the accompaniment of the triumphant "Volsung Race" motif that heralds the union of these incestuous siblings (and referring to himself in the third person): "Weib! Als Brautgabe bringt er dies Schwert" ["Wife! As bridegift he brings this sword"]. Does not this reappearance of the "Love's Renunciation" motif register the affirmation of romantic devotion rather than its forswearing?

Yes, except—and this is the manner in which the motif prompts a probing of the prevaricating verbal narrative—Siegmund's grasping of the sword commits him to a course of action that will lead to his death and to Sieglinde's ruin. Taking up the weapon, furthermore, engages the hero as an unknowing agent in Wotan's long-brewing stratagem (doomed to fail, although Wotan himself does not yet recognize that fact) to regain the errant ring for himself. Just as Wotan first obtained his godly powers by wresting a branch from the World Ash Tree and fashioning his spear from it, so too Alberich aspired to domination by plundering the golden ring from the primordial Rhine; Siegmund now aspires to warrior's might by pulling the instrument of his power from the same World Ash Tree from which Wotan drew his authority. Thus the musical motif does maintain a consistency, but one united not

around the concept of "Love's Renunciation" but rather around . . . well, what exactly? Something having to do with the complex idea that any gambit to secure dominance in the realm of worldly affairs through the spoliation of the basic forces of nature must involve the sacrifice of some natural aspect of one's self (such as innocence, or, more often, love) and will inevitably lead to ruin. The cataloguers have proposed a variety of labels for this notion, none quite hitting the mark: "Renunciation, often amounting to acceptance of destiny," "The Moment of Choice," "Liebe-Tragik." The concept's resistance to attempts to gloss it in a word or a short phrase testifies not to confusions within the motif but to the inadequacies of verbal language. Verbal language is buffeted by its usage beyond the opera cycle, whereas the motifs are not.

The complex sense of a linkage between power and sacrifice, moreover, was already present at the moment of the motif's first articulation by Alberich near the beginning of *The Rhinegold.* Auditors following the linear flow of the cycle from start to finish cannot know that yet, since they lack the godlike perspective, encompassing the complete tetralogy as an immobile whole, from which the consistency of all motifs can be perceived. The second instance of the motif does not trope the first, in other words, since the first instance on its own never possessed the status of proper or conventional usage. One instance cannot turn ironically against another. Propriety establishes itself only retrospectively—or, rather, atemporally— once all instances of the motif have been realized; from that vantage all applications of the motifs are proper. The existence of each motif only within the contained expanse of the tetralogy mandates a commensuration of meaning in all actual instances of its application, and for the most part the cataloguers comply. None of them want to throw up their hands and declare that they cannot grasp the underlying unity of the principal elements of Wagner's musical expression.[18]

We might illustrate this character of the motifs with a geometric metaphor. The base of a triangle that represents the playing of the *Ring* cycle over time may be wide—the widest in the corpus of canonical musical works, in fact—but it is finite: about fifteen hours. Along this finite line we could plot the various appearances of a given motif, and from the resulting definite number of points we should be able to triangulate that motif's fixed meaning. The preceding two paragraphs exemplify such a triangulation of the "Love's Renunciation" motif. Verbal language can never fix its meanings through this manner of triangulation because the base defined by actual and potential use of any given word is infinite, extending both into the inaccessible recesses of the past and into the unknown future. The result is that the significance of each musical motif may be embedded deep in the complex operas, at the far point of a vast triangle spreading out into the plane of signification as it were, and yet its position can always be fixed from the perspective of the motifs along the base. The triangle, while large, is finite; its far point may lie at considerable depth upon the plane of signification, but it always remains within grasp. Once the meaning of motif has thus been determined, it manifests itself in every specific application of the motif, just as the far point of a triangle, once positioned, can be used to designate any given point along the base by a

set of coordinates denoting angle and distance. Much as the dramatic referents of Wagner's motifs exist fully in their musical expression—because, as I argued earlier, motif and referent are actually selfsame—so too the meanings of the motifs manifest themselves fully at the level of their musical articulation. The meanings of the motifs may be deep, but they also lie along the surface. To employ an oxymoronic figure of speech, we could say that the motifs are profoundly superficial, in the literal sense of the terms. A single motif rendered by orchestra or singer during the course of a performance of the *Ring* cycle can no more fail to evoke its proper significance than can its dramatic reference miss its mark. It is not that gods choose not to trope in the language of music; they simply cannot do so with their miraculously self-correcting motifs.

3. PATERNAL LEGACY AND FILIAL GIFT

Siegfried, act 3, scene 2. The god Wotan encounters Siegfried, his human grandson, offspring of the incestuous twins Siegmund and Sieglinde. In this descendant rest all Wotan's hopes for setting right the world's accounts. The deity himself cannot accomplish that rectification owing to the many treaties and obligations with which he has become encumbered in his futile efforts to procure lasting power and security.[19] Siegfried, it seems, is not bound by the interdiction to restore the ring to the Rhinemaidens on Wotan's behalf, for he, unlike his father, was not conceived with that express purpose. Siegfried has reforged his sword, unaware of its origins (Wotan is most pleased when Siegfried proves his ignorance during their verbal exchange), whereas Siegmund drew his weapon from the World Ash Tree fully aware that it had been planted there and left as a legacy by his father, whom he knew by the names Wolfe and Wälse. Actually, Siegfried has been informed that the sword fragments came from his father but knows little about him. He certainly does not know that Siegmund received the weapon from his father, the god Wotan. Siegfried appears to be an independent actor, a human hero whose deeds bear none of the damning weight of Wotan's intent.

As Wotan and Siegfried meet, only Wotan is aware of their blood relation. Siegfried, in fact, is not aware of much. Whereas Wotan has effectively been stripped of the power to act and spends his time contemplating his fate, Siegfried is a man of action and not thought. He would like to get on with scaling the fiery mountain to earn his bride, Brünnhilde, and becomes annoyed to the point of vulgar and unwitting rudeness with the "störrischer Wicht" ["stubborn creature"] who blocks his way and wants to parley. Wishing to receive respect, Wotan almost gives the game away by baldly hinting at their close kinship: "Kenntest du mich, kühner Sproß, den Schimpf spartest du mir!" ["If you knew who I was, bold sprout, you would spare me insult!"—with "sprout" figuratively "descendant"]. Only Siegfried's obliviousness preserves the secret.

In their verbal exchange, Wotan speaks in concord with music, the language of the gods. Listen to the regal cadence of the woodwinds and pizzicato strings when Wotan pronounces

in iambs: "Wer *schuf* das *Schwert* so *scharf* und *hart, daß* der *stärk*ste *Feind* ihm *fiel?*" ["Who created the sword so sharp and hard, that it felled the strongest foe?"]; and again during his following proclamation: "Doch, wer *schuf* die *stark*en *Stück*en, dar*aus* das *Schwert* du *dir* ge*schweißt?*" ["But who created the strong pieces, from which you yourself forged the sword?"]. The syllabic accents (indicated here by italics) correspond precisely to the lilt of the music. Siegfried and the orchestra, in contrast, hurry through the hero's intervening passage, and in reply to Wotan's second, more portentous, question, Siegfried shouts, out of synchrony with the underlying orchestral articulation, "Was *weiß* ich davon?" ["What do I know about that?"]. During the extended passage between Siegfried's arrival and his final confrontation with the god, Wotan's words are much more integrated into the flow of the orchestra than are those of his grandson. Wagner achieves this differential effect by repeatedly having Siegfried sing in patterns of subdivided threes against the orchestra's subdivided fours (or vice versa), whereas Wotan sings in rhythm with the musical accompaniment, so that Wotan's speech seems to emerge out of the music.

Until the two clash. The conversation, having begun on Wotan's side as something like playful banter, escalates in the god's eye to genuine affront. Against his own best interests, Wotan acts impetuously. He holds up his spear to bar Siegfried's progress toward Brünnhilde, rebuking the lad even as he must realize that Siegfried's mission will succeed only if the hero obtains his bride. The god's spear shatters when struck by the mightier sword wielded by the mortal. This is the end of Wotan's authority and the last time we will see him onstage. The music recognizes this human triumph, the passage of mastery from Wotan to Siegfried. The god sings his final admission that he is now powerless over the human, "Zieh' *hin!* Ich kann dich nicht *halt*en!" ["Pass on! I cannot stop you!"], on a musical line that no longer carries the strong accents of the earlier passages—the penultimate syllable *halt* hardly qualifies as a stress at all. Moreover, the vocal line moves in a direction contrary to that of the orchestra and possesses a different tonal center. The singer, with a downward leap to an aharmonic B-natural in his predominant key of F minor, breaks off halfway through the complete orchestral passage, which speaks the truth in the form of the "Twilight of the Gods" motif. Siegfried can now claim affinity with the music, and he does so almost immediately. The hero and the string basses together recommence on the note of G, and within a phrase he is rendering a modified version of the "Rhinegold" motif (which one commentator has labeled "Joy") in concert with the horns and the oboes. Siegfried's final phrase of scene 2, basically an arpeggiated chord of F major's dominant of C, launches the orchestra straight into the triumphant musical interlude between scenes that begins with the horns blaring "Siegfried's Horn Call" in the cadence-resolving key of F.

What has transpired here? On the one hand, nothing: the "will" of music continues to express itself through two different (though inconsequentially so) phenomenal "representations," the characters Wotan and Siegfried. On the other hand, everything: we have witnessed the momentous passing of the powers of music from god to hero. (Siegfried is an ideal recipient of those powers, for he, like the motifs, is profoundly superficial. While his

virtues are great, he wears them on his sleeve.) Herein lies a deep tension, perhaps the fundamental contradiction, at the heart of the *Ring* cycle. Whereas the narrative of the libretto demands temporal development from the first wresting of consciousness out of nature until the cataclysmic fall of the gods, the divine character of the music requires an absolute stasis of immutable truth free of all contingency. No character better personifies this tension than Wotan. He does sometimes undertake action: he sires the Volsung twins, assembles dead heroes to protect Walhalla, and so forth. And yet Wotan and his like are irrevocably doomed from the moment the ur-goddess of nature, Erda, prognosticates their demise using the "Twilight of the Gods" motif in scene 4 of *The Rhinegold*. Erda makes it clear, in fact, that the gods have always been fated to pass: "Wie alles war, weiß ich; wie alles wird, wie alles sein wird, seh ich auch" ["How everything was, I know; how everything is, how everything will be, I also see"]. The task of the tetralogy thus becomes managing two irreconcilable propositions: that the course of things can change, and that it cannot.

To a certain extent, as we have seen, Wagner's opera cycle accomplishes this task through a neat division of labor. Words chronicle the narrative development, while music abjures development for the sake of preserving enduring truth. It was this aspect of Wagner's music that most troubled Theodor Adorno, who wrote some seven decades after the premiere of the *Ring* cycle in Bayreuth. For him, Wagner's congealing of musical expression into static motifs, presented without breaks in a continuous flow of melody, precluded all thematic development. The composer could do no more than string together a sequence of discrete musical cells.

> Gesture can be repeated and intensified but not actually "developed." . . .
>
> The eternity of Wagnerian music, like that of the poem of the *Ring,* is one which proclaims that nothing has happened; it is a state of immutability that refutes all history by confronting it with the silence of nature. The Rhine maidens who are playing with the gold at the start of the opera and receive it back at the end are the final statement both of Wagner's wisdom and of his music. Nothing is changed; and it is the dynamics of the individual parts that reinstate the amorphous primal condition.[20]

Adorno may seem to be talking about the story, but written narrative is here serving as little more than a convenient figure for what the philosopher cares most about, the character of the music. As a healthy alternative to such atemporal stasis, Adorno offered the sonata form of Viennese classicism, which—with its presentation of theme, counterthemes, development through thematic juxtaposition, and cadential resolution—nicely replicated "the dialectical progression of substance, its inner historicity" (42), on whose continued drive toward a better future Adorno staked so much of his intellectual and political program. For him, Wagner's operas constituted one massive act of bad faith because by substituting the illusion of resolution for the realities of contemporary contradictions, they arrested any dialectical progress toward actual historical synthesis. "Wagner's music simulates [the] unity of

the internal and external, of subject and object, instead of giving shape to the rupture between them," Adorno claimed (38).

Adorno's condemnation of Wagner presupposes the alienated condition of modern humanity—an assessment that, however valid, depends on experience culled from somewhere other than the opera itself. In essence, the critic faulted Wagner's music for thwarting the sort of development that the composer might well have claimed characterized the narrative drive of his own libretto. This is a tale, after all, of the passing of one social order and the emergence of another.[21] Adorno championed the real need for development while bemoaning the illusory character of stasis; Wagner championed the truth of a static "will" while despairing over the tragic misfirings and duplicities of an unfolding story—whether of the doomed Nordic gods or of the human revolution that failed in 1848. (Wagner took such an active part in that uprising that he was forced in 1849 to flee from his official post as Kapellmeister in Dresden.) In an odd sense, then, Adorno and Wagner actually agreed regarding the tetralogy's music as the manifestation of stasis. For one it was a negative attribute, and for the other a positive one.

Nonetheless, the music undergoes a definite development in the scene of Wotan and Siegfried's confrontation: not a musical elaboration, but a shift in its possessor within the narrative. Siegfried, no longer a youth in the wake of the Oedipal confrontation, emerges a mature hero of superhuman powers. He has previously slaughtered dwarves and dragons, but this time he has defeated a character from on high. And Wotan has lost his divine authority, as embodied in the spear and the treaties engraved upon it. (Similarly, Brünnhilde was earlier cashiered from godly ranks and became mortal as punishment for filial insubordination.) The god will perish, with all the tragic consequences—but also enabling limitations—that the mortal condition implies. "Enabling" because Wotan, by indulging in impetuous action, has acquired a will; the "will" no longer has him. More important, time newly matters to him, because he can proceed through narrative development to what was previously denied him: an end. Siegfried has given Wotan mortality, and Wotan in return has passed on to Siegfried the mission of the music.

4. GODS CANNOT TRADE

Music is exchanged for mortality, then. "The theme of exchange and contracts is the central theme of the *Ring*," Slavoj Žižek has written in summary of his wily analysis of Wagner's operas.[22] In many respects, Žižek's account is an elaboration on the concise, insightful essay about the tetralogy sketched some years earlier by Claude Lévi-Strauss. Lévi-Strauss had discovered in Wagner's mythic universe a system of social interaction that closely resembled the potlatch societies of the Pacific Northwest coast, where decades earlier the young anthropologist had derived many of his structuralist ideas. "The problem posed by *The Rhinegold,* and that the three subsequent operas will seek to resolve," wrote Lévi-Strauss,

is that of the conflict between contradictory demands of the social order which, in any conceivable community, prohibit receiving without giving. The spirit of the laws, as engraved by Wotan on his lance, is that always, even among the gods, and certainly among men, one will get nothing for nothing.

. . . Even when one believes one has the two things, one cannot hold on to both of them—the unvarying element throughout the plot.[23]

Wotan had paid for the construction of Walhalla by delivering to the giants the love-goddess Freia and had then bought back the indispensable Freia with the booty of the gold. But that gold carried with it, twice over, the curse of its theft: first from the Rhinemaidens by Alberich, and then from Alberich by Wotan, assisted by Loge's cunning. (It could be argued that Alberich did pay for the gold with the love he renounced to obtain it, yet from the perspective of the Rhinemaidens, who hardly consent to the transfer, the dwarf's sacrifice was far from an equal exchange.) The debt, transferred to Wotan through Alberich, ultimately redounds to the Rhinemaidens—and the narrative proceeds with this liability as an underlying assumption. In essence, Wotan has obtained Walhalla for "nothing." Yet he cannot rightfully hold on to "two things," Walhalla and the spear of his authority, since the treaties and laws engraved on his weapon oblige him both to give the gold to the giants (which he has done) and to give it back to the Rhinemaidens (which he cannot do). The confrontation with Siegfried thus doubly resolves Wotan's difficulties, since it both empowers the mortal grandson to proceed on a course that will eventually restore the gold to the Rhinemaidens (the restoration takes place in *Twilight of the Gods,* though not quite as anyone, other than Erda, could have foreseen) and, with the shattering of the spear, relieves Wotan of the burden of upholding irreconcilable laws.

Nonetheless, this complex transfer of powers, responsibilities, and liberties between god and man entails troubling consequences—especially for the music. In the numerological spirit of such myths and fables, I will present three.

First: In this transaction neither party may actually gain much that is worth having. On the one hand, while the shattering of the spear may seem to release Wotan from its terrible onus, the fact that Siegfried now becomes the sanctioned agent who will restore the gold to the Rhine means that Wotan may actually be seeing to the proper settling of all accounts indirectly by passing that task on to his grandson. The god cannot so easily free himself from the laws of the spear, that is, from Lévi-Strauss's inexorable economy of exchange. Precisely at the moment when he is relieved of the irreconcilable obligations pressing down on him, Wotan manages to satisfy them all. He (willfully) casts aside the lance, only to find it (and the "will") firmly back in his hands. Even with the god's passing, his laws and purpose live on.

On the other hand, Wotan's transmitting of mission and music to Siegfried quite obviously violates the prohibition against the god's meddling in the process by which man, the supposedly independent actor, is to return the golden treasure. Wotan sets himself up as Siegfried's penultimate trial (the circle of fire awaits) before the hero can obtain Brünnhilde,

and thus what Siegfried wins in the encounter comes at a cost: the loss of his independence. "His self-madeness," David J. Levin has quipped about the hero, "is made by others."[24] Wotan's intervention here in *Siegfried* condemns the grandson no less than his earlier planting of the sword in the trunk of the World Ash Tree in *The Valkyrie* condemned the son. The lien of the fundamental violation (getting something for nothing) inevitably attaches to any granting of the divine deed. Like Siegmund, Siegfried cannot use Notung for nothing.

But does not this inevitable attachment compromise the music thereby passed on? Music, to recapitulate, was to have no rhetoric. Each motif used in the finite tetralogy was self-same with its referent and could not trope others as it transparently yielded up essential meaning of profound superficiality. Yet it now turns out that the divine power manifested by the musical motif ("manifested" rather than represented: that was the conceit of transparency) inherently contained within itself the impossibility of its own realization. The betrayal of music's purity is here twofold: Music cannot speak the language of unrestrained divine power, because narrative development will eventually curtail that power; and that limitation is revealed through an ironic turn that exposes transparency as nothing more than a pretense used to hide the inevitability of its rhetorical reversal. It is as if Adam's language could talk of nothing but the Fall.

Second: Irrespective of the final success of the transaction, music loses its divine aspect by being drawn into the bargain. Music is to be exchanged for something else—in this case mortality and the liberating resolutions it provides. Thus, by the logic of the market, music assumes a value equal to that for which it is exchanged. It becomes commensurate with that thing according to the standard of value while at the same time maintaining its essential difference both from that thing and from the value assigned to both. Karl Marx, writing *Capital* over roughly the same long period during which Wagner labored on the tetralogy, described the process in pertinent terms:

> A given commodity, *e.g.* a quarter of wheat is exchanged for x blacking, y silk, or z gold, &c.— in short, for other commodities in the most different proportions. Instead of one exchange-value, the wheat has, therefore, a great many. But since x blacking, y silk, or z gold &c., each represent the exchange-value of one quarter of wheat, x blacking, y silk, z gold &c., must, as exchange-values, be replaceable by each other, or equal to each other. Therefore, first: the valid exchange-values of a given commodity express something equal; secondly, exchange-value, generally, is only the mode of expression, the phenomenal form, of something contained in it, yet distinguishable from it.[25]

A given entity, music, is surrendered to obtain, on Wotan's side of the transaction, a certain measure x of relief from obligations; or it is acquired, on Siegfried's side, at the loss of a certain measure y of independence. Once this processes of assessing the equal value of things commences, the interchangeability of actors and the transitive character of the market operation make it impossible to cease. What would Wagner, or members of Wagner's audience, or I, or you, give for the full possession of divine music? For relief from obligations?

What would any of us exchange for a certain degree of independence? Each potential item of exchange, expanding infinitely beyond the finite supply of goods and services present in the opera itself, assumes a relation to music—and to x relief, and to y independence, and so on without limit—in which it assumes music's value without ever pretending to be music itself. Thus although music on its own may manifest the divine in profound superficiality, it can only represent, like the commodity fetish that conceals essence as much as it reveals value, all those other commensurate yet different items for which it might be traded on equal terms. (In this regard, commodities function not like Marion's idols, which pretend to fix the absent essence in themselves, but as icons, which recognize the distance between themselves and that other thing.)

The relation of music to value itself, moreover, is similarly figured and likewise lacking in transparency, because music's value is only the "phenomenal form" of music. Marx's use of the term is different from yet commensurate with Schopenhauer's. In both instances, when the phenomenal veil descends between human consciousness and the true essence of the thing (roughly, use-value for Marx and the "will" for Schopenhauer), that essence is no longer humanly accessible, no matter how deep our cognitive reach. The profundity of music—now that music has become just another chit in the market, merely representing the value of other things—has tragically lost its superficiality.

That Wotan and Siegfried thus enter mutually into commerce, moreover, highlights the distinction between this patrilineal pair and the Christian Father and Son. In one sense, to be sure, church doctrine does describe the "persons" of the Trinity transacting with each other and with mortals, thereby transforming themselves, for the sake of manifesting the Godhead on earth. Hence kenosis, whereby the Father sends the Son into the world and Christ "empties" himself to become human; hence God's sacrifice of the Son on the cross and Christ's submission to that fate as an act within history for the expiation of sin. Theologians have come to label the Triune God when thus perceived in its temporal, terrestrial engagements as the "economic" or "dispositional" Trinity. The Gospels and the book of Acts, all written in the first century, are replete with accounts of such divine investments and returns: the Annunciation, the Crucifixion, the Resurrection, and Pentecost, for example. By the fourth and fifth centuries, however, the failure of the final Messianic reckoning to arrive in the form of the Second Coming of Christ, which instead remained perpetually imminent, prompted the patristic authors of the canonical creeds to codify a second, soon doctrinally dominant, account. The "immanent" or "essential" or "ontological" Trinity affirms a fundamental immutability in all three persons, manifest in their eternal shared identity in the Godhead. In the words of the Athanasian Creed of the fifth century: "The Father is one person, the Son is another, and the Spirit is still another. But the deity of the Father, Son, and Holy Spirit is one, equal in glory, coeternal in majesty." In essence, the economic Trinity accounts only for what God does, in the contingent and passing terrestrial realm, rather than, as immanent Trinity would have it, what God actually is, everywhere and always.

Placed against this ultimate benchmark, the relation between Wotan and Siegfried reveals

itself as strictly economic, never immanent. Whereas the immanent nature of Christ lifted him away from earthly accident toward otherworldly permanence following those events some two thousand years ago (in Chapter 4 we will see an image of him enthroned in celestial glory, for instance), the exchange with Siegfried draws Wotan downward to make him merely mortal. Likewise, Wotan's gift of music to Siegfried, far from rectifying terrestrial misdeeds, only compounds them. Wotan is no God the Father, and Siegfried—impetuous, ignorant, now hopelessly entwined in Wotan's messy dealings—is far indeed from Christ. Commerce compromises the transcendence of both.[26]

Third: It matters what music is being traded for. The mortality granted to Wotan and the debt incurred by Siegfried (it is now solely his responsibility, however unwitting he is, to effect the return of the gold) are both devices of narrative development. Wotan's story comes to an end as Siegfried's enters its final, mature phase. Hence, according to the musico-linguistic dynamic of the *Ring* cycle, these elements in trade have the character of the spoken word, as the scene of exchange itself demonstrates. Just as concordance with the music passes from Wotan to Siegfried, verbal language disconnected from the eternal verities of the motifs passes from Siegfried to Wotan. Music is the commensurate counteroffering to the contents of the story and thus a representation of the narrative's value—not in spite of but because of the fundamental difference between music and the tale.

The inescapability of this trade-off, the fundamental polarity between music and words, stands out in starker relief in an anomalous encounter that precedes the meeting of Siegfried and Wotan: *Siegfried,* act 2, scene 3.[27] During the final confrontation between Siegfried and Mime (the false guardian of the hero's childhood), the plot requires that words temporarily take on the quality of transparent messengers of truth. Siegfried has tasted the blood of the slain dragon, which not only makes the voice of nature, in the form of the Woodbird, suddenly comprehensible but also reveals to Siegfried Mime's treacherous plan lurking behind the flattery of the dwarf's intended words. "Was möcht ich? Sagt ich denn das? *[Er bemüht sich, den zärtlichsten Ton anzunehmen.]* Ich will dem Kind *[mit sorglichster Deutlichkeit]* nur den Kopf abhaun!" ["What do I want? Did I say that? *(He endeavors to assume the most tender tone of voice.)* I only want *(with the most exacting clarity)* to hack off the head of the boy!"]. The effect of the dragon blood is transient, and by the time Siegfried descends the mountain at the beginning of *Twilight of the Gods,* he is unable to cut through Hagen's similarly nefarious verbal deceptions.

Nonetheless, during this brief period when verbal language cannot mislead, what is music to do? Music, always the opposite of words, must take on the task of rendering Mime's disingenuousness. Motifs bearing labels such as "False Flattery," "Shuffling," and "Crocodile [Tears]" underlie Mime's various backfiring declarations, and each has its comic effect, through such devices as pizzicato cellos and basses on the downbeats, the striking of strings with the wooden side of the bow, grace notes and appoggiaturas at the beginnings of melodic phrases, and thin orchestration to allow the penetrating squawk of double reeds. Against the forthright declarations of evil intent in Mime's words, this music is mincing. At worst, the

motifs manifest duplicity and thereby, in a patently rhetorical operation, turn ironically against their ostensible true nature. At best, they maintain their purchase on veracity only by representing, not manifesting, the true fact of Mime's attempts at dissimulation. At one point, a truncated version of the Nibelung motif rumbles in the cellos as a reminder of the unalterable baseness of this bent race. Yet even in this better of the two scenarios, music sacrifices its capacity to embody profound essence on its accessible surface, not only by representing rather than manifesting but also by representing duplicity, the distorting distance between sign and referent that typifies verbal language. Music then grounds its claim to unmediated meaning on the hopelessly mediating character of words. Castles built on sand; a fortress built on a rainbow.

In sum: even if we grant the conceit that musical motifs in the tetralogy somehow have the divine property of lacking rhetoric, the gods, proprietors of music, simply cannot manage to pass this valuable resource on to their human legatees. Either the gods cannot trade, or what they trade is not actually divine, or what enters into the trade as divine exits burdened with the profane traits of verbal language. It is precisely when the music changes hands that its godlike character turns into the mere representation of godliness, and that music becomes a rhetorical performance.

5. SOMETHING FOR NOTHING

Stepping back a bit from this extended excursion into the internal logic of the *Ring* cycle and returning soberly to the mundane world outside the tetralogy, we might wonder why all this confounding and bungled swapping really matters. Why, after all, should auditors of the operas care, beyond the minor requirements of engaged entertainment, whether the divine resides with one crew of Wagnerian characters or another? Perhaps there is a good reason they should. The compromised exchange between Wotan and Siegfried may serve in this massive musical work as a prefiguration of a weightier transaction. Wagner, assuming the vaunted role of Wotan (I omit examination of the complex and fascinating mechanisms involved in the composer's assuming this particular role), endeavored to give his audience in Bayreuth, cast in the receptive position of Siegfried, a legacy of the tetralogy capable of lifting them high above their secular station. The act of viewing replicates the dynamics internal to the spectacle.

As I have noted, a number of commentators anticipated how the *Ring* cycle might confer such power on its audience, a transmission similar to that of the ring in the tetralogy. In *The Birth of Tragedy,* the young and admiring Nietzsche suggested a likeness between the Wagnerian crowd and the Greek polis caught up in Dionysian ecstasy, and thus he credited the composer with inducting his audience into a collective state of mind that allowed them to approach the Schopenhauerian "will." Even the older Nietzsche, who chided Wagner for pulling gods and Bovarys into absurd proximity, recognized the powerful potential of the

music. Adorno feared the Wagnerian audience that was deluded into believing in its own transcendence. In short, Wagner's operas would hardly have generated a stir, could certainly not have accrued their highly charged political legacy, had they not had the hubris to promise those who experienced them a chance to grasp something much greater than the operas themselves.

It would be churlish to deny that, at a visceral level, the operas have some capacity to deliver, if not actually that "something greater," then at least a sense of its expansiveness. Even after repeated hearings, I still feel the hairs on my neck rise to the surge of Siegfried's trip down the Rhine and cannot repress a complicitous thrill at the palatal fricatives and rhythmic thump-thump of Hagen's shouted revenge: "rächt' ich!" We can regard this effect as programmatic in the *Ring* cycle. As its final endeavor, the tetralogy explicitly takes up the transfer of its powers to the audience as its represented theme and as its real purpose. Just as music earlier passed from divine Wotan to superhuman Siegfried, now it is handed down from superhuman Brünnhilde—protector and bride of Siegfried and now, as it were, executor of his musical estate—to the human audience at Bayreuth, and beyond.

The stage, at the end of *Twilight of the Gods,* has largely cleared of the quick. Siegfried and Gunther have perished, Gutrune and Hagen have slumped into inactivity, and in the distance the unseen gods in Walhalla silently await their consumption by fire. Attention turns to Brünnhilde, and she commands almost all (more about that "almost" in a moment) of the remaining eighteen minutes of the opera. Brünnhilde's words are devoted mostly to a final reckoning of accounts that remain open: between the dead-but-alive Siegfried (his hand has just risen) and her alive-but-dead self (she too will momentarily plunge into the cleansing flames); between the gods (who can now peacefully expire) and the Rhinemaidens (who can now rejoice); and within the symbolic economy of matrimonial pairings so disastrously thrown into disarray, between the Gibichung and Volsung clans. She also ruminates alliteratively on the oxymoronic infidelity of words (the irony emphasized by alliteration): "Mich mußte der Reinste verraten" ["The truest had to betray me"], and so forth. Yet, once all is settled with a balance of zero—including language, with its self-negating juxtaposition of oppositional terms—Brünnhilde has no more to say. Words have no more to say. The final four minutes, with the exception of a short, impotent interjection from Hagen before he too succumbs, belong to the orchestra, to music alone.

What, then, does the closing music declaim? It seems at first to prolong the tallying of accounts and declaring them all paid in full. In contrast to the preceding stretch of orchestral accompaniment to Brünnhilde's last speech, in which motifs intertwined in a complex manner verging on the linguistic, the final orchestral passage—from the Rhinemaidens' recovery of the ring to the concluding chords—is simple, a straightforward presentation of overlapping yet clearly distinct musical statements. The exposition oscillates between basic summary motifs, juxtaposed in obvious thematic contrast: from the "Curse" (the affliction attached to the ring owing to its history of spoliation and theft) to the "Rhinemaidens" (whose recovery of the ring brings the curse to an end); from "Rhinemaidens" (personifications of

untouched nature) to "Walhalla" (loftiest creation of the striving of consciousness away from the grounding of nature); from "Walhalla" and "Siegfried" (figures of fortitude and heightened heroism among the gods and among their superhuman progeny) to "Twilight of the Gods" (the proclamation now of the demise of both of these generations). Back and forth, the music closes the books on all conflicts formulated and then resolved in the tetralogy as it represents the reestablishment of the world's equilibrium through the systematic pairing of these antithetical motifs.

One motif, however, escapes the logic of this balanced economy, a lilting bit of melody in G major. Bernard Shaw dismissed it as having the quality of "the pet climax of a popular sentimental ballad," and he is right.[28] In this final scene of *Twilight of the Gods,* the motif first appears when Brünnhilde calls her faithful steed Grane to carry her into the flames (her fate is now sealed), and its presence grows through the concluding orchestral passage. For a time, it floats in melodic counterpoint above the exposition of antiphonal opposites, serving as a device that adjudicates between those antithetical forces. At the very end, however, it soars on its own in full, florid glory. With this motif Wagner brings to an end the fifteen hours of the *Ring* cycle.

Auditors have encountered this final motif only once before during the entire course of the tetralogy. In act 3, scene 1, of *The Valkyrie,* Sieglinde, dispirited by the death of her brother-lover Siegmund and wishing for her own demise, finds new purchase on life when informed that she carries in her womb the fruit of their passion, the newly conceived Siegfried. To the notes of this special motif, she launches into a speech—it will be her last—in which she declares her renewed purpose to live, in order to bear this child. The motif announces, in short, a fresh start, a miraculous, unexpected beginning unencumbered by the debts of the past, one that brings freedom even from the social obligations between clans engendered by non-incestuous couplings (the social economy of sexual partner exchange, of course, intrigued Lévi-Strauss in his anthropological work). Although the foretelling of Siegfried's birth may entail payoffs in the future—Sieglinde sings prophetically to Brünnhilde: "Meines Dankes Lohn lache dir einst!" ["The reward of my thanks will one day smile upon you"]—that birth owes nothing to anterior generations. The innocent Siegfried will not even bear the obligations normally owed by offspring to their parents. The widowed Sieglinde's role in the drama has now been so radically reduced to that of mere "Schoss" [figuratively "womb," and perhaps a pun on the "Schloss" of Walhalla] that it hardly needs saying that she will expire, offstage and without further word, in childbirth. The self-interested Mime will raise the child, and Siegfried owes him nothing but contempt. This moment in *The Valkyrie,* then, stands as a fundamental turning point in the tetralogy, for it declares the dawn of a heroic race brought into being in full independence from all previous conflicts and liabilities (we have seen how later in the saga Wotan ham-handedly forfeits Siegfried's autonomy). Thus despite the various names that have been proposed for this signal melody—"Redemption," "Assurance," "Transformation," and so forth—I believe it could most accurately be labeled the "Something for Nothing" motif.

And here it sounds again at the end of the *Twilight of the Gods.* All debts have been paid, all dangling obligations resolved—yes, finally, even that business with the curse and the ring. Who then remains to reap the benefit of a new beginning? Who will carry on the legacy of Wagnerian music (words are now dumb) while assuming none of the debts accumulated by the Nordic gods and their progeny of heroic superhumans? Except the motionless, gawking vassals and a pathetic Gutrune, no one remains on stage. The rituals of purifying fire and flood are performed for the benefit of the good burghers in the house. To these citizens of a newly unified German nation the *Ring* cycle bequeaths its legacy of divine powers. Yet they no more owe their inheritance to the tetralogy than Siegfried was indebted to his unknown parents. The "Something for Nothing" motif obviates all debts to the past. Germany will be a nation and a people born of pure, divine "will."

A curious contradiction thus characterizes the end of the tetralogy. On the one hand, the members of the audience have received that not inconsequential thing that the operas have to deliver, yet they never have to enter into the market of exchange in order to obtain it. In fundamental violation of the basic rules of social existence insisted on by Lévi-Strauss, these auditors need give nothing for the divinity of music to be bestowed upon them. Wagner's *Ring* cycle offers a gift to all, on a silver platter; no reciprocal gesture is required. In contrast to the many balances of obligation promulgated by the action of the *Ring* cycle—for which, seen retrospectively, the entire tetralogy preceding the concluding orchestral passage now stands as a convenient rhetorical figure—the gift of music arrives as a pure, unaccountable supplement, beyond the compromising figures activated in trade. "Something for Nothing," a sublime motif, realizes—makes real—the godly potential of Wagner's audience. In Christian terms, it arrives like grace: unforeseeable, undeserved, unearned, simply there.

On the other hand, "Something for Nothing" can manifest its divine essence only to the extent that it can represent its supplementary nature over and against the market in social obligations and in words. And that market, despite Wagner's most wishful political fantasies, obviously survived the twilight of the gods to prosper in his (and our) own age. The very act of representing the logic of the market in the form of the various economies of the *Ring* cycle ensures that exchange and obligation will survive as long as does their miraculous, sublime, debt-free alternative. Once again, castles built on sand. The divine exists only as the alternative to the secular world and its compound forms of rhetoric. It manifests itself only by turning ironically against them (or by working metaphorically from the miraculous pro-creation of Siegfried). If the essence of the final musical motif must reside in its character as supplement, the tetralogy can no more deliver the divine to its audience than Wotan could pass the mission of music on to his mortal grandson. The tetralogy can represent that delivery only through the operations of its own rhetoric and thus can deliver nothing at all that is freed from rhetoric and representation. The older Nietzsche, then, may have been right: Wagner's audience consisted of just so many Emmas—and, by extension, "Something for Nothing" plays as nothing but a catchy show tune, preposterous in its sentimentality.[29]

The play of this contradiction, nonetheless, ends up enabling the audience as much as

it undermines it. Precisely as much, for the two are horns of the same dilemma. Either the "Something for Nothing" motif manifests a fundamental truth, in which case the audience sitting in the house at Bayreuth does miraculously receive something godly at no real cost to themselves; or "Something for Nothing" expresses a falsehood. But in the latter instance, the audience still receives something that bears the stamp of divine certainty: the knowledge that everything must have its price. What would make such knowledge absolute? The fact that its truth, like the wisdom of the gods, is not contingent on the rhetoric of its expression. It lacks such contingency because any conceivable rhetorical turn that taints the certainty of the truth (that nothing can come from nothing) can do so only by reintroducing the notion that something other than nothing, namely "Something," can be had "for Nothing." Either the musical motif delivers the divine directly to its audience miraculously, without liens from the debts of the past; or it generates that singular verity that, while itself existing outside the realm of rhetoric, nonetheless underwrites the inescapable economy of rhetorical exchange.[30] And what better message to bring to this audience of freshly minted Germans, who were building a new nation that enjoyed some measure of independence from previous conflicts and liabilities? The divinely sanctioned proposition that nothing comes from nothing could, after all, serve as the unshakable foundation not only for a certain conception of the market but also for an entire system of civic responsibilities and moral principles that made possible the modern meritocratic order. Quite an exhilarating pair of options to face after four long evenings at the Festspielhaus, is it not? Either one stood tall as the successful legatee of Wotan's godly estate, or one emerged triumphant in the guise of young Siegfried, equipped with divine assurance and ready to conquer new worlds.

3

Monet's Orangerie

1. PROCESSION

By the advent of the twentieth century, the sexagenarian Claude Monet, despite an occa-
sional voyage, had settled into his country estate at Giverny. At this point in his career—
seemingly late but in fact only a bit more than halfway through his active years—Monet's
paintbrush had the touch of Midas, and he lived well in a fine manse, with gurgling red and
bleu d'Auvergne. He gardened: first the expansive flower beds sloping down from the house
in overgrown but orderly rows; later the pond fed by a diverted branch of the river Epte,
surrounded by willows, spanned by a Japanese footbridge, and filled with his abundant,
beloved, coddled water lilies. Hundreds of canvases depicting the abundant flora of his
grounds emerged from his oversized studio near the house. The garden furnished the motif
for his painting for almost a quarter century, while the sale of paintings paid for the garden.

In November 1918, Monet proposed a major gift of new works to the nation in recogni-
tion of the Armistice. His old friend Georges Clemenceau, then French premier, hastened
to accept and committed the nation to construct a building dedicated to their display. Bu-
reaucratic wrangling and architectural recasting went on for nearly a decade, until in May
1927, six months after Monet's death at age eighty-six, Clemenceau inaugurated the galleries
of the Musée Claude Monet in the Orangerie of the Louvre in the Tuileries Gardens at the
heart of Paris (since renamed the Musée de l'Orangerie). Twenty-two canvases depicting
water lilies abutted one another in twos or threes to form eight two-meter-high panoramic
compositions, affixed to curved walls at the four compass points in two oval rooms newly
constructed in the back half of the long narrow building (Fig. 19).

The "immense body of work" that Monet had "pulled" from "a pond of several square
feet," the critic Louis Gillet marveled, could on its own "reflect the spectacle of the uni-
verse."[1] Monet had painted a "canticle without words" to fill the Orangerie (110). "In a drop
of water," the critic declared, Monet "found the great ecstasy of the hidden side of the world,
that secret of oblivion where our puny individualities lose themselves and that is still one of

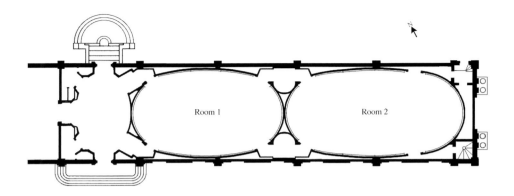

19. Camille Lefèvre (architect), Musée Claude Monet in the Orangerie of the Tuileries, completed 1927. Plan. Drawing: Daniel M. Herbert.

the forms of adoration" (114). Gillet's phrases—and those of other writers enthusiastic about the installation, including Clemenceau—ring with clear religious overtones. As we will see, critics had perceived Monet to be engaging the church ever since his depictions of Rouen Cathedral, exhibited in 1895 (Plate 3). And the interpretive approach proved lasting: By 1952 the artist André Masson could declare the Orangerie to be "the Sistine Chapel of Impressionism."[2] To call the gallery a church, however, was no mere indulgence in florid prose. The flower paintings themselves and their arrangement in the two rooms had already enticed the empyrean into the Orangerie. Whether the artist achieved the effect through the paintings or the paintings on their own served as agents of the divine is a question whose answer must draw as much on theological doctrine as on contemporary aesthetics. What the pictures of the water lilies in the Orangerie decidedly do not do—what distinguishes this place from Versailles Palace or the Festspielhaus in Bayreuth—is to permit any attempt to embody the deity, to allow the divine to enter into the spheres of the installation's space in the semblance of human figures.

Imagine being among the visitors to the Musée Claude Monet at the time of its opening. We begin in a soaring foyer (pared down and truncated in the 1960s but recently restored to its original size), entered from one of three directions (Fig. 20). With a skylight and high glass exterior doors to the north and south, the space feels like the narthex of a church, a place both within and without, a secular locus of gathering before entering the sanctums beyond.

"One enters there as into a temple," remarked the architect Pierre Olmar—and through one of two side portals leading in from the narthex we penetrate what would be the nave (Fig. 21).[3] A band of paintings, commencing at shin level and rising well above head height, completely surrounds us. The oval's continuity is interrupted only by four narrow doorways, the two available for entry and two more that lead to the second room. The painting enti-

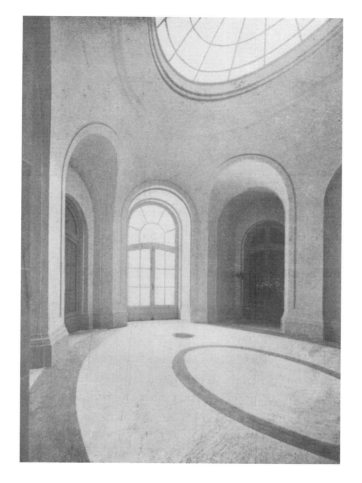

20. Foyer of the Musée Claude Monet, 1927. From *La revue de l'art ancien et moderne* 52 (June 1927): 42.

tled *Green Reflections,* mounted directly across the room from the entry, between the two doors to the second room, may well be the first to catch our eye (Plate 4).

Green Reflections exemplifies the uniform theme Monet chose for this ensemble. In each instance, the artist recorded a view from the edge of his own lily pond at Giverny. What he saw there, gazing into its waters, and what we now see here, is the weft and warp of surface and reflection (Plate 5). The weft: rafts of pads and blossoms stretch in roughly horizontal bands across the width of the canvas. And the warp: among the horizontal accumulations of suspended lilies, vertical stripes abound. These are the reflections of the streaming branches of willows lining the far shore. Because reflections call forth what they reflect, imaginary trees may seem to rise up, as if filling the empty space of the walls and ceiling higher than the circle of canvases. (In other pictures from the ensemble, reflected clouds serve a similar

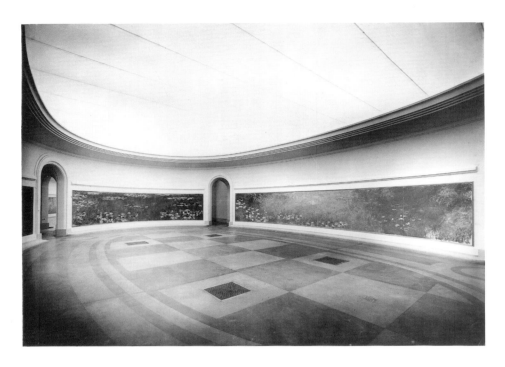

21. First room of the Musée Claude Monet, 1927. Photo: Archives Photographiques, collection Médiathèque du Patrimoine, © Centre des Monuments Nationaux, Paris.

role.) Finally, dark patches of paint, neither weft nor warp, suggest depths below. The effect is a gradual unfolding upward and downward, until we find ourselves, already dwarfed by the circle of tall canvases, enwombed in a sphere of depicted and implied subject matter: sky, trees, blossoms, water, dark submersion. "The *Water Lilies* eschew the idea of arrangement and linear composition," wrote the critic Waldamar George in his review of the new Musée Claude Monet. "[They are] surfaces of water that nothing circumscribes and nothing delimits."[4]

The two larger paintings to the north and south, *Clouds* and *Morning,* embrace the viewer facing *Green Reflections* like arms (Plates 6 and 7). The broad middle passages of these works surround and suspend the spectator much as *Green Reflections* does, but their edges left and right provide more solid support. It is not certain whether in *Clouds* we witness the shore or the shadows of its overgrowth, but in *Morning,* especially on the right, we obtain firm footing. Like elongated landscapes by Claude Lorrain, these two compositions frame their prospects with comforting, conventional *repoussoirs.* Such solid ground arrests any vertical unfolding at the picture's ends and attaches the broad canvases to the architecture of the doorframes just beyond. In the first room, at least, the water lilies do not drift unmoored.

"The hours of the day can be read on the canvases," wrote the critic Marthe de Fels about the ensemble in this first room.[5] The title *Morning* commences the theme. Yes, the bright

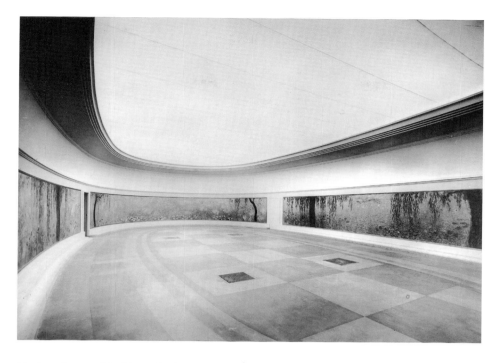

22. Second room of the Musée Claude Monet, 1927. Photo: Archives Photographiques, collection Médiathèque du Patrimoine, © Centre des Monuments Nationaux, Paris.

blues and greens of this work do seem to capture morning's brilliant light. Once time enters this space, *Green Reflections* and *Clouds* happily assume the roles of midday. The clearest exposition of the day's progress awaits visitors when they pivot back toward the entrance portals to confront *Setting Sun* (Plate 8). This painting, the smallest and the one with the least horizontal composition of the group of eight, has at its center left an accumulation of vivid yellows and pinks, a fiery tonality unmatched by the other canvases, which are all much cooler with their watery tones. And well it should glow, for the work captures the oblique reflection of the sun as it approaches the horizon. *Setting Sun* both affirms the proper passage of diurnal time and decisively orients the nave of the Orangerie, in a liturgically appropriate manner, to the points of the compass. Whether we see it as setting sun or as glowing rose window, we are looking west.

Passing through one of two side aisles that will have to serve as a transeptless crossing in this slender house of worship, we enter the second room, in effect the chancel (Fig. 22). With fewer doors and greater size, this gallery allows a larger expanse of painting. Yet for all the added acreage, the pictures here are more uniform in both theme and tone. The exception is *Reflections of Trees* (Plate 9; behind us as we view Fig. 22). By evoking a crepuscular moment, this dark composition harks back to *Setting Sun* and to the first room's temporal concerns. The titles of the larger side paintings, *Morning with Willows* and *Clear Morning with*

Willows, may, like that of the work on the south wall of the first room, name an early phase of the day (Plates 10 and 11). Yet the similar hues and tones in the central sections of both pictures—light and airy as if morning were approaching noon, evocative of the midday cumuli in *Clouds* on the north wall in the first room—effectively suspend temporal differentiation to envelop the visitor in a sea of sameness. The art historian Raymond Régamey mused about the second room in a review published at the time of the inauguration: "Between the trunks and the leaves of the willows, the gaze wanders over water without boundaries. In which season are we? What is the hour? Is the sun high or does it only gild the crowns of the trees? We don't know any longer; and does it matter?"[6]

The nearly identical compositions of *Morning with Willows* and *Clear Morning with Willows*—two tree trunks each, not reflections this time—shift the material support, previously provided by the melding of pond bank with doorframe, into the picture itself. *Repoussoirs* for the waters between, certainly; but these columns also liberate the pictures from any dependence on surrounding architecture. Moving deeper into the room enhances this impression. From its western edge each work resolutely frames all that appears farther east: in the north with a trunk hard against the edge; in the south with a trunk farther in that curves solicitously toward the remainder of the canvas. Meanwhile, the eastern trunks move far inward. Such positioning leaves the final stretches of canvas cantilevered, as if they were floating beyond the mundane world of burdensome weight.

When we combine the two side paintings with *Reflections of Trees,* the progression from dark to light and the symmetrical layout of the thick trunks make it clear that the three set the stage for, or rather form an amphitheater poised to witness, the culminating achievement of the entire ensemble at the Orangerie: *Two Willows,* the longest, lightest, most weightless composition of them all (Plate 12). The photograph of the installation deceives in making this painting, which is one-third longer than the canvases to either side, appear not much larger than the diminutive pictures on the other eastern and western walls (Fig. 22). This effect results from the dramatic curve of the wall on which *Two Willows* is glued. In viewing the work as a person in the room rather than through a wide-angle lens at its far end, one finds oneself surrounded, engulfed by this endless image. The ideal viewing spot positions the visitor before the apse; viewed from there, the painting replicates the sweep of vision from peripheral limit to peripheral limit. From this perspective, the two trees, spindly in comparison with the rest of the forest in the room, provide no support for the vast, deeply arching center of the composition. The trunks align with the viewer's ears, inconsequential to the visual experience of the central waters. They serve as brackets, quickly dropped from one's attention, when one peruses the work the only way it can be viewed in its entirety: through a seemingly endless scan, back and forth. Eventually the sweep slows, and the central passage of *Two Willows* beckons (Plate 13). Here surface, reflection, and depth unfold. Here we watch blue vapors dip down and green depths rise up. Here we observe the rustle of the blossoms and the slow stirring of the waters. This is the crowning spiritual moment of the ensemble of the Orangerie, Monet's paean to the mysteries of rarefied nature.

2. PROPERTY AND PANTHEISM

In step with the museum's first visitors, we have followed the pilgrimage route (though not quite all of it yet) through these hallowed spaces. Nonetheless, as we imagine beholding *Two Willows* from the center of the installation's inner sanctum in emulation of previous visitors, we cannot today wholly occupy the spot inhabited by the ghosts of 1927—and not simply because the latest renovation of the rooms, opened in 2006, placed large oval benches where originally the floor was open. Conceptually, that central place is in certain respects too constricted for us, because the particularities of French social concerns in the years leading up to the opening of the Musée Claude Monet bar us from assuming as our own the perspective it offers in the Musée de l'Orangerie. Yet the middle of the room is also too expansive for us, and the same was true for the visitors who passed through it some eighty years ago. By the logic of the installation, the privileged location belongs to no mortal, but is proper, if not to God, then to his pantheist surrogate.

How are we excluded from the inaugural viewpoint by its historical specificity? Monet's canvases depict a garden within a churchlike structure, and in France of the early twentieth century, neither garden nor church was a neutral institution. In counterflow to the massive influx of provincials into Paris during the nineteenth century, many of the city's successful denizens took advantage of the nation's new rail network to maintain former homesteads in the countryside as their occasional leisure residences.[7] Where patrimony provided no such property, one could be bought. Monet followed the herd. As his fortunes grew, he acquired ever larger estates at ever greater distances from Paris, until he settled at Giverny in 1883. Although the artist eventually lived permanently in the countryside, he was no rube. He carried with him from Paris his experiences and professional triumphs, he traveled to the capital to attend to his affairs until the infirmities of age set in, and he regularly welcomed visitors from the city—including, frequently, Clemenceau—who would take the train or motor up for the day.

Beyond repose, the countryside offered Parisians something distinctly missing from their apartment-bound lives in the city: the opportunity to possess land. To maintain an estate in one's region of origin both declared in the capital the family's identity based on ties to the land and represented in the countryside the clan's metropolitan success. For those lacking a legacy of property, the function could be reversed: rural residency could effect the illusion of ancestors. An extensive estate, ambitious improvements, and fields filled with flowers rather than crops or cows all connoted luxurious inutility, with aristocratic overtones. Monet the aspiring urban artist became Claude de Giverny.

The concept of property even carried a valence in straight party politics. The actual allegiances of Monet or Clemenceau, both of whom possessed solid leftist credentials dating from their early years, are not important here. Simply to be propertied, to be counted among the ranks of *propriétaires,* distanced a Frenchman from the goals of socialist collectivization or from the anarchist abolition of ownership—and only a short generation separated the

opening of the Musée Claude Monet from the days of the syndicalist general strike and the bearded bomb-tossers. In strictly thematic terms, to devote a museum to the pleasures proffered by nature on a private estate was to celebrate one of the ideological pillars of the Third Republic.

The Catholic Church had not similarly prospered under the republic.[8] Throughout the late nineteenth century, the clergy's often close ties to monarchist factions alienated the church from the government. The Dreyfus Affair in the 1890s further revealed the conservative, even reactionary, bent of the religious establishment. Emboldened by the Dreyfus controversy, the anticlerical premier Emile Combes pushed during the early 1900s to weaken the clergy through such means as expropriating church buildings and property, curtailing Catholic control over education, and exiling religious orders. His efforts culminated in the Act of Separation, passed in December 1905. Clemenceau, first as minister of the interior and then as premier beginning in 1906, enthusiastically enforced the new law.

To many on the left, the Catholic Church had become an anachronistic institution fixated on dead myths and moribund practices. The ardent republican Léon Bazalgette unleashed a particularly biting attack at the end of the nineteenth century in his article "The Two Cathedrals." Using the edifice as a figure for organized religion, he wrote: "The cathedral is only the petrifaction . . . of the medieval soul. It thus appears to us as the symbol of an epoch and a world. A symbol alive for centuries is now a defunct symbol; and because that epoch is over and that world has been transformed, it only still subsists as a vestige. Its soul, the result of the communion of heaven and humans, dissolved with the winds of the spirit of the age."[9] By these lights the Catholic Church in France had reduced itself to the rote performance of empty gestures and words. Lost in the past, it had no spiritual purpose in the present.

The role of revelation had, according to Bazalgette, passed to others. It had passed to Monet. In 1895 the artist had exhibited a set of twenty paintings depicting Rouen Cathedral seen in various atmospheric conditions and at different times of day. *Rouen Cathedral, West Façade,* of 1894, for instance, captures the edifice in dappled sun and shade (Plate 3). Bazalgette argued that Monet's genius lay in his capacity to treat the ancient edifice not as an aggregation of religious motifs—prophets and patriarchs in the archivolts, the tree of Jesse in the tympanum, the cross atop the gable—but rather as a piece of nature where light plays across stone, exuding vitality even in the modern age.

Entirely disengaged from all remembrance, from any cult and any religious tradition, the painter considered the edifice only as a fragment of nature, according to reality, not according to dogma. Occult meanings did not trouble him for a single moment, nor did Christian symbols. His eye saw, rising up somewhere, on a spot on the earth, an imposing architecture bathed alternatively by light and shadow. This caress by daylight of the melancholic face of the sanctuary of yesteryear, this alliance of venerable stones and the eternally vital sun, have captivated all his being, basking in this sight. For him it was neither a matter of liturgy nor of symbolism: no mystery of deciphering, no

uncertainty of interpretation, no theological debate could touch him. Reality was there in front of him, completely free of every equivocation: he saw it and interpreted it. . . .

There is the Universe that is simultaneously body and soul; [and] man plunged in the ocean of cosmic forces, becoming conscious bit by bit of the reality of the world, from which he emerged in order to return. (376, 378–79)

The paintings themselves provide ample support for such animated, deconsecrating praise. In all of Monet's canvases, either the picture frame crops off the surmounting cross or the artist has vaporized it altogether, leaving empty sky. The deeply encrusted surfaces—built up over months by layers of textured undercoats and surface coloring, by troweling and stippling and brushing—obliterate any discernible Christian icons. Monet treated the hewn stones at Rouen much as he had, in previous years, the savage banks of the Creuse River and Etretat's craggy cliffs.[10]

Bazalgette even provided a label for the new religion opened up by Monet's art (it could also be termed an antireligion; the effect was the same): "One could say that this concept presented a certain analogy with the doctrine known as pantheism. In truth, it achieves a new pantheism—infinitely broader than the old one—completely impregnated with reality and science" (387). Monet used his commanding powers of perception, his sophisticated comprehension of visual phenomena, and his intuition about the world to capture not only appearances but also the divine vitality that pantheism posited to infuse all corners of the material world. The artist had supplanted the priest as the mediator between a new laity, presumably "broader than the old one," and profound spiritual truths.

In the installation in the Orangerie some three decades later, the cathedral itself no longer served as Monet's motif. However, the sentiment that his paintings disclosed deeper spiritual truths had, if anything, intensified. We have already heard Gillet's spiritual transport, and Gillet was not alone. More than any other descriptive term—except "poetry," perhaps, or "music"—"pantheism" (in its various grammatical forms) enticed the critics of 1927.[11] It was as if, with the added sagacity of years, such visitors could step through the portals only depicted from the exterior in the canvases from the 1890s into the holy, yet hardly Catholic, space itself.

And what received there a pantheistic blessing? The geographic and temporal situation proposes an answer: the garden, embodiment of the principles of property. In the same decades when organized religion was ceding its lands to the state, privately owned property received the sanction of the spirit embedded directly in the expanse of Monet's pond. We might imagine in the late 1920s a self-possessed successful gent poised at the center of the second room at the Orangerie, surveying the sweep of *Two Willows,* reflecting on his own good fortune (perhaps in his pocket a train ticket to his weekend retreat where family awaited), and sensing, at some level between the subliminal and the conscious, how nature and art lift the relation of man to land beyond the contingencies of time and place into the realm of

the eternally right and true. We cannot step into his natty shoes. Such an act of social ratification we can only witness from our distance—greater or lesser depending on personal circumstance, but always ineluctable—from the Catholic Church during that particular crisis, from the satisfactions of owning a piece of French countryside in the days when the number of republics had reached only three.

3. CEDING THE CENTER

The walls of the Orangerie bestow yet grander prowess on the two spots at the centers of the oval rooms. From the movement of a man ensued the immobility of a god. As we have seen in Chapter 1, any such implied omnipresence carried with it, in Europe, the legacy of powers attributed to the Christian deity.

In order to paint the water lilies, or at least to render preliminary sketches before proceeding to his huge studio next to the house, Monet would have stood at the edge of his own pond, gazing inward. We might suppose that, for the first room, he lingered on the southern bank to paint *Clouds* and along the northern edge to render *Morning* (Plates 6 and 7). Perhaps he approached from the west when he conceived *Green Reflections,* and for *Setting Sun* he certainly scrutinized from the east the sun reflected in the waters (Plates 4 and 8). There is no need to adhere strictly to the compass, especially when we envision Monet assembling the canvases for the less-anchored and more-timeless second room. The point is, the artist moved to make his pictures. He gained his different, discrete perspectives by displacing his corporeal being.

In a felicitous geometric congruity forced by the narrowness of the architectural shell, the two rooms in the Orangerie replicate the basic shape of the pond. The viewing experiences of artist and audience, however, are diametrically opposed. Whereas at Giverny the points of view circle around the pond directing themselves inward, at the Orangerie the point of perspective arrests all movement, and eyes gaze outward. It is as if, through a topological inversion, inside has become outside and outside has become inside; the figure of water has become ground, and the ground of soil has become water.[12] Coupled with the unfolding of each painting into the skies and the depths, each center provides a comprehensive view of the garden's envelope. The result is the greatest theological triumph of this space. The idealized view given sanctuary within the walls of the Orangerie resembles the prospect of God, who, from the stationary position of his ubiquity, is able to see all things, from all angles, without the shifting required of the human body to see more than one thing at a time. (Recall Weiss's account of Descartes's description of God's omniscience.) The Orangerie proffers nothing less than majestic, immobile omniscience.

We could hypothesize that the attribution of divinity to the central spots further ratified our wealthy Frenchman's relation to his country garden, for it implied that to own property was akin to viewing it with the eyes of a god. Yet while the conjecture holds some truth, to

thus reduce Monet's installation to a performance of a political purpose with contemporary concerns both misrepresents the experience of standing at the rooms' centers and underestimates the paintings' broader powers.

Even more than the focal points at the Orangerie ascribe a measure of divine vision to the visitors who step into them, the spaces represent to those viewers their human incapacity to assume such universal sight. The complete surround of water and the unfolding of surface ribbon into encompassing sphere solicit a weightless and ubiquitous perceiver. The visitors to Monet's installation, today as in 1927, cannot be omnipresent in this manner. Before any of us arrive at the center (which the benches now prevent us from occupying anyway), we must be elsewhere: at our homes, in the Tuileries Gardens, in the foyer of the Orangerie, at some more peripheral location within the two rooms. Just as Monet walked around his lily pond, visitors (or at least those whom architecture permits) must step with two human legs into the privileged spot. We assume the godly position only for a moment if at all; we cannot persist in it.

Nor can a visitor hover. As the critic François Fosca quipped at the time (albeit in a different context): "In a painting by Monet, one would never know where to set down one's feet with security."[13] If we stepped into the center of the rooms at the Orangerie, we would necessarily feel the pressure of our own mass against the hard floor. Any intimations of expansiveness are perforce accompanied by the proprioceptive awareness of the constrained spatial boundaries and specific single location of one's own weighted body. This may be an irreducible aspect of all human encounters with the divine. Sitting in temple or church, one may at times sense the presence of some greater and everlasting spiritual force, but one cannot do so without simultaneously sensing oneself sitting, exerting pressure on one's all-too-human, all-too-mortal rump. Although in the Musée Claude Monet of 1927 we would have remained standing, the installation would even have given us the equivalent of a wooden pew. The floor with its earthy "yellow ocher" color (now an off-white) would seem to place viewers on the solid footing of an island in the middle of the pond, which never existed at Giverny.[14] We may be saved from drowning, but our flights have been grounded and our position bounded by the few square meters of this fictive isle.

And then there is the matter of visual range. The paintings installed in ovals require perception in all directions at once, exceeding by more than twofold the physiologically determined scope of the human visual field. To see more than one section of the room, one must turn one's head and eventually rotate one's body: a corporeal registration, a proprioceptive representation to oneself, of the absolute limit of embodied sight. Consider, in contrast, the fantastic visual aptitude offered by Jean-Baptiste Martin's presentation of Louis's view out the front of the Versailles Palace (Plate 1). The angle between the avenues of Saint-Cloud and of Sceaux is actually only sixty degrees, one-sixth of a full circle and about one-third of the human visual field. Yet owing to the sheer number of the king's subjects bustling within that spread and the radical diminution of people and buildings as they recede into depth, the painting gives the impression, in the manner of a fish-eye camera lens, that all of the

king's domains may well fall within that arc made grand. Martin's painting cannot expand the visual field beyond human limits to attain divine comprehensiveness, but it nonetheless formulates a representation of bringing into the compass of royal sight more than the human eye can actually hold.

Walking, weighted, with vision not nearly wide enough, each visitor to the Orangerie is constantly aware that he or she encounters these paintings with the same capacities Monet had when he circled the pond at Giverny: as a human. Given the preponderance of such humbling experience, it would seem that the presence of divine omniscience in the centers of the rooms, caught in a momentary flash of recognition, serves principally as a foil against which the human character of one's course through the Orangerie measures itself. God, or his pantheist equivalent, arrives by means of the paintings' unfolding and inversions. In occupying the center, God or his surrogates are everywhere; or because they are everywhere we find them at the center. We venture into that privileged spot of immobile divinity—in fact or in imagination—and then, in our constant mortal passage through time and space, immediately move through it and back into mundane territory. Whereas Versailles endeavored to embody God's majesty in the living king, the Orangerie shuffles the bodies of its visitors away from the impossible place it reserves for the divine. (Accordingly, the recent benches may better realize the Orangerie's program than its original empty floor space did.)

Yet this displacement hardly needs to be experienced as a loss. It can come as a liberation—and a union. We are relieved of the unsustainable burdens of godliness that the configuration of the paintings thrusts upon the installation's two privileged spots: the locked-in stasis of ubiquity, the disorienting disembodiment of ethereality, the lack of sharply focused attentiveness owing to the demands of panoramic inclusiveness. We slip comfortably back into our human attributes as into a favorite old jacket, whose frayed edges and inevitable ruin we can for a time overlook, or perhaps even cherish. And in stepping away from the center, we discover fellowship with the visitors who attended the inauguration of the Orangerie in 1927. While we may not replicate their attitudes toward landed estates in the French countryside, we partake with them in the characteristic of not being divine in the manner mandated by the surround of Monet's paintings. Surely we can trust in some measure of common experience together with our brethren only decades distant and of a similar cultural heritage. We who are many are one, sharing in that one humanity.

Thus we need not regard the production of the divine omnipresence at the Orangerie with cynicism alone, as no more than a ploy in the politics of church and land. That interpretation is not wrong, but it is not complete. Eschewing the position of greater comprehension and judgment offered by historical retrospection (itself a stance with godlike pretensions), we might instead allow the two panoramas to work their magic on us, as they may have on the viewers of 1927. Rather than thus reduce the divine to a set of mundane matters, we might let the divine exceed the human concerns both of the inaugural visitors and of us. Proffered as it is by the Orangerie, the relinquishment of a claim to godliness draws us closer to others across time and cultural difference, others who likewise experience that

release. (This moment may be the turning point in the overarching trajectory traced by the case studies presented in this book, as humans cede the center to the divine.) Such unity need not posit some universal observer—Louis XIV, for example, would be mystified by our camaraderie with the citizens of 1927. A community larger than a small group defined by circumstance yet smaller than all humanity can conjoin; together we place ourselves in thrall to what Monet's paintings have to give, and together we acknowledge what they withhold. Let us abandon ourselves to that wonder, witnessing the terrifying beauty of nature that, even in its quietest retreats, can in an unexpected instant arrest and hold our souls, and to the astounding accomplishment of any cultural artifact to touch even a corner of that power to transport.[15]

4. APPROACHING THE SURFACE

Where are we to go? If we, together, step away from the divine center, what path is left open to us? There can be only one destination, no matter which direction we head. Every route approaches the periphery, bringing us closer to the surfaces of Monet's canvases. Even as they allow for omniscience at the center, the paintings in the Orangerie also encourage this corporeal move toward the perimeter. Monet's details draw our human selves near.[16]

Many sections of the broad fields of color, it is true, lack distinguishing traits. Although the acres of canvas confronted Monet with a monumental task, we can still be taken aback by the sizable swaths of the pictures that remain conspicuously underworked, even after more than a decade of the artist's labor. The light blue that sets the prevailing tone in *Two Willows* appears almost as if it could have been applied by a housepainter's roller (Plates 12 and 13). Across the inner sanctum from this work, *Reflections of Trees* presents much the same aspect with its nearly uniform deep purple (Plate 9); while in the first room *Setting Sun* takes scarcity of paint to its extreme when, across its lower half and especially in its bottom right corner, patches of untouched priming show baldly through (Plate 8).

Nevertheless, all these areas of broad, abbreviated technique cause a few exceptional spots of labored medium with vivid pigments to entice our eyes. Consider the whorl of paint near the center of *Reflections of Trees,* the highlight of the picture (Plate 14). Orangey reds and pinks accumulate in thick layers, topped with foamy crests of creamy white. Whereas the canvas measures in meters, this blossom occupies a space no larger than the size of a hand. In order to see it well, we must approach quite near, lean over (the blossom lies somewhat below waist height), and let our eyes shift their focal length. Only then can we examine the licks of Monet's brush, laden as it was with skilled combinations of color. A similar accumulation of thick paint denoting a flower appears a bit below and to the right of the center of *Two Willows* (Plate 13, lower right). It becomes the complement—though less pronounced in contrast to its surroundings—to the bright blossom directly across the room in *Reflections of Trees.* Others rise up regularly throughout the eight ensembles of the series. The result is a stark juxtapo-

sition of the tight attentiveness of proximate sight against the broad sweep of panoramic vision, with relatively little to engage the viewer in midrange.[17] The affirmation of the visitors' mundane character becomes twofold. The human habit of constrained perception, concentrating on one thing while excluding all others, differentiates itself from the comprehensiveness of divine oversight. And the very activity of moving forward and bending over accentuates the embodiment of human perception. It registers the presence of fallible, corruptible flesh in this room, attached to these eyes.

In Martin's view from the king's bedroom at Versailles, Louis was similarly offered two modes of vision (Plate 1). Despite superficial similarities, however, the two modes here do not correspond to the pairing at the Orangerie of panoramic omniscience and tight attentiveness. The painting from the French court, I have argued, granted to the monarch not only a broad visual sweep that converted heterogeneous elements of city and countryside into the isotropic space of the kingdom, but also a capacity to scrutinize minute details in order to detect anomalies within that space. Yet Louis did not displace his body when his eye went on patrol; rather, his vision zoomed in like a telephoto lens. In Martin's painting, moreover, sweep and concentration work in concert, as two parts of the same appraising operation. The godlike king scanned for the sake of fixing upon each detail that required extra attention, while his extra attention could be fixed upon any point along the scan. Martin's technique gives perfect artistic representation to the conjoined character of the two modes. The work does not discriminate in its finical treatment of every particularity, with the effect that the monarch's realm becomes a homogeneous field of unflagging attentiveness. Such uniform perceptual thoroughness certainly lies beyond human capacities. Panoramic and focused vision, each on its own and together, manifest the divine perceptual capacities attributed to the monarch.

Within the Orangerie, one views either as a deity or as a mortal; one either surveys while floating or moves in to concentrate. Divine omniscience claims as its object the full circumference circling around—all parts equally, at all times—while humans inhabit the radii, following a trajectory perpendicular to the full circle of the divine sweep. The broad view from the center is indifferent to details as such. It incorporates the occasional pile of paint as accents within the wide colored screen but pays no heed to the particularities of how, say, the hairs of the brush in a specific stroke have pushed this vein of pigment into that. Meanwhile, the human scrutiny of an individual blossom demands inattention to the surrounds. Whereas Monet's curved walls when viewed from the center evoke the manner in which a deity would survey its aqua-horticultural domains, when a mortal examines a detail at arm's length, these indeterminate surfaces superbly represent the vague sensations hovering in the periphery of concentrated vision but not quite seen. The regular contrast between thick and thin technique in Monet's paintings ensures both that detail will not be spread across the general field and that the generalized view will not become saturated with details. The installation allows both modes, but it conflates neither the respective objects seen nor the

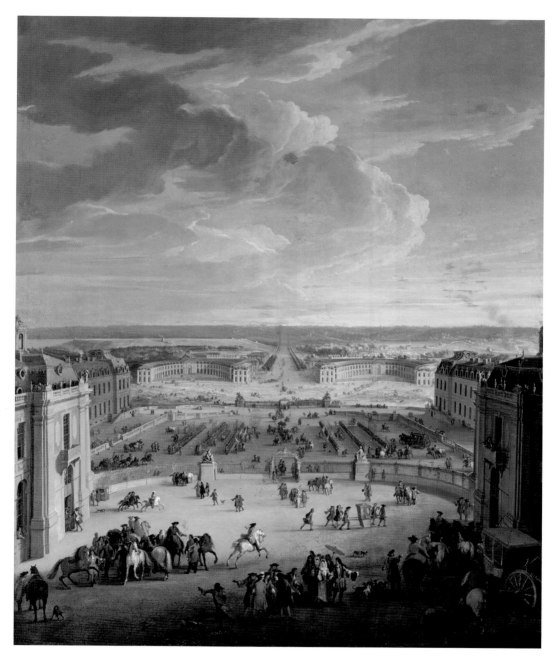

1 Jean-Baptiste Martin, *Perspective View from Versailles Palace of the Place d'Armes and the Stables*, 1688. Oil on canvas. Musée des Châteaux de Versailles et de Trianon, Versailles. Photo: Réunion des Musées Nationaux, Paris / Art Resource, New York.

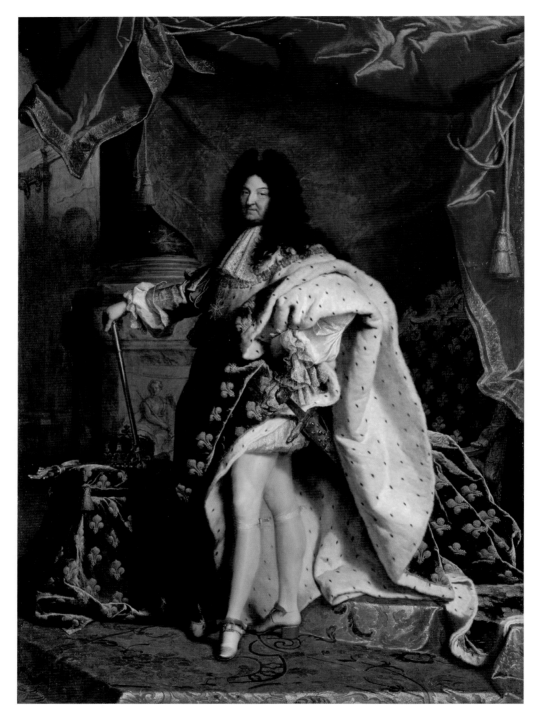

2 Hyacinthe Rigaud, *Louis XIV,* 1701. Oil on canvas. Musée du Louvre, Paris. Photo: Réunion des Musées Nationaux, Paris/Art Resource, New York.

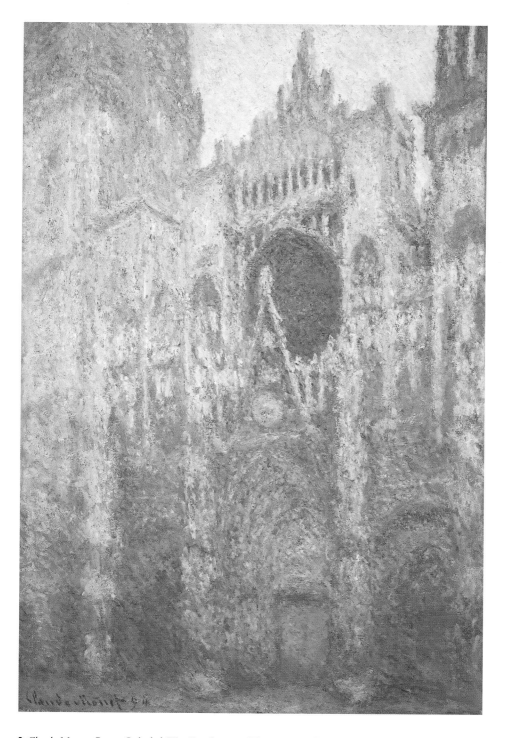

3 Claude Monet, *Rouen Cathedral, West Façade*, 1894. Oil on canvas. Chester Dale Collection, National Gallery of Art, Washington, D.C. Photo: © Board of Trustees, National Gallery of Art, Washington, D.C.

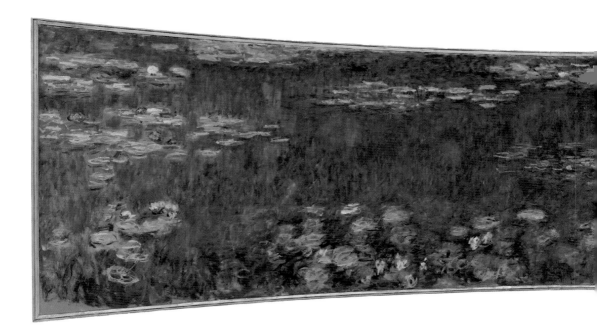

4 Claude Monet, *Green Reflections*, c. 1914–26. Oil on canvas. Installed on the east wall of the first room of the Musée de l'Orangerie, Paris. Photo: Réunion des Musées Nationaux, Paris /Art Resource, New York.

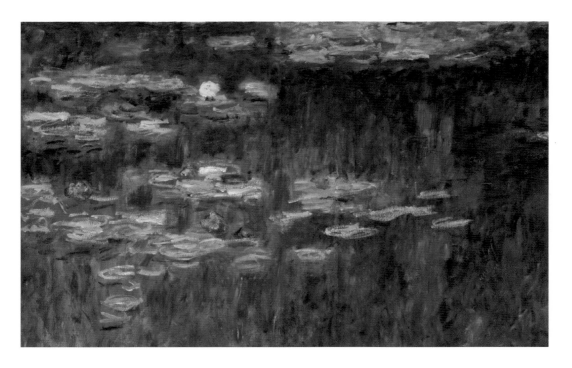

5 Claude Monet, *Green Reflections*, c. 1914–26. Detail of Plate 4. Photo: Réunion des Musées Nationaux, Paris /Art Resource, New York.

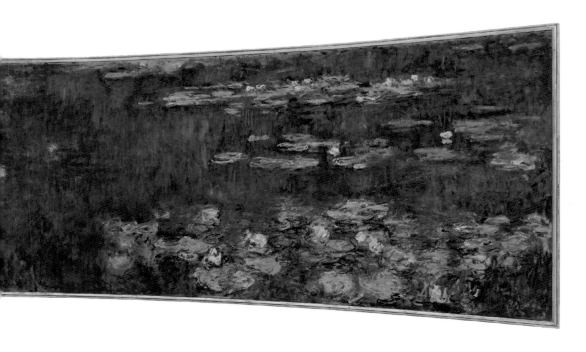

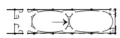

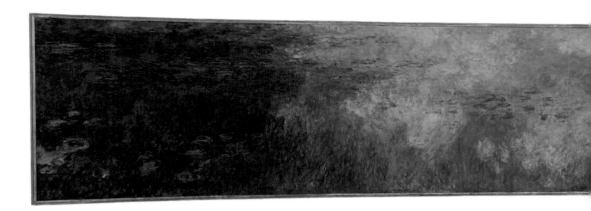

6 Claude Monet, *Clouds*, c. 1914–26. Oil on canvas. Installed on the north wall of the first room of the Musée de l'Orangerie, Paris. Photo: Réunion des Musées Nationaux, Paris /Art Resource, New York.

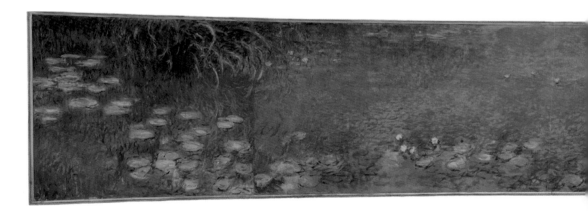

7 Claude Monet, *Morning*, c. 1914–26. Oil on canvas. Installed on the south wall of the first room of the Musée de l'Orangerie, Paris. Photo: Réunion des Musées Nationaux, Paris /Art Resource, New York.

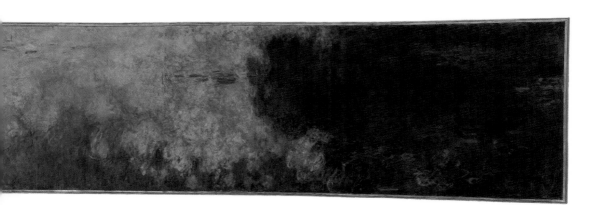

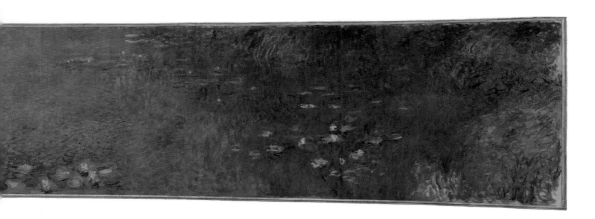

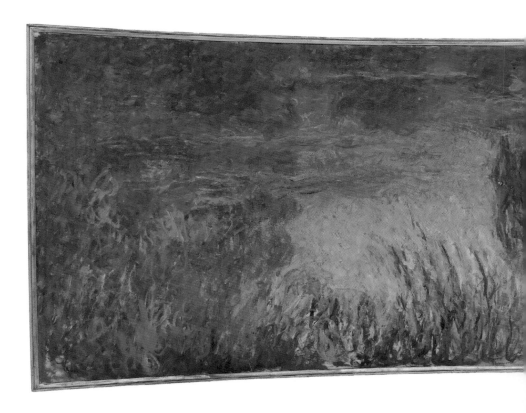

8 Claude Monet, *Setting Sun*, c. 1914–26. Oil on canvas. Installed on the west wall of the first room of the Musée de l'Orangerie, Paris. Photo: Réunion des Musées Nationaux, Paris / Art Resource, New York.

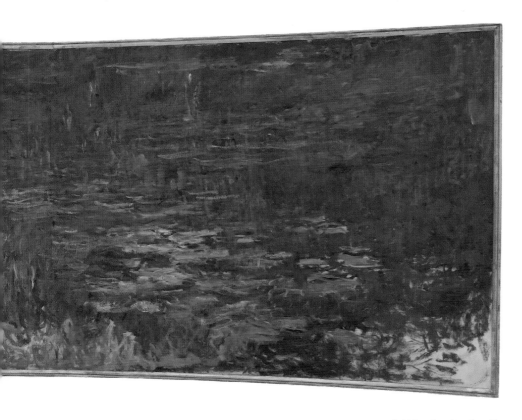

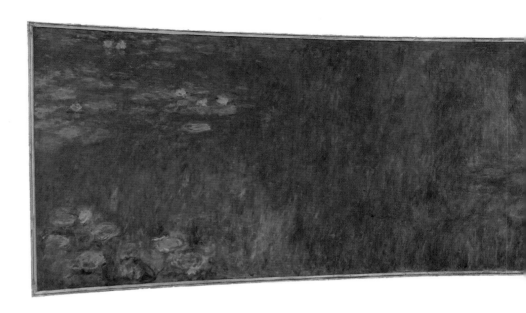

9 Claude Monet, *Reflections of Trees*, c. 1914–26. Oil on canvas. Installed on the west wall of the second room of the Musée de l'Orangerie, Paris. Photo: Réunion des Musées Nationaux, Paris / Art Resource, New York.

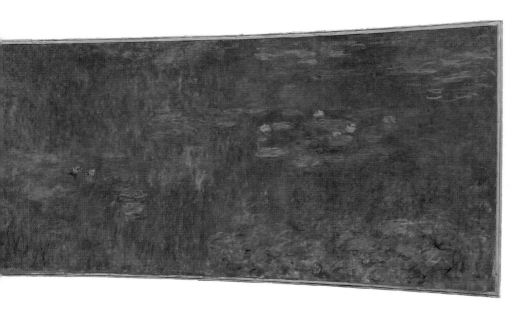

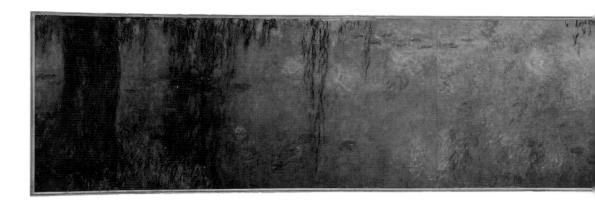

10 Claude Monet, *Morning with Willows*, c. 1914–26. Oil on canvas. Installed on the north wall of the second room of the Musée de l'Orangerie, Paris. Photo: Réunion des Musées Nationaux, Paris /Art Resource, New York.

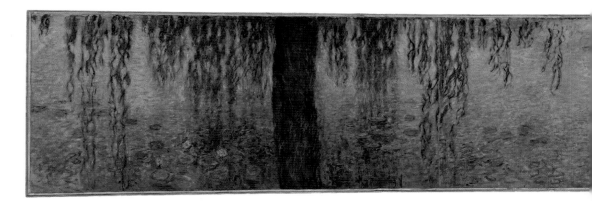

11 Claude Monet, *Clear Morning with Willows*, c. 1914–26. Oil on canvas. Installed on the south wall of the second room of the Musée de l'Orangerie, Paris. Photo: Réunion des Musées Nationaux, Paris /Art Resource, New York.

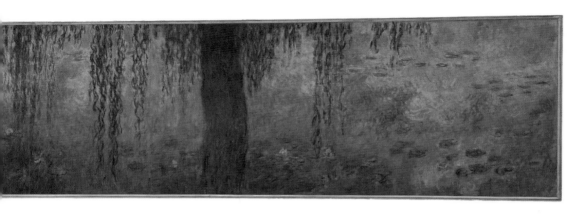

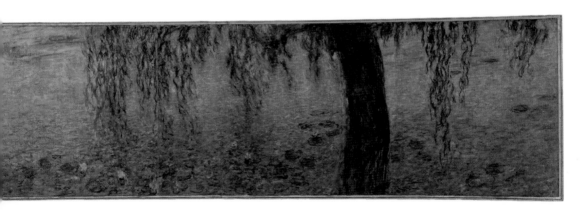

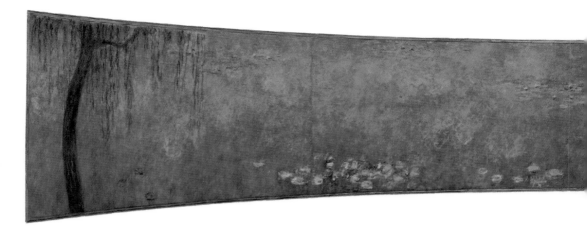

12 Claude Monet, *Two Willows*, c. 1914–26. Oil on canvas. Installed on the east wall of the second room of the Musée de l'Orangerie, Paris. Photo: Réunion des Musées Nationaux, Paris /Art Resource, New York.

13 Claude Monet, *Two Willows*, c. 1914–26. Detail of Plate 12. Photo: Réunion des Musées Nationaux, Paris /Art Resource, New York.

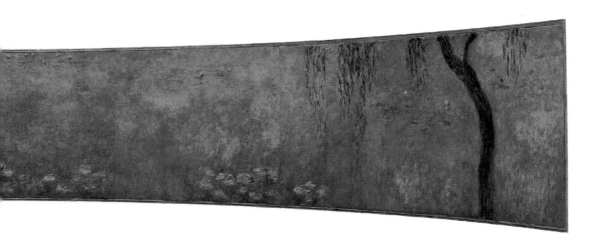

14 Claude Monet, *Reflections of Trees*, c. 1914–26. Detail of Plate 9. Photo: Maura Coughlin.

15 Claude Monet, *Morning*, c. 1914–26. Detail of Plate 7. Photo: Réunion des Musées Nationaux, Paris / Art Resource, New York.

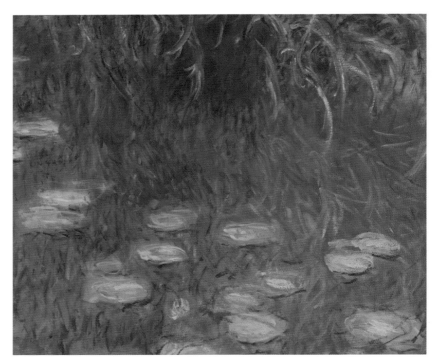

16 Graham Sutherland, *Christ in Glory in the Tetramorph*, completed 1962. Tapestry. Coventry Cathedral, Coventry. Photo: © Richard Sadler.

17 Robert Wilson, *14 Stations*, 2000. Mixed media. Station 12, "He dies on the cross." Photo: Lesley Leslie-Spinks.

18 Robert Wilson, *14 Stations*, 2000. Mixed media. Station 13, "He is taken down from the cross." Photo: Lesley Leslie-Spinks.

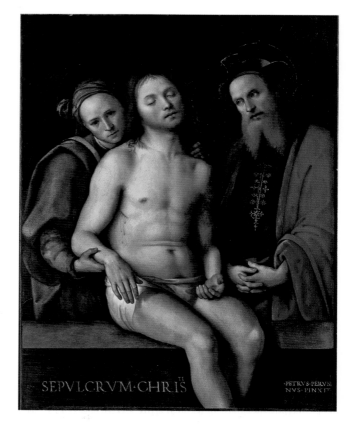

19 Tableau from the Passion play, 2000. Oberammergau, Germany. Photo: Brigitte Maria Mayer /© Gemeinde Oberammergau.

20 Pietro Perugino, *Sepulcrum Christi*, 1498. Oil, possibly with some tempera on panel, transferred to fabric on panel. Sterling and Francine Clark Art Institute, Williamstown, Massachusetts. Photo: Clark Art Institute.

entities charged to perceive them. When humans leave the precinct of the divine center, they find their own distinct view.

Furthermore, what the details reveal—and conceal—differs not just in precision but also in kind from the view from the center. It is a hoary description of Impressionist painting but nonetheless often holds true. As one nears the surface of an Impressionist picture, discernible iconographic features—elements of a landscape, or a still life, or a portrait—largely dissolve into a sea of undulating strokes of paint that seem to describe little more than themselves. Depiction cedes to technique. The scale of the paintings in the Orangerie magnifies this effect. With a conventional framed canvas, one might perform the contrast between scene and stroke by a mild lean of the torso, transporting one's eyes from arm's length to palm's width. Within the Orangerie we must take several strides to accomplish the same transformation. The ensembles with the greatest curves, such as *Two Willows,* allow us actually to enter the embrace of the expanse. The frame passes beyond the sides of our sight as we join company with the material deposits of Monet's means.

Viewed from this close vantage, the details oblige us with a clear exposition of the artist's technique. As if striving to remain in scale with the expanse of the picture, the brushstrokes themselves often grow outsized, and each remains distinct (Plate 15). For the most part, Monet had abandoned the minute crafting of complex multilayered encrustations that typified his paintings of Rouen Cathedral. With that series from the last decade of the nineteenth century, the evolution of his technique through the first half of his career toward more convoluted technique reached its apogee.[18] By the time he painted the works for the Orangerie, the artist was moving his whole arm, not fingers or wrist, to lay down large yet individuated strokes. Such strokes serve better as a record of the artist's gesture than of lily pad or flower. As a result, the physical displacement of our bodies from center to periphery within the two rooms of the Orangerie causes an abrupt shift from one discrete object of our attention to another, in the manner of the canonical illustration of rabbit and duck. First we see water garden, then we see painted canvas, but never quite both in the same set of mind. Do the paintings concern the blossom floating atop the calm pond, or the heap of pigmented medium adhering to the colored canvas? The leap between one construal and the other entails a cognitive flip from water's horizontal plane to painting's vertical face. That axial shift captures our brusque passage from distant to proximate, from divine overview to mundane concentration.

Nonetheless, the distinct and discrete characters of the two modes of vision do not lead to pitting the one against the other. Rather, the two manners of looking complement each other across the divide that separates species of viewers, with each observing its counterpart at work. (Not in spite of but because of their ineluctable differences, God and humanity can esteem each other.) Let us venture again to the center. Even with the inclusion of the worried buds within the calm panorama, God or his pantheist surrogate still sees everything. From that distance the heavily worked sections of the canvases tip toward the task of de-

piction, giving to this prospect individual flowers just as the full ensemble gives to it the fullness of the watery world. To be sure, the highlights are not really blossoms; they are just paint. Yet from an omniscient vantage, the recognition of Monet's medium constitutes not an occlusion of the divine eye, which can see through such incidental mediation, but rather a visible manifestation of the limitations of mundane perception. Humans grasp the world only indirectly, through their conceptual and technical means. The deity looking from the center of the room can even observe the constrained creatures as they linger near the surfaces of the glued canvases, confronting the fact that they perceive only earthly shadows, not ethereal essences. (Visitors to Giverny fare little better. They may overcome the mediation of paint, but they still perceive creation only partially, phenomenally, as through a warped and smoky glass.) From the prospect of the center, people inching along the periphery embody human limitation. That enactment, too, is given to a God who made humanity and then beheld its Fall. More than simply witnessing the world, divine sight sees human sight seeing. Then we humans step tentatively (perhaps only imaginatively) into that center to observe—contingently, with all our incapacities—what God must see. We discern aspects of what it might be like to possess divine vision, although given our pitiful restraints, we see only a representation of such perceptual genius and what it sees, not the genius itself or its essential objects.

In this light let us approach the surface again, aware that the divine eye behind our back is now witnessing what we are about to scrutinize. From up close we see hefty brushstrokes, which we trust represent something different from themselves, though we know not quite what. It might be a water lily floating back at Giverny. It might be the Platonic "Idea" of flower, or a bit of Schopenhauer's "will," of which the blossom in Monet's garden is but the accidental and dim derivative. Nonetheless, divine oversight would now serve to assure the reality of an essence elsewhere. From the center—which is to say, from everywhere—the deity observes both our flawed means and that essence, and it thereby warrants the existence and character of the connection between the two, however distant. We, in contrast, could only possibly know of such a connection through faith.

Moving in toward the pictures is not an attempt to overcome the perceptual failure of humans at a distance by scrutinizing up close what Monet has to offer. Rather, the thick paints and loose handling seen proximately affirm with even greater force the separation between medium on these walls and some referent elsewhere. Within these rooms surrounded by these opaque canvases, the near view encourages us to knowingly accept the limited compass of human perception, now set off by and against the authorizing eye backing it up. Once again, Martin's painting stands in striking contrast (Plate 1). The depicted perspective strives for verisimilitude whereby even the smallest patch of picture is to correspond visually to its counterpart in the world. The artist troubled himself greatly to maintain the conceit, using the finest of brushes and thinnest of paints. Yet when we approach near enough to detect the traces of Martin's refined technique, the attempt at perfect veracity inevitably cracks.[19] And with the shattering of the illusion, Martin's manner of working reveals its suspect sin-

cerity, its attempt to deceive. A successful copy depends on the dissimulation of means, and in such a picture the visibility of the medium testifies to the artist's failure as a limner of likeness. In comparison, the robust paints smeared across the canvases at the Orangerie openly profess their categorical difference from water lilies and unreachable essences. These are but honest human brushstrokes for humble human eyes.

5. MATTER AND MASS

Modest means, perhaps—yet they hold the intimations of a miracle. I argued earlier that when we human visitors relinquish the omniscient center to the divine, we can discern a community that surpasses each of our particular circumstances of time and place. In like manner, when the material brushstroke abandons its mimetic task, it opens itself to embody something grander than itself—something with spiritual, even Catholic overtones.[20] The heritage of Impressionism shows the way.

"[In the Musée Claude Monet] Impressionism finds its complete expression," rhapsodized Waldamar George in his review of the inauguration. "The technique of pure tones, typical of Monet during the Argenteuil period, reappears in these tapestries of colors."[21] Despite the unfurling of fifty years, despite Monet's midcareer exploration of visibly complex technique, despite the exponential increase in the surface area of the artist's canvases, the paintings in the Orangerie constituted for all critics at the time an extension rather than a refutation of Monet's youthful style.

And for good reason. The concept of the impression was a powerful one because it suspended the difference between two distinct yet related aspects of perception. It could refer both to phenomena generated by the world, such as rays of light bouncing off objects, and to the individual artist's personal experience of such stimuli, shaped by a particular subjective temperament.[22] The fusion of the two facets into one allowed for an extension of the self outside its shell by equating internal sensation with external stimulation, thereby crediting the human mind with a certainly godlike capacity to know with certainty some feature of the surrounding world: godlike, not godly, because what the perceiver encounters is phenomena, not things themselves.

Implicitly in the prose of many contemporary critics, color carried out the confounding of external atmosphere and internal perception. François Fosca, in his book on Monet published at the time of the opening of the Orangerie, typifies the approach: "With Monet, ground, water, sky, all seem formed of the same matter; or more exactly, the material world seems replaced by an iridescent tremor, from which the idea of solidity is excluded."[23] It is impossible to determine whether Fosca intends "iridescent tremor" to refer to the scintillation of hues emanating from concrete objects or to some vibration in Monet's brain—or even to the shimmering pigments spread by the artist across the canvases. In this regard, color functioned in Impressionism as music did in Wagner's *Ring* cycle, as the rhetorical figure

for the lack of rhetorical figuration. Just as an instrument cannot represent middle C but can only present it, a painting does not depict a color but rather makes it manifest.

Color, however, could exceed its connective function. Indeed it did so perforce. Fosca continued:

> A canvas by Monet never remains only a sketch fixing a visual sensation in the most abrupt and direct fashion. Visual sensation constitutes the very essence of painting, it is true; but it is not all of painting. We ask the artist to give us something other than raw, unadorned sensation. (62)
>
> In front of a landscape, instead of holding fast to reality, [Monet] gives himself over to his unbridled temperament that connects him to the forces of nature, enlarging the importance of what he has before his eyes. . . . [Monet] enriches what nature offers him. He exhausts the most sophisticated combinations of his palette, lavishing his colored treasures. . . . There is an obvious disproportion between the object and the means employed to paint it. (64–66)

The pronounced degree of chromatic amplification at the Orangerie certainly abetted the assignation to Monet of the mystifying role of pantheist. Yet Fosca conceded nothing from his insistence on fidelity to nature's sensations; and conversely, the logic of Impressionism had always required some excess, however small, of means over scene.[24] Without fidelity, transcription risked obliteration by unrestrained artistic caprice. (Fosca can allow only a glimpse of "unbridled temperament" before tying it fast again to "the forces of nature.") Yet without the supplement, viewers could not have discerned a distinction between external sensation and internal sensibility at all, and thus would have lacked any means to assess the proximity of the two. Paul Cézanne's lapidary pronouncement "Monet is only an eye, but what an eye!" nicely captures the dual aspect of the resilient interpretation.[25] "Only an eye" underwrites the fusion of phenomenon and perception. "What an eye!" both recognizes Monet's active engagement in the process by means of his representational prowess and hints that the artist provided something more—the "what!"—beyond what nature gave to him.

Commentators looking at Monet's final contribution never needed to pit his late paintings against his earlier ones, to forward some polemic championing synthesis over observation, temperament over impression, the lyric over the real. All such terms in the criticism complement each other. They spin the same compound tale. Léon Werth, though he wrote after the artist's death, described Monet's final triumph from a hypothetical moment following the preceding series but before the Orangerie pictures: "One did not yet know where this power of technique would culminate, a power that . . . ends up restoring to things . . . their ordinary aspect, their very appearance which he pulled away from them. He will attain that point where technique and dream seem to merge, where his language will no longer be a transcription of things, but rather be like a second reality, and where we will no longer be able to distinguish between the moment when he sees, the moment when he remembers, and the moment when he dreams . . ."[26] Werth assigns different tasks to Monet, yet all are identical. How patent the ordinary aspect of things and how veiled the artist's second real-

ity, yet how remarkable that the two are selfsame! Impressionist vision allows the sensations of the world to approach and retreat through this constant recognition and disavowal of the difference between nature's appearance and Monet's reverie.

The composite yet conflating function attributed to vision—fetishism in its purest form—launches sight on the quest, basic to humanity, of grasping after the strangeness of the world to render it more familiar to mortals. We may give a name to that quest, with all its exhilarations of wondrous presence and its tragedies of ineluctable absence: representation. And what does Impressionism represent? The movement's nearly exclusive reliance on weightless vision, so magnificently manifest in the lack of footing at the Orangerie, has the effect of leaving the substance of the world beyond account.[27] Listen again to Fosca, now with the phrase about "iridescent tremor" removed: "With Monet, ground, water, sky, all seem formed of the same matter; . . . the idea of solidity is excluded." On the one hand, the Impressionist emphasis seems to diminish the importance of the world's material character as measured against its chromatic luster. Along such lines, Marthe de Fels in 1929 could conclude her extended retrospective of Monet's career—in which she declared that "the religion of light vivified his heart"—with the encomium "At the frontier between dream and reality, no painter limited by the constraints of matter knew how to bring greater facility to the representation of the immaterial."[28] On the other hand, the adoption by vision of the agonizingly uncertain human struggle to know the world liberates matter from that dark realm of doubt. It is only because Impressionism strips human perception of the opportunity to distinguish ground from water from sky (as opposed to their thoroughly scrutinized appearances) that such entities, along with all other material things, can reside together in an unalienated other-place of their own. Monet's surface, in the manner of Marion's icon, "does not abolish but reveals" the distance of material nonresemblance separating the painting from the world. Fallen humans with their representational figures, with their twisting and feigning tropes in word and paint, will not be allowed to taint God's vacated Eden, where the world is always and fully present to itself.[29]

Of course, the representational gambit of resemblance can also be ventured by playing upon the material similarity between things. Think of Gustave Courbet using his palette knife to sculpt depicted stones with heft; or, closer to the era of the Orangerie, Marcel Gromaire smearing his muddy medium across soldiers in the trenches (Figs. 23 and 24). This ploy is precisely what Monet's large last pictures refuse to do. Amassed paints seen at a distance may look like blossoms, but up close they bear material characteristics quite distinct from aquatic vegetation. Whereas lily pads in life are slippery slick, the brushstrokes Monet dragged across the canvas to depict them are rough-edged and dry, even chapped (Plate 15). Each item—out there in the world, here on the walls of the installation—possesses its own physical attributes and can be neither duplicated nor imitated.

Paradoxically, therein lies the unity of things. Smooth, coarse, thin, thick, glossy, matte, frothy, dense: all such traits may be regarded as the accidental properties of an underlying, persisting, indescribable matter. Human perception attends to change and particularities,

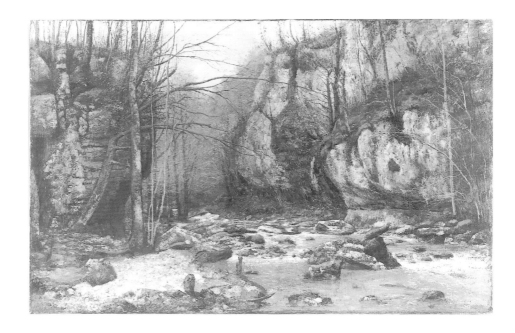

23. Gustave Courbet, *Stream of the Puits-Noir at Ornans*, c. 1867–68. Oil on canvas. Gift of Mr. Norton Simon, Norton Simon Art Foundation, Pasadena. Photo: Norton Simon Art Foundation.

but an indeterminate substrate seems to endure, affirmed in human consciousness apophatically, as the negation of all contingency. Such constant matter defies all representation. Nonetheless, the paintings in the Orangerie manage to evoke it in perhaps the only manner available to the medium, by repeatedly revealing the lack of material resemblance between things. Our physical bodies, as they move toward the perimeter, do not share many characteristics with the mounds of pigmented medium piled up on the canvas. This whipped-up bit of unctuous paint is not like that crusty sweep (Plates 14 and 15). Beyond the enclosure of the Orangerie's two ovals, the stuff of paint does not emulate the substance of water lilies, or of willows, or of clouds. And yet further afield, any entity—past or present, near or far, manifest or recondite, earthly or elsewhere—can join with us in shared presence, not through the overreach of resemblance but through our common participation in unspecified being. Disencumbered of their accidental differences, all people and things, everywhere and at all times, conjoin. Because there is one matter, we who are many are one substance, for we all partake of the one matter.

In Monet's time and place—which ours still resemble, even in unexpected ways—such ideas would surely have resonated with a particular intellectual heritage. In 1902 Pope Leo XIII proclaimed in the Encyclical *Mirae Caritatis* (drawing freely from the Decrees of the Thirteenth Session of Council of Trent of 1551):

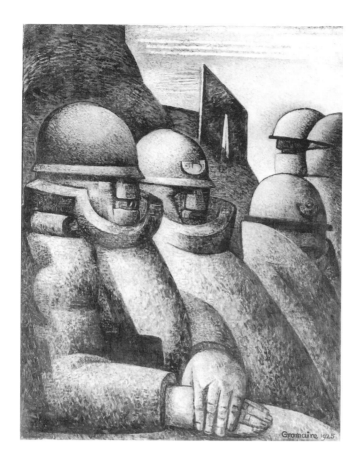

24. Marcel Gromaire, *War*, 1925. Oil on canvas. Musée d'Art Moderne de la Ville de Paris, Paris. © 2006 Artists Rights Society (ARS), New York / ADAGP, Paris; photo: © PMVP / Pierrain.

[We] worship Him as really present in the Eucharist, as verily abiding through all time in the midst of men. . . .

Here all the laws of nature are suspended; the whole substance of the bread and wine are changed into the Body and the Blood; the species of bread and wine are sustained by the divine power without the support of any underlying substance; the Body of Christ is present in many places at the same time, that is to say, wherever the Sacrament is consecrated. (§§4, 7)

The accidental characteristics of bread and wine, here called the "species," may remain the same, but their "underlying substance" becomes Jesus Christ. Bread and wine do not represent body and blood; they are body and blood. The superficial resemblance between, say, claret in the chalice and the bodily fluid flowing from Jesus's wounds is but a distraction from the real identity of one with the other. Accordingly, the corporeal Christ would be as

accessible to communicants at the rail today as he was to the Apostles at the Last Supper. Participation in the Eucharist by disciples at all times in all places constitutes the church, in the sense of the catholic collectivity of all the faithful. "Because there is one bread, we who are many are one body, for we all partake of the one bread" (1 Corinthians 10:17).

How Christ assumes "real presence" in the Host remains a "great mystery," affirmed not by reason but by faith. Nonetheless, according to Catholic doctrine, transubstantiation is an act, not a fact. The conversion needs to be effected, in the words of *Mirae Caritatis,* by "priests, to whom Christ our Redeemer entrusted the office of consecrating and dispensing the mystery of His Body and Blood" (§19). Without a cadre of clerics officiating as celebrants of the Eucharist, bread and wine remain bread and wine. This principle would seem to attribute godly properties to the clergy themselves, making them the active agents not simply in discerning the invisible truth of substance but also in transforming and transporting it. What Wotan attempts with music, the curates would do with bread.

Yet doctrine hardly allowed priests and bishops independence as mediators of the divine. What made a priest a priest? *Mirae Caritatis* echoes the argument of the Fourth Lateran Council of 1215, which proclaims: "Nobody can effect this sacrament except a priest who has been properly ordained according to the church's keys, which Jesus Christ himself gave to the apostles and their successors" (§1). Christ declared "This is my body" (the archetypal speech act), then passed that capacity on to the Apostles, who in turn assigned it to their first followers, who transferred it to the line of popes, who over time have conferred it on legions of bishops, who have bestowed it on the multitude of priests. John Paul II expounded in *Ecclesia de Eucharistia* of 2003:

> It is he who, by the authority given him in the sacrament of priestly ordination, effects the consecration. It is he who says with the power coming to him from Christ in the Upper Room: "This is my body which will be given up for you This is the cup of my blood, poured out for you . . ." The priest says these words, or rather *he puts his voice at the disposal of the One who spoke these words in the Upper Room* and who desires that they should be repeated in every generation by all those who in the Church ministerially share in his priesthood. (§5)[30]

Closer to Monet in time and place, in 1920 the prelate and church historian Pierre Batiffol could publish these words: "The priest really takes the place of Christ if he replicates what Christ did, and he offers a true and full sacrifice to God the Father in the Church. . . . Thus the priest is another Christ, he does (*imitatur*) what Christ did: although he is not crucified, he offers the sacrifice as Christ offered it at the Lord's Supper."[31]

The mystery redoubles. The priest's act of transubstantiation renders Christ present, yet through the sacrament of ordination Christ also becomes present in the priest (in his substance, as it were, not in his accidental features) for the purpose of celebrating the Eucharist. The priestly role, though indispensable, is but the means by which Christ throughout time makes himself present as both the giver and the gift of the Mass.

We can now, finally, complete our procession through the sanctuary of the Orangerie. Imagine a visitor arriving at the Musée Claude Monet with the legacy of Catholicism embedded somewhere in his or her habits of mind. Imagine ourselves as that visitor. That identification, I would venture, is not as implausible as we might tend to believe—and more catholic than Catholic. Despite our distance in time and place from Monet's mono-denominational France, despite our varied histories of religious instruction or the lack of it, despite the range of our current efforts to embrace or reject institutionalized religion of whatever stripe, mental proclivities of the sort I have been describing are still very much with us. To give an example, surely the most telling one: Do not a great number of us envisage "nature" as both the author and object of many a soulful spiritual moment? And do we not also attribute to, say, the Romantic poets special powers to render to us nature's redemptive powers, all the while regarding their passionate drive as itself a force of nature?

Imagine, then, our passage through the two oval rooms with the religious legacy in mind. We have witnessed the diurnal cycle of atmosphere and light in the first room. We have felt the paintings unfold to enclose us in their sphere. In the second room, we have experienced the suspension of gravity and time within this sea of weightless sameness. We have been directed, by the amphitheater of the paintings to the west, north, and south, toward *Two Willows,* into whose central section we may fall as into a dream. We have occupied the center (physically or by mental projection) and sensed the inversion into omniscience. We have recognized our transience in that place that is not our own. We have moved on.

We move outward toward the perimeter, which we approach in the manner of a communicant nearing the rail. Rather than kneel to eat and drink, we bend to scrutinize and ponder. Rather than taste the tasteless wafer followed by the liquid cut of sweet acidity, we feast our eyes on the swirls and streaks and whorls of Monet's colors, thin and thick, matte and glistening. We anticipate that we will receive something more, and if we are fortunate (which, I suspect, many of us often are), we will be gratified. Monet's brushstrokes, not because they resemble nature but because at this distance they do not, possess a heft that we trust, in faith, embodies more than their own prosaic weight. Their physical presence refuses to deceive through the devices of resemblance and representation. They exude boundless communion with all matter, our sense of which begins with our proprioceptive awareness of our own corporeal presence. We might even imagine a new inversion in the Orangerie, this one accomplished on behalf of the mortals in the room rather than the deity. Our regular senses blocked by the opacity of these walls and our representations of the world disarmed by the lack of resemblance, we nonetheless gain an awareness of the infinite expansiveness of matter when Monet's surfaces fold (in the sense of kneading) the essence of substance back into the realm of our own physical containment.[32]

And where is Monet? Perhaps against expectations, not in his old role as Bazalgette's pantheist who painted cathedrals three decades before. The works from that earlier campaign, like Bazalgette's panegyric to them, promote a polemic. Nearly every picture in the series sets up a pronounced visible distinction between encrusted paints of Byzantine complexity,

which cover the greater part of the canvas, and a corner or two of gossamer pigments, or even exposed priming (Plate 3). The spare bits along the borders accomplish little beyond emphasizing, through contrast, the slathered thickness and scabrous surface of the central part of the picture. As a result, whatever truth the cathedral has to offer retreats to a double remove. First, the textural rhyming of Monet's dried and cragged medium to the weathered stones at Rouen makes the picture a tactile representation of the edifice, thereby allowing the real thing to hide beyond the plane of resemblance—even though that resemblance is based not on visual appearance but on materiality, in the manner of Courbet or Gromaire. In this regard, the relation between the painting and the underlying substance of the building resembles the linkage and resulting distance separating Marion's idol from God: the painter provides a "face," but merely a face, for the facade (as the facade, in turn, provides merely a face for substance). Second, Monet's convoluted technique mystifies the making—we simply cannot discern the tactics involved in the underpainting. Consequently, the pantheist needs to "plunge" from here to there and then return (Bazalgette's argument), bearing essences that he generously dispenses to those of us trapped on this side of untraversable representation.

While they present a contrast between great fields of rarefied color and exceptional patches of heaped paints, the canvases at the Orangerie never tend toward polemic. Thick and thin here always complement each other: the salient horticultural event accenting aquatic uniformity; the acuity of focused attentiveness paired with a vagueness at the periphery of vision; the felicitous mutual observation of divine vision by mortals and of mortals by divine vision. Regardless of their weight, moreover, Monet's brushstrokes are almost always simple. The blossom at the heart of *Reflections of Trees* may churn and swirl, but we can grasp at a glance its constituent parts (Plate 14). No deep texture layers and surface coloring. Just this sweep of a brush, and then that. It is as if Monet no longer felt obliged to press the point, no longer needed to prove himself capable of going where we dare not follow, no longer had anything to hide. All of it rests right there, to see as if touch. Werth in his book of 1928, while still professing awe at Monet (owing now more to the artist's age than his raw skill), nonetheless recognized how, at the Orangerie, simplicity replaced complexity, mystery superseded mystification, and joy dispelled conflict. The contrast with Bazalgette's feisty words thirty years earlier could hardly be more pronounced. Werth continued:

In this way, before dying he touched the most mysterious limits of his art. . . .

Great painters who reach this age . . . surpass themselves[;] they seem to surpass the limits of painting. Intoxicated by liberation, in a state of grace . . . Their technique, the result of a life of searching, is stripped of all appearances of effort. It seems that their language cannot be defined any longer according to human laws, insofar as it encompasses, in its exulting joy, contradictions which we no longer know how to resolve. (36–37, third ellipsis in the original)

Here vision is stripped . . . of the conventions of composition, that set of regulations that is often only an excess of anthropomorphism or an ephemeral formula of an era or of a society. (39)

Rather than a Promethean struggle to achieve the divine, the artist enjoys a happy freedom from the regular constraints of human existence while in the simple presence of paints.

The polemics presented in and prompted by the Rouen Cathedral pictures cast Monet as paradoxically both unlike a priest, in that he personified a pantheist alternative, and very much like one, to the extent that he himself assumed a spiritual occupation. At the Orangerie he adopted a role more directly parallel to that of the celebrant of the Mass. Touched by "grace"—not a human trait but the gift of divine love—the painter becomes the human channel for the "mysterious" manifestation of something that exceeds both himself and his mundane technique. Monet paints with a confidence that allows simplicity, with the humility appropriate to one moved by forces beyond. Rather than the artist commanding his art and what it represents, the Triune One—at the Orangerie, art, nature, and what might best be called "spirit"—makes itself present through the means of a transported Monet.

The sanctuary in the Tuileries draws the divine into its two oval rooms, but that place is not ours. If any one of us—the poised gentleman of 1927 or the visitor in the twenty-first century—presumes to step into that central position of knowing all, he or she will encounter not the false promise of divine omniscience but rather the reassurance of circumscribed human embodiment. The place of the divine will remain void to our eyes. Yet it is only owing to that mundane emptiness that it might come to be filled. Although we can never find a figure for it (even the word "God" can be no more than a cipher), it might provide much. It warrants that the essences of the world, not merely their representation, might arrive here. Monet does not effect that miracle. In the manner of a priest, he might appear one step closer to divine insight than we, but he remains a man with us on this side of the eight ensembles of canvases that he painted. From the central and universal perspective of God, these pictures could well look like a pond of water lilies ("look like," but in a manner not compromised by the iteration or representation). To us up close, the paintings may tender most when we do not ask them to resemble much. Upon, across, through their marvelous, mysterious surfaces, the no-longer-Catholic Three-in-One might then materialize, in our presence.

Spence's Cathedral and Britten's *War Requiem*

1. CATHEDRAL REBORN

On the night of November 14, 1940, the Anglican Cathedral Church of Saint Michael in Coventry fell victim to the first heavy aerial bombardment inflicted on England during World War Two. The church dated from the fourteenth century but had not been elevated to the rank of cathedral with its own diocese until 1918. Although the factories of this industrial city of the Midlands were the obvious targets of the Luftwaffe bombers, the ancient wooden beams supporting the cathedral's vault flared up swiftly under the inexact rain of incendiary shells. By dawn only the masonry walls and the tower remained to circle the charred remnants of roof and interior. The desecration of this holy building, along with the death of hundreds in surrounding neighborhoods, served advocates of the Allied cause as damning evidence against the enemy. After an uneasy interlude of barely twenty years, it seemed, the barbaric Hun once again threatened Western civilization. During the following war years, the resolve voiced by the local clergy on the morning of the conflagration came to carry great symbolic import for all of the nation. Coventry Cathedral would be rebuilt. The English way of life would survive.

And so it came to pass. Following the usual rounds of hopes and false starts, of failed commissions and contentious architectural competitions, of journalistic polemics and ecclesiastical bickering, of town council machinations and New World fund-raising, in May 1962 a new Coventry Cathedral (Figs. 25 and 26) welcomed to its consecration Queen Elizabeth II, the archbishop of Canterbury, and (through the media) the eyes and ears of a grateful Christian kingdom.[1] This cathedral, the decade-long work of architect Basil Spence, did not so much replace the destroyed structure as augment it. Shunning the plans of competing designers to build within the surviving walls or on top of their cleared foundations, Spence chose to preserve the open-air ruins as a monument to the sacrifices of the past. His modernist edifice instead extended northward from an opening cut in the bar tracery of the old cathedral's surviving wall, its own "east" altar now at the far north end of the L-shaped

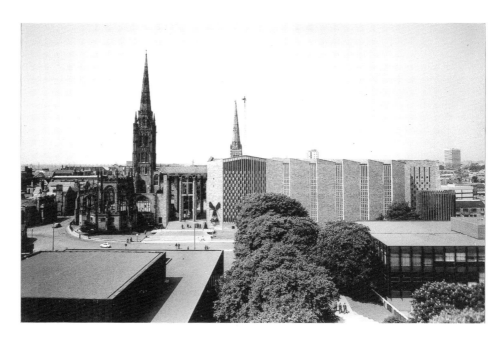

25. Basil Spence (architect), Coventry Cathedral, completed 1962. View from east. Photo: © Richard Sadler.

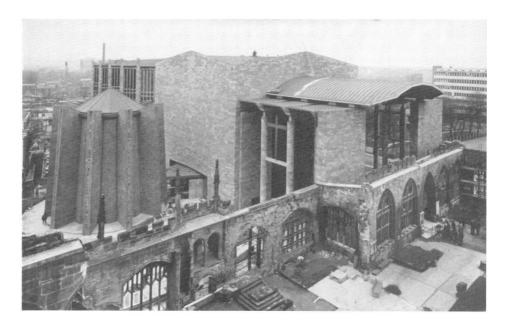

26. Basil Spence (architect), Coventry Cathedral, completed 1962. View from southwest. Photo: © Richard Sadler.

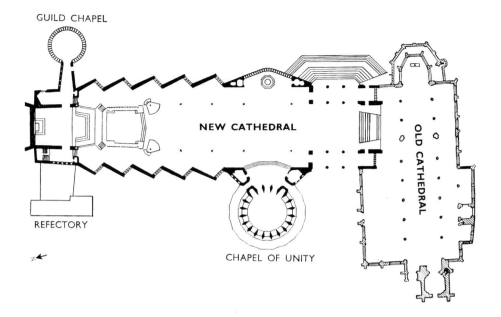

GUILD CHAPEL

NEW CATHEDRAL

OLD CATHEDRAL

REFECTORY

CHAPEL OF UNITY

27. Basil Spence (architect), Coventry Cathedral, completed 1962. Plan. From R. T. Howard, *Ruined and Rebuilt: The Story of Coventry Cathedral, 1939–1962* (Coventry: Council of Coventry Cathedral, 1962), plate 11. Direction marker added. Drawing: P. W. Thompson.

site (Fig. 27). Processing through the cathedrals from the old to the new, visitors follow the eastward line of the exposed former nave to the erstwhile location of the high altar, turn abruptly to the left, traverse the blasted shell to enter a newly constructed porch, pass through the enormous cut-glass, south-facing "west" wall of Spence's cathedral, and then proceed toward the new altar of hammered concrete to the north, behind which presides, in the world's largest tapestry (stretching seventy-two feet in height), Graham Sutherland's rendition of Christ seated in glory against a field of emerald green (Fig. 28 and Plate 16). A path from ruins to renewal, from wartime sacrifice to postwar resurrection, from the crucifixion of the Lord to his redemption—and purportedly our salvation.

2. REQUIEM AETERNAM

"Requiem aeternam dona eis, Domine" ["Lord, grant them eternal rest"], voices implore in the even cadence of a monotone chant. Chimes toll a regular rhythm, accentuating the call for divine mercy. A full orchestra alternates phrase for phrase with the choir. Entering above a quiet pedal tone held by piano, tuba, and timpani, the ensemble insinuates greater motion, as short sixteenth notes slurred to more sustained quarter notes (often chromatic neighbors) impel the piece forward. The instruments, moving together in a near unison of

parallel octaves—only the bassoons and the low brass offer a subdued hint of harmonic structure—seem intent on reaching some resolution in a cadence. Yet without a solid base in a key (neither the pedal A nor the key signature of one flat provide meaningful guidance), their wanderings in pitch can never settle on one. The voices, meanwhile, offer tension trapped in stasis. After an initial declaration of the words by sopranos and tenors on F-sharp, altos and basses rearticulate the supplication on C. This pair of notes—repeated over and again by the antiphonal voices—constitutes a tritone. The tritone, which emerges as a recurring motif unifying the entire eighty-five minutes of Benjamin Britten's *War Requiem,* derives its name from the three whole-tone steps it takes along the twelve half-tone notes of the chromatic scale.[2] It splits the standard octave awkwardly in half, creating a dissonance that led to its centuries-long proscription in virtually all diatonic church music—the tritone was the "devil's interval." No harmonic repose here for those souls whose salvation the choir pleads.

Suddenly, the angelic voices of boys. In many churches this juvenile choir would have perched high in the rear balcony to achieve celestial effect, but at Coventry Cathedral—for whose consecration the *War Requiem* was commissioned and where the piece's premiere performance occurred on the evening of May 30, 1962—the uninterrupted expanse of the great glass "west" wall precluded such literal elevation. "Te decet hymnus, Deus in Sion" ["Thou shalt have praise in Zion, oh God"], these ephemeral yet clarion tongues beckon from beyond the divide separating humanity from the eternal peace that will reign after the Last Judgment. The tritone has not been banished from these heavenly spheres. Each phrase of the boys' unison chorus begins or ends with alternating Cs and F-sharps, while their final, evenly paced chant splits the voices into these same two notes (the first and second violins from the orchestra, moreover, alternate in sustaining the two notes of the tritone throughout the beatific interlude). A different valence for the atonal dyad, however, emerges here. The boys' phrases themselves are markedly chromatic. The first two, for instance, each exclude only one note—and each phrase a different one—from the full twelve-tone chromatic scale. The evanescent timbre of a harmonium accompanying the boys may hold diatonic triads, but it does so only by systematically passing through all twelve tones of the full chromatic series. Coupled with the rhythmic regularity of the boys' line, this tonal homogeneity grants to the empyrean chorus an aura of timeless stability.

This, then, seems the true dialectic forwarded by the opening passages of the *War Requiem:* not the opposition of full choir and orchestra, but the contrast between those two as a collective entity and the boys' choir with harmonium. The juxtaposition, moreover, offers all the clarity of a polemic. Against the striving of a humanity uncertain of its absolution, the certitude of eternal salvation rings forth. Against the dramatic movement of the orchestra searching out tonal resolutions and the dissonance voiced by its accompanying choir, the boys arrest forward development toward a cadence through the extraordinary stability offered by the homogeneous twelve-tone scale, as if superseding the rules of harmony represented in each of the harmonium's diatonic triads.[3] This differentiation between conflict in the human realm and its cessation in celestial spheres employs the same rhetoric that underlies

Britten's Latin source text. The various sections of the Missa pro defunctis, centered on the theme of the Last Judgment, set off the articulation of anguished uncertainty in anticipation of that moment of truth faced by all when the trumpets sound (Dies irae; Libera me) against the proclamation of divine glory awaiting only the blessed (Sanctus). The tritone, on its own, thematizes the dynamic. Unstable and stable at the same moment, this dyad represents both the temporal act of striving and the atemporal state of what is sought.

But Britten's requiem will not leave us with this comfortably hoary formulation of faith. Following a reprise of the main choir's supplication with its accompanying orchestral dirge, a chamber orchestra of twelve players, conducted by Britten himself during the premiere, strikes up a martial cadence. One can envisage the English lads in fatigues and puttees rushing off in a hunched, double-time march to the chaos of the front (evoked by the general cacophony of the chamber orchestra), as "wailing shells" (imitated by the high woodwinds) fly overhead and the "stuttering rifles' rapid rattle" (replicated in the staccatos of the double reeds and the snare drum's tattoo) takes its toll. The quoted words are from Wilfred Owen, poet-martyr of the Great War; a solo tenor sings their strain.[4] Line by line, Owen's "Anthem for Doomed Youth" mocks the rituals—prayers and bells, candles and flowers—of religious mourning. These soldiers, destined to die, will never know of the miraculous mutation, promised by the church, of impermanent body into eternal spirit ("ad te omnis caro veniet" ["all flesh shall come before Thee"], sing the boys). Instead, their flesh is mere flesh; they are men who perish "as cattle." ("Was it for this the clay grew tall?" the tenor will ask later in the *War Requiem* with words from Owen's "Futility"; "—O what made fatuous sunbeams toil / To break earth's sleep at all?") The tritone, earlier the emblem of the drama of salvation, appears again here, but it has lost its power to enact any such spiritual transcendence. The brief but recurring tritone tremolo in the harp, recalling the earlier chimes that accompanied the main choir, marks out not the measured gait of a religious procession but rather the quick pace of the military march. At the end of his passage, the tenor repeats the same eleven-tone melodic line beginning in C and ending in F-sharp initially sung by the boys, but the words he sings are "And each slow dusk a drawing-down of blinds," directly countering the main choir's earlier plea of "Et lux perpetua luceat eis" ["And let the perpetual light shine upon them"]. Beneath the tenor a bass drum played by snare sticks captures the unending, mind-numbing rumble of artillery. The tritone, in short, no longer signals the moral affliction of human expiation, nor can it evoke the divine timelessness of chromatic equilibrium. It speaks instead of the interminable, and all too mundane, agony of men in battle.

In one sense, then, the dynamics of the *War Requiem* appear more tripartite than bipartite: terrestrial troops, a heavenly host, and a congregation of supplicants entreating the transportation of the doomed former into the timeless realm of the latter. When confronted with the tenor singing in contemporary English about the modern engines of slaughter, however, the ageless spiritual matters expressed by the Latin Mass—articulated by both the main choir and the boys' chorus—fade from immediate concern, becoming remote indeed. Why all this Latin fuss about whether one will be saved when, as the lines from Owen imply, the

mechanisms of salvation may simply not exist, at least in the modern era? The main choir and the boys alike declare an investment in a sacred program that the disturbing English poetry deems played out, bankrupt. Thus a dialectic in the *War Requiem* reemerges, but it has evolved yet again. No longer a dialogue between the penitent and the saved, the piece has become a dispute between the distant ethereal spirit and the proximate tragedy of earthbound armed conflict. Whereas Spence's plan had a cathedral rise out of the ashes of war, Britten's requiem allows the ashes of war to issue out again from the new cathedral.

3. THE CHURCH OF SAINT MICHAEL

If Spence's Cathedral promised rebirth from ruin, who might be redeemed through that beneficence? All of humanity, seemingly. The postwar ministry of the Coventry diocese explicitly embraced the principle of reconciliation between adversaries, former and current, potential and real. This meant, first and foremost, a rapprochement between competing nations in the world, and above all, in the words of R. T. Howard, provost of Coventry from 1933 to 1958, a healing of the "long breach between Britain and Germany."[5] Thinking analogically from this basic precept, Howard could imagine the church also working as a vehicle for the forging of communal unity in the face of the many divisions—of denomination, of class, of age, and so forth—that tended to fragment modern urban populations. Concluded H. C. N. Williams, Howard's successor and the presiding force at Coventry Cathedral at the time of its consecration: "The belief must be declared that the Church is the Church, and only becomes the Church when it starts to proclaim its gospel from an unassailable position which is above every human division . . . racial, economic, political, industrial, social and ecclesiastical. . . . The Church is a supra-national, supra-racial, supra-political fellowship."[6]

Spence's building appears to realize, in stone and glass, these ideals of social reconciliation and religious ecumenicalism. The designated themes of its two large, semidetached chapels contribute to the message. At the Chapel of Christ the Servant, the so-called industrial chaplains dedicated themselves to the amelioration of labor relations in this Midlands factory town, while the Chapel of Unity housed the effort to impel the Church of England and other Christian denominations (the Roman Catholics chose not to participate) toward a "World Church" ideally joining all of Christendom.[7] So, too, the materials chosen for building bespoke ecumenical ambitions. Not only did items incorporated into the edifice arrive in Coventry from around the globe (a mosaic floor from Sweden, a baptismal font from Bethlehem, a symbolic stone from Kiel), but also the sheer variety of stuff crafted together to construct the cathedral (pink-gray sandstone for the exterior walls and textured white plaster for the inside, slender columns of reinforced concrete and a canopy of spruce slats, black marble floor and wooden clergy stalls, the cut-glass "west" wall and many sets of stained-glass windows, a fleche in aluminum alloy, and of course the giant tapestry) demanded a de-

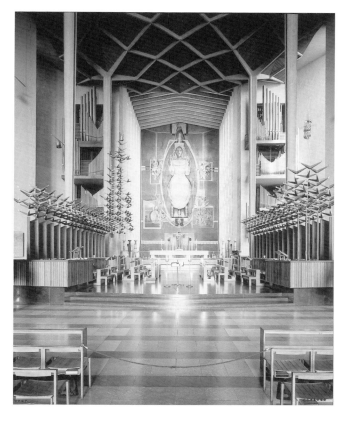

28. Basil Spence (architect), Coventry Cathedral, completed 1962. View of nave from south. Photo: Alan Watson, courtesy of History of Art Department, University of Warwick.

gree of skilled workmanship and a coordination of artisanal effort that evoked the hopes for class accord through honest work imagined by aesthetic-social theorists of the mid-nineteenth century such as John Ruskin and William Morris.

Nothing manifested the ideal of all-encompassing human harmony as effectively as the basic layout of Spence's plan. The high altar, all those involved could agree, constituted the very heart of the cathedral. The competition brief of 1951 stipulated as much—"This should be the ideal of the architect," decreed the preface to the document, "not to conceive a building and to put in an altar, but to conceive an altar and to create a building"—and Spence enthusiastically concurred.[8] This holy table for the preparation of the Eucharist brought the living members of the congregation together through a shared liturgical act and also reaffirmed the ostensible bond connecting the body of man to the spirit of God through the real presence of Christ.[9] Spence's high altar not only enjoyed pride of place—raised, framed beneath the feet of Sutherland's Christ, visible from all precincts of the nave, unobstructed by a screen of the sort frequently intervening in the older cathedrals (Fig. 28). It also was

bathed in light streaming in from a host of stained-glass windows, all oriented toward the altar and fully visible only from there owing to the saw-toothed pattern of the cathedral's exterior walls (Fig. 27). The single point in the cathedral that both drew in iridescence from the natural sun passing through the colored windows and radiated out the illumination of supernatural divinity, the high altar gave spiritual expression to the modern secular mission of the church, as articulated by Provost Williams: "The basis of the experiment is the conception of a 'secular' Cathedral, with a community of men working and worshipping in a close fellowship, and undertaking specific tasks in the community around it. The Cathedral thus becomes not primarily a place to which people go, but a place from which activity goes out; a base for an outgoing operation into as many categories of activity in the community as possible."[10] Indeed, given the location of Coventry in the northern climes of Europe and the odd reorientation of the new cathedral with its "east" altar facing due south, it was as if the rays of blessed light flowing into and out from the high altar through Spence's angled windows unfolded, like so many ribs of an opening umbrella, to shelter the teeming masses of the globe's populations to the south.

Nonetheless, the geometry of the altar as a point of radiance entailed exclusions. Seen from above—from the perspective of the architect's plan, or of God's higher eye—all lines traversing the plan were able to rise sooner or later to the latitude of the high table, save for one: the line running directly perpendicular to the religious radiance emanating southward from the altar. Spence took full advantage of this cartographic idiosyncrasy to finesse a doctrinal difficulty. How were members of other denominations to participate in the services at the Chapel of Unity without implicitly endorsing the liturgical centrality of the Eucharist, spurned by most Protestants yet embodied by the Anglican high altar? The architect's solution:

> I put [the Chapel of Unity] on the axis of the [baptismal] font, as there were to be two main axes— from the old Cathedral to the altar and from the Chapel of Unity to the font. . . .
>
> If Baptists and Methodists are to worship [in the Chapel of Unity] according to their consciences and with sincerity, it may be wrong to be completely within sight of the altar. The Act of Baptism, however, is another matter, and, as unity is a primary consideration, the chapel is on the axis of the font. During combined Services, those wishing to be within sight of the altar can sit near the grille, which is the limit of the Chapel of Unity.[11]

Presumably, those Protestants not wishing to stand at the threshold of the cathedral proper could find shade from the iridescence of the Anglican high altar deeper within the sanctuary of their perpendicularly protected chapel.

This artful axial orientation of the Chapel of Unity was called on to perform no more than a doctrinal nuance, since Protestants were first and foremost invited to Coventry on the basis of their shared religious sensibilities as Christians rather than turned away from a liturgical act distinguishing Anglicans from others. Nevertheless, the axis laid down by the

Chapel of Unity and the baptismal font initiated a larger scheme of differentiation. Just to the south of this line and (for all intents) running parallel to it, the walls of the ruined shell delineated the axis of the former cathedral. This perpendicular juxtaposition of prior and current naves carried much greater programmatic weight. Even as Provost Williams was declaring the need to use proper architectural means for the purpose of rising above social divisions inherited from the past, the nature of his argument itself revealed the difficulty of realizing that goal:

> The old Cathedral was destroyed in hate. Christians may not leave open wounds of hate unhealed. Human hope had by that act been crucified on a world stage. It was on a world stage that the drama of forgiveness, reconciliation and resurrection had to be enacted. Every act of hate and bitterness and destruction leaves humanity at a parting of two ways: either to entomb hate and bitterness, and to erect memorials so that they will not be forgotten, or to "roll away the stones" from these tombs, and let hope rise again. The first of these choices makes it certain that the circumstances of hate and bitterness will be repeated. The latter makes it certain that the vision of hope will be made brighter, and the power of hate diminished by a little.[12]

The quandary for Coventry resided in the fact that Williams's second option at the "parting of two ways" depended on also exercising the first, at least to a degree. No reconciliation without recognition of the preceding violation, no healing without first hate. The declared ministry of the diocese in the wake of the conflagration could not avoid this ineluctable paradox—which, to be sure, was not of its own choosing but rather was imposed on it by the falling of German fire.

In preserving the burned cathedral beyond the porch of the new edifice, Spence's plan monumentalized the senseless destruction of the past with the clarity of a polemic. "The decision to retain the ruins was courageous and wise," pronounced R. Furneaux Jordan in the souvenir publication commemorating the reconstruction.

> It was not merely that the ruins—including, of course, the magnificent and intact tower and spire— could become a most impressive memorial in themselves; they were also the starting point of a theme that was ultimately to dictate the whole scheme. This was the theme of Sacrifice and Resurrection.
> . . . Only when we understand this theme do we realise that what we are seeing is not just a cathedral; it is two cathedrals, in fact an ecclesiastical group in the mediaeval tradition.[13]

One cathedral on the east-west axis to represent destruction and division, a second on the north-south axis to represent reconciliation and rebirth, with the Christian allegory of the Resurrection lying close at hand. The "ecclesiastical group" gave expression not only to humanity's loftiest accomplishments but also to its basest deeds. It juxtaposed good against evil. Given the human origins of the tragedy and the resulting embodiment of vice on earth, a certain stark social division ensued. The sanctity of religious service in the new cathedral

performed by the English necessarily manifested itself with special force owing to the carefully preserved evidence of sacrilegious perfidy perpetrated by the Germans looming just outside the glass "west" wall.

The patron saint for old and new cathedrals—an infelicitous appellation, inherited from bygone days—could well have pushed the balance at Coventry toward vilification. This was Saint Michael's church. Michael, the weigher of sins at the Last Judgment and the leader of the saved into God's eternal kingdom (he makes a passing appearance in this role during the Offertorium of Britten's *War Requiem*). Michael, the archangel who wrestles Satan and throws him down to earth (Revelation 12:7–9). This patron saint is a warrior, not a maker of peace, and his goodness cannot be realized without a personification of evil to be vanquished.

Nowhere was this characteristic more clearly expressed than in Jacob Epstein's large sculpture of Saint Michael, mounted on the cathedral's east wall flanking the grand ceremonial steps leading to the porch (Fig. 29). Bishop Cuthbert Bardsley of Coventry attested: "This particular piece of work has captured the imagination of very many people who . . . have seen, in this quite lovely work, something of the simple, profound message of good triumphant over evil, of God having the final word over the forces of Evil."[14] Epstein's sculpture deploys precisely the same geometry of virtue and vice as does the plan of the cathedral itself. Divine righteousness radiates from the saint's sunlit brow down his slanting arms and legs, much as the light from the new cathedral's altar shines diagonally southward through the structure's saw-toothed windows. The supine Satan incarnates the vanquished forces of the wicked, much as the ruins memorialize the fiery atrocity perpetrated by the now defeated Germans. The congruency would seem to undercut the mission of universal reconciliation by equating the earthly laying low of the recent human enemy with Michael's holy triumph over Lucifer.

Yet the saintly vanquisher, or his figuration, might nevertheless assist humans in grappling with the paradox, even if he cannot resolve it. It would be an evasion for us to disown our inclination, arguably an imperative placed upon us, to look squarely into the face of barbaric acts perpetrated here on earth and to declare them evil. The dropping of bombs randomly on a civilian population would seem to qualify. Yet we cannot lay claim to personal possession of any moral absolute that renders such unconditional judgment, lest we endorse the poisonous proposition that to the victor falls the ethical spoils. Rowan Williams, the current archbishop of Canterbury, has recognized the nature of the predicament. We cannot escape the bias of individual interest by appealing to the common good, because that move only expands the social compass of human interest without removing its inherent contingency. The prelate writes:

As soon as the appeal to common answerability is defined as an instrumental construction, we are in danger of returning to our starting-point: *really* human interests are conflictual, but it is more convenient to pretend otherwise, since social harmony is desirable. However, on such an account,

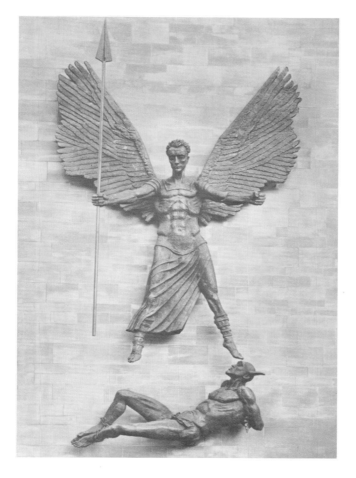

29. Jacob Epstein, *Saint Michael and the Devil*, completed 1962. East wall, Coventry Cathedral. © Tate, London 2006; photo: The Dean and Chapter, Coventry Cathedral © Richard Sadler.

it is desirable, presumably, because it is in *my* interest. I don't like being disturbed. And I assume that others have a similar distaste for being disturbed, and will to that extent co-operate in realizing my desire. . . .

What we are to say in evaluation of our behaviour is not to be determined, or even shadowed, by consideration of how this or that action succeeds in securing the place and interest of a particular subject or group *vis-à-vis* its environment.[15]

Righteousness—the sense that certain actions must surely in their core be just or justifiable, regardless of context—so easily cedes to self-righteousness, with its moral aggrandizement of whatever social circle, however large, assumes the task of passing judgment. We are back with the problem of Pauline universalism, as I discussed it in the Introduction, where I referred to the ideas of Daniel Boyarin. Any earthly manifestation of the purportedly limitless

collective necessarily becomes stained by human contingency through that very manifesta-tion ("In Christ Jesus you are all children of God through faith," Paul writes in Galatians 3:26, thereby naming the historical contingency, Christ on earth, that defines the group) and thus loses its absolute comprehensiveness.

What if, however, we were to cede moral certitude, along with custody of the universal, to a deity—much as the human visitors to Monet's Orangerie granted omniscience to the divinity that remains in the center of the rooms as they stepped toward the periphery? What if, in Rowan Williams's words, we were to rely on "a non-negotiable and therefore non-competitive presence 'before' which ethical discourse [can be] conducted" (247)? This ap-peal does not require the presupposition of the prior existence of some celestial arbiter of human virtue and vice. We can just as well regard such a judgmental deity (or deities, if you prefer) as the product of the human need for displaced moral authority as consider it (or them) aglow in immanence. Or we can suspend the question of Being altogether, either out of principled agnosticism or in light of Marion's rigorous theological argument. In all of these cases, the effect is much the same. When we humans visit the Orangerie and approach the perimeter, we confront the opacity of the painted surface yet can trust in some omnis-cient eye at the center peering over our backs and through those walls to vouchsafe some connection between the images and the material essence of the water garden, both physi-cally and epistemically distant. In a similar manner, to grant Saint Michael, as the per-sonification of celestial adjudication, the power of judgment beyond the particularities of any lived situation allows us to posit—or, if you prefer, to acknowledge—an obdurate eth-ical standard appraising human behavior irrespective of circumstantial opportunism. (The role could be served by Saint Michael, or Christ, or God, or Allah, whichever contingent placeholder we adopt as an icon, not an idol, for the always absent final arbiter.) We can del-egate in this manner even as we recognize, in due humility, that we will never be able grasp the degree of accord between our own moral pronouncements and the measure of ourselves and of others against that greater benchmark. "Because of the Father's secrecy," Rowan Williams writes, "the divine judgement, the only one actually of any truthfulness or final import, remains beyond anyone's power of utterance. It is not an *esoteric* truth . . . but an inaccessible truth" (260). Human compassion begins here, with the prospect of ethics shared across time and space, across the divisions of nations and of class, at the level of the unut-terable universal, yet never there to be claimed by any one group as assuredly its own.

Still, the temptation always remains strong to assert some true alignment between Saint Michael's ultimate verdicts and particular human efforts to adjudicate wrong from right. As with any temptation worthy of the name, it may be one to which humans inevitably suc-cumb. Even Provost H. C. N. Williams, generous in spirit, needed to declare the cathedral destroyed in hate before he could advocate the rolling away of stones. The danger at Coven-try lay in the ease with which the equivalence could be drawn. The name of the cathedral was, in this regard, most unfortunate. The divine Michael, or his sculpted figure, seem-ingly stood ever present to defend the values of the earthly diocese dedicated to him, and

the devout there may well have felt they were authorized to further the saint's bellicose mission by acting in his name. The geometry was infelicitous as well. With the altar at the spot of Spence's floor plan corresponding to the judgmental scowling brow of Epstein's Saint Michael, the celebrant at the moment of consecrating the Eucharist looks southward through his elevated arms, held up in the position of the sculpted Michael's wings.[16] As he lifts the Host—Christ's body—he espies the old cathedral laid low by fire, seemingly Satan's own.

Moreover, behind the celebrant rises the giant figure of the Savior woven into Sutherland's tapestry (Plate 16). This is not the peripatetic Jesus, but Christ enthroned; not the humble teacher and the healer of yore, but the arisen one in the time "after this" (the surrounding tetramorph situates us in Revelation 4). Just as the deity in the Orangerie who looks over the shoulders of the visitors may fortify their epistemic claims, this Christ in Glory appears prepared to back up the ethical assessments of the priest—who in scale matches the comparatively minute figure tucked protectively between the Savior's Passion-marked feet. Even a liberal dose of saintly discipline might not suffice to resist this beckoning invitation to self-righteous conviction.

4. AGNUS DEI

It would be fatuous to deny the presence of devices both textual and musical in Britten's *War Requiem* that similarly distinguish a sanctimonious us from a blameworthy them. Certainly the Missa pro defunctis, with its central subject of the Last Judgment, calls for such a separation of the saved from the damned, as in this passage sung by the main choir in the Dies irae (the requiem's second movement):

Inter oves locum praesta,
Et ab haedis me sequestra,
Statuens in parte dextra.
Confutatis maledictis,
Flammis acribus addictis,
Voca me cum benedictis.

[Give me a place among the sheep
And separate me from the goats,
Let me stand at Thy right hand.
When the damned are cast away
And consigned to the searing flames,
Call me to be with the blessed.]

"Let me stand at Thy right hand": what could be more clearly an aspiration for a place for oneself in immediate proximity to the divine, sharing its certain moral righteousness?

The juxtaposition inevitably plays itself out between the main chorus and the orchestra (supplemented, after the Requiem aeternam, by a solo soprano) and the tenor and chamber orchestra (joined for the remainder by a solo baritone), with the latter ensemble more than once positioned on the higher moral ground. Consider the contemplative atmosphere set by the chamber orchestra after distinct musical breaks away from the main ensemble halfway through both the Sanctus (the fourth movement) and the Libera me (the concluding sixth), which grant the male singers a platform from which to reflect, in the Sanctus, on the brilliance of divine glory and, in the Libera me, on the fretting of tormented souls, under the new and sobering light of modern warfare's terrible cost. Or consider how, in the Offertorium (the third movement), the male soloists explicitly refute the Mass's evocation of the holy promise of salvation made to Abraham "and his seed." In that movement, Owen's "Parable of the Old Man and the Young" recasts the Great War as justifiable grounds for the breaking of that promise by God to humanity, since Abraham in his recent incarnation ignores the angelic staying hand and instead chooses to slaughter his son and "half the seed of Europe, one by one." Again and again, the smaller musical company diminishes the religious sentiments embodied by the larger choral group, treating them as overly optimistic for the modern period, if not simply naive.

Yet the *War Requiem* abjures the clarity of Saint Michael's victory, for the musical composition allows for a reciprocity of inflection between the two juxtaposed sides. Either can turn on the other.[17] The fact that this requiem was composed for this cathedral on this occasion constitutes on its own an intriguing and knotty inversion of poles. When the chaos of modern warfare plays itself off against the (perhaps no longer) eternal verities of the church and does so in a setting dedicated to the proposition that the modern church can overcome the destructiveness of past wars, then neither the modern nor the ancient, neither the comfortably whole nor the tellingly fragmented, can unambiguously assume the mantle of moral authority. It is also true that, since Owen's verses regard war principally as a tragedy of lost life and hope on both sides rather than as a battle between men for the causes of opposed nations, Britten's resuscitation of such poetry from World War One undermines, at least to a degree, any self-righteousness claimed by England in its triumph over the Germans in World War Two.

The reciprocity results, however, not only from the location and the date of the inaugural performance but also from rhetorical turns within the *War Requiem* itself. These devices begin promptly following the Requiem aeternam, in the first bars of the Dies irae. Military fanfares across major triads in the brass open the movement, joined shortly by the brisk cadence of marching drums. This passage of the *War Requiem* seems to concede that belligerence in God's domains is necessary, but for a purpose. That purpose is the destruction on Judgment Day of the human realm irrevocably stained by evil and, through the "awful sound[ing]" of the trumpets ["Tuba mirum spargens sonum"], the calling of mankind "to render account before the judge" ["Judicanti responsura"]. Yet the Latin text and its accompaniment by the main orchestra does not have the final word. The Dies irae is the longest

and most interwoven of the requiem's movements, interpolating four of Owen's poems or poem fragments, whereas no other movement includes more than one. It serves as the requiem's principal vehicle for the extended development of the basic antithesis between divine perfection and the human tragedy of war first set out by the Requiem aeternam, and each proposition by one ensemble evokes a countering response from the other. Hence, the martial tones of this opening call to judgment are followed by an untitled Owen fragment sung by the baritone in a quieter, melancholic setting played by the chamber orchestra. The brass fanfares transmute into a lilt in the high woodwinds, giving a playful cast to the "voices of boys" to be heard by the riverside. A slow and forlorn horn solo, however, has already sounded to fill the role of Owen's "Bugles . . . saddening the evening air." Battle awaits, and "the shadow of the morrow weigh[s] on men" who can find rest only in the false peace of sleep. What purpose to the grim trump, this passage asks, when it preternaturally turns boys into men and extinguishes only their innocence?

Thus the movement continues, as the two principal ensembles (the boys' choir takes no part) borrow and rework each other's thematic and musical material, each refiguring the issues of life and death on its own terms. Together they pass through a variety of moods—melancholic, tragicomic, enraged—before settling on a mournful exchange between soprano and tenor. The sad yet dulcet high voice, accompanied by choir and orchestra that set a stately though slightly uneven pace in a seven-beat meter, refrains from judgment and instead pleads for mercy:

Lacrimosa dies illa,
Qua resurget ex favilla,
Judicandus homo reus:
Huic ergo parce Deus.

[On this day full of tears
When from the ashes arises
Guilty man, to be judged:
Oh Lord, have mercy upon him.]

The tenor interposes Owen's "Futility," and his freely declaimed verse, accompanied by suspended pianissimo tremolos in the chamber orchestra, arrests the slow forward progress of the soprano's call for clemency.

Move him into the sun—

.
If anything might rouse him now
The kind old sun will know.

.
Are limbs, so dear-achieved, are sides,
Full-nerved—still warm—too hard to stir?

Back and forth the free and more rhythmic groups alternate and interweave. The multiple exchanges and reformulations of the Dies irae have brought them together to this outcome: a certain shared concern for the dead, a desire for resuscitation and redemption. Only one difference seems to separate them now, but it is the crucial one between celestial hope and terrestrial hopelessness.

This apparent inclination toward reconciliation at the end of the Dies irae prefigures the gesture toward even greater proximity performed by the instrumentalists in the short and achingly beautiful Agnus Dei (the fifth movement). Here the orchestra and chamber orchestra find common ground—or, to be more precise, a common ground bass. The strings of the chamber orchestra open with an undulating ostinato of two measures metered in a slow but forward-leaning five-sixteenths time, consisting of evenly spaced descending scale steps from the fifth to the first note in B minor, followed by a similarly regular ascent on the first five notes of the C major scale; the first notes of the two measures thus rearticulate the tritone of F-sharp and C. This elegantly compact musical turn, reiterated throughout the movement, maintains perfect symmetry in two senses. It follows the same pattern of whole and half steps descending and ascending, and it assembles two clusters of four chromatic notes on each side of an omitted D-sharp (at the end of key phrases, a thrice-repeated extension of the ground bass into the span of notes from G-sharp to C completes the full set of chromatic tones—excepting the still-excluded D-sharp). A pithy figuration, then, of the interweaving of optimism (in major) and pessimism (in minor)—but now accomplished entirely within a single musical motif rather than through the juxtaposition of antiphonal ensembles. As the singing of the texts passes back and forth from tenor to choir, the strings and low woodwinds of the main orchestra pick up and pass back this same ostinato in such a seamless fashion that, in a sound recording, it becomes difficult to detect where one group of strings ends and the other begins. At long last, it might seem, the pleas of holy petitioners in Latin and the sentiments of soldiers sung in English can, upon this shared foundation, join in common cause.

The content of the texts, however, belies any such mawkish reconciliation.[18] "Agnus Dei, qui tollis peccata mundi, dona eis requiem" ["Lamb of God, that takest away the sins of the world, grant them rest"], repeats the chorus throughout the movement. These are lofty notions, no doubt. Yet cast under the pall of Owen's somber poetry, they seem the sort of words that might be uttered by priests and ministers who, from the safety of home shores, are shepherding the souls of their countrymen sent off to battle. That men of the cloth far from the trenches could presume to sermonize in this manner emerges as the target of Owen's poem "At a Calvary near the Ancre," sung by the tenor:

One ever hangs where shelled roads part.
 In this war He too lost a limb,
But His disciples hide apart;
 And now the Soldiers bear with Him.

Near Golgotha strolls many a priest,
 And in their faces there is pride
That they were flesh-marked by the Beast
 By whom the gentle Christ's denied.

The scribes on all the people shove
 And bawl allegiance to the state,
But they who love the greater love
 Lay down their life; they do not hate.

These words are harsh. Only suffering soldiers (Owen, a long-term combatant killed in the last week of combat, certainly qualified) join a twice-crucified Christ—once outside Jerusalem, once near the Ancre—as his true brethren. Those "disciples" and "priest[s]" who claim to follow but actually keep their distance from Calvary, who sacrifice others but not themselves, are worse than weak-hearted. They bear "the name of the beast or the number of its name . . . marked on the right hand or the forehead" (Britten, through Owen, returns us to Revelation 13:16–17). War, after all, is fought in Christ's name, and those petitioning for the righteousness of their cause—including such supplicants as the singers of Latin Masses—themselves play a minor yet indispensable role in the devil's crimes.

What to make of this mismatch in the Agnus Dei between the concord of the orchestral accompaniments and the discord of the meanings of the texts? Two possibilities (at least two) present themselves. The first is that in the face of the incapacity of the distanced church to preach the lessons of war properly, soldiers themselves must take on the task of singing out the battle's grim but momentous refrain. And nothing confirms this interpretation more surely than the final musical phrase of the Agnus Dei. The tenor, now alone, picks up the initial note of F-sharp and the even pace of the orchestra ostinato, but in his first measure, instead of descending the B minor scale, he works his way upward to form a sparklingly fresh major scale fragment of five notes in F-sharp. From here, the tenor steps back down a half step to C, as if beginning the descent through an anticipated F minor, but then rises again to produce an entirely unexpected scale fragment of C minor—the first rising scale fragment of the movement in the more somber mode. A half step down to the F-sharp resolves the phrase on the octave. The words—unique, for the male soloists—are in Latin: *"Dona nobis pacem" ["Grant us peace"]* (the score on this sole occasion employs italics). The interweaving of the high hopes of religious spirituality and the hard truth of worldly tragedy here attains full completion in the appearance, owing to the astonishing lowering of the third note in the scale fragment rising from C, of the previously absent E-flat (that is, D-sharp) and in the adoption by the soldiers' musical surrogate of the church's own tongue for the sake of soliciting not, as in the first movement, "eternal rest" for "them" but "peace" for themselves. "Peace": as much a literal need on war-weary earth as a figural attribute of heaven.

The second possible interpretation is that the conflict between preachers of the word and doers of the deed, between the nominally saved and the brutally sacrificed, between (ulti-

mately) the quick and the dead can never be overcome by any such passing and merely apparent agreement achieved through the facile intertwining of notes. And nothing confirms this interpretation more surely than the final musical phrase of the Agnus Dei. The tenor—no soldier he, but rather the agent of the church, performing in its lustrous modern cathedral far from Golgotha—switches to Latin to confirm the sheer impossibility that the ritual consecration at Coventry in 1962 could ever touch on the real unfathomable horrors of war in France during the 1910s. His Latin phrase interpolates (again, uniquely in the *War Requiem*) a line from the Ordinary of the Mass, the Mass for the living, into a text otherwise devoted strictly to the deceased. "Grant peace to *us*," the words can be taken to mean, "to those of us living here and now as churchgoers in this cathedral, for we have evaded the fate—as well as, perhaps, the closeness to Christ—to be found in the trenches." The tenor's closing scale fragments, even as they strive for new heights, can only replicate the unresolved tension lurking in the tritone, in the undying difference between major and minor, a minor that anomalously reappears in spite of that ascent.

In this deferral, this endless deferral of the problem, how might we adjudicate between two such competing interpretations (and many others like them)? The *War Requiem*—this is its governing conceit, its powerful message—proposes that, just as we cannot reconcile the second-level difference between orchestral concord and textual discord, just as we cannot grant the final moral turn either to the celestial choir or to the haunting voice of Owen, we cannot step up to any unequivocally higher platform, ethical or epistemic, from which to resolve such quandaries of interpretation. "We" here means the composer, the Anglican church, the devout congregation gathered at the consecration, the pious (along with the musically inclined) listening on their radios to the ceremony in May 1962, many more auditors paying heed after the fact to renditions on vinyl or compact disc, and the writers and readers of scholarly books. The *War Requiem* warrants no such righteous "us" and likewise permits no personification of evil in "them." Members of humanity—the faithful and the infidel, the English and the German, the living and the dead—may not all be standing on level ground, but not one among us possesses the means or authority to definitively map out the complex and ever-shifting terrain.

5. FATHER FORGIVE

If the *War Requiem* perpetually turns the tables on any claimant to moral authority, so too might Coventry Cathedral—when viewed from a perspective other than looking south from the altar.

Consider again the usual progression of pilgrims through the "ecclesiastical group" at Coventry. We visitors begin at the porch of the old cathedral, admiring the intact facade and tower. We pass through the preserved portal to the emptied, roofless former interior, reminder of and monument to the destructive night in May 1940. Walking forward down the erst-

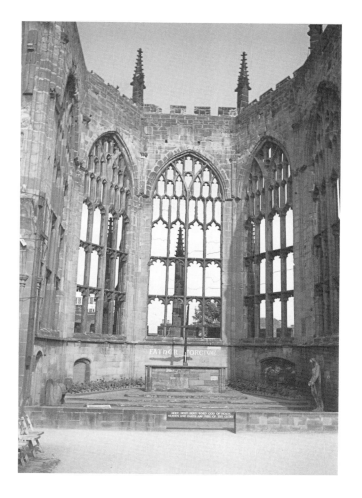

30. Altar in the apse of the old Coventry Cathedral, with Charred Cross. Photo: © Richard Sadler.

while nave, we reach that point where the gap cut in the left wall beckons us into the new cathedral. Rather than make that turn, let us pause here. Directly in front of us once stood the high altar of the older structure (Fig. 30). Behind the reconstructed table and the Charred Cross—a replica of the two burned beams bound together among the smoking ruins on the morning after the conflagration—appear the words of Provost Howard, inscribed on the apse wall in 1948: "Father Forgive." A verb that is frequently transitive has here been rendered intransitive by the absence of an object. From that omission springs the obvious questions. Forgive what? And thus, forgive whom?[19]

One answer would merge text and material support, filling out the predicate in a manner that voices reproach. Father, forgive the sacrilegious burning of our, and your, church. Father, forgive the perpetrators of this crime; forgive the Germans. In this form the entreaty

compromises itself to a degree, for it cannot articulate its request for divine clemency without redirecting attention to the earthbound wound—the object of the transitive verb—that would require absolution. Judgment and forgiveness conjoin, like two sides of the same coin. Surely we cannot begrudge the survivors of the actual firebombing (and their sympathizers, including us) the prerogative, paid for at a high price by those present in 1940, to call down upon the enemy such exculpation-cum-censure. Nevertheless, when earthly circumstance seemingly warrants such direct access to the deity, the act of supplication—especially when petition for oneself gives over to pleas for intercession on the behalf of others—cannot avoid having the effect of differentiating us virtuous sheep (near the shepherd) from the sinful goats. Sanctimoniousness tempts us, much as it may have tempted the celebrant looking down toward the ruins from the new altar, with Sutherland's enthroned Christ looming behind.[20] Indeed, when we stand in front of the Charred Cross and the lapidary "Father Forgive," a glance through the glass to our left might—when the light is right—afford us a view of the same risen Christ backing the celebrant during the Eucharist. The Son promises to swing behind us, providing assurance of the legitimacy of the self-righteous prayer to the Father placed on our lips by the words inscribed into the smoke-stained wall.

A different answer to the query "Forgive what, and whom?" would capitalize on the intransitivity of the verb. All of us are drawn together beneath the infinite capaciousness of the concept, the object of which it would be presumptuous for us to specify. All we humans, inescapably flawed as we are—and "sinning," for those who accept that vocabulary—are alike in our need for some form of pardon. The devout at Coventry would have no doubt about the agent of that absolution: he is named on the wall. Those not thus persuaded might land on other entities (our victims, ourselves, loved ones, "life," and so forth) whom we might beseech for acceptance and clemency. The possibility of such appeal, in any case, appears indispensable, for does not culpability without expiation always torment? In this second answer to the question concerning forgiveness, we could abstract the patriarchal subject of the phrase, as we did the ruins as its object, to voice the simple human imperative: "[someone or something] forgive [us]"—with the agent unspecified and "us" now consisting of the totality of humanity, past and present. (The nature of that universality we might intuit, but because of the Pauline paradox I describe in the Introduction, we can never claim human custodianship of it.)

The difficulty with this second reply is that it can prevent us from differentiating among the varieties and degrees of human vice. It may even invite a dangerous indifference. "We" (some collectivity as small as an individual or as large as humanity) might maintain—in a manner ostensibly generous in its refusal to reckon comparatively—that every (forgivable) violation directed against us is matched by a (forgivable) abuse of our own. The Lord's Prayer, as given in the Book of Common Prayer of the Church of England, seems to express this economy of ethics: "And forgive us our trespasses, As we forgive them that trespass against us." Within this system of moral general equivalence, however, the grounds to distinguish between, say, war crimes and quotidian affronts (to take an absurd extreme) drop out from

under us. The generally courageous *War Requiem* may suffer a failure of nerve in this regard when, in the dialogue between two living-dead soldiers from opposing trenches incorporated from Owen's "Strange Meeting" into the concluding Libera me, the universal tragedy of premature mortality simply suspends any questions about relative war guilt between the Germans and the English. There may even be a form of cruelty hidden in the principle of infinitely capacious forgiveness (and likewise in the phrase "forgive and forget"): "I forgive," the pardoning agent might be saying, "because I no longer care that you did what you did, because I no longer care about you in that way. I grant clemency because I have given up on you to be different, to be better, to be decent." In this sense, to forgive may be to forsake.

It lies beyond human capacities to square these two answers: the censure in the transitive version of the verb and the indifference in its intransitive form. Ultimately, forgiveness demands a superhuman agent able, impossibly, to accomplish contradictory tasks. It must know all with divine omniscience, judge dispassionately, and forgive compassionately and fully, while not losing sight of the gravity of the specific offense. (Bishop Howard's directive concerning Christ's face in the tapestry, written in a letter to Sutherland in 1953, struggles with the sort of tension involved: "Victory, serenity, and compassion will be a great challenge to combine.")[21] To be sure, the compound need does not specify the character or timing of its satisfaction. One might suppose the prior existence of a Christian (or other) deity to fill the role. Or the very act of attempting to forgive as a human might generate that figure (specified and acknowledged or not) as the entity that authorizes full pardon yet does not ignore the offense.

In essence, the dynamic of judgment here gets lifted to a second level. Whereas judgment mandated a benchmark without our having certain knowledge of its markings, the amalgam of judgment and forgiveness likewise depends on some intimation of its just achievement without our ever achieving it ourselves. If human judgment requires something beyond itself to be ethical in an unmitigated sense (even if it can never know itself to be), then human forgiveness of a strong sort depends on the resolution of the irresolvable contradiction at the heart of absolution. To reverse the direction of the Lord's Prayer: "We forgive them that trespass against us" in a manner modeled on the way in which we would like to imagine that God (or some other abstracted agent) will "forgive us our trespasses." Or we could paraphrase the plea on the wall at Coventry to read: "Father, we need you to forgive [them and us], because we require some assurance that forgiveness is possible, and yet we, and they, cannot find the means to do so fully." Because of such an agent beyond ourselves—real, imagined, or ontologically suspended between the two—we humans can forgive. We do so in a rich manner, however, only if our acts of pardon align, in an always indeterminate manner, with some preexisting or posited equilibrium between acknowledgment and atonement abstracted from our own interests and perceptions. (This is not a mandate for faith; it is a simple exposition of a conditional.)

Unwittingly but effectively, Spence's design presents visitors at the turning point in front of the old altar with a representation of the delicate balance between the uncertain presence

and the possible absence of a deity both judging and forgiving. R. Furneaux Jordan observed while standing at the entrance of the new cathedral:

> To imagine that glass [of the "west" wall] is transparent is not wholly correct. It is transparent when viewed from within; from without it reflects, or even looks black. Certainly, at this point, in the porch, the architect intended to support his general theme, in that he hoped that the Christ in Glory on the tapestry would be visible through the great west wall of glass. From the old cathedral, he hoped, one would look down the long vista of the new. . . . In fact, this does not happen except when the Cathedral is fully lit.[22]

Jordan simplifies the experience somewhat (at least, he simplifies mine). During a typical English day, the passage of the sun, the drifting of clouds thick and thin, and perhaps the fall of rain or sleet or snow cause the south-facing "west" facade to pass through varied states of opacity, reflectivity, and transparency, with one effect often dappled across another. Sutherland's Christ emerges into view and passes out again. The divine appraisal and pardon he personifies comes and goes. Perfect forgiveness, like fair and certain judgment, resides elsewhere, beyond our human ken. Yet it may not be completely concealed from us, and we might catch tentative glimpses of it. Those of us willing to apprehend the complexity of the spot before the old altar may discern intimations of the relief promised by real pardon, and may confront the obligation to answer fully for our deeds. We would do so divested both of the sanctimonious certainty bestowed by a known god and of the easy but empty comfort (occasionally posturing as anguish) provided by the belief that judgment and forgiveness will happen according to an always contingent script that we write for ourselves.

6. LIBERA ME

"Dona nobis pacem": with its culminating twist of all judgments back around themselves, the Agnus Dei would seem to eschew the existence of any ethical standard hovering above, or abstracted from, the human realm. Likewise, any forgiveness imparted by the words earlier during this brief movement—"But they who love the greater love / Lay down their life; they do not hate"—seems undone both by equivocation over whether (human) priest or (human) soldier sings the final Latin phrase and by the expression of just such hate earlier in the verse: "They were flesh-marked by the Beast." In the end, the Agnus Dei appears to place all its faith, and find deep sadness, in the absence of any higher standard or of any agent who condemns and pardons with authority. Soldier and priest, English and German are all left milling about on the same rough moral ground—or, to compound the uncertainty, nailed to the same cross. Sutherland's tapestry may have soared over the inaugural performance, but the requiem here offers no full or partial prospect of Christ in Glory or any other orienting and disorienting deity. Near the Ancre would seem a godless place, and by extension so might

Coventry. "Grant us peace," the closing entreaty in the Agnus Dei, receives in reply only the ominous rumbles at the opening of the following Libera me. Taken in its entirety, however, that long concluding movement may still offer hope, of a sort. Before we abandon Britten's piece to the certain uncertainty at the end of the Agnus Dei, we must let the Libera me have a chance to propose its inconclusive conclusion.

In the Libera me, the give-and-take of previous exchanges between full and chamber ensembles distills down to the clarifying dialectics of a straightforward polemic followed by ostensible resolution. The full orchestra and singers in Latin commence in their most martial mode yet. Soon the soprano and the choir are quaking in apprehension: "Tremens factus sum ego, et timeo, dum discussio venerit, atque ventura ira" ["I am seized with fear and trembling, until the trial shall be at hand and the wrath to come"]. They have reason to fear as they face a crescendo in the thundering orchestra, joined for the first time by the powerful church organ, that represents a wrathful Jehovah distant indeed from the merciful God to whom appeals the "Father Forgive."

And then, accompanied by orchestration of gossamer thinness, the tenor and the baritone role-play the tragic encounter from Owen's "Strange Meeting" between an English soldier who does not realize that he is dead and his German victim from the previous day who appears unaware of his reanimation. The baritone bemoans the terrible losses incurred by his demise:

> Whatever hope is yours,
> Was my life also; I went hunting wild
> After the wildest beauty in the world.
>
> For by my glee might many men have laughed,
> And of my weeping something had been left,
> Which must die now.

The heartbreak of death renders divisive nationalism suspect, while the poem's placement in the requiem transports the political neutrality of the quiet tragedy from World War One to World War Two. At the premiere, in fact, the English tenor Peter Pears sang with the German baritone Dietrich Fischer-Dieskau. It is reported that Fischer-Dieskau was so overcome by the reenactment that he finished the performance in tears.[23]

The melodrama of the poignant dialogue between two soldiers united in their doom, following close upon the belligerent opening, leads to a saccharine denouement. "Let us sleep now . . ." the two male voices intertwine around the last line of Owen's poem, rediscovering an alternative mental state halfway between sentience and oblivion that, in this context, too easily sidesteps the ghoulish horror of a living death. The chamber orchestra, and soon the full orchestra joining it in the only section during the entire requiem played collectively, effuses a pleasing cloud of harmonic—indeed, largely pentatonic—accommodation. Eventually, the passage settles on the Lydian mode of D, in its key signature only one accidental

away from the warm and familiar comfort of a major scale. Devices suitable for a Hollywood score—the plucking of pretty arpeggios on a harp, the crescendo and decrescendo of soft mallets on a hanging cymbal—reinforce the happy effect. The boys' choir, soon supplanted by the soprano and the main choir, voice the kind fate that awaits (but has yet to befall) these "sleepers" from the trenches: "In paradisum deducant te Angeli" ["Into Paradise may the Angels lead thee"]. The divine, it would seem, is not absent. It stands ready to redeem needless affliction, for the human dead will arise again to follow the way of him who also suffered on earth and went on ahead.

The very artificiality of this sweetness, however, bespeaks its contrivance. Even were the listener to miss the self-ironizing aspect of this collectively rendered passage (critics have, in fact, frequently characterized the segment as overly sentimental), Britten's next musical turn assures that the point should not be missed. After the sustained period when the ears have been soothingly cleansed of harmonic conflict, the chimes and the boys, at a dilatory pace that arrests the smooth forward flow of the larger ensemble, return with a jarring, unadulterated recapitulation of the tritone. "Requiem aeternam dona eis, Domine." The boys' words, repeated from the main chorus's opening to the entire piece, remind us that even the "rest" of this lately found sleep harbors only the illusion of peaceful resolution and contains as well the seeds of ceaseless perturbation. Twice the larger ensemble attempts to soldier sweetly on, and twice the boys persist in their disquieting chant. The bells will prevail, and finally the main choir (the soloists, the chamber orchestra, and the main orchestra are now done) concedes to the tritone, drawing the requiem virtually to its close with a set of slow, striving, disharmonic tone clusters built principally from the C and the F-sharp struck once more by the chimes (a recapitulation, actually: both the Requiem aeternam and the Dies irae conclude in a like manner musically, though the words differ in each of the three cases).

One final twist remains (as also at the finish of those two previous movements). After working through its tone clusters, all containing a disruptive F-sharp (sustained throughout by the sopranos and the tenors), the choir modulates into a pure, harmonic triad in F-*natural* major. It is as if the thumb and middle finger of a keyboardist had slipped off the chromatic black keys to land, surprisingly and by chance, on a triad that actually rings true.[24] This final chord, however (and on this point the critical and historiographical assessment has been unanimous), is less a final resolution than a declaration of the impossibility ever to resolve. The means of arriving at this tonal triad is so forced, so inadequate to the task of coming to terms with the complex history of the tritone's stabilities and instabilities that precede it in the *War Requiem,* that the F major chord—seemingly one of the simplest in music—now cannot help but contain within itself a representation of the severe constraints inevitably limiting its capacity to reach harmonic closure.

In this apparent shortcoming, however, lies the chord's quiet power. The concluding triad does not rebuff the awaiting angels, for its harmony bespeaks a better place than the cacophonous realm of soldiers' death and cathedral's destruction. Yet because the memory of the tritone's dissonance lingers within it, the chord perforce evokes—simultaneously and

with commensurate weight—both the clarity of the divine realm and our hopelessly cloudy perception of it. The disillusioning insight may interrupt good tidings, yet celestial vision also disturbs the comforting faith often placed by terrestrial despair in its own ineluctability. Much as the view from the old altar within the ruined walls toward the glass facade of the new cathedral neither renders present Christ in Glory nor occludes Sutherland's tapestry from view, the F major chord at the end of the *War Requiem* neither affirms the divine nor denies it. If the Agnus Dei precludes any resolution over whether priests or soldiers possess the right to judge and forgive, the Libera me suspends the determination of whether ethics lie in just such contingent human struggles or reside rather in the hands of the constant deity. Ultimately, the *War Requiem* proposes neither belief nor disbelief; it demands neither full faith nor sure skepticism. Instead, it proffers a place where belief or its lack is not the relevant question, where the hubris of either such certainty cedes to the prospect that we bear full responsibility to condemn evil and to forgive it, even as we know that our limited powers can do neither in the manner in which they need be done.

7. EUCHARIST

Let us now complete the pilgrimage. We turn away from the old altar, pivoting to our left. We pass through the great glass wall of the "west" facade, opaque and reflective and transparent. Christ in Glory now reigns in full view. Yet rather than stopping to bask beneath the radiance of the god depicted in Sutherland's tapestry, let us continue our advance. We travel down the nave. Imagine the inaugurating bishop Bardsley or some subsequent celebrant standing before us at the new altar, delivering the Eucharist. The Order of the Administration of the Lord's Supper, or Holy Communion, from the Book of Common Prayer of the Church of England supplies the words: "Hear us, O merciful Father, we most humbly beseech thee; and grant that we receiving these thy creatures of bread and wine, according to thy Son our Saviour Jesus Christ's holy institution, in remembrance of his death and passion, may be partakers of his most blessed Body and Blood."

According to the litany, Christ is indeed in the sacrament.[25] The Anglican celebrant presents the blessed bread and wine to the communicants not as bread and wine but as, in the words of the Office of Holy Communion from the Book of Common Prayer, "the Body of our Lord Jesus Christ" and "the Blood of our Lord Jesus Christ." Ecumenical efforts on the part of the Catholic and Anglican bishops of England in the years following the consecration of Coventry Cathedral led to a joint declaration on the subject in 1971: "Communion with Christ in the eucharist presupposes his true presence, effectually signified by the bread and wine which, in this mystery, become his body and blood."[26] This shared doctrine stood in contrast to the position of many Protestant denominations, according to which bread and wine, remaining in both essence and appearance human comestibles, served rather to represent the absent Christ.

Christ present in the Eucharist: that was accepted dogma. Yet the Church of England, in the words of a report from the House of Bishops from 2001, has "consistently been loath to speculate as to the mode of that presence and [has] been content to reverence the mystery."[27] The Catholic Church could endorse the doctrine of transubstantiation whereby the real substance of bread and wine, if not their accidental characteristics, actually do change into the body and blood of Christ.[28] Anglican liturgy rejected any such definite claim. The twenty-eighth of the Thirty-Nine Articles, a founding document of the Church of England that still appears in the Book of Common Prayer, declares:

> Transubstantiation (or the change of the substance of bread and wine) in the Supper of the Lord, cannot be proved by Holy Writ, but is repugnant to the plain words of Scripture, overthroweth the nature of a Sacrament, and hath given occasion to many superstitions.
>
> The body of Christ is given, taken, and eaten in the Supper, only after an heavenly and spiritual manner. And the mean whereby the body of Christ is received and eaten in the Supper is Faith.[29]

"Faith," perhaps, but one can also sense the hard pull of skepticism. Without it there could have been no break from Rome. In steering something of a middle course between Catholicism and the Protestant denominations, the Church of England seems to have relied on terrestrial pragmatism to doubt papal declarations concerning the actual physical transformation of bread and wine, yet also to have resisted that other form of human certainty according to which people can speak authoritatively against the possibility of divine transformation of mundane things.

Bread is the staff of life, and wine its tonic. Each is as simple and timeless as an F major chord. Yet ritual has impregnated mundane food and drink with a complexity beyond themselves, much as eighty-five minutes of repeated tritones became embedded in Britten's closing triad. In Anglican liturgy, it may be more telling to say that the Eucharist makes present the mystery than that the mystery makes Christ present in the Eucharist. The presence or absence of the divine during the Lord's Supper may not, in the end, be the most meaningful question to put to the Anglican sacrament, if we heed the manner in which the final notes of the *War Requiem* render moot the distinction between belief and disbelief. In their most intriguing form, sacrament and chord alike do not manifest the tragic perpetuation of unholy terrestrial conflicts, nor the presumptive human expropriation of the powers of judgment and forgiveness granted (by whatever agent) to God. Rather, these exceptional entities constitute and represent (another suspended distinction) a humbling expanse of uncertainty—and the type of ethics made possible by that place both inclusive and excluded, both beside and between.

Wilson's *14 Stations*

1. AN OVERVIEW

It is a place of omniscience: a platform extending from a higher room at the entrance to the vast gallery on the second floor of Building 5 at the Massachusetts Museum of Contemporary Art (MASS MoCA), a museum that occupies an abandoned factory complex in North Adams, tucked in the Berkshire Hills at the far northwestern corner of Massachusetts. Like the perspective provided by Martin's painting from a little above the king's bedroom at Versailles, the viewpoint from this dais rises ten steps above what it oversees (Fig. 31). Such a lifting of viewers by the stairs begins an ascent toward that ultimate height from which the mind's eye makes known everything below with the all-seeing extensive eye of the map.

A quick glance at the wall to our right finds a caption, "Robert Wilson" (an artist most noted as a theatrical set designer), and to our left another one, "14 Stations." In front of us a lightweight stand supplies a pamphlet with a floor plan of the sort anticipated by the mild lift provided by the platform (Fig. 32). And then we look past the stand, a bit downward, outward. First a spare, windowless bunker traversing the width of the gallery, with a cornice of artificial light as the only exterior feature marking the building as something other than a utilitarian structure. Save for unadorned cuts through the near and far walls, the bunker blocks the visitor's access to the remaining installation. To proceed we will need to pass through its uninviting cavity. Beyond that (seeing beyond: the prowess of this platform) the peaked roofs and gray clapboard walls of twelve Shaker huts line up in two rows of six. And farther beyond, glowing in the distance, we see a stark white inverted mannequin suspended in front of a semicone of dried foliage.

The platform provides a sonic compendium as well. Each of the structures below emits recorded sounds. From the platform we can already hear, escaping from the nearby bunker, whispered and shouted commands mingled with the gushing of water; from the twelve cottages, a cacophony of rumbles and crashes and caws; and from around the inverted white figure, the celestial sound of the chords of an organ, steady but distant and faint.

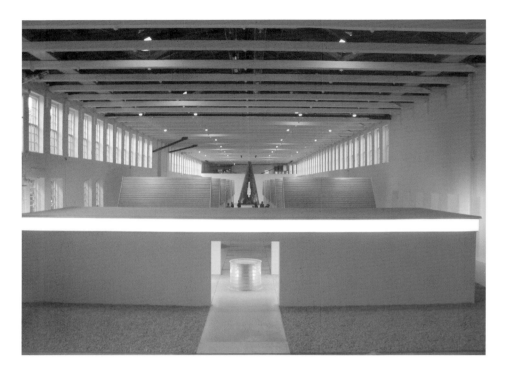

31. Robert Wilson, *14 Stations*, 2000. Mixed media. The Watermill Collection, New York. Viewed from east end (entrance) of Building 5, installed at MASS MoCA, North Adams, Massachusetts, 2001–3. Photo: Arthur Evans.

This platform may be raised in the manner of Martin's prospect, yet it is no standpoint for a king, much less for a god. We are in an art museum, and the perspective bestowed by that institution on all those who tread this concrete slab is that of contemporary aesthetics. In MASS MoCA's Building 5, that sensibility directs attention toward thematic material that has not occupied modern art much over the past two centuries: the *Via Crucis,* or Way of the Cross, Christ's passage through the Passion from his condemnation to his entombment. (Barnett Newman's series entitled *The Stations of the Cross: Lema Sabachthani,* "zip" paintings produced from 1958 to 1966, are so purely abstract that they sidestep specific evocations of the biblical subject matter.)[1] People in the guise of God do not survey humanity from the platform. Rather, humanity in the guise of contemporary art surveys the final route of God-in-man.

Down this long hall the museum has turned sacred tradition about. From the platform we can trace out the passage from the vestibule, down the nave between the side chapels of the twelve cottages, to the white figure floating before the apse of branches. The trajectory runs east to west, contrary to the liturgically prescribed direction. Contrary, that is, to the orientation of the great cathedrals, and of Monet's aquatic sanctum in the Orangerie, and of Saint Michael's in Coventry before the firebombing. Contrary, also, to the orientation of

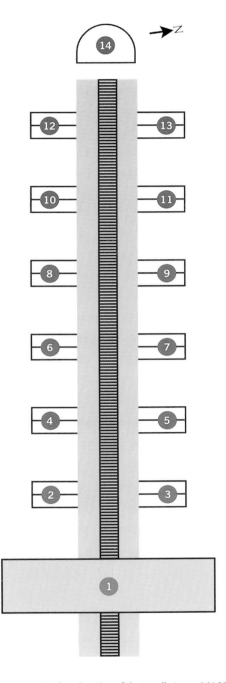

32. Robert Wilson, *14 Stations*, 2000. Mixed media. Plan of the installation at MASS MoCA, 2001–3. Direction marker added. Drawing: Doug Bartow.

Saint Anthony of Padua Church, directly opposite MASS MoCA across Marshall Street in North Adams, and of Saint Francis of Assisi Church, more distant but still visible from MASS MoCA's entrance.

Wilson's *14 Stations,* installed here, represents religion—both repeating and reversing it—held before the scrutiny of contemporary art.

2. A DIFFERENT APPROACH

Wilson's structures themselves traveled far before their entombment inside cavernous Building 5. Oberammergau, a Catholic village snuggled in the foothills of the Bavarian Alps (not unlike the rustic setting of North Adams in the Berkshires), has been performing its version of the Passion play every decade or so since at least 1634.[2] For its fortieth staging in 2000, the community commissioned *14 Stations* as an added attraction to its internationally famous—in the opinion of many, infamously anti-Semitic—drama. Wilson's work filled a pasture near the Festspielhaus (Fig. 33). The grassy plane is nearly flat, and thus the installation lacked any lofty prospect from which to preview the thirteen stations waiting beyond the first, although visitors did have the opportunity to hold a ground plan in hand. Approaching viewers saw only the bunker (and perhaps a glimpse of a distant mannequin through it) from a human perspective as they neared a gate and a doorway appropriate to their mortal elevation and scale.

Few visitors traveled to Oberammergau during the summer of 2000 with the purpose of encountering Wilson's *14 Stations.* Most happened upon it by chance, led onward by the free ticket included in all packaged tours for attending one of the daylong performances of the Passion play. Undoubtedly most of these arrived for the play itself not as aficionados of drama—despite periodic innovations, nothing much distinguished the production as theater—but as religious pilgrims attracted to a performance renowned for a general realism that promised to transport members of the audience as close as they were likely to get to Golgotha.

These devotees perceived Wilson's art through religious eyes, even as that art itself contemplated the Passion. They did so, however, without any aspiration toward the omniscience of God. That sort of presumption, more fitting for Louis XIV, would have been an anachronism among this crowd. These visitors apprehended the installation within the larger compass of their human spiritual journey to sense the divine rather than to become godly. In temporal terms, they may have bracketed it so. Surely many must have elected to visit Oberammergau's supplement-in-the-pasture during the two-and-a-half-hour lunch break between the three-hour halves of the performance. What could this interpolated work of art have meant to them? The difficult abstractions within the various stations, the work's failure to recount the scriptures clearly, its distance from the literal presentation of the Passion at the Festspielhaus, all this undoubtedly vexed many a pilgrim.

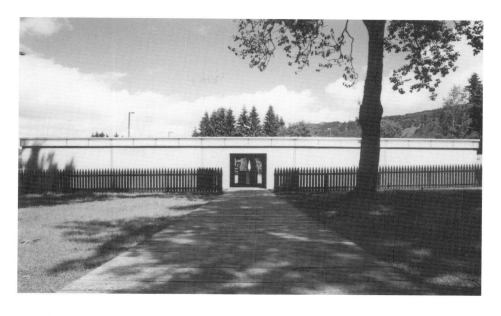

33. Robert Wilson, *14 Stations*, 2000. Mixed media. Installed in Oberammergau, Germany, 2000. Photo: Robert Wilson Archive, Byrd Hoffman Watermill Foundation.

A perplexed experience may not have been far from the intent of the village leaders who commissioned the work (a number of whom, it is true, were themselves disturbed by Wilson's maquettes once they arrived). The conservative script of the Passion play with its imputation of the guilt of the Jews had come under enormous international pressures for revision. Despite the selection in 1990 and again in 2000 of the young and innovative production team of director Christian Stückl and dramaturge Otto Huber, a referendum in the village mandated the use of the traditional text with only minor revisions. The commissioning of *14 Stations* thus allowed the community to make a gesture of atonement, not in spite but because of the work's jarring incongruity. The Passion play may have stood steady on its timeless foundations, but the full experience of the packaged tour promised the dialogue between tradition and modernity so problematically reduced to a whisper within the drama itself. Oberammergau needed Wilson less as a reiteration of the Passion (though it was that) than as an artistic counterweight to it. The inclusion of *14 Stations* claimed for the trip to the Bavarian countryside kinship, however distant, to the cultural festivals that dot the tourist-saturated landscape of summertime Europe.

The setting in MASS MoCA in 2001 thus inverted the relation between the sacred and the secular as it existed at Oberammergau in 2000. Museum visitors to the converted factory in the Berkshires faced the surprise of religion within an irreligious site, whereas pilgrims standing in the Bavarian pasture witnessed the inruption of the profane within a pious location. Yet MASS MoCA's was just the inversion of an earlier inversion. At one time Ober-

ammergau's performances amounted to a secular practice confronting religious authority. In the late eighteenth century the Catholic Church, jealous of its control over the liturgy and bristling at the popular appeal and commercial success of widespread communal theatricals, attempted to ban all Passion plays in Bavaria. Oberammergau's was one of the few to survive. Undoubtedly the religious and the secular, the traditional and the modern, often fold and refold over each other in this manner, neither ever serving well as ground against which the other can present itself definitively as figure.

MASS MoCA, like Oberammergau, never provided its human viewers with soaring transcendence over *14 Stations:* the spectator on the platform in Building 5 rose only incrementally higher than the viewer on-grade in the pasture. Nonetheless, both institutions granted to those who held presuppositions similar to those reigning at the two encompassing venues—or who, thus addressed, accommodated to those presuppositions—something of a leg up over their hypothesized or actual opposites. Just as in Massachusetts the aesthetic looked down on and over a religious theme, in Bavaria the higher vision of piety cultivated by attendance at the Passion play found itself, when placed for a passing while before the exterior wall of Wilson's bunker, drawn low by art—and drawing art low—to a mundane perspective.

3. CONDEMNATION

Whether stepping inside from the pasture at Oberammergau or descending from the platform in Building 5 of MASS MoCA, the visitor begins the journey through *14 Stations* by entering the bunker, Station 1 of Wilson's interpretation of the Passion, "Pilate condemns Jesus to death" (Fig. 34).

At the building's exact center, obstructing clear and quick traversal through the two doors, an upended culvert with hip-high rim bids approach. Catholic hands may instinctively commence the summoned gesture. The cylinder, located here in the vestibule and with the noise of water intermittently gurgling around it, mimics a stoup. A fixture in the narthex of all Catholic churches, such a basin would be filled with holy water. And such water would wet fingers that make the cross upon forehead and chest, recalling the sacrament of baptism, the pledge that the moistened body will partake in the miraculously divine corporeality of Jesus. "We have been buried with him by baptism into death, so that, just as Christ was raised from the dead by the glory of the Father, so we too might walk in newness of life" (Romans 6:4).

Yet the water actually swirling in the cylinder, deep in a smaller well sunk at the center of the culvert's converging walls, is out of reach, its surface below the level of the floor on which we stand. Humans here cannot touch that which would promise, were this a normal stoup, participation in the human-that-is-more-than-human. Whereas Monet's galleries at the Oran-

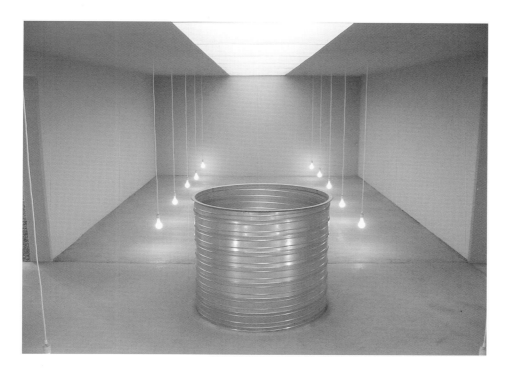

34. Robert Wilson, *14 Stations*, 2000. Mixed media. Station 1, "Pilate condemns Jesus to death." Installed at MASS MoCA. Photo: author.

gerie inverted water and soil to grant visitors a momentary intimation of the omnipresent divine, the centered basin in Wilson's first room immediately reminds all who stand at its rim of their mundane footing.

Red tints the water. A deafening, deep flushing sound, infrequent enough to take us by surprise, threatens from within. "[Pilate] took some water and washed his hands before the crowd, saying, 'I am innocent of this man's blood; see to it yourselves'" (Matthew 27:24). Peering into the depths, our role may have transmogrified from Catholic parishioner to Roman persecutor.

And by his name we are hailed. At sporadic intervals and from unpredictable corners of the bunker, masculine voices, high in pitch and low, slow and fast, shouting and whispering, in German and in English eight loudspeakers recessed in the ceiling, are broadcast from. "Pi-la-tus"; "PILATE!" Other words, also in both languages, join in. What has been washed: phonetically "hant" in German and "hænd" in English. The act of judging: "Verurteilt!"; "Sentenced." It may not be the imperial prefect alone whom these voices call. After the plosive "p" in "Pilate" sounds for just an instant, we mostly hear the long diphthong "aɪ" blended to an "l." Similarly, the frequent shrieking of the final syllable in "ver-ur-TEILT!"

emphasizes the same phonetic cluster. In conservative southern Germany within earshot of a Passion play once celebrated by Hitler and still suspected of anti-Semitism, or in MASS MoCA with that earlier venue in mind, these verbalizations can hardly fail to evoke the German salute "Heil!" In whose boots are we standing now? The low-hanging lights receding in rows into the wings of the bunker fortify the insinuation by placing us on the wrong side not only of an ancient act of sentencing but also of a notorious modern form of interrogation.

These transmutations—from parishioner to Pilate, from Pilate to Gestapo—confuse any easy segregation of victims from victimizers. To gaze into bloody waters may position viewers as the Roman prefect who ordered the Crucifixion. That would seem a neat displacement of guilt away from the Jews, thereby palliating the political sore long festering at the Passion play at Oberammergau. Costume and staging alterations in recent decades might have blurred the clear distinction that bedeviled earlier productions, between Jesus's white-clad Christian followers and the dark-robed Sanhedrin; now the Last Supper appeared as a Passover feast among Jews. Changes to the script might well have eliminated some incendiary passages from the traditional text, including the infamous moment when the Jews who gather outside Pilate's praetorium to demand the execution of Jesus shout "His blood be on us and on our children!" (Matthew 27:25). Yet the production in 2000 could shed neither the weight of the play's history nor its basic narrative in which the Sanhedrin and the Jewish crowd force Pilate's hand. Jewish leaders who had objected to the Passion play for decades were still not mollified.

Wilson's swirling well may shift culpability away from the Jews; but then again, it may not. If these waters cleansed Pilate but remain beyond our reach, perhaps we assume the role not of the Roman but of the Jews stained by bloodguilt. But then again, the implied "Heil" and interrogation lights may recast us as persecutors of the Jews rather than Jews who persecute. But then again, this evocation might revivify the viewpoint of those Nazi Party members, including featured actors in earlier productions of the Passion play, who could imagine that the lasting bloodguilt of the Jews from biblical times justified brutal treatment of them in the present. But then again, the aesthetic stance proffered by *14 Stations* within MASS MoCA might disassociate our perspective from those of ancient Jews and of recent Nazis alike, when we experience both groups as fittingly provocative subjects for adventurous contemporary art. But then again, the religious attitude prevailing in the pasture at Oberammergau could prompt us to regard Wilson's secular outrages there with a sanctimoniousness that places us back in that initial position of the parishioner about to cross himself or herself with holy water.

What a tour de force of contemporary art, it might seem, thus to confound these many viewpoints and thereby throw them all into question. Perhaps. Yet this mélange of sinners and sinned-against just as easily constitutes a fundamental tenet of Christianity. "Forgive us our sins as we forgive those that sin against us," intones the Lord's Prayer. The imperative remains shallow if it calls for nothing more than a dispassionate settling of "debts" (as other translations have it), as if rectitude could be determined by checking the bottom line on the

ledger of misdeeds endured and meted out. As a supplement to this reckoning, the mystery of faith—of the sort manifested at Coventry Cathedral and in Britten's *War Requiem*—would entail the willful suspension of any mundane presumption to pass final judgment, recognizing the depths of moral uncertainty that should always terrify us all. To encounter within the bunker of *14 Stations* traces of ancient and recent depravity perforce encumbers all visitors with a real responsibility to adjudicate the past. Yet only a touch of humility can prevent that obligatory task of moral engagement from devolving into arrogant self-righteousness, blind and cold. What difference does it make, in the end, whether the spirituality of the church or the aesthetic of the museum allows that embrace of the unfathomable, whether the one or the other dispenses that grace?

4. ECCE HOMO

Excepting the distant inverted figure, the view when one exits the bunker is plain (Fig. 35). The small glassless and mullioned windows on the cottages do not from this angle reveal their vivid tableaux, which will stand in stark contrast to the flat gray of the cabins' exterior walls. In North Adams the evocations prompted by the structures are too numerous and multidirectional to cohere. With "Heil!" still audible behind us, they may speak of the barracks of a concentration camp; given the proximity of MASS MoCA to the preserved Hancock Shaker Village, the architecture of that austere religious sect comes to mind; in anticipation of a glance out Building 5's northern windows we might think of the clapboards of the chic Porches Inn across the Hoosic River; ruminating on a less-upscale era of tourism in the Berkshires, our imagination might turn to period-piece unplumbed vacation cabins. Not much in this faint and feinting mixture to sustain compelling meaning.

Sounds rather than sights assault us here—and will continue to do so as we proceed down the nave. Garish, nightmarish noises emanate from the interior spaces, intermixing in a manner that the isolated views into the stations, unable to bend and blend, cannot. We can already anticipate our prescribed acoustic passage, from the shouts and gurgles behind us in Station 1 toward the comforting yet eerie organ chords awaiting at Station 14. Yet to travel this route, made wobbly by the irregular railroad ties upon which we tread, will subject us to strange pairings of dissimilar sound loops coming at us from left and right. Between Stations 8 and 9, for instance, the lilt of a simple folk melody rendered by fiddles, pipes, and clapped hands—unexpectedly disquieting rather than comforting—will compete with terrible crashes and piercing electronic distortions that uncertainly resemble bird cries, or mechanical screeching, or a human scream. This is the grating gauntlet we will need to pass through in order to attain the promised respite of the organ at Station 14.

The configuration possesses a compelling geometry. Front, back, left, right: down the nave these imposing noises repeatedly will make the sign of the cross within the soundscape of the visitor. Upon this acoustic framework will hang the discrete viewings of the cabins' con-

35. Robert Wilson, *14 Stations*, 2000. Mixed media. View from western exit of Station 1, as installed at MASS MoCA. Photo: author.

tents. The pains and humiliations and alleviations to be undergone one by one—"[Jesus] falls for the first time," "Veronica wipes his face with a veil," "He is stripped of his garments," and so on—will be drawn together into a coherent experience of the Passion by the acoustic cross we, in lurching down the railroad ties, must bear (Figs. 37, 40, and 44).

Here and now at the exit from Station 1, all that lies before us. Here and now, the combination of strident sounds and unseen trials amplifies our foreboding in the face of the anticipated but yet unknown. Perhaps the museum visitor may bring to this moment an attitude of pleasurable aesthetic expectancy, but such a mood is difficult to sustain owing to the harshness of the noises and the possibility that the contents of the cabins will be as grisly as the theme demands. That realization puts us—partially!—in the position, historical and mythic, of Jesus himself, who at the beginning of the long walk to his death must certainly have foreseen tortures of unforeseeable extremity.

Partially! Therein lies the power of this spot at the base of the railroad ties in Building 5. We are certainly unlike Jesus because we are here and now, not there and then. We will not suffer the same physical ravages, pain of such intensity that no human body could ever actually imagine it beforehand, just as we never fully remember severe pain after the fact. Nonetheless, we join Jesus the man at a more accessible moment, not during but in anticipation of trials and eventually of death. Every human, in his or her own manner, inevitably faces such a future. And, as the scriptures would have it, God became incarnate in Christ expressly to undergo the essence of this human fate. "Since, therefore, the children share flesh and blood, he himself likewise shared the same things" (Hebrews 2:14), "so that by the grace of God he might taste death for everyone" (Hebrews 2:9).

From this spot just outside Station 1, we look out at the imminent Passion not through our own but through Jesus's eyes. Works of art typically address their audience in the second person. "You there, creature with two pupils mounted atop a body," the polychrome surfaces of paintings often command us, "look at me!" Wilson's cottages, in contrast, avert their eyes from us, their solitary windows staring across the central aisle at each other. The sounds reach us, yet from here they seem in like fashion chiefly caught up in dialogue across the nave. At this point we attend to the cabins, not they to us. From the bunker's exit, *14 Stations* offers us the first-person singular: "I will walk down this path, I will experience these things."

Even when we proceed down the aisle, we bring this perspective with us—partially!—just as we bear our acoustic cross. As solitary individuals we will look past the mullions at each tableau in its cabin (the windows are too small to allow more than one viewer without a squeeze). We will look as voyeurs, as if each scene persevered in turning its gaze away from our "I." In one sense this remove distances us from Jesus's perspective, as we become merely observers of his Passion. In another sense, it locates us within the semidetached attitude of the Godhead as its most earthly aspect discourses with its heavenly one about the folly of humanity: "Father, forgive them; for they know not what they do" (Luke 23:34, RSV).[3] Or, this view might be the disembodied perspective of a mortal being in such terrible pain that he witnesses his own torture as if from outside. Facilitating our continued perception through his eyes, the figure of Jesus appears in only three of the cabins (Figs. 38, 41, and 43).

We are with Jesus, then, to the extent that he is human and partakes in—no, more than that—enacts in its most extreme form—the ultimate tragedy of human existence. And not with Jesus to the extent that he remains removed from us in time, space, physical suffering, and (according to some) divine essence. On this last score, we may find ourselves closer to the position of the always ambivalent Peter, who not only thrice denied Jesus immediately after the arrest but also, years later, insisted on his own human difference from the martyred divine Jesus by requesting that he be nailed upside down on his own cross in Rome. Such is the orientation of the white figure we see in the distance (a figure that will take on different meaning later in our passage). On the installation's plan into which we situate our own bodies as we move through this space, the same shape appears as the inverted cross formed by the

nave and the premature transept of Pilate's bunker (Fig. 32). At this exit from the praetorium, *14 Stations* allows our first-person selves either to struggle forward in identification with Christ in his Passion or to fall backward with Peter into what will eventually be our human demise.

5. BLASPHEMY FOR THE FIRST TIME

A pall of uneasiness may be descending. Perhaps the identification with Jesus proffered by *14 Stations*—the forward struggle away from Peter's humanity—has stepped beyond proper bounds. To the pilgrims at Oberammergau, presumably well able during open-eyed sermons and close-eyed prayers to imagine themselves in Jesus's place, the presumption here to walk the *Via Crucis* may suggest more hubris than humility—especially when attempted by seemingly secular contemporary art viewers. Moreover, the sense of proximity to the reality of Christ's Passion in the Festspielhaus may actually have depended on a distance generated by the combination of a vaulted shed for spectators and an open-air stage, which not only implied a proscenium in the form of the shed's arched leading edge but also placed the action in a light and ambience different from those of the house. In Wilson's pasture, to step out of the enclosed bunker into the sunlight may have felt as if one had unwittingly entered a replication of the theatrical space and violated the separation of the stage that allowed the illusion of reality to be produced. In these terms, it was a step too far, certainly for Robert Wilson with his contemporary aesthetic sensibilities, and perhaps even for the pilgrims themselves.

The venue at MASS MoCA is in this regard less demanding on its visitors architecturally, both because the configuration of the Festspielhaus at Oberammergau lies beyond most viewers' awareness or concern and because Building 5 so resembles the perpendicular bunker within it. We have not stepped out in the open but rather are still in Pilate's praetorium, now writ large. (We are also spared an abrupt shift in ambient light.) Nonetheless, the sensitivities of the viewers may be greater. Among visitors to museums of contemporary art, the desire to seek some personal affinity, some affective propinquity, with the works on display may (or may not) be strong. Into our own day persists a healthy dose of the sensibility we have heard voiced by the critic Bazalgette in response to Monet's paintings of Rouen Cathedral, that the artist becomes a spiritual mediator replacing the tired and suspect rites of the priest. Accordingly, the church may still stand as an improper institution for modern art to engage with a close and sympathetic attitude. How much safer the platform of aesthetic overview at the entrance to the long hall than this spot at the bunker's exit that demands empathy with the personal experience of Jesus's anguish, which lies at the very core of Christianity. How great the temptation to take up the offer of Building 5's sheltering roof and return to the position of Pilate, with his self-protective reluctance to partake in (or worse, be perceived to partake in) sectarian bickering among the autochthons: "Take him yourselves and judge him according to your law. . . . I am not a Jew, am I?" (John 18:31, 35). Is there not a sim-

ilarity between the pagan Pilate's implied view down at Jesus through the interrogation lights in Station 1 (from which spoken commands still beckon us back from the more dangerous spot at its exit) and the perspective down from the entrance platform upon Christianity in the cabins? Is there not a family resemblance between Pilate's avoidance of epistemic commitment—"Jesus answered, . . . 'For this I came into the world, to testify to the truth.' . . . Pilate asked him, 'What is truth?'" (John 18:37–38)—and the disinclination of contemporary aesthetics to grant (or worse, be perceived to grant) that religion may have any truth to offer?

In Bavaria, too close an approach by contemporary art may have tainted religious belief. In Massachusetts, too close an approach by religion may have tainted the contemporary creed. In both venues, *14 Stations* may have placed visitors irreverently close to Jesus. Blasphemy toward the Passion, it might seem. Yet the last difficulty in this list—qualms (for the devout) about stepping too far into a divine role or (for the irreligious) about stepping into a role where they might be perceived by others as stepping into a divine role—reiterates a key hesitation recounted by the Gospels themselves. A distraught Jesus in Gethsemane, praying during the last moments when he might exert control over his destiny before the arrest that will commence his inexorable journey toward death, asks for a reprieve: "Father, if you are willing, remove this cup from me; yet, not my will but yours be done" (Luke 22:42). The viewer at the bunker's exit can more plausibly identify with Jesus by finding likeness to the Galilean's own uncertain location between the mundane and the divine than by donning the mantle of divinity as if it fully bedecked the Son of God with no human aspect left uncovered—a theologically dubious notion, at best. One need not identify with Jesus by adopting the position he takes up between earth and the heavens. As the tale is told, one probably cannot. Rather, one would more easily identify with his distress at confronting the terrifying, unfathomable disparity between this world and that quality (whichever and wherever it is) that exceeds it.

But, it will be objected, one need not identify with Jesus at all. That is true, both in principle and, on the part of many of the visitors to *14 Stations* at both venues, in practice. Yet once one is standing in the doorway of Station 1 and confronting the prospect of the Passion, that refusal is itself a choice to position oneself in relation to the split between the human and the divine, specifically at one of its two extremes. Irreligiosity of such purity, like unadulterated divinity, may be more difficult to maintain here than it might appear initially. In the Alpine pasture or in Building 5, the atheist's secular convictions and the devotee's religious doubts may, in fact, twine around each other. It is possible to dismiss the religious dimension of the view from the bunker with the comfort of a certainty that never troubles itself with contemplating its alternative. And by whose authority is that done? Whose name underwrites that certainty? One's own. Or that of whichever group—subscribers to the strain of the modernist aesthetic that replaces religious spirituality with its own sensibility, or scholars wedded to a certain species of secularism—whose practices and ritual incantations one adopts for oneself. Such a move hazards a divine presumption. It endorses one's belief by

one's belief. It takes on precisely the responsibility Jesus in the garden grants to God. One removes the cup, one's own will being done. Taken to its sanctimonious extreme, secularism of this sort seeks omniscience, at least over religious matters. Its adherents—limited bodies aspiring to a limitless principle—find themselves positioned between physical existence in this world and personal participation in transcendent knowledge and agency, much in the manner of Jesus in Gethsemane.

By taking up the explicitly religious theme of Jesus's balance between corporeality and divinity, *14 Stations* cannot help but activate these complex and capacious mechanisms of identification. No amount of irony exercised by contemporary aesthetics can undo the ineluctability of this engagement—and it is far from self-evident how much irony *14 Stations* directs toward Christianity, or even that it directs any. The juxtaposition of contemporary art and religion, rather than undermining the dilemma of those caught between the mundane and the divine, animates the anguish of its unassimilable challenge. The Eucharist in Spence's Coventry Cathedral and the F major chord at the end of Britten's *War Requiem* did much the same thing. The only way for the viewer to avoid entanglement in these serious and troubling issues is to shun Wilson's work altogether, to reel backward into Pilate's house and from there up the stairs, across the platform, and back out of Building 5. Such self-protective detachment serves only to ward off the risks that sustained attention and affective proximity to *14 Stations* occasion. Whether in terms of religion or of aesthetics, that refusal may be the most blasphemous course of all.

6. LANGUAGE RULES

To proceed forward from the praetorium is to accept the invitation to engage with places in-between: between the bunker and the inverted mannequin, between the cabins left and right, between the mundane and the divine. Appropriately, the vignettes in the interiors both address us in a manner that accords with our human capacities and present *14 Stations* as communicating in a divine visual language. Let us continue collectively down the wide nave and then as individuals wait patiently with others, or jostle against them, to obtain solitary views into the cottages.

In contrast to the legibility of the Passion play's extravagant and solicitous realism, the stark juxtapositions of unexpected objects in the stations leave us with enigmas. In Station 5, "Simon of Cyrene helps Jesus carry the cross," a biblical robe in a human pose but devoid of a body floats beneath and before a Shaker-style chest of drawers with an open lower drawer radiating light (Fig. 39). In Station 8, "He meets the women of Jerusalem," a phalanx of seated Shaker women staring rigidly forward while holding sharp rods are backed by a small theater flat depicting mountains—more Alps than Berkshires—that rises and lowers with slow mechanical regularity (Fig. 42). Gaps of space within empty settings isolate each of these items from the others, giving them the quality of discrete linguistic units.

How might meaning emerge from these combinations of items? Semantics surely must play a role. These objects, each on its own, are familiar often to the point of banality, and reference to things beyond the work seems obvious enough. The archaic garment evokes biblical events. The Shaker women and furniture speak of a culture geographically more proximate to North Adams but not unlike Oberammergau in its willed anachronism (in contemporary Bavaria, somewhat of a ruse for the sake of the tourists). We have already called on such denotations and their obvious connotations—water in a well, interrogation lights—and will do so again. The objects' saturated hues, detached placement, and material precision (consider the sharp wrinkles and folds of the garment in Station 5) give them the character of words articulated with exaggerated, pedantic clarity.

Yet semantics fall short of satiating our exegetical appetites, for two reasons. First, while the objects in *14 Stations* enunciate their direct meanings, their allusions remain obscure. Shakers, why? A chest of drawers emitting light? Those spikes in the hands of the seated women—yarnless, so not knitting needles—what are they supposed to convey (especially when the women of Jerusalem, when they make their sole appearance in Luke 23:27–28, are compassionate, not aggressive)? Denotations are clear, but they do not clearly pertain.

Second, with the juxtaposition of such discrete and pronounced elements, syntax asserts its importance. The visual grammar of *14 Stations* is blunt. This, that. The work gives virtually no guidance about how to link the items. Even when one object looms closer than another, the two still tend to preserve equal signifying weight. In only one instance in the cottages, Station 12, does figure manifestly loom against ground (Plate 17). Consider how in Station 8 the lifting of the theater flat of mountains off the wall and putting it into motion precludes its role as neutral backdrop to the women (Fig. 42). The combinations, in short, lack both conjunction and subordination. Each interior, with its contents enclosed away from the other cabins, seems to want to make visual sentences out of its own set of discrete units, but Wilson writes in even less than simple declaratives. Just things, together. Parts. Parataxis.

Yet, in a different sense, the items do travel from cottage to cottage, in the form of the immediate memories of visitors attempting to make sense of the whole of *14 Stations*. Even minimal attentiveness allows the grouping of elements into families of things. Wrinkled empty garments appear in two stations, forward-facing Shaker women in two, mountains in two, Shaker-style furniture in three (and a simple utensil in a fourth), suspended boulders in three, cast hands in two, and (not counting the Shaker women in Station 8 or the inverted mannequin from Station 14) white figures in three. Sounds, likewise, have their kin: bird cries and crashing sounds, snippets of radio and drops of water. In one syntactic interpretation we might imagine lexical decisions reached along the paradigmatic axis in contrast to paratactic juxtapositions made along the syntagmatic one: employing a Shaker-style table in Station 9, for example, rather than utilizing there the Shaker-style chest of drawers from Station 5 or the Shaker-style cast-iron stove from station 7 (Figs. 43, 39, and 41). In an alternative reading, the salient characteristic could be the shared one, so that Stations 5, 7, and 9 are

36. Robert Wilson, *14 Stations*, 2000. Mixed media. Station 2, "Jesus is made to bear the cross." Photo: Lesley Leslie-Spinks.

alike in bringing "Shaker" (again, without any self-evident sense of the connotations) to the specific juxtaposition of discrete elements within each of their cabins.

We have encountered this dynamic before. In the manner of Wagner's leitmotifs, Wilson's lexemes such as "Shaker" or "Boulder" manifest a range of variations without thereby inflecting their basic nominative purpose. (In fact, "Shaker" and "Boulder" probably constitute a single lexeme that might be labeled "Worldly Weight." It all depends on whether differential significance plays a role. In Section 9 I will discern meaning in the broader concept, but I have never managed to detect importance in the dissimilarity between furniture and rocks.) Like Wagner's use of leitmotifs, Wilson's establishment of discrete devices of a larger scale diverts attention from their constitutive parts. Like Wagner's leitmotifs, Wilson's signifying elements create a hermetic system, discouraging evocations beyond the work (just as both Wagner and Britten used middle C, Wilson conceivably could have relied on the

37. Robert Wilson, *14 Stations*, 2000. Mixed media. Station 3, "He falls for the first time." Photo: Lesley Leslie-Spinks.

same sort of rocks as Robert Smithson or on the same texture of cloth as Faith Ringgold without such similarities conveying anything). Like Wagner's leitmotifs, Wilson's basal units discount semantic references (even as they make them) in order to spin meaning principally out of internal syntactic relationships. Like Wagner's leitmotifs, Wilson's lexemes cannot be troped, cannot misspeak, because their horizon of proper usage is limited to, and thus fully interpolated out of, the confines of the single work *14 Stations*.

7. OTHERWORLDLY UTTERANCES

It follows that the contents of Wilson's cabins, like Wagner's music, speak—or serve to represent speech—in a divine language, which always and necessarily states what it means even

38. Robert Wilson, *14 Stations*, 2000. Mixed media. Station 4, "He meets his mother." Photo: Lesley Leslie-Spinks.

when we cannot grasp what it says. But then the question arises: Which gods, and in whose church?

Given the theme of *14 Stations,* the Christian God would be a likely nominee. Theologically, the Passion can certainly be regarded as the Godhead communicating to itself in the form of reclaiming that aspect of itself that had been extended into the figure of Jesus through kenosis. Were it not for this self-referential character of the event, the Crucifixion would be just another mundane sacrifice that would perpetuate the appeasement of a wrathful deity. Instead, it brings such always inadequate propitiation to an end as God himself atones for the original sin of his own creations. Only by reclaiming itself through this sacrifice can sacrifice itself be reclaimed by the Godhead. Only thus are sacrifice and reclamation, according to doctrine, one and the same. Accordingly, it should be impossible for humans—even as they attempt to listen in, by contemplating the Passion—to understand the terms of the Godhead's intra-Trinity monologue. This incomprehensibility not only safeguards the pu-

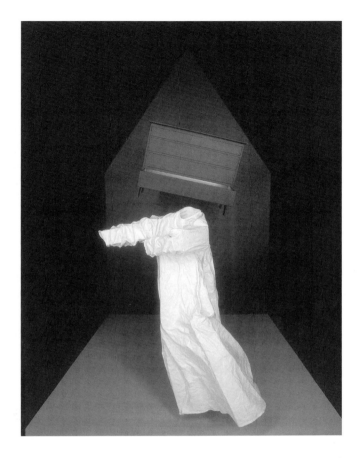

39. Robert Wilson, *14 Stations*, 2000. Mixed media. Station 5, "Simon of Cyrene helps Jesus carry the cross." Photo: Lesley Leslie-Spinks.

rity of divine speech (or, alternatively, serves as the representation of that purity through the trope of irony); it also constitutes (or represents) the unfathomable mystery at the core of Christianity without which it could not exist as a religion.

Wilson's work well represents (or realizes) this impregnable divide between humanity and God. The juxtapositions of enigmatic things occur entirely within the walls of the cabins, spaces into which spectators cannot enter. Viewers are held back by the diminutive size of the windows and their rudimentary grills of crossed mullions, like the grates holding back visitors at the doors of sealed monasteries. The objects, moreover, appear indifferent to our presence as they interact only with one another. Even when they orient themselves in our general direction, they seem to look right past us, as if at the other objects inside the cabins across the way. The Shaker "women of Jerusalem" in Station 8 and their sole, enormous sister in Station 6, "Veronica wipes his face with her veil," all looking rigidly forward toward the north, personify this conceit (Figs. 42 and 40). The only possible exception is the whitened

nude man crawling across grass in a video loop installed on the floor of Station 7, "He falls for the second time," who gives the impression of looking up at us imploringly (Fig. 41). But, then again, he may actually be gaping over our shoulder at the much more intimidating giantess in the opposing cabin, Station 6. Divine syntax overrides human pragmatics as easily as it does earthbound semantics. To the extent that visitors have accepted the risky invitation proffered at the exit of Station 1 to identify with the mundane aspect of Jesus and mimic his corporeal passage down the *Via Crucis* by sending their own bodies across the rough railroad ties, they share his human incomprehension at God's message conveyed only by blinding pain. "My God, My God, why have you forsaken me?" (Matthew 27:46; Mark 15:34).

8. ARTISTIC MEANS

As at the exit from the bunker, however, the extent of each visitor's identification with Christ remains uncertain, a matter of human, not divine, choice. Especially at MASS MoCA, visitors donning the mantle of contemporary aesthetics rather than Jesus's ragged garments can gaze into the cabins with eyes attuned to Wilson's artistic maneuvers rather than the Godhead's unfathomable self-address. Indeed, they may find relief here from the challenge posed at the head of the *Via Crucis.* They are back in the business of viewing art from a certain contemplative distance rather than confronting averted, dehumanized gazes down the nave that force a first-person reckoning of their likeness with the human aspect of Jesus. Pilgrims at Oberammergau may similarly have recognized the summons of this aesthetic appeal, even as many of them might have found it a bothersome interruption of their religious experience at the Passion play. Nonetheless, they too were thus released from any discomfort potentially brought on by having the view from Jesus's eyes forced on them when entering the open-air nave.

Contemporary art, too, has its ways of speaking. And while the sorts of works that appear in MASS MoCA cannot be reduced to a single visual language, we might venture a provisional hypothesis—which I will reverse in a moment—concerning the various languages they utilize, or formulate. "Or formulate": is that not itself an expectation placed on recent art? By these lights, it is not enough for an artist to express a new idea. The artist must also devise afresh the terms and turns of that expression, and the interest and value of the work depends at least as much on the distinctiveness of those means as on the message (if any) imparted. To be sure, period and group styles exist. Without them, artists would probably not know where to begin, and viewers would be left adrift, unable to make sense of anything. Nonetheless, once a style becomes too uniform across a number of artists or too easily pegged by the collective audience, it can be seen as having entered its terminal, mannerist phase, and critics will often declare that it is time to move on. To hold their own, the languages of contemporary art need to challenge and surprise. They need to be idiosyncratic.

They need to remain, to a degree, unrecognizable, and thus, to a degree, difficult. They need to avoid pandering to their art audience or to any other. And thus, specifically, they need to avoid the available, easily legible idioms of mass culture (although mass culture, to be sure, likewise speaks in various dialects with varying degrees of legibility to various audiences large and small).

Now the reverse: formulating a new language may not be an expectation placed on recent art. The tale can be told that artists of the past several decades—since Andy Warhol, say—have reacted against the realization of innovative means personified by the figures of heroic modernism—Jackson Pollock, say—by speaking in conventional or even banal terms. A readily available method to thus speak simply is to mimic the devices and contents of mass culture, a practice for which the perfect replication of knickknacks by Jeff Koons could serve as an extreme case. Yet escape from the modernist expectation is more easily said than done. The setting of the museum, like the label "art" itself, inevitably raises the question, and the questioning, of means. One cannot look at an evocation of mass culture by any such works and not assess the degree of the appropriation, the purpose and seriousness of that reutilization, and its interplay (if any) with discernible characteristics of artistic practice. Rather than negating viewers' anticipations that they will discover innovative languages in art, this tack inverts that expectation; the two differ only in their placement of emphasis. Whereas in the first case the audience in the gallery searches for individual novelty within collective practices (such as Jackson Pollock within Abstract Expressionism), in the second case viewers try to discern collective practices within individual novelties (mass culture within Andy Warhol, for example). Thus when one enters a museum such as MASS MoCA, one takes on the assignment of divining aesthetic means and message, neither of which gives itself freely— or if they give themselves freely, they do not freely reveal why they give themselves freely. Have we not all experienced the pleasures in the museum of detecting a message and then querying the means, or worrying the means in order to arrive at some sort of message? Have we not all at times become fatigued by this demand for tight attentiveness and wished the damn thing would just say what it has to say?

The interiors of Wilson's cabins epitomize this sort of cultural interplay, often to a hyperbolic degree. In Station 13, "He is taken down from the cross," a scrim wafting in a fan-induced wind carries the visage of the Madonna in mourning (Plate 18). The grieving woman is, in fact, Madonna by name, that chameleon-faced rock singer who here makes a guest appearance while keeping her vamp side in check. Or perhaps in cheek, with a hint of a smirk in her slightly drawn-back and overly rouged lips, and with plucked eyebrows and mascara-thickened eyelashes around dazzling blue eyes. Metallic beads on rods radiate outward across her face from a brooch mounted on a headband. Beyond recalling head-ware of both the saintly and the vintage varieties, the effect also evokes Man Ray's famous photograph *Tears*, in which glass droplets across a feminine face reduce an initial impression of genuine sorrow into melodramatic bathos (see Fig. 46, page 159). The scrim in Station 13 floats above

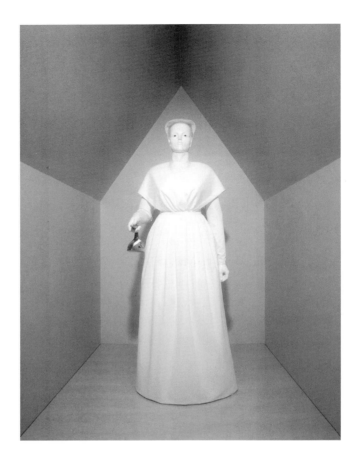

40. Robert Wilson, *14 Stations*, 2000. Mixed media. Station 6, "Veronica wipes his face with her veil." Photo: Lesley Leslie-Spinks.

a sea of glass vials. A sound loop featuring the ringing of glass bells quickening into a cataclysmic crash reinforces the avant-garde oddity of this amassing. At the same time, illumination through the vials from below suggests some early Hollywood effect to place the Virgin anachronistically already in heaven. Finally, fourteen taxidermized magpies suspended on transparent lines allegorize the disciples dispersing before the Resurrection but in this cinema-saturated space also cannot help calling to mind Alfred Hitchcock's avian killers from *Birds* of 1963.

In front of this assemblage and its like in previous cabins, museumgoers are culled from the crowd to wonder at Wilson's indecipherable language of culturally disparate paratactic juxtapositions. Art in its hermetic language, it seems, will be approached but never grasped by its devotees. And it will be approached only one viewer at a time. Wilson's mullioned windows fend off, in an almost parodic fashion, Harold Rosenberg's storied "herd of independent minds," who leap at easy, predigested truths dispensed unreservedly to all holders

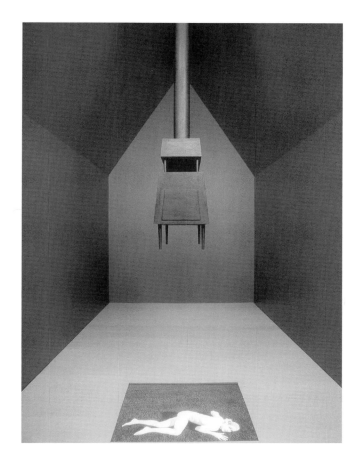

41. Robert Wilson, *14 Stations*, 2000. Mixed media. Station 7, "He falls for the second time." Photo: Lesley Leslie-Spinks.

of informed public opinion.⁴ According to Rosenberg, such fashion-followers avoid the difficult challenge of authentic aesthetic experience, despite their intellectual pretences. Only solitary souls, amid Wilson's architecture as in Rosenberg's article, are in a position to confront art in its inscrutable profundity.

From the perspective of the pasture at Oberammergau, the nearby Passion play in the Festspielhaus served up the predigested spectacle to the mass. There, crowds of thousands seated in the house witnessed a crowd of hundreds onstage. There, the events of the Crucifixion were passed on smoothly to the audience through realistic stage action (whether one regards the paschal lessons themselves to be similarly transparent is a question of religious conviction and interpretation). Among other things, the ironic turn that contemporary art performs in *14 Stations* against the Passion play—which need not constitute an ironic turn against the Passion itself—betokens a replacement of a southern German Catholic Mass by something closer to individuated religious reckoning of a Protestant sort.

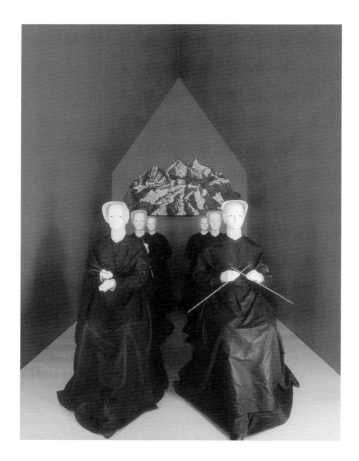

42. Robert Wilson, *14 Stations*, 2000. Mixed media. Station 8, "He meets the women of Jerusalem." Photo: Lesley Leslie-Spinks.

9. LIGHT AND WEIGHT

Yet *14 Stations* is hardly speaking in tongues. Though the language may be posed as inaccessibly divine, we are allowed to discern traces of its thought. The artistic means may be idiosyncratic, but we are allowed to discriminate aspects of content. Concerted hermeneutic effort promises insight beyond the surface appearance of the work. *14 Stations* abstracts—from heavenly essences or from earthly things; in this regard it doesn't matter which—yet also materializes the abstractions back near us in the form of the tableaux in the cabins. They describe and they don't, and they withhold and they don't, in the manner of Moses' "tablets of stone, written with the finger of God" (Exodus 31:18) or of a painting by Picasso or Matisse.

It is a human hand, surely, in Station 2, "Jesus is made to bear the cross" (Fig. 36). As human in its size and shape and lines as the actual hand from which it seemingly was cast. It

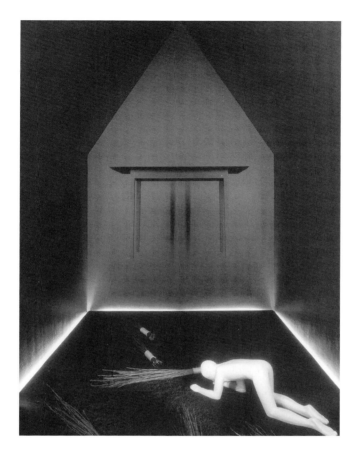

43. Robert Wilson, *14 Stations*, 2000. Mixed media. Station 9, "He falls for the third time." Photo: Lesley Leslie-Spinks.

reaches upward. Is it too much to discern in this gesture supplication in the face of duress? Or is that something we read into the hand once we perceive the boulder suspended above the limb, poised to crush it? The rock may not be wood, but in this instance it captures the beam's salient aspect better than wood itself. It is weight, suspended weight, the cross that Jesus as embodied in the hand must shortly bear.

But then again, it is not really a hand. It cannot embody Jesus well because it lacks too many indispensable characteristics of bodies and their parts. Although this sculptural bit appears to be cast, it obtains a burnish that both understates epidermal irregularities and replaces the mat pliability of flesh with the glistening hardness of surface sheen. Its vivid, uniform red could hardly be further from the mottled chromatic admixtures of lived corporeality. The clean cut at the base of the forearm, revealed as the limb tips away from us, annuls any remaining claim this part may have had on anatomical veracity. Wilson could have attempted

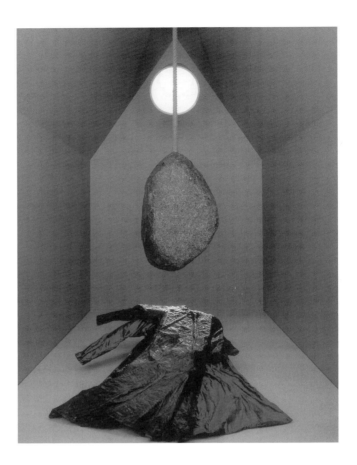

44. Robert Wilson, *14 Stations*, 2000. Mixed media. Station 10, "He is stripped of his garments." Photo: Lesley Leslie-Spinks.

the illusion of a whole body pushing its arm upward through the floor. Instead the object strikes an impossible balance upon the back edge of its severing circle. The hand floats ethereally, rather than forcing its way physically through substance.

The boulder above possesses all the brute materiality that the hand below lacks. Hacked at and hammered, its craggy surface is pockmarked by accident. Erratic white abrasions scar the otherwise brownish hue. It has much mass. The rock may hang in the air, yet that very fact tends to emphasize its demanding pull on the rafters. The coiled rope supporting it, presumably wrapped around a cable of industrial strength, reiterates with its bulges and frays the irregularity of the stone's surface. Such a solid, marred thing epitomizes the weight borne everywhere and by everyone in our messy mundane world.

The contrast in Station 2 inclines toward polemic. The purified and perfected realm of disembodied spirit (necessarily embodied here imperfectly) faces off against material heaviness. The opposition pervades the tableaux. In Station 3, "He falls for the first time," the

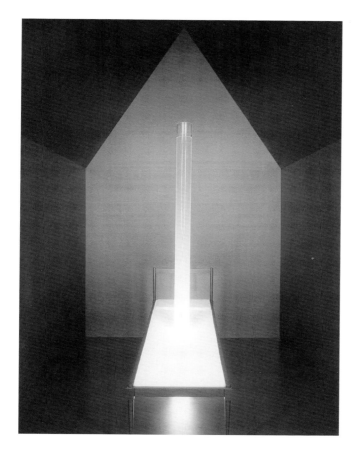

45. Robert Wilson, *14 Stations*, 2000. Mixed media. Station 11, "He is nailed to the cross." Photo: Lesley Leslie-Spinks.

stone from Station 2 seems to have dropped and shattered around a smooth wooden paschal lamb (the sole instance of overt symbolism in *14 Stations*); from the side of the animal a yellow cast hand strains in the direction of its red companion across the nave (Fig. 37). In Station 4, "He meets his mother," a hanging boulder, now rotating, is set off against both small glossy mannequins below and light within a tube that pierces it (Fig. 38).

Weight, especially suspended weight, need not always manifest itself as stone. In Stations 5, 7, and 9, items of Shaker furniture serve the role (Figs. 39, 41, and 43). The rocks and the aging furniture are alike not only in looming as substance, but also in bearing the unpredictable idiosyncrasies of objects not precision made and subject to the weathering of time. These characteristics—rather than, say, being granite from a certain quarry or furniture from simple Christian communes—convey their primary meaning as one-half of the polemic in *14 Stations*. "Worldly Weight," I have already suggested, would be an appropriate label for this lexeme. Just as "Spear" among Wagner's leitmotifs takes on importance less as a weapon

than as a nominative signifying something akin to the law within the logic of the *Ring*, "Worldly Weight" here breaks free from the material specificity of any one type of object, the better to realize the principles contained within its name.

And the lexeme, or lexemes, for the other half of the polemic? I propose two: "Shiny Smoothness," exemplified by the hands and the mannequins, and "Channeled Light," with its second word nicely encompassing the related concepts of illumination and lack of weight. ("Shiny" in the first lexeme also evokes reflected light.)

If Station 2 with its hand and its boulder expresses in stark terms the crushing of "Shiny Smoothness" by "Worldly Weight," Station 11, "He is nailed to the cross," allows a clear articulation of the triumph of "Channeled Light" over "Worldly Weight" (Fig. 45). A transparent plastic tube filled with a faintly dyed liquid juts through a narrow, chaste bed of a generally Shaker character. At regular intervals some mechanism beneath the bed generates an ample bubble, as wide as the tube itself. It rises to break the surface, releasing its gaseous contents upward to mingle with the surrounding atmosphere. Breath, with its respiratory regularity, joins the wider ethers. And where are the cross and the nails evoked by the title? The tube and the bed form a roughly inverted cross ("Inverted Cross," another lexeme), while the corner posts of the bed appear to consist of cylindrical legs hammered through holes bored in the frame. "Worldly Weight" is here laid low, directed downward. The action named in the title of the station serves principally to allow the spirit, now lighter than ever before, to ascend.

10. BLASPHEMY FOR A SECOND TIME

Theologically, the matter has become all too clean, too easy to grasp. In Station 11, as in the other polemical stations that precede it, spirit and matter divide readily into two distinct, opposed entities. It is practically Cartesian, as if Christ's divinity could be assigned to dematerialized mind and his humanity becomes tied to earthly body. This division flies in the face of both the Gospels and church dogma, which insist on the hypostatic union of God and man in the living body of Jesus. "The Word was God . . . And the Word became flesh and lived among us" (John 1:1, 14). The Athanasian Creed of the fifth century affirms the principle:

> Our Lord Jesus Christ, God's Son, is both God and man. He is God, begotten before all worlds from the being of the Father, and he is man, born in the world from the being of his mother—existing fully as God, and fully as man with a rational soul and a human body. . . . Although he is God and man, he is not divided, but is one Christ. . . . He is completely one in the unity of his person, without confusing his natures. For as the rational soul and body are one person, so the one Christ is God and man.[5]

Herein lies one of the profound, humanly impenetrable mysteries of Christianity, the dual character of Christ in which both aspects are fully realized despite the manifest contradiction.

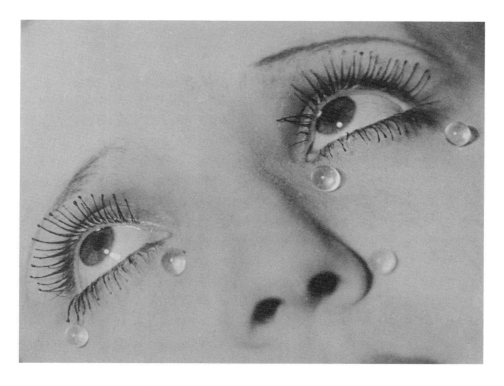

46. Man Ray, *Tears*, 1930–33. Photograph. The J. Paul Getty Museum, Los Angeles. © 2006 Man Ray Trust / Artists Rights Society (ARS), New York / ADAGP, Paris; photo: J. Paul Getty Museum.

In the Passion the nailing of Jesus to the cross registers the difficult concept. Divinity invested in body will be fixed, in the most brutal manner possible, to rigid matter. Divinity will not separate itself off from this human fate. "Those who passed by derided him, shaking their heads and saying, 'You who would destroy the temple and build it in three days, save yourself! If you are the Son of God, come down from the cross'" (Matthew 27:39–40). Yet, as the Bible recounts it, the Triune Godhead, fully invested in the body of man, does not.

One need not accept these words, one need not subscribe to any such doctrine to recognize the conceptual loss brought about by Wilson's hygienic divide. This aspect of *14 Stations* begs the question of the relation of spirit and body by making them distinct. It narrowly preconceives the problem in a way that makes such pairs of terms as "spirit" and "body," "divine" and "mundane," "Channeled Light" and "Worldly Weight" easily arise. Viewers are allowed the safety of identifying in a straightforward manner with one or the other property—"I see the light!" (at Oberammergau, perhaps); or "I appreciate Wilson's clever constructions" (at MASS MoCA, perhaps)—and thus avoiding the troubling confrontation with the possible amalgamation, necessarily full of contradictions, of the two into an impossible one.

Christian doctrine may not be the only creed thus compromised. Contemporary art, I have been arguing, likewise strives to suspend the easy division of message into distinct

oppositions—between, say, high art and mass culture. It seems to achieve its program best when it draws enough attention to its arbitrary means that its message abandons any claim to transparent truth, or when it highlights how ostensibly transparent means lead to arbitrary messages. It prospers when it both achieves that brief and refuses to do so. The problem with Station 11 and its like is that they make the task of parsing the lexemes difficult while nonetheless, in the end, allowing them to become quite legible. The dichotomies at the heart of the theme thereby appear hard-won while actually remaining simple. Once discerned through the scrim of Wilson's formulated artistic language, "up" and "down," or "light" and "heavy," serve the aesthetic no better than "divine" and "mundane" serve the Christian mystery.

For the devout who care, the facet of *14 Stations* that frustrates hypostatic union blasphemes a central precept of the church. For the impious who do not, the work's sharp divisions diminish its aesthetic potential. Yet the greatest reduction may reside here, in this difference between the two groups. When the differentiating character of *14 Stations* encourages the reification of the spiritual and the secular into such distinctions as light and weight, the religious and the irreligious alike can rest secure in their sanctimonious difference from the other.

11. TABLEAUX AND TIME

From weight crushing lightness to lightness ascending through weight, stations 1 through 11 have told a tale. Indeed, even without all the particulars yet in place, they have related the full Passion in its essence. *14 Stations* is a narrative ensemble, and the story will continue through the final station (and beyond). Let us pause here, though, and let the work pause as well. For the very stillness of Wilson's vignettes arrests the strong narrative impulse of the Passion play.

A distinguishing characteristic of the play at Oberammergau—one that has added considerably to its length—has been the interpolation of more than a dozen set pieces from the Old Testament within the chronicle of the Passion. Dramaturgically, a contrivance or two preserves a clear separation between the two covenants. Whereas the recounting of the final days of Jesus's life are acted out, the events from the earlier history of the Israelites freeze into tableaux struck by performers for a period between the raising and dropping of the curtain. Whereas standard theatrical dialogue relates most of the Passion, a chorus accompanied by the orchestra explicates the stilled scenes from the Old Testament. These tableaux lack narrative drive not only because they lack physical movement but also because their order follows a set of correspondences posited between them and the unfolding Passion rather than the chronology given in the Old Testament. Daniel in the lion's den, from the book of Daniel (Plate 19), prefaces Jesus brought before his accusers; the angel's staying of Abraham's

hand at the throat of Isaac, from the earlier book of Genesis, anticipates God's sacrifice of his Son for the sake of saving humanity.

This practice of discerning and presenting biblical parallels at Oberammergau generated objections from the international community monitoring the Passion play for evidence of anti-Semitism. The typologies had the effect of recasting the Old Testament as little more than a prefiguration of the New. At best, the text sacred to the Jews was superseded by the Gospels of the Christian Bible. At worst, the history of the Israelites emerged as a record of irredeemable sin miraculously redeemed through the Christian Messiah.

When *14 Stations* was seen in the pasture at Oberammergau, the running narrative of the Passion play became, in turn, just a prefiguration of Wilson's installation. In the simplest formulation: *14 Stations* recast the earlier religious material from the Festspielhaus to reveal a new and greater aesthetic truth. Yet the dynamic devised more than a linear narrative chronicling progress from the Passion story to the spiritual triumph of contemporary art (by way of Monet's water lilies, if you like). The tableaux in the cabins echoed those in the play. It would have been difficult for the theatergoers at Oberammergau to miss the striking visual similarity. In the production of 2000, the stage sets for the Passion story tended to be quite spare, thereby emphasizing the human action. In contrast, the bold compositions of the tableaux from the Old Testament juxtaposed discrete elements vivid in hue and shimmering in surface treatment. Props in the stations resembled those in the play. The bearish lions from the tableau of Daniel found their carnivorous kin among the wolves howling in Station 12, "He dies on the cross" (Plates 19 and 17).

The likeness was not happenstance. Stefan Hageneier, designer of the sets at Oberammergau in 2000, was a Wilson protégé; that personal connection undoubtedly paved the way for the commission of *14 Stations*. Viewers did not need to know of the mentorship, however, to reflect on which came first, the stage set or the art. The tableau of Daniel, for instance, was struck during the second half of the performance, so those pilgrims who ventured out to *14 Stations* during the play's lunch intermission would have encountered Wilson's wolves before they did Hageneier's lions. Beyond such specific juxtapositions, the general character of the play's tableaux clearly derived from the stilled visual arts. Theatrical tableaux are like *tableaux,* that is, like paintings. The struck scenes accompanied by music—such a conspicuous artifice on stage—must certainly have appeared more solidly grounded in Wilson's installation work, described in publicity material as a "light and sound installation," a staple of European artistic festivals.[6] So while the Old Testament scenes herald the Passion story and the Passion play anticipates *14 Stations, 14 Stations* in a palpable sense precedes the Old Testament scenes.

In their lack of movement, the play's tableaux and Wilson's work outnumber the main Passion story two to one. More important, the metanarrative of how the three stories (or nonstories) interconnect has them circling back on one another. Progress toward an end, specifically the compelling narrative of Jesus's passage from interrogation to death on the

cross, freezes into a set of vignettes that can commence and end at any given place. The model experience, the experience that the entire trip by pilgrims to Oberammergau most resembled, would be that of moving back and forth between the various cabins of *14 Stations,* sampling this, revisiting that. One grounds nothing on nothing, except perhaps on the text that could be taken as the timeless ground for them all.

With the Passion play out of mind at MASS MoCA, this entire dynamic, it might seem, should disappear. Instead, it takes a different form. Wilson's work, when in need of it, posits an alternative narrative against which its discrete episodes can declare their independence. The story now is the Passion itself—not Oberammergau's play but the biblical tale well embedded, at whatever level of sketchiness or precision, in the mind of every visitor entering Building 5. In passing through Pilate's praetorium, in hazarding the trip down the railroad ties, in peering into the windows in order, one rehearses that foundational story. Yet there is no exit to the rear, and one must return down that same corridor. The temptation is irresistible to look in again on this station or that, recapitulating one's earlier passage, cataloguing favorite bits or pondering lingering riddles.

Again, a simple metanarrative is possible: contemporary art of the static variety trumps the overconfident drive of the religious chronicle. Again, a second, circular dynamic undercuts the first—thereby revealed as overconfident in its own right. What, after all, is the source of the Passion tale? The Bible. The Bible does not consist of a simple story delivered beginning to end. The Passion itself is related four times, in four intertwining voices that echo each other: Matthew, Mark, Luke, and John. The books of the Old Testament are similarly episodic—indeed, they follow a different order in the Jewish scriptures than they do in the Christian covenant. It is a disjointed document, having been stitched together in different manners at a variety of times and places to form relatively stable yet arbitrary canons. Whether in oral readings from the lectionary during church service or through personal reading, the devout engage the Bible in a fitting fashion, fragmentary and repetitive. Even the irreligious among us experience references and allusions to the tales of the Bible—so frequent in our culture—in incidental order.

The presentation of *14 Stations* revivifies the biblical texture of the telling. In this regard, the Passion story with its seeming authenticity does not precede Wilson's installation with its seeming artifice. Rather, *14 Stations* would appear to reclaim the quality of authentic religious revelation, which in contrast exposes the transmutation of the Passion into a story as a secular artifice of the sort against which the Bavarian Catholic Church objected in the late eighteenth century when it attempted to suppress the plays. The narrative of the Passion play prefigures Wilson's installation, providing it typologies for its aesthetic covenant; the installation reactivates the Bible; the Bible prefigures the narrative, providing episodes for the Passion play to realign into a linear structure. *14 Stations* completes the circle, this time in a manner that draws the source text itself into circulation. The time of narrative, which wants to string the events of the Passion along a single thread, becomes a rosary. The stations are beads, fingered one or two at a time, passed back and forth, as their import dwells in the mind in their own time.

12. BETWEEN RED AND BLUE

Frozen time. Not then, not now. Between biblical times and the contemporary moment; between 2000 in Oberammergau and 2001 in North Adams; between Pilate's praetorium that commences *14 Stations* and this place at this moment; between what we confront here and what we may face in our own past or future.

Frozen place. Not here, not there. Between Station 12, "He dies on the cross," and Station 13, "He is taken down from the cross" (Plates 17 and 18). This spot through which all must pass, the penultimate moment of *14 Stations,* reaches the highest pitch, the most intense conflict, of the work. It can terrify; perhaps it should.

"He dies on the cross," and the wolves howl. Their white teeth glisten, their black maws gape. They are blind, eyeless, in their rage. They are senseless: their fury explodes outward to render them insensate to the surrounds. Likewise senseless: such insane viciousness defies all reason and measure.

This is death, surely: "He dies on the cross." Or rather, it is the might of Rome imposed upon the suffering Jesus. "He said, 'It is finished.' Then he bowed his head and gave up his spirit" (John 19:30). The sound loop of Station 12 emits, in addition to the sound of a pencil slowly hitting the edge of a table that evokes Jesus's trudging footsteps up Golgotha, a ripping sound suggestive of the separation of body and spirit. Yet it is not so much that the body of Jesus gives up the spirit as that the spirit gives up on the bodily aspect of Jesus ("spirit" here not individuated soul, but the Holy Spirit, the divine force invested for a time in human form while nonetheless remaining whole within the Godhead). The Gospels will have that corporeal aspect reclaimed by and reunited with the spirit in three days. In the interim, bodies and the powers that kill them remain of this world, alone.

Wilson's wolves are, appropriately, earthbound. Seen from the angle of the small window, the Alpine landscape painted across the interior walls of the cabin locates the beasts deep in a valley, below jagged summits and more rolling foothills (much like the geographic situation of Oberammergau itself). The roiling, crinkled skin of the animals bears all the broken contingency of the material boulders suspended in earlier stations above the lexemes of spirit. The mountains themselves are monuments to asperity, their crags exaggerated both by their hyperbolic rendition and by the anamorphic view on the side walls that foreshortens their width and thus amplifies the sharpness of their peaks. Just as the earlier rocks show signs of abrasion and wear, just as the pieces of Shaker furniture testify to the passage of time that has brought the cultures that produced them to an end, so the snarling wolves and eroding mountains foretell the messy demise of all material things.

This is death, then, but just as surely it is the force of life. The surfaces of the animals, while rough, acquire the fully saturated hue and high sheen of the hand in Station 1 that strives upward from below. The wolves crackle with vitality and destructive power. Destruction can be as much a passion as its safer opposite. Consider the wanton oblivion of Dionysian ecstasy, or the volatile intensity of the death drive *thanatos.* Consider how close

eros and *thanatos* approach when unbridled sexual abandon permits, even demands, the obliteration of the regularity of life that appears to constrain it. What is the Passion if not an orgy of the wild bloodlust that consumes Jesus's cruel tormenters, who wish to penetrate his body, to feast on it? In abandoning the body of Jesus on the cross, the spirit also gives over a seething, brutish vitality to the mindless material of earthly existence.

To where, then, has the Holy Spirit flown? Despite the direction indicated by the title "He is taken down from the cross," Station 13 soars upward. Madonna-as-the-Madonna gazes blissfully toward the heavens, as if witnessing not the broken body of her son but the ascent of his liberated spirit. The undulations of the glass vials across the illuminated floor—each an instance of the lexeme "Channeled Light"—place us above the clouds rather than at the dirt base of the cross. This is Mary not of the Deposition but of her own Ascension. Such light, the radiant blue walls, the gentle wafting of the scrim, the crystalline ringing of glass bells on the sound loop: here in Station 13 we might find comfort and calm in the face of the frightening forces across the way in Station 12.

What have we gained here in the empyrean, however, if we have lost contact with the inescapable tragedies—cruelty, violence, death, senselessness—of the world? The distance enervates the contents of Station 13. Madonna's gaze, I proposed earlier, is pure melodrama. Cosmetically smooth skin, deadpan expression, and fake tears capture no real sadness. Station 13 lacks any figure onto which to cathect our own earthly heartbreak (whatever its particular causes). Madonna does not grieve, in the manner of those who depose in paintings by the likes of Van Eyck or Memling. When cleansed of violence, the station may also be deprived of vitality. Bereft of the recognition of blindness, it is equally stripped of the capacity for insight. Separated from death and from delirious life of destruction, the disembodied spirit dies.

Yet Station 13 is not so naive and disengaged as it might first appear. The thin layer of blue paint on the side walls allows us to discern the flows and whorls of plywood grain beneath, as irregular as the crumpled surface of rock or wolf. Especially with their transportation and reinstallation at MASS MoCA, a number of the vials have become chipped, cracked, or shattered. The sound loop reinforces the impression of accident: we hear the glass bells accelerate and crash. Beyond registering the inevitable degradation of all material things, this pile of glass with broken pieces can (as John Rockwell noted in his review of *14 Stations* in the *New York Times*) evoke the mountains of eyeglasses—and, by extension, of suitcases, and shoes, and bones—discovered at the concentration camps.[7]

And then there are the birds. They are magpies, but their mostly black coloring also suggests ominous ravens or crows. Notwithstanding the earlier sculptural representations of humans and wolves, these hanging bodies are the first and only instance in *14 Stations* of actual animal matter. The trailing edges of the wings and the tail feathers exposed in flight bristle with natural inconsistency. When we view the ensemble as a flat tableau, the dark spots of suspended earthy matter punctuate the field of color and the light beyond. When we view the flock as objects positioned in three dimensions, the once living creatures burst outward,

as if an extension of the artifice of beads-on-rods radiating from Madonna's forehead. The birds fly toward us, and also beyond us into the terrible chaos of Station 12. They may even pull the remainder of the contents with them. Blue belongs to us; it is part of our material world. Light infuses our daily existence. As irregular life erupts out of Station 13, a bit of its saccharine character infuses the interior of Station 12. Those mountains, after all, are rather cartoonish, Disneyesque. And the wolves, in comparison with the taxidermized birds, stand forth as shellacked caricatures of living beings.

So we find ourselves, when positioned between these final two cabins, suspended not just between death and life, body and spirit, irregularity and order, earthiness and ethereality, but also, at a metalevel, between the polemical juxtapositions posited by all these pairings and the constant interfusion of all such opposing elements. We perform the division when we experience Stations 12 and 13 in narrative order. We forestall it when we arrest the progress of the story and let the two tableaux echo each other, with both consonance and dissonance. The real danger, the event to fear, lies not in the mad, vital terrors of Station 12 but in the prospect of a clean separation between its life-in-death and the death-in-life of disembodied spirit. And that is precisely the horror thematized by the killing on the cross. A certain clarity, purified by its departure from the earthly, leaves the material world to its sightless ecstasies.

The Incarnation of the Godhead in Jesus (manifested there in life or represented there in legend, depending on one's religious convictions, on whether one approaches Wilson's work as a pilgrim or as a museumgoer) entrusted spirit to body rather than moving body into the heavens. The tragedy of the death on the cross is that, for a time, spirit leaves the body again. Stations 12 and 13 threaten to segregate back into their own separate spaces, the one isolated from the other. In that case, indeed, "It is finished."

13. BLASPHEMY FOR THE THIRD TIME

We turn to face west, and something is seriously amiss. If the penultimate pause between Stations 12 and 13 bemoans the separation of body and spirit, Station 14, "He is entombed in the sepulcher," exacerbates the catastrophe by presenting a body of Jesus devoid of lived corporeality (Fig. 47). This human form lacks humanity. It is cold whereas we are warm. It is faultless whereas we are flawed. It leaves us behind, an empty idealization, tipping decidedly in the direction of the saccharine aspect of Station 13.

White and smooth, the inverted figure gives off a bright sheen, repeating the lexeme of "Shiny Smoothness" that conveys striving spirit. The surface lacks the chromatic variations of real skin, the blemishes, the inevitable asymmetries. In *14 Stations,* crumbled irregularity in human shape shifts to empty clothes, as in Stations 5 and 10 (Figs. 39 and 44). Absent from the white form in Station 14, too, are the wounds inflicted on the person of Christ: no nail holes in hands and feet, no laceration in his side. At the moment in the Passion when

47. Robert Wilson, *14 Stations*, 2000. Mixed media. Station 14, "He is entombed in the sepulcher." Installed at MASS MoCA. Photo: author.

the violated body nears the earth, Wilson's mannequin fails to register the passage of Jesus through the trials and degradations of the material world.

How much more discerning Pietro Perugino's treatment of the same theme! In *Sepulcrum Christi* of 1498—which hangs just down the road from MASS MoCA in the galleries of the Clark Art Institute in Williamstown—artistic rendition coupled with the passage of time has captured a nuanced version of the character of Christ (Plate 20). In the painting the body of Jesus approaches perfection, but of a radically different sort than it has in Station 14. The martyr dies in his early thirties, when his body has fully matured but not yet begun

48. Pietro Perugino, *Sepulcrum Christi*, 1498. Detail of Plate 20. Photo: Clark Art Institute.

its inevitable natural decline. Perugino uses the finest tricks of the trade to render the man in all his excellence: highlights on thigh and chest and upper arm, chiaroscuro to round out limbs and torso. Yet perfection does not lift this body; we can feel its weight. The volume fills with organs and blood. De-animated in death, the body sinks onto its material supports: head and shoulders against Nicodemus's head and shoulders, forearm against his hand, buttocks and thighs against the horizontal lid of the sarcophagus. Skin folds at the belly to register the collapse of the core. Most important, the signs of the Crucifixion remain. One hand cups around its wound, while the other Nicodemus holds forth for our acknowledgment. Where the spear pierced, just to the left of the highlighted peak of the chest, Jesus bleeds.

The human body in its finest state is subjected to a particularly vicious form of corporeal abuse. The story of the Crucifixion distills and amplifies the fate of all living beings: physical flowering, followed by ineluctable decay and death. Perugino distills and amplifies the biblical lesson: a perfect body violated, a perfect body presented to us vertically, then allowed to drop back toward the horizontal. Time distills and amplifies Perugino: the astonishing crackle that corrupts yet embellishes Jesus's head, and arm, and chest (Fig. 48). Like the body of the ancient Galilean, the medium itself registers the inescapable rhythms of creation and ruination to which are subject all material things.

Wilson's figure in Station 14 will have none of this—or purports not to (though of course the white plastic will eventually degrade). The approach of this inviolate body toward the ground is a caricature of entombment. With its head straight down, the figure is the literal inversion of a rigidly erect stance, as if such direct negation were sufficient to suggest the limp horizontality of the dead. And it still floats, supported by a hidden beam jutting out

from the surrounding tent of trees. From a distance at the exit of the bunker we might have been led to think of Peter, but closer up, the dove of the Holy Spirit seems the more apt figure, diving straight down as in so many Annunciation and Baptism paintings. It is as if the spirit had never invested in the body, never been ruined by its passage through humanity. The body appears as the spirit would want to have it, were the spirit to make no real concessions to the demands and dangers of actual embodiment.

And below the figure, where there should be a tomb, Wilson provides instead a hard, narrow bed. If the bed in Station 11 was simple, this blue platform is simpler still, stripped of any suggestion of linens or even a minimal reference to Shaker construction. In relation to the actual pallets we sleep on, the bed is as idealized and as unreal as the white figure above is in relation to our lived bodies. Our lived bodies, our sexed bodies. The bed, with a width suitable for a monk's cell and a stiffness that remonstrates of asceticism, mocks a vital purpose of this piece of furniture among human habits. The disposition belongs equally to the mannequin above. What a terrible lack, what a travesty of humanity! This Jesus has lost his sex.

14 Stations systematically disowns all carnality. Its lack surpasses mere abstinence to become essence. The lexeme "Shaker"—and all those unyielding, frontal women in Stations 6 and 8 from that celibate sect—certainly contribute to the message (Figs. 40 and 42). And consider the repugnant implications of Station 4, "He meets his mother" (Fig. 38). Here Jesus, unbent by the cross, stands starkly upright with a body nearly identical in miniature to the inverted figure in Station 14. Across from him, Mary is similarly stiff. Neither has genitals. Nothing differentiates them except a slight protuberance granted to the Virgin's breasts, and perhaps a nearly imperceptible variation in the curve of hairless skulls or pelvises. This is not humanity as we know it. This is Adam and Eve, before the Fall. No sex here, no temptation, no longing, no union, no estrangement, no loss. No death, and thus also, no life.

Christ's conception, as church dogma if not as the Gospels have it, may have been immaculate, but Mary gave birth as a woman. Jesus may or may not have been celibate, but he was not sexless. Temptation surrounded him—personifying it is one purpose in the Bible of, say, the women who anoint Jesus's feet—and abstinence would for him have been as much a choice about what do with his human sexuality as would gratification. How could Jesus, or Mary, not have been caught up in sexuality? They were human. To be devoid of it would be not to be human, not to ever really reside in a human body. And sexuality involves hazarding an extension of oneself, in all sorts of ways, into the world. It involves erection and distention. It involves acceptance and refusal and probing and opening and deformation and violation. It is messy. It involves blood, sweat, semen, amniotic fluid, tears.

Perugino understood much of this reality. His Christ is, among other things, stunningly sensual. His body carries signs of both sexes. It has been penetrated, and bleeds where the spear has entered.[8] Whereas Wilson's mannequin would never require such a garment, Perugino's Jesus wears a loincloth that must cover something. Is not the position of the left hand suggestive? If that shadow lying across the palm and extending onto the loincloth does not evoke, then perhaps the white bulge in the fabric running lower right to upper left will.[9] Higher

up, Christ invites caress. The ribs and belly folds, the dip of the sternum, the chest muscles and that remarkable nipple, even the fracturing crackle of the paint, all beg for a hand to pass across them. Nicodemus partially obliges, with his right hand cradling Jesus's forearm and his left fingertips resting with infinite tenderness on trapezius and clavicle. Even the attendant's chin and cheek approach, as if to nuzzle.

Touch, caress: a crucial aspect of sexuality is the contact between selves. Were the Godhead in the form of Jesus to enter the world, it would perforce participate. By Perugino's lights, Jesus does so even in death. Nicodemus behind him doubles the body of Christ; Joseph of Arimathea exchanges glances with Jesus's closed lids. The interdigitation of Joseph's fingers, so near to Christ's open hand, hints at a grasp with the Savior now wrested by death away from humanity. We may regard the figures in *Sepulcrum Christi* not just as three individuals but as a group united by their affective bonds.

In contrast, the inverted figure in Station 14 covets its perfect coherence and autonomy, and isolation. These things would be put at risk with any sexual or social encounter. The blank face bears the inscrutable expression of aloof mannequins populating the windows of high-fashion boutiques. So this Christ is a monad. It has not engaged humanity. The white figure and its harsh bed shun life. Vitality in Station 14 shifts yet lower, to the patch of grass growing beneath the bed—even in the indoor installation at MASS MoCA. Blades of grass lack differentiation. In our eyes, one blade is a good as another. The lawn will not do as a metaphor for human interaction, for people are not fungible in such a manner. Our affective relations create complex strata of intimacy and alienation, of proximity and distance. Jesus (myth or man) touched specific individuals—Nicodemus, Joseph, Mary, the Apostles, Pilate—as do we. Station 14, top to bottom, gives us the extremes of isolated autonomy and homogeneous mass. Human life lies dangerously somewhere in-between.

As Station 14 would have it, the Holy Spirit, not stillborn but rather not born at all, never arrived. The Incarnation never happened.

14. RESURRECTION

So with its final station, Wilson's installation has saved us from, or deprived us of, too close a contact with the divine. Relations with deities, like those with other humans, entail both rewards and risks. At the exit from Pilate's bunker, *14 Stations* invited the visitor (who, protecting autonomy, could refuse) into a demanding, always incomplete, first-person identification with Jesus. Standing before Station 14, the spectator can regain the comfort of secular human existence by witnessing the transportation of all of Jesus, spirit and now idealized body, away up there, away from here. The spectator can regain that comfort, but only through the concomitant loss of whatever engagement with the unfathomable might be offered by whichever church, the Christian one or that of contemporary aesthetics.

That dead end is where *14 Stations* leaves us, at least in Oberammergau. In the Alpine

49. Robert Wilson, *14 Stations*, 2000. Mixed media. Station 14, "He is entombed in the sepulcher." Installed in Oberammergau, Germany. Photo: Lesley Leslie-Spinks.

pasture beyond Station 14, a blue picket fence and a wall of trees barricaded any further advance (Fig. 49). In Building 5 of MASS MoCA, however, our pilgrimage need not yet be over.

To the left in back of the foliated tent of Station 14, a doorway cuts into an enclosed suite of low-ceilinged, windowless rooms (Fig. 50). The light is dim. Drawings by Robert Wilson, mostly sketches for stage sets (including some for Wagner's *Parsifal*), line the walls. All are charcoal, black and white. The compositions are abstract, the lines forceful. The effect disquiets. Directly across from the entrance, a drawing for *Dante's Death* of 1992 suggests a long dark corridor, with light and escape only in the far distance. It is the sort of space through which we ourselves are traveling as we pass through these rooms. Within the suite an alcove to the right presents Wilson's video *Deafman Glance* of 1981, in which we witness within an

50. Robert Wilson, 1972–98. Drawings. Installed in lower gallery at west end of Building 5, MASS MoCA, 2001–3. Photo: author.

infernal setting of endless domestic tedium the slaughter of two boys by their mother (Medea hovers in the shadows). Following Wilson's version of the Passion, the suite evokes the harrowing of hell. The Athanasian Creed provides the appropriate text: "He suffered death for our salvation. He descended into hell and rose again from the dead."

He rose, and we rise. A stairway beyond the darkness takes us up a full story to the space above the enclosed suite. Atop this platform overlooking *14 Stations* stand a dozen strange chairs, stage props from various productions for which Wilson served as designer. Large in center front, closest to the stations, presides the "Father's Chair," from *The Days Before: Death Destruction & Detroit III* of 1999 (Fig. 51). Again, the Athanasian Creed: "He ascended into heaven and is seated at the right hand of the Father." Not so in Building 5. He has not ascended; he remains below. Over the railing we can see the back of the tent of trees, now a screen, behind which we know the inverted, idealized Jesus floats (Fig. 52). We, the human visitors to *14 Stations,* we the humans from whom the Christ in Station 14 has taken away not the sins but the deadly perfections of the world, we as humans, in all our frailty, arrive at this place.

Versailles strove to invest divinity in the terrestrial Louis XIV at its center. Monet's Orangerie tried to place the divine at the middle of its rooms, separate from humans at the pe-

51. Robert Wilson, "Father's Chair," from *The Days Before: Death Destruction & Detroit III*, 1999. Beech wood. Installed in upper gallery at west end of Building 5, MASS MoCA, 2001–3. Photo: author.

ripheries. Here on the platform at the far end of Building 5 we meet the godly—not halfway between earth and heaven, but in an intermediate, indeterminate zone akin to the place of judgment and forgiveness at Coventry Cathedral. Here we do not speak in a godly manner, with uninflected language of the sort that Wotan, through Siegfried, failed to pass on to the audience in Bayreuth. Such transparent yet esoteric expression we have left behind us, among the lexemes in the cabins. Ideal representation (which is to say, presentation, in the manner of Borges's map) and ideal (dis-)embodiment play out below, as do mundane utterances— "ver-ur-TEILT!"—and a number of purely human roles, such as gazing up at the inverted figure of Station 14. The visual and aural cacophony down in the nave will gladly have its many dialogues occupy themselves. Toward us it now (again) averts its gaze—and turns a deaf ear. Which means we may be freed from the endless, irreconcilable opposition between the celestial and the earthly. In this space apart we can provisionally inhabit neither, and both.

52. Robert Wilson, *14 Stations*, 2000. Mixed media. Viewed from upper gallery at west end of Building 5, MASS MoCA. Photo: author.

In the Introduction I quoted Jean-Luc Marion: "God withdraws in the distance, un-thinkable, unconditioned, and therefore infinitely closer."[10] Because on the platform beyond *14 Stations* we sense that we have left the "unthinkable, unconditioned" God and his overide-alized Son below among the cabins and the railroad ties, we perchance feel that here the Fa-ther to whom this chair belongs may approach "infinitely closer." He does not fly off on high. It is as if the deity—the Christian God or, if you prefer, one of his surrogates—will sit here with us on these chairs. It sits where we sit, It sits in us, and we in it. It is not us, for we contain it no less than it contains us. We still confront its mysteries. Which is to say, we may choose to reflect on the possibility that aspects of human existence always exceed hu-man existence, that human understanding cannot grasp human understanding. We might ponder the idea that existence and understanding may not be solely the dominion of hu-mans. We may be willing to consider that within our limited human lives the divinely un-fathomable, in all its promise and terrors, always awaits, as near as it is far.

INTRODUCTION

1. Martha Mel Stemberg Edmunds provides a meticulous account of the various chapels at Versailles in *Piety and Politics: Imaging Divine Kingship in Louis XIV's Chapel at Versailles* (Newark: University of Delaware Press, 2002). See also Alexandre Maral, *La chapelle royale de Versailles sous Louis XIV: Cérémonial, liturgie et musique* (Sprimont, Belg.: Pierre Mardaga, 2002).

2. Jacques-Benigne Bossuet, *Politics Drawn from the Very Words of Holy Scripture,* trans. and ed. Patrick Riley (Cambridge: Cambridge University Press, 1990 [Fr. posthumous ed. 1709]), 60.

3. Gianni Vattimo, *Belief,* trans. Luca D'Isanto and David Webb (Stanford, CA: Stanford University Press, 1999 [Ital. ed. 1996]), 43. This "secularization" thesis is often associated with the name of Karl Löwith (with whom Vattimo studied), although the thesis appears constantly throughout the historical and sociological literature. Karl Löwith, *Meaning in History* (Chicago: University of Chicago Press, 1949). The most influential rebuttal to Löwith has been Hans Blumenberg, *The Legitimacy of the Modern Age,* trans. Robert M. Wallace (Cambridge, MA: MIT Press, 1983 [Ger. ed. 1966]).

4. Much recent art historical scholarship engaging religion features the study of various historical instances of idolatry, in which artistic depictions of divinities are treated as if they were themselves divine, or instances of iconoclasm, in which viewers (often resorting to violence) resist any such attribution of divine presence to the work. See, for example, Hans Belting, *Likeness and Presence: A History of the Image before the Era of Art,* trans. Edmund Jephcott (Chicago: University of Chicago Press, 1994 [Ger. ed. 1990]); Alain Besançon, *The Forbidden Image: An Intellectual History of Iconoclasm,* trans. Jane Marie Todd (Chicago: University of Chicago Press, 2000 [Fr. ed. 1994]); David Freedberg, *The Power of Images: Studies in the History and Theory of Response* (Chicago: University of Chicago Press, 1989); and Joseph Leo Koerner, *The Reformation of the Image* (Chicago: University of Chicago Press, 2004). Within a recent surge of scholarship on Christianity in American visual culture, most studies focus on artifacts that depict divine figures or scenes, or on the social use of such images. See David Morgan, *The Sacred Gaze: Religious Visual Culture in Theory and Practice* (Berkeley: University of California Press, 2005); David Morgan, *Visual Piety: A History and Theory of Popular Religious Images* (Berkeley: University of California Press, 1998); David Morgan and Sally M. Promey, eds., *The Visual Culture of American Religions* (Berkeley: University of California Press, 2001); and Sally M. Promey, *Painting Religion in Public: John Singer Sargent's* Triumph of Religion *at the Boston Public Library* (Princeton, NJ: Princeton University Press, 1999). James Elkins has written an intriguing study of religion in the works of five contemporary artists, which begins with a useful historical and historiographical introduction to the interaction between religion and art. James Elkins, *On the Strange Place of Religion in*

Contemporary Art (New York: Routledge, 2004). In various writings, Mark C. Taylor has also attempted to open up a dialogue between religion and art of the twentieth century. See, most notably, Mark C. Taylor, *Disfiguring: Art, Architecture, Religion* (Chicago: University of Chicago Press, 1992).

5. Jean-Luc Marion, *God without Being: Hors-Texte,* trans. Thomas A. Carlson (Chicago: University of Chicago Press, 1991 [Fr. ed. 1982]), xix.

6. A particularly concise and incisive summary of the two positions appears in the introduction by John D. Caputo and Michael J. Scanlon to their jointly edited book *God, the Gift, and Postmodernism* (Bloomington: Indiana University Press, 1999). While ideas on religion appear throughout Derrida's writings, he takes on the issue of negative theology most directly in "How to Avoid Speaking: Attestations," trans. Ken Frieden, in *Derrida and Negative Theology,* ed. Harold Coward and Toby Foshay (Albany: State University of New York Press, 1992). Arguments over whether Derrida's deconstruction of negative theology refutes or extends the apophatic tradition have emerged as a major scholarly debate. See Thomas A. Carlson, *Indiscretion: Finitude and the Naming of God* (Chicago: University of Chicago Press, 1999); Coward and Foshay, *Derrida and Negative Theology;* Kevin Hart, *The Trespass of the Sign: Deconstruction, Theology, and Philosophy* (Cambridge: Cambridge University Press, 1989); Richard Kearney, *The God Who May Be: A Hermeneutics of Religion* (Bloomington: Indiana University Press, 2001); Robert P. Scharlemann, ed., *Negation and Theology* (Charlottesville: University of Virginia Press, 1992); Yvonne Sherwood and Kevin Hart, *Derrida and Religion: Other Testaments* (New York: Routledge, 2005); and James K. A. Smith, *Speech and Theology: Language and the Logic of Incarnation* (London: Routledge, 2002).

7. Jean-Luc Marion, *The Idol and Distance: Five Studies,* trans. Thomas A. Carlson (New York: Fordham University Press, 2001 [Fr. ed. 1977]), 215. It could be objected that "distance" might itself emerge as a concept and thus repeat the error of onto-theological idolatry earlier committed by Being. Marion forestalls this argument by maintaining that we also maintain distance from distance itself:

> The distance of the Ab-solute precedes every utterance and every statement by an anteriority that nothing will be able to abolish. Anterior distance escapes every conception. But precisely, must distance be conceived? Anterior distance conceives us because it engenders us. Distance is given only in order to be received. Anterior distance demands to be received because it more fundamentally gives us [the chance] to receive ourselves in it. . . . We discover ourselves, in distance, delivered to ourselves, or rather delivered for ourselves, given, not abandoned, to ourselves. . . . In receiving himself from distance, man comprehends not only that distance comprehends him, but that it renders him possible. Distance appears, then, as the very disappropriation through which God creates—not the break of alienation, but the ecstatic place that saves irreducible alterity. . . . To admit that the incomprehensible cannot, must not, and does not have to be comprehended amounts to recognizing, receiving, and referring distance as distance. (153–54, brackets in the Carlson translation)

8. David Summers, *Real Spaces: World Art History and the Rise of Western Modernism* (London: Phaidon Press, 2003), 560, 562. While Summers wishes to regard metaopticality as "a tradition of place and image-making among other traditions" (549) and thus not the outcome of some inexorable teleology culminating in Western modernism, he does argue that the capacity for this spatial regime to appropriate and subordinate other pictorial logics renders it part of the "fungible, cultural homogenous world of the flow of capital and power" (23) that exerts global dominance in the contemporary age. Whitney Davis has written an illuminating assessment of Summers's book, which will appear in *Visuality and Its Discontents: Essays on Art Theory in World Art History* (forthcoming) and as I write is available for download on Davis's faculty Web page at the University of California, Berkeley.

9. The literature on perspective is vast, but I have found a number of recent books to be especially useful: Hubert Damisch, *The Origin of Perspective,* trans. John Goodman (Cambridge, MA: MIT Press, 1994 [Fr. ed. 1987]); James Elkins, *The Poetics of Perspective* (Ithaca, NY: Cornell University Press, 1994); J. V. Field, *The Invention of Infinity: Mathematics and Art in the Renaissance* (Oxford: Oxford Univer-

sity Press, 1997); and Martin Kemp, *The Science of Art: Optical Themes in Western Art from Brunelleschi to Seurat* (New Haven, CT: Yale University Press, 1990).

10. Erwin Panofsky, *Perspective as Symbolic Form,* trans. Christopher S. Wood (New York: Zone Books, 1997), 57, 61.

11. Karsten Harries, *Infinity and Perspective* (Cambridge, MA: MIT Press, 2001), 123. Harries cites Alexandre Koyré and Etienne Gilson as scholars who establish the link between Descartes and Saint Thomas.

12. Marion, *God without Being,* 140; interpolated quotation, 46.

13. Harries has written: "A totally adequate description . . . would be nothing other than the [thing] itself. The gulf between being and understanding, reality and language would have been bridged. But such an understanding is denied to finite knowers. It characterizes the creative Word of God alone in which word and thing, logos and reality are one." Harries, *Infinity and Perspective,* 52.

14. All biblical passages, unless otherwise noted, are taken from the New Revised Standard Version.

15. Gianni Vattimo, "The Age of Interpretation," in *The Future of Religion,* by Richard Rorty and Gianni Vattimo (New York: Columbia University Press, 2005), 51; Gianni Vattimo, *After Christianity* (New York: Columbia University Press, 2002), 38; Vattimo, *Belief,* 48.

16. Richard Elliott Friedman, *The Disappearance of God: A Divine Mystery* (Boston: Little, Brown, 1995).

17. My thought here was inspired by passage written by Joseph Leo Koerner: "The Christian image was iconoclastic from the start. Pictures of a God who suffered and died, of the deity transformed into a monster through his abject, fleshly wounds: these were meant to train our eyes to see beyond the image, to cross it out without having to do something so undialectic as actually destroying it." Koerner, *The Reformation of the Image,* 12. I can't quite overcome an uncertainty I have about Koerner's argument, however: Does he mean that iconoclasm has been around as long as have "*pictures* of a God who suffered and died"; or does he imply (as I would like to read him) that "the *deity* transformed into a monster through his abject, fleshy wounds" inaugurates the legacy whereby the contingent image fails to convey the immutable essence? The play between the two interpretations is, of course, a perfect illustration of the confusion that gives rise to idolatry in the first place.

18. Daniel Boyarin, *A Radical Jew: Paul and the Politics of Identity* (Berkeley: University of California Press, 1994), 2. See also Alain Badiou, *Saint Paul: The Foundation of Universalism,* trans. Ray Brassier (Stanford, CA: Stanford University Press, 2003 [Fr. ed. 1997]); and Julia Reinhard Lupton, "Citizen Paul," in *Citizen-Saints: Shakespeare and Political Theology,* chapter 1 (Chicago: University of Chicago Press, 2005). While the literature on the historical Jesus is massive, Bart D. Ehrman provides a usefully concise historical and historiographical summary in *Jesus: Apocalyptic Prophet of the New Millennium* (Oxford: Oxford University Press, 1999).

19. Marion, *The Idol and Distance,* 5.

20. Rowan Williams, *On Christian Theology* (Oxford: Blackwell Publishing, 2000), 243.

21. *The Book of Common Prayer* [Episcopal] (New York: Oxford University Press, 1979), 864.

CHAPTER 1

1. For the history of this room, see Piganiol de La Force, *Nouvelle description des chasteaux et parcs de Versailles et de Marly,* 2nd ed. (Paris: Florentin Delaulne, 1707), 124–25; Gérald Van der Kemp, *Versailles* (New York: Vendome Press, 1978 [Fr. ed. 1977]), 82–84. For descriptions of the various building campaigns at Versailles, I have also relied on Robert W. Berger, *A Royal Passion: Louis XIV as Patron of Architecture* (Cambridge: Cambridge University Press, 1994); Robert W. Berger, *Versailles: The Château of Louis XIV* (University Park: Pennsylvania State University Press, 1985); Peter Burke, *The Fabrication of Louis XIV* (New Haven, CT: Yale University Press, 1992); Alfred Marie, *Naissance de Versailles: Le château, les jardins,* 2 vols. (Paris: Editions Vincent, Fréal, 1968); Jean-Marie Pérouse de Montclos, *Ver-*

sailles, trans. John Goodman (New York: Abbeville, 1991); Guy Walton, *Louis XIV's Versailles* (Chicago: University of Chicago Press, 1986); and Andrew Zega and Bernd H. Dams, *Palaces of the Sun King: Versailles, Trianon, Marly* (New York: Rizzoli, 2002).

2. At the bottom left of a text panel accompanying Le Pautre's map (not shown in Fig. 4) appears the notice from the publisher, Demortain: "With authorization of the King 1717." However, the map almost certainly was prepared before the king's death in 1715. A cartouche containing a portrait bust labeled "Louis XIV, King of Fr[ance] and Nav[erre]" declares the map to be "Dedicated to the King" (Fig. 6), and the accompanying text panel extols Louis XIV's architectural accomplishments without mention of his decease or his successor. Le Pautre, identified in the cartouche as "architect and general engraver to His Majesty," himself died in 1716. A related volume published by Demortain around 1715 that includes plates by Le Pautre bears a title indicating when the architect was at the site to depict the palace and its grounds: *Les Plans, Profils, et Elevations des ville et château de Versailles, avec les bosquests et fontaines, tels quils sont a present; Levez sur les lieux, dessinez et gravez en 1714 et 1715.* Although Louis XIV may never have held this particular map in his hands, it surely was intended for him.

3. Ernst Kantorowicz analyzes the dual attribution of human and divine characteristics to the figure of the monarch in his highly influential study, *The King's Two Bodies: A Study in Mediaeval Political Theology* (Princeton, NJ: Princeton University Press, 1957). I have benefited from another writer who owes a substantial debt to Kantorowicz: Jean-Marie Apostolidès, *Le roi-machine: Spectacle et politique au temps de Louis XIV* (Paris: Les Editions de Minuit, 1981). Louis Marin also elaborates on Kantorowicz's thesis in *The Portrait of the King,* trans. Martha M. Houle (Minneapolis: University of Minnesota Press, 1988 [Fr. ed. 1981]); I will engage Marin's argument on royal embodiment in due course.

4. Allen S. Weiss, *Mirrors of Infinity: The French Formal Garden and 17th-Century Metaphysics* (New York: Princeton Architectural Press, 1995 [Fr. ed. 1992]), 33–34.

5. Marin, *The Portrait of the King,* 175.

6. In addition to the sources on the building of Versailles that I cite above, I also rely for my analysis of the gardens on the following books: Robert W. Berger, *In the Garden of the Sun King: Studies on the Park of Versailles under Louis XIV* (Washington, DC: Dumbarton Oaks Research Library and Collection, 1985); Pierre-André Lablaude, *The Gardens of Versailles,* trans. Fiona Biddulph (London: Zwemmer Publishers, 1995); Chandra Mukerji, *Territorial Ambitions and the Gardens of Versailles* (Cambridge: Cambridge University Press, 1997); Stéphane Pincas, *Versailles: The History of the Gardens and Their Sculpture,* trans. Fiona Cowell (London: Thames & Hudson, 1996); and Beatrix Saule, *Versailles Gardens,* trans. Alexis Gregory (New York: Vendome Press, 2002).

7. Circumstance forced the Figure 7 photograph to be taken two bays to the left of the central window in the Hall of Mirrors.

8. Jacqueline Lichtenstein, *The Eloquence of Color: Rhetoric and Painting in the French Classical Age,* trans. Emily McVarish (Berkeley: University of California Press, 1993 [Fr. ed. 1989]), 126.

9. See the Introduction. The phrases placed in quotation marks in the next few sentences are drawn from the long passage given there, from Jean-Luc Marion, *The Idol and Distance: Five Studies,* trans. Thomas A. Carlson (New York: Fordham University Press, 2001 [Fr. ed. 1977]), 8–9.

10. Bernard Vonglis provides a thorough account tracing the origin of both statements to the historian P. E. Lémontey, writing in 1818. Vonglis reports that Lémontey "affirmed having personally discovered" the former passage in "a public law course written at the behest of Louis XIV for the instruction of his grandson," but that document has not since been located. Bernard Vonglis, *"L'état, c'était bien lui": Essai sur la monarchie absolue* (Paris: Editions Cujas, 1997), 15, 23.

11. Cited and analyzed in Vonglis, *"L'état, c'était bien lui,"* 29–30. The full memoirs appear in Louis XIV, *Mémoires pour l'instruction du Dauphin,* ed. Pierre Goubert (Paris: Imprimerie Nationale Editions, 1992).

12. See the excellent discussions of the concept of the *corpus mysticum* of Christ in Jean Barbey, *La fonction royale: Essence et légitimité d'après les* Tractatus *de Jean de Terrevermeille* (Paris: Nouvelles Editions Latines, 1983), 157–268; and Kantorowicz, *The King's Two Bodies,* 194–206.

13. Jacques-Benigne Bossuet, *Politics Drawn from the Very Words of Holy Scripture,* trans. and ed. Patrick Riley (Cambridge: Cambridge University Press, 1990 [Fr. posthumous ed. 1709]), 58.

14. *The Book of Common Prayer* [Episcopal] (New York: Oxford University Press, 1979), 864.

15. Michel Onfray uses the coronation ritual as a key to decode the meaning of all items included in Rigaud's portrait, in "The Mirrors of Narcissus at the Theatre," *Parkett* 50–51 (1997): 15–22. See also Kristin Ahrens, *Hyacinthe Rigauds Staatsporträt Ludwigs XIV: Eine typologische und ikonologische Untersuchung zur politischen Aussage des Bildnesses von 1701* (Worms: Wernersche Verlagsgesellschaft, 1990); Kristin Ahrens, "'Honor praevia virtus': Une interpretation de l'architecture à l'arrière-plan du portrait officiel de Louis XIV peint par Rigaud en 1701," *Gazette des beaux-arts* 115 (1990): 213–26; and Donald Posner, "The Genesis and Political Purposes of Rigaud's Portraits of Louis XIV and Philip V," *Gazette des beaux-arts* 131 (1998): 77–90.

16. Louis Marin, *Food for Thought,* trans. Mette Hjort (Baltimore: Johns Hopkins University Press, 1989 [Fr. ed. 1986]), 199.

17. See Norman Bryson's analysis of this painting in *Word and Image: French Painting of the Ancien Régime* (Cambridge: Cambridge University Press, 1981), 34–36. Regarding the ceiling murals in the Hall of Mirrors, see also Paul Duro, "Containment and Transgression in French Seventeenth-Century Ceiling Painting," in *The Rhetoric of the Frame: Essays on the Boundaries of the Artwork,* ed. Paul Duro (Cambridge: Cambridge University Press, 1996); and Gérard Sabatier, "Beneath the Ceilings of Versailles: Towards an Archaeology and Anthropology of the Use of the King's 'Signs' during the Absolute Monarchy," in *Iconography, Propaganda, and Legitimation,* ed. Allan Ellenius (Oxford: Clarendon Press, 1998).

18. Marion, *The Idol and Distance,* 5–6. In sections of this passage that I have excised, Marion is yet more radical when he argues that believers can even be fully aware that the idol is of their own manufacture: "The worshipper knows himself to be the artisan who has worked with metal, wood, or stones to the point of offering the god an image to be seen so that the god should consent to take on a face in it." I elide this additional point because it does not pertain well to Versailles, where Louis stood as the agent responsible—either personally or through artists and artisans working under his direction—for the production of his own image, so that that idol seems to fabricate itself.

19. Marin, *Food for Thought,* 189. Similarly, Marin writes in *The Portrait of the King:* "When the king contemplates his portrait, there are two kings face to face who are comparable to none other than each other, the king to the portrait and the portrait to the king. It is in this way that . . . if the portrait is the king's portrait, the king is no less than the portrait of the portrait" (213).

20. I return to the topic of the Eucharist, in both Catholic and Anglican liturgies, in Chapters 3 and 4.

21. The Lacanian foundation for Marin's interpretation stands out clearly in his first sentences on the topic in *Food for Thought:* "If there is a scene that sums up or condenses all the signs and insignia of a political power operating at the greatest level of efficacy, it must be that of a king contemplating his own portrait. Such a scene would make manifest to its royal impresario or spectator the imaginary character that affects, if not infects, all power in its consubstantial desire for the absolute. In recognizing the icon of the Monarch that he wishes to be, the royal spectator would recognize himself in the portrait and identify himself with it" (189). In thus treating the presentation of the king principally as the imaginary operating in the mirror stage, Marin's account fails to recognize how Louis's body, which is not present in the portrait, also functions both as a symbol of God's absence (the attired body and its portrayal, of course, also symbolize much else) and as a hard kernel of the unassimilable real.

22. Alfred Marie transcribes the text accompanying the print of the Latona group by Pierre Le Pautre in 1678: "Latona between her two children, Apollo and Diana, demanding vengeance from Jupiter for the insolence of the peasants of Lycia who are changed into frogs." Marie, *Naissance de Versailles,* caption to plate 80.

23. Berger, *In the Garden of the Sun King,* 27; Nathan T. Whitman, "Myth and Politics: Versailles

and the Fountain of Latona," in *Louis XIV and the Craft of Kingship,* ed. John C. Rule (Columbus: Ohio State University Press, 1969).

24. Phrases from Marion that appear in this paragraph and the next have all been quoted before in the Introduction or earlier in this chapter and are drawn from *The Idol and Distance,* 6–8.

25. Jorge Luis Borges, "On Exactitude in Science" (1960), in *Collected Fictions,* trans. Andrew Hurley (New York: Viking, 1998), 325, ellipsis in the original. To this one-page chronicle, given in its entirety in this passage and the one in the following paragraph, Borges appended the spurious attribution: "Suárez Miranda, *Viajes de varones prudentes,* Libro IV, Cap. XLV, Lérida, 1568."

26. For the history of the commissions and placements, see Claire Constans, *Musée National du Château de Versailles: Les peintures,* 3 vols. (Paris: Réunion des Musées Nationaux, 1995), 615, 623; and Antoine Schnapper, *Tableaux pour le Trianon de marbre, 1688–1714* (Paris: Mouton, 1976), 109, 114, 124–25.

27. Sabatier, "Beneath the Ceilings of Versailles," 234.

28. See, for instance, at the Getty Research Institute in Los Angeles, both the volume of Willem Swidde's depictions of Versailles (including Figs. 14 and 18) and the three volumes of assembled prints dating from 1640 to 1700 that depict Versailles and other royal French palaces, executed by Gabriel Perelle, Adam Perelle, Nicolas Perelle, Pierre Aveline, and Israël Silvestre. Copies of Demortain's album (including Figs. 1 and 2) are held by more than a dozen American libraries.

CHAPTER 2

1. Friedrich Nietzsche, *The Case of Wagner,* published in one volume with *The Birth of Tragedy,* trans. Walter Kaufmann (New York: Vintage Books, 1967), 176, translation slightly altered.

2. The literature on the relation between text and music in Wagner, and even that regarding only the *Ring* cycle, is vast. Important recent contributions include Carolyn Abbate, *Unsung Voices: Opera and Musical Narrative in the Nineteenth Century* (Princeton, NJ: Princeton University Press, 1991); Matthew Bribitzer-Stull, "'Did You Hear Love's Fond Farewell?': Some Examples of Thematic Irony in Wagner's *Ring,*" *Journal of Musicological Research* 23 (2004): 123–57; Sandra Corse, "Language and Music in the *Ring,*" in *Wagner and the New Consciousness: Language and Love in the* Ring, chapter 2 (Rutherford, NJ: Fairleigh Dickinson University Press, 1990); Thomas S. Grey, "Music as Natural Language in the Moral Order of Wagner's *Ring: Siegfried,* Act 2, Scene 3," in *Nineteenth-Century Music: Selected Proceedings of the Tenth International Conference,* ed. Jim Samson and Bennett Zon (Aldershot, Eng.: Ashgate, 2002); and Jean-Jacques Nattiez, *Wagner Androgyne: A Study in Interpretation,* trans. Stewart Spencer (Princeton, NJ: Princeton University Press, 1993 [Fr. ed. 1990]).

3. I have relied on a number of sources for texts and translations of the libretto, occasionally cobbling together more than one translation or making minor alterations of my own. These sources include Richard Wagner, *The Ring of the Nibelung,* trans. Andrew Porter (New York: W. W. Norton, 1976); Rudolph Sabor, *Richard Wagner,* Der Ring des Nibelungen: *A Companion Volume,* and the four accompanying volumes titled after the individual operas (London: Phaidon, 1997); Richard Wagner, *Wagner's* Ring of the Nibelung: *A Companion,* trans. Stewart Spencer (London: Thames & Hudson, 1993); and the uncredited translations accompanying the recordings of the operas by George Solti and the Vienna Philharmonic Orchestra (released by London on vinyl in 1959–66; rereleased in 1984–85 on compact disc, numbers 414 101–2, 414 105–2, 414 110–2, and 414 115–2).

4. I say "simplifying somewhat" because, as Anthony Newcomb has argued (exemplifying one strand of Wagnerian scholarship), Wagner did construct his tetralogy with musical concerns, as well as thematic imperatives, in mind. Newcomb forwards the thesis that Wagner constantly struck a balance between the two. "There is . . . a tension between the demands of shape or form [i.e., standard musical structures] and those of theme and motive on the other. . . . In some units . . . the network of themes and motives may be the primary focus of the music. . . . Although the balance never goes quite

as far in the other direction—toward the demands of traditional musical shape and away from those of thematic gesture—the tension between the two poles is always present." Anthony Newcomb, "The Birth of Music out of the Spirit of Drama: An Essay in Wagnerian Formal Analysis," *19th-Century Music* 5 (Summer 1981): 41–42. Nonetheless, the prominence of the motifs in the *Ring* cycle, and the resulting relative laxity of its musical structure, undoubtedly would have struck most of Wagner's auditors, accustomed as they were to accepted classical forms, as the operas' salient characteristic. Karl Dahlhaus has made the case in terms that resonate well with the argument I am about to build.

> The orchestral motives in the *Ring* are more accurately described as successive than as harmonically and melodically complementary, or as antecedent and consequent clauses of periods in the manner of classical musical syntax. Wagner's basic syntactical form is paratactic, not hypotactic.
>
> Periodic structure—in ruins for long stretches of the *Ring*—had been the foundation of all musical form since the 1720s. In the Classical period, the decisive structural element, the source of the coherence and integration in any musical work, was not the thematic material and its development, but the syntax, the grouping of the constitution parts. . . .
>
> [With the *Ring*] Wagner disrupted or annulled the rules of classical syntax. . . . From *Rheingold* onwards, the basis of Wagner's musical form is no longer primarily syntactic but motivic.

Karl Dahlhaus, *Richard Wagner's Music Dramas,* trans. Mary Whittall (Cambridge: Cambridge University Press, 1979 [Ger. ed. 1971]), 106–7. Carolyn Abbate and Roger Parker provide an excellent historiographical summary of the debate in Wagnerian scholarship between those who have analyzed motifs (beginning with Hans von Wolzogen in 1877) and those who have discerned musical forms (first rigorously studied by Alfred Lorenz in 1924). Carolyn Abbate and Roger Parker, "Introduction: On Analyzing Opera," in *Analyzing Opera: Verdi and Wagner,* ed. Carolyn Abbate and Roger Parker (Berkeley: University of California Press, 1989).

For the names of the motifs in this essay, I tend to rely on those provided by J. K. Holman, *Wagner's* Ring: *A Listener's Companion and Concordance* (Portland, OR: Amadeus Press, 1996), although on occasion I modify them a bit.

5. In *Unsung Voices,* Carolyn Abbate provides an elegant and incisive analysis of Wotan's extended monologue in act 2, scene 2, of *The Valkyrie.* She discerns close parallel structures between Wotan's verbal rhetoric and the underlying musical exposition. "Whenever we touch the monologue's music, it seems to cast back its singer's view of history and its singer's discursive habits. . . . The tautologies [between music and text] in the monologue are significant, for they tell us that the music comes from the singer of the tale, who cannot step outside the circle of his narrative—the music comes from Wotan" (201). Accordingly, Abbate surmises that the music necessarily takes on Wotan's capacity for verbal mendacity and that this characteristic, derived from an admittedly anomalous passage, undercuts the credibility of music throughout the tetralogy: "[The monologue is] an enunciation emanating both textual *and musically* from Wotan, and hence . . . music . . . is itself unreliable" (xiv); "[The tetralogy] giv[es] us music that may ring false" (157). Although Abbate's argument for the parallel is compelling, the conclusion she draws does not necessarily follow. She asserts that the structural similarity indicates that the "music comes from Wotan," but we could equally well determine that, in this exceptional case, Wotan comes from the music. That is, during the monologue, the god follows the example of the music and cannot dissimulate with his words, and here can only tell the truth both musically and verbally. Thematically, this alternative interpretation might well seem justified. Wotan's long soliloquy in *The Valkyrie* is perhaps the moment in the tetralogy when verbally he is most honest about his aims and prospects—honest above all to himself.

6. Cooke's analysis first appeared as a sound recording entitled *An Introduction to* Der Ring des Nibelungen, released in 1969 to accompany the recordings of the *Ring* by George Solti and the Vienna Philharmonic Orchestra. It is now available as a 2-CD set from London (D 208789).

7. I take this comparison from Sabor, *A Companion Volume,* 82.

8. Richard Wagner, "Zukunftsmusik" (1860), in *Wagner on Music and Drama: A Compendium of*

Richard Wagner's Prose Works, ed. Albert Goldman and Evert Sprinchorn, trans. H. Ashton Ellis (New York: E. P. Dutton, 1964), 153–54, translation somewhat modified.

9. Arthur Schopenhauer, *The World as Will and Idea,* trans. R. B. Haldane and J. Kemp, 3 vols. (London: Routledge & Kegan Paul, 1957 [1st Ger. ed. 1818; 1st ed. of this trans. 1883]), 1:339–40. Kaufmann modifies this translation slightly when he has Nietzsche quote from Schopenhauer in *The Birth of Tragedy,* 101–2. For the title of Schopenhauer's book, I prefer "Representation" over "Idea" as a translation of "Vorstellung."

10. For this summary I am indebted to Jerrold Levinson's article "Arthur Schopenhauer," in *The Encyclopedia of Aesthetics,* ed. Michael Kelly, 4 vols. (New York: Oxford University Press, 1998). See also Bryan McGee, *The Tristan Chord: Wagner and Philosophy* (New York: Henry Holt, 2000).

11. Nietzsche, *The Birth of Tragedy,* 103; Wagner, "Beethoven" (1870), in Goldman and Sprinchorn, *Wagner on Music and Drama,* 179.

12. Friedrich Nietzsche, "On Truth and Lying in an Extra-Moral Sense," in *Friedrich Nietzsche on Rhetoric and Language,* ed. and trans. Sander L. Gilman, Carole Blair, and David J. Parent (New York: Oxford University Press, 1989), 249, 250.

13. John Bender and David E. Wellbery, "Rhetoricality: On the Modernist Return of Rhetoric," in *The Ends of Rhetoric: History, Theory, Practice,* ed. John Bender and David E. Wellbery (Stanford, CA: Stanford University Press, 1990), 14, 15, 19. For a discussion of the German model of the university, see Bill Readings, "The University and the Idea of Culture," in *The University in Ruins,* chapter 5 (Cambridge, MA: Harvard University Press, 1996).

14. On this point, Stanley Fish summarizes the ideas of the seventeenth-century English bishop John Wilkins as claiming that "a language purged of ambiguity, redundancy, and indirection" could return humanity to "that original state in which the language spoken was the language God gave Adam, a language in which every word perfectly expressed its referent (on the model of Adam's simultaneously understanding the nature of the animals and conferring upon them their names), a language that in course of time and 'emergencies' has unfortunately 'admitted various and *casual alterations.*'" Stanley Fish, *Doing What Comes Naturally: Change, Rhetoric, and the Practice of Theory in Literary and Legal Studies* (Durham, NC: Duke University Press, 1989), 477.

15. I am working here from the ideas of Group μ, which proposes that we think of the proper use of a term to be the "degree zero" of its meaning, which language in practice can approach but never attain. Group μ [Jacques Dubois, Francis Edeline, Jean-Marie Klinkenberg, Philippe Minguet, François Pire, and Hadelin Trinon], *A General Rhetoric,* trans. Paul B. Burrell and Edgar M. Slotkin (Baltimore: Johns Hopkins University Press, 1981 [Fr. ed. 1970]), 15–16, 30–33. See also Patricia Parker, "Metaphor and Catachresis," in Bender and Wellbery, *The Ends of Rhetoric,* who suggests that every proper metaphor is, in some basic sense, also an abusive catachresis.

16. The Wagnerian motifs do enjoy fresh application and acquire new meaning each time they are performed, are mentioned in the scholarship, or are reused in new cultural artifacts—as when Francis Ford Coppola in the film *Apocalypse Now* of 1979 famously has the "Valkyrie" motif accompany a pack of Hueys attacking a Vietnamese village. In a sense, "potential" use remains alive, and *parole* can exceed *langue,* precisely to the degree that the *Ring* cycle retains its cultural currency. Nonetheless, invoking the legitimating principle of origin grants an indisputable propriety to the appearances of the motifs within the tetralogy, against which any future uses necessarily stand as improper turns. Outside the tetralogy, the motifs have nothing resembling common usage.

17. This apparent contradiction has long been worried in the literature. At least three writers have featured it by making it the opening problematic of their arguments: Claude Lévi-Strauss, "A Note on the Tetralogy" (1975), in *The View from Afar,* trans. Joachim Neugroschel and Phoebe Hoss (New York: Basic Books, 1985 [Fr. ed. 1983]); Deryck Cooke, *I Saw the World End* (London: Oxford University Press, 1979); and Slavoj Žižek, "'There Is No Sexual Relationship': Wagner as a Lacanian," *New German Critique* 69 (Autumn 1996): 7–35.

18. Matthew Bribitzer-Stull argues that the *Ring* is characterized by "strokes of musical irony" that "invoke musical-dramatic recontextualizations." Bribitzer-Stull, "Did You Hear Love's Fond Farewell?" 126. My point is that irony is structurally impossible because the motifs cannot be "recontextualized," having only the single proper "context" of their cumulative but finite use within the tetralogy. Irony is an illusion produced when the analyst ignores the cumulative effect and arbitrarily deems one particular instance of a motif's use as proper; the other instances then appear to be tropes of the one thus privileged. In practice, Bribitzer-Stull's exposition of specific examples of "musical irony" often leads him toward such a commensuration of meaning. For instance, his analysis of the "Parting Kiss" motif, used when Wotan departs from Brünnhilde and from Alberich, resembles the account I have just presented of "Liebe-Tragik": "Thematic irony here actually points to the dramatic parallel between Brünnhilde and Alberich. As each represents an aspect of Wotan (Brünnhilde as his will, Alberich as the dark side of his lust for power), the use of 'Parting Kiss' seems fitting: In each case, Wotan is bidding farewell to a portion of himself" (126). In the end, we analysts may be describing the same phenomenon in different terms. Whereas Bribitzer-Stull (and others) juxtaposes relatively simple uses of motifs against each other to forge a complex amalgam, I stress the cumulative but finite effect, believing that the logic of Wagner's system makes it appropriate to regard that totality as the motif's proper form.

19. Three recent contributions to the long history of ruminations on Wotan's intractable dilemmas are Adrian Anderson, "The Tragic Crisis in Wagner's *Der Ring des Nibelungen*," *AUMLA: Journal of the Australasian Universities Language and Literature Association* 95 (May 2001): 35–53; Jeffrey L. Buller, "The Messianic Hero in Wagner's *Ring*," *Opera Quarterly* 13 (Winter 1997): 21–38; and Philip Kitcher and Richard Schacht, *Finding an Ending: Reflections on Wagner's* Ring (Oxford: Oxford University Press, 2004).

20. Theodor W. Adorno, *In Search of Wagner*, trans. Rodney Livingstone (London: Verso, 1991 [Ger. ed. 1952]), 36, 40.

21. G. Bernard Shaw penned a renowned early description of the *Ring* as an allegory of class conflict in *The Perfect Wagnerite: A Commentary on the Niblung's Ring* (New York: Time, 1972 [1st ed. 1898]).

22. Žižek, "There Is No Sexual Relationship," 14.

23. Lévi-Strauss, "A Note on the Tetralogy," 237–38.

24. David J. Levin, *Richard Wagner, Fritz Lang, and the Nibelungen: The Dramaturgy of Disavowal* (Princeton, NJ: Princeton University Press, 1998), 67. Levin is actually discussing Siegfried's inheritance and reforging of the sword in act 1, but the paradox is the same.

25. Karl Marx, "*Capital:* Selections" (1867), in *The Marx-Engels Reader,* ed. Robert C. Tucker, trans. Samuel Moore and Edward Aveling (New York: W. W. Norton, 1972), 200.

26. Buller explores the parallels between Christ and Siegfried and concludes that Brünnhilde is closer to being a Messianic figure, in "The Messianic Hero in Wagner's *Ring*." See also Alan David Aberbach, "Archetypal Man: Jesus and Parsifal," in *The Ideas of Richard Wagner: An Examination and Analysis of His Major Aesthetic, Political, Economic, Social, and Religious Thoughts,* chapter 8, rev. ed. (Lanham, MD: University Press of America, 1988). Parsifal, I would argue, also does not serve well as a Christic figure. As a pure innocent in act 1, he can neither comprehend the ritual nor act to alleviate Amfortas's suffering. Only after assuming in act 2 a full load of human guilt as "a sinner"—both for abandoning his mother and for failing Amfortas—is he able to perform holy offices in act 3. In contrast, Christ redeems while having been, as the Definition of the Council of Chalcedon of 451 would have it, "like us in all respects, apart from sin." *The Book of Common Prayer* [Episcopal] (New York: Oxford University Press, 1979), 864.

27. This scene has been discussed by Grey in "Music as Natural Language in the Moral Order of Wagner's *Ring*"; by Levin, *Richard Wagner, Fritz Lang, and the Nibelungen,* 73–79; and by Marc A. Weiner, "Reading the Ideal," *New German Critique* 69 (Autumn 1996): 72–79.

28. Shaw, *The Perfect Wagnerite,* 77.

29. This dilemma concerning the delivery of divinity to the Wagnerian audience is related to the paradox artfully described by James Treadwell.

Wagner's idea of a transformed society is identical to his hope for a reformed audience. However, his writings seem unable to determine the causality of this relationship: will the revolution create the conditions for the performance of the *Ring*, or will the performance enact the revolution? . . .

It is impossible for the audience to have its hermeneutic capacity "brought to consciousness" before the drama is presented to it; it is equally impossible for the drama to be performed without an audience that will understand it. So the *Ring* is left in a strange limbo, its promised hermeneutic utopia at once the precondition and the result of the drama's completion.

James Treadwell, "The *Ring* and the Conditions of Interpretation: Wagner's Writing, 1848 to 1852," *Cambridge Opera Journal* 7 (November 1995): 215, 218. In essence, the paradox in Treadwell's account is the inversion of the one in mine. Whereas Treadwell's audience can gain the new consciousness only if they already have it, my auditors get mired in rhetoric by the very process that is meant to deliver them from it.

30. Again, this paradox interrelates with Treadwell's. Although Treadwell maintains that there is no "solution" to Wagner's dilemma, he does argue that the difficulty can be finessed through a proper incorporation of the debilitating dilemma within the narration of the tetralogy itself.

Narration does provide a prefiguration, a model of interpretative context in which the latency of the present will turn into the fulfilment of the future, the hermeneutic utopia. . . .

Wagner's paradox is itself transformed into a narrative (a story told to a particular audience), establishing the conditions in which it might be resolved. . . .

The hermeneutic response will bring about the drama. Wagner's longed-for audience is empowered to create itself. . . .

The *Ring*'s constant self-narrations are its most significant moments. Narrative admits the impossibility of action and substitutes a yearning desire; narrative directs that desire to the reciprocal understanding of its audience.

Treadwell, "The *Ring* and the Conditions of Interpretation," 223, 225, 226, 230. In Treadwell's exegesis of Wagner's dilemma, telling the audience it is impossible to attain new consciousness can arouse its desire that anticipates its own self-realization; in my account recognizing the inevitability of rhetoric may lead that same audience to a truth beyond rhetoric.

CHAPTER 3

1. Louis Gillet, *Trois variations sur Claude Monet* (Paris: Librairie Plon, 1927), 109. Gillet's review elicited an extended response from Georges Clemenceau in *Claude Monet: Les Nymphéas* (Paris: Librairie Plon, 1928), a book of Clemenceau's own lengthy ruminations on his friend's artistic legacy. Together these two volumes constitute the most thoughtful contemporary assessment of Monet's final paintings. Steven Z. Levine provides a detailed account of criticism about the Orangerie in *Monet and His Critics* (New York: Garland Publishing, 1976); see his bibliography. Other important secondary works on the Orangerie paintings include Pierre Georgel, *Monet, le cycles des* Nymphéas: *Catalogue sommaire* (Paris: Editions de la Réunion des Musées Nationaux, 1999); Romy Golan, "Oceanic Sensations: Monet's *Grandes Décorations* and Mural Painting in France from 1927 to 1952," in *Monet in the 20th Century,* by Paul Hayes Tucker (New Haven, CT: Yale University Press, 1998); Robert Gordon and Andrew Forge, *Monet* (New York: Abrams, 1983); Robert Gordon and Charles F. Stuckey, "Blossoms and Blunders: Monet and the State," *Art in America* 67, part 1 (January–February 1979): 102–17, part 2 (September 1979): 109–25; Michel Hoog, *Les Nymphéas de Claude Monet au Musée de l'Orangerie* (Paris: Editions de la Réunion des Musées Nationaux, 1984); John House, "Monet: The Last Impressionist?" in Tucker, *Monet in the 20th Century;* Steven Z. Levine, *Monet, Narcissus, and Self-Reflection* (Chicago: University of Chicago Press, 1994); Grace Seiberling, *Monet's Series* (New York:

Garland Publishing, 1981); Virginia Spate, *Claude Monet: The Color of Time* (New York: Thames & Hudson, 1992); and Paul Hayes Tucker, "The Revolution in the Garden: Monet in the Twentieth Century," in Tucker, *Monet in the 20th Century.* Because of production limitations, large-scale reproductions of the Orangerie paintings do not appear in this book, so readers may wish to consult the foldout plates in Georgel and in Hoog.

2. André Masson, "Monet le Fondateur," *Verve* 7 (1952): 68. While declaring that Monet was "not a theologian" because he was a "painter of appearances in accordance with reality," Masson considered the artist's "cosmic vision" at the Orangerie to be "vast enough . . . that it embraces the world." Repeatedly in this chapter, we will encounter this attribution to the late Monet of the seemingly contradictory characteristics of prosaic verisimilitude and sublime expansiveness.

3. Pierre Olmar, "Le Musée Claude Monet à l'Orangerie des Tuileries," *L'architecture* 40 (June 15, 1927): 185.

4. Waldamar George, "Notes d'art: Les Nymphéas," *La revue mondiale* 177 (June 15, 1927): 379.

5. Marthe de Fels, "Claude Monet," part 3, *La revue de Paris* 36 (April 15, 1929): 899. Parts 1 and 2 appeared on March 15 and April 1. The full set was republished as *La vie de Claude Monet* (Paris: Librairie Gallimard, 1929).

6. Raymond Régamey, "Les Nymphéas de Monet à l'Orangerie des Tuileries," *Beaux-arts* 5 (June 1, 1927): 168.

7. I examine an earlier phase of this internal migration in James D. Herbert, "The North Revisited, Impressionism Revised," in *Fauve Painting: The Making of Cultural Politics,* chapter 1 (New Haven, CT: Yale University Press, 1992).

8. John McManners provides a thorough account in *Church and State in France, 1870–1914* (New York: Harper & Row, 1972).

9. Léon Bazalgette, "Les deux cathédrals," in *L'esprit nouveau dans la vie artistique, sociale, et réligieuse* (Paris: Société des Editions Littéraires, 1898), 374. Robert L. Herbert directed me toward this essay many years ago. He analyzes it insightfully in "The Decorative and the Natural in Monet's Cathedrals," in *Aspects of Monet: A Symposium on the Artist's Life and Times,* ed. John Rewald and Frances Weitzenhoffer (New York: Harry N. Abrams, 1984), reprinted in Robert L. Herbert, *From Millet to Léger: Essays in the Social History of Art* (New Haven, CT: Yale University Press, 2002).

10. George Heard Hamilton makes the observation about the cross in *Claude Monet's Paintings of Rouen Cathedral* (London: Oxford University Press, 1960), 25. About the surface, Stephanie A. Moore writes: "Monet deprives the building of religious iconography and statuary so that it appears a pure lapidary mass. The relief of the canvas, which gives the paintings an almost three-dimensional feel, appears to replicate the rough texture of natural stone." Stephanie A. Moore, "Reviving the Medieval Model: The Cathedrals of Claude Monet, Joris-Karl Huysmans, and Claude Debussy," in *Interart Poetics: Essays on the Interrelations of the Arts and Media,* ed. Ulla-Britta Lagerroth, Hans Lund, and Erik Helding (Amsterdam: Rodolpi, 1997), 196.

11. See, for instance, Waldamar George, "Les Nymphéas," *La revue mondiale* 177 (June 15, 1927): 379; Camille Mauclair, "Claude Monet," *Mercure de France* 193 (January 1, 1927): 23; and François Monod, "Les 'Nymphéas' de Monet à l'Orangerie des Tuileries," *L'art et les artistes* 78 (June 1927): 317. The term also appears regularly in books and articles written about Monet around this time.

12. Eldon N. van Liere has written: "Monet created . . . a synthesis of views and impressions from the bank that surrounded his pond, and by surrounding the viewer with these murals things are reversed, for where the land surrounded the water at the outset, water now surrounds." Eldon N. van Liere, "Monet and the Pillars of Nature: Articulation and Embodiment," in *The Elemental Passion for Place in the Ontopoiesis of Life: Passions of the Soul in the* Imaginatio Creatrix, ed. Anna-Teresa Tymieniecka (Dordrecht: Kluwer Academic Publishers, 1995), 263–64.

13. François Fosca (pseud. Georges de Traz), *Claude Monet* (Paris: L'Artisan du Livre, 1927), 61.

14. Régamey identifies the color of the resin flooring in "Les Nymphéas de Monet à l'Orangerie des Tuileries," 167. John House recognizes the possibility of the island interpretation: "The viewpoints

in the Orangerie are the reversal of the ways in which Monet himself would have viewed his pond. Installed as the *Décorations* are, we seem to look outward; but there is no central island viewpoint at Giverny." House, "Monet: The Last Impressionist?" 11.

15. It is because of such expansiveness that I find Stephan Oettermann's assessment of the panorama in the nineteenth century—a genre of which the Orangerie can be described as an extension—to be unnecessarily reductive and constricting. He writes: "The panorama is . . . the pictorial expression or 'symbolic form' of a specifically modern, bourgeois view of nature and the world. . . . The pictorial panorama was in one respect an apparatus for teaching and glorifying the bourgeois view of the world; it served both as an instrument for liberating human vision and for limiting and 'imprisoning' it anew" (7). Oettermann argues further: "The only framework is the new middle-class vision of the world" (21); and "God's all-seeing eye . . . has been replaced by the democratic 360-degree vision of panorama visitors" (25). Stephan Oettermann, *The Panorama: History of a Mass Medium,* trans. Deborah Lucas Schneider (New York: Zone Books, 1997 [Ger. ed. 1980]). The Orangerie does not replace God's eye with narrow bourgeois concerns; it keeps both in play. The human exclusion from divine vision, rather than restricting viewers to a narrow temporal and geographic perspective, opens it up. The same can be said, I believe, about most panoramas of the sort that Oettermann is describing.

16. In passing, Walter Benjamin recognizes a similar interplay between detail and broad prospect in panoramas of the nineteenth century. He characterizes the new literary genre of the *feuilleton* as typified by its "isolated sketches, the anecdotal form of which corresponds to the plastic foreground of the panorama, and their informational base to its painted background." Walter Benjamin, "Paris, Capital of the Nineteenth Century" (publ. posthumously 1955), in *Reflections,* trans. Edmund Jephcott (New York: Harcourt Brace Jovanovich, 1978), 149.

17. In a similar vein, Elaine Scarry describes the two extremes of vision (though she is dealing with actual blossoms, not the painted representations of them):

> The imaginability of the flower can in part be attributed to its *size* which lets it sit in the realm in front of our faces and migrate into the interior of what Aristotle called "our large moist brains." . . . If one closes one's eyes and pictures, for example, a landscape that encompasses the imaginative equivalent of our visual field, it is very hard to fill in its entirety with concentrated colors and surfaces. If, in contrast, one images the face of a flower—a much smaller portion of the visual field with its sudden dropping off at the edge of the petals where no image production is required—the concentration of color and surface comes within reach.
>
> We might call this the ratio of extension to intensity. The flower brings the work of imagining into the compass of our compositional powers.

Elaine Scarry, "Imagining Flowers: Perceptual Mimesis (Particularly Delphinium)," *Representations* 57 (Winter 1997): 97–98.

18. Robert L. Herbert and John House have each provided scrupulous accounts of Monet's increasingly complex technique as his career developed toward the 1890s. Robert L. Herbert, "Method and Meaning in Monet," *Art in America* 67 (September 1979): 90–108; and John House, *Monet: Nature into Art* (New Haven, CT: Yale University Press, 1986).

19. Daniel Arasse writes: "[In a picture] one can recognize the transparent image of an object, perfect in its imitation down to the 'least detail.' Yet elsewhere one can see the raw material of [that] picture, manipulated, as opaque for [the purpose] of representation as it is brilliant in its own right, dazzling in its effective presence." Daniel Arasse, *Le détail: Pour une histoire rapprochée de la peinture* (Paris: Flammarion, 1992), 11.

20. Debora Silverman offers an intriguing alternative interpretation in which the materiality of modernist means becomes associated more with Vincent van Gogh's Protestantism than with Paul Gauguin's Catholicism. Silverman and I both wish to examine the quest by French artists around the turn of the twentieth century to "discover a new and modern form of sacred art to fill the void left by the

religious systems that they were struggling to abandon but that had nonetheless left indelible imprints in their consciousness, shaping their theories of life, attitudes toward reality, choice of subject, and repertoire of artistic techniques." Debora Silverman, *Van Gogh and Gauguin: The Search for Sacred Art* (New York: Farrar, Straus and Giroux, 2000), 3.

21. George, "Notes d'art: Les Nymphéas," 379.

22. Richard Shiff has expounded brilliantly on the nature of this ongoing distinction and conflation in the critical literature. His argument appears in a number of places: Richard Shiff, "The End of Impressionism: A Study in Theories of Artistic Expression," *Art Quarterly* 1 (Autumn 1978): 338–78; Richard Shiff, "The End of Impressionism," in *The New Painting: Impressionism 1874–1886* (San Francisco: Fine Arts Museums of San Francisco, 1986); and Richard Shiff, *Cézanne and the End of Impressionism: A Study of the Theory, Technique, and Critical Evaluation of Modern Art* (Chicago: University of Chicago Press, 1984). My summary and analysis of the double meaning of the term "impression" appears in the article "Impressionism," in *The Encyclopedia of Aesthetics,* ed. Michael Kelly, 4 vols. (New York: Oxford University Press, 1998).

23. Fosca, *Claude Monet,* 60–61.

24. The continuity of Impressionism in this regard from its early to late phases, with only a shift in emphasis from nature to temperament, is one of Shiff's main points in his "End of Impressionism" essays.

25. Gustave Kahn repeated the oft-quoted adage in his review of Fosca's book on Monet, which (appropriately, given the date) mentions the opening of the Orangerie. Gustave Kahn, "Art," *Mercure de France* 197 (July 1, 1927): 166.

26. Léon Werth, *Claude Monet* (Paris: Les Editions G. Crès, 1928), 35–36, final ellipsis in the original.

27. This is the gist of Maurice Merleau-Ponty's indictment of Impressionism (against which he casts Paul Cézanne as redeemer): "Impressionism tries to capture, in the painting, the very way in which objects strike our eyes and attack our senses. Objects are depicted as they appear to instantaneous perception. . . . The result of these procedures is that the canvas—which no longer corresponds point by point to nature—affords a generally true impression through the action of the separate parts upon one another. But at the same time, depicting the atmosphere and breaking up the tones submerges the object and causes it to lose its proper weight." Maurice Merleau-Ponty, "Cézanne's Doubt" (1945), in *Sense and Non-Sense,* trans. Hubert L. Dreyfus and Patricia Allen Dreyfus (Evanston, IL: Northwestern University Press, 1964), 11–12.

28. De Fels, "Claude Monet," part 3, 903, 906.

29. Jean-Luc Marion, *The Idol and Distance: Five Studies,* trans. Thomas A. Carlson (New York: Fordham University Press, 2001 [Fr. ed. 1977]), 9.

30. The odd lack of punctuation and the elision without ellipsis from Luke 22:19–20, as well as the ellipsis at the end of the quoted phrase, appear here exactly as they do on the Vatican Web site. See also Pius XII, *Mediator Dei* of 1947, citing Saint John Chrysostom (347–407): "The priest is the same, Jesus Christ, whose sacred Person His minister represents. Now the minister, by reason of the sacerdotal consecration which he has received, is made like to the High Priest and possesses the power of performing actions in virtue of Christ's very person. Wherefore in his priestly activity he in a certain manner 'lends his tongue, and gives his hand' to Christ" (§69).

31. Pierre Batiffol, *Leçons sur la messe,* 7th ed. (Paris: Librairie Victor Lecoffre; J. Gabalda, 1920), 177.

32. Now that I have proposed the similarity of Monet's paints to the Eucharist, I can acknowledge the important influence of Georges Didi-Huberman's argument about Fra Angelico on my analysis here.

The story [of Jesus] is past, whereas in the living present of a Dominican friar in San Marco, the mystery has never ceased to exist. It is there, present on a daily basis, within the walls of the convent [in the form of Fra Angelico's idiosyncratic frescos that resemble nothing]. And it is disseminated everywhere in religious life: it is disseminated in *signs that are at the same time presences.* The Eucharist, of course,

constitutes the model par excellence for these signs. What is the host? The host is both a sign and the presence of Christ's flesh. Yet the host is only a white surface, "figureless," by which I mean it is utterly without resemblance to the thing of which it is the sign and presence. It is as if the element of presence required the sign's nonresemblance to its referent.

Georges Didi-Huberman, *Fra Angelico: Dissemblance and Figuration,* trans. Jane Marie Todd (Chicago: University of Chicago Press, 1995 [Fr. ed. 1990]), 35.

CHAPTER 4

1. The story of the destruction of the old cathedral and the building of the new has been told from a variety of points of view: from the perspective of the architect in Basil Spence, *Phoenix at Coventry: The Building of a Cathedral* (London: Geoffrey Bles, 1962); from that of the clergy in R. T. Howard, *Ruined and Rebuilt: The Story of Coventry Cathedral, 1939–1962* (Coventry, Eng.: Council of Coventry Cathedral, 1962); H. C. N. Williams, *Coventry Cathedral* (Norwich, Eng.: Jarrold & Sons, [c. 1962]); and H. C. N. Williams, *Coventry Cathedral: A Guide to Coventry Cathedral and Its Ministry* (London: Hodder & Stoughton, 1966); and with the hindsight of art-historical reconstruction in Louise Campbell, *Coventry Cathedral: Art and Architecture in Post-War Britain* (Oxford: Clarendon Press, 1996).

2. My analysis of the musical structure of Britten's Mass is indebted to the following musicological sources: Mervyn Cooke, *Britten: War Requiem* (Cambridge: Cambridge University Press, 1996); Peter Evans, *The Music of Benjamin Britten* (Minneapolis: University of Minnesota Press, 1979); David B. Greene, "Britten's *War Requiem:* The End of Religious Music," *Soundings* 83 (Spring 2000): 89–100; Michael Kennedy, *Britten* (New York: Oxford University Press, 2001); and Anthony Milner, "The Choral Music," in *The Britten Companion,* ed. Christopher Palmer (Cambridge: Cambridge University Press, 1984). Throughout this chapter, I quote from the text of the *War Requiem* exactly as it is printed on the first several pages, preceding the music, of the authorized score published in London by Boosey and Hawkes in 1962.

3. On a more technical level (pointed out to me by Margaret Murata), the repeated cycle of the harmonium's twelve diatonic triads implies an authentic cadence when the C major dominant at the end of each series resolves to the F major tonic at the beginning of the next (and a second similar, though less regular, cadence when at the midpoint of the series an F-sharp major triad resolves to a B minor chord). Yet by the end of the boys' interlude, such diatonic cadential relationships give way to alternating F major and B minor chords, which have C and F-sharp, sung by the boys, as their perfect fifths. Once again, the chromatic symmetry of the tritone supersedes the imperatives of diatonic resolution.

4. It appears that in composing the *War Requiem,* Britten copied Owen's verse from the volume in his personal library, at some points altering the text slightly. *The Poems of Wilfred Owen,* ed. Edmund Blunden (London: Chatto & Windus, 1955 [1st ed. 1931]).

5. Howard, *Ruined and Rebuilt,* 123.

6. H. C. N. Williams, *Twentieth Century Cathedral* (London: Hodder & Stoughton, 1964), 6.

7. Spence, quoted in Howard, *Ruined and Rebuilt,* 45; Spence, *Phoenix at Coventry,* 115.

8. Quoted in Howard, *Ruined and Rebuilt,* 115; Spence, *Phoenix at Coventry,* 14, 117.

9. I return at the end of the chapter to the topic of the Anglican Eucharist and the doctrine of real presence.

10. Williams, *Twentieth Century Cathedral,* 78.

11. Spence, *Phoenix at Coventry,* 11, 118.

12. Williams, *Twentieth Century Cathedral,* 76.

13. R. Furneaux Jordan, "A Challenge to a Thousand Years," in *Coventry Cathedral: A Souvenir*

Publication to Commemorate the Reconstruction and Consecration of the Cathedral Church of St. Michael, Coventry [cover title: *Cathedral Reborn*], 3rd ed. (Leamington Spa, Eng.: English Counties Periodicals, 1964 [1st ed. 1962]), 24. Similar sentiments are expressed by Spence, *Phoenix at Coventry*, 33.

14. C. K. N. Bardsley, interviewed by F. A. D. Kelsey, "This Magnificent New Cathedral," in *Coventry Cathedral: A Souvenir Publication*, 19.

15. Rowan Williams, *On Christian Theology* (Oxford: Blackwell Publishing, 2000), 244–45, 250.

16. A photograph in the Pitkin Cathedral Guide for Coventry Cathedral shows a celebrant standing behind the altar in precisely this posture. In contrast, Terence Coneo's painting of the inaugural ceremony in 1962, *The Consecration,* depicts Bishop Bardsley blessing the Eucharist with his back to the congregation, while a set of microphones standing behind the altar preclude the use of that space for the Mass. The difference in placement may well document a shift in liturgy at Coventry following liberalizations of the Anglican Church instituted in the late 1960s and early 1970s. Even in the earlier practice, however, the celebrant after the blessing would have turned to present the Eucharist to the assembled worshipers in a position similar to the one I describe, facing south toward the ruins. *Coventry Cathedral* (Andover, Hampshire, Eng.: Pitkin Unichrome, 1991), 16. Cuneo's *The Consecration* is reproduced in *Coventry Cathedral: After the Flames* (Norwich: Jarrold Publishing, 1987), n.p.

17. On this point, my analysis differs from that of David B. Greene, who maintains that Britten's settings of the verses by Owen always have the upper hand morally as they turn ironically against the Latin Mass. Thus for Greene the *War Requiem* constitutes an unrelenting "rejection of what religious music can supposedly do." Greene, "Britten's *War Requiem*," 97.

18. The analysis of the texts of the Agnus Dei that follows differs from those offered by Cooke and Milner (Evans is more equivocal), both of whom find a compatibility of message to match the seamlessness of the orchestrations. Cooke, *Britten: War Requiem;* Evans, *The Music of Benjamin Britten;* and Milner, "The Choral Music."

19. My thoughts on forgiveness have been greatly aided by the chapter entitled "The Forgiveness of Sins" in the book of collected sermons by Archbishop Williams. Rowan Williams, *A Ray of Darkness: Sermons and Reflections* (Cambridge, MA: Cowley Publications, 1995). See also the essays on the theme of forgiveness by Jacques Derrida, Robert Gibbs, John Milbank, and Mark Dooley, as well as a useful introduction by the editors, collected in *Questioning God,* ed. John D. Caputo, Mark Dooley, and Michael J. Scanlon (Bloomington: Indiana University Press, 2001).

20. In an earlier published version of this essay, I labeled this attitude—the only one I then attributed to the devout at Coventry—as a form of "bad faith." That was a form of self-righteousness on my own part, and I no longer level the charge.

21. [Graham] Sutherland, *Christ in Glory in the Tetramorph: The Genesis of the Great Tapestry in Coventry Cathedral,* ed. Andrew Révai (London: Pallas Gallery, A. Zwemmer, 1964), 24.

22. Jordan, "A Challenge to a Thousand Years," 24–25.

23. Humphrey Carpenter, *Benjamin Britten: A Biography* (New York: Charles Scribner's Sons, 1992), 408.

24. Murata has informed me that the resolution may not be as fortuitous as it first appears. The final cluster of F-sharps and C-sharps—two of the three notes of the triad G-flat, B-flat, and D-flat—constitutes a modified plagal cadence resolving to an F major tonic (since this major triad of F's minor second differs only one note from the minor chord of its perfect fourth, B-flat, D-flat, and F; although the implicit subdominant would be minor, the final triad benefits from the traditional *tierce de Picardie,* the raising of its third degree to constitute the major). Nevertheless (as Murata and I agree), the closing chord still comes as a surprise, an unexpected irruption of pure harmony within an otherwise dissonant setting.

25. William R. Crockett provides a succinct summary of Anglican doctrine concerning the Eucharist in *The Study of Anglicanism,* ed. Stephen Sykes and John Booty (London: SPCK; Philadelphia: Fortress Press, 1988), 272–85.

26. Anglican–Roman Catholic International Commission (ARCIC), "Agreed Statement on Eucharistic Doctrine" (1971), in *The Final Report: Windsor, September 1981* (London: CTS [Catholic Truth Society] / SPCK [Society for Promoting Christian Knowledge], 1982), 14.

27. *The Eucharist: Sacrament of Unity* (London: Church House Publishing, 2001), 14.

28. For my discussion of Catholic doctrine of the Eucharist, see the final section of Chapter 3.

29. Lasting doctrinal differences along these lines prompted the combined bishops in 1979—surely, in this case, the Anglicans—to elaborate on the joint statement on the Eucharist from 1971:

> Criticism has been evoked by the statement that the bread and wine become the body and blood of Christ in the eucharist. The word *become* has been suspected of expressing a materialistic conception of Christ's presence. . . .
>
> *Becoming* does not here imply material change. . . . It does not imply that Christ becomes present in the eucharist in the same manner that he was present in his earthly life. It does not imply that this *becoming* follows the physical laws of this world. What is here affirmed is a sacramental presence in which God uses realities of this world to convey the realities of the new creation: bread for this life becomes the bread of eternal life.

ARCIC, "Elucidation" (1979), in *The Final Report,* 20–21.

CHAPTER 5

1. Mark Godfrey relates the subtitle of Newman's series—Christ's cry of despair from the cross, "Why have you forsaken me?" (Mark 15:34; Matthew 27:46)—to postwar Jewish reckoning with the Holocaust but does no better than earlier commentators in discerning the theme of the Passion in the paintings themselves, beyond a general starkness and blankness that aid in the creation of a "sense of place" for contemplating loss. Godfrey writes: "Calling the paintings *Stations of the Cross* was never then a matter either of form or of iconography, but of affect." Mark Godfrey, "Barnett Newman's *Stations* and the Memory of the Holocaust," *October* 108 (Spring 2004): 38.

2. Here and throughout, I depend on James Shapiro, *Oberammergau: The Troubling Story of the World's Most Famous Passion Play* (New York: Pantheon Books, 2000), an accessible account of the history of the Passion play at Oberammergau and of the controversies surrounding the production of 2000. See also Saul S. Friedman, *The Oberammergau Passion Play: A Lance against Civilization* (Carbondale: Southern Illinois University Press, 1984).

3. The complex amalgam of sentiment that I discuss in Chapter 4 in relation to the phrase "Father Forgive" at Coventry recurs at this moment of our identification with the Godhead in *14 Stations.* We both condemn and pardon Jesus's persecutors, and in pardoning them we extend to them both care and indifference.

4. Harold Rosenberg, "The Herd of Independent Minds," *Commentary* 6 (September 1948): 244–52.

5. International Consultation on English Texts translation, which appears on the World Wide Web at various locations.

6. The publicity material may be viewed at www.passionsspiele2000.de/passnet/english/index_e.html.

7. John Rockwell, "Stepping Past the Wolves on Jesus' Path toward Death," *New York Times,* October 5, 2000.

8. Graham Ward has written, "The medieval Church bears witness to this ambivalence in finding it appropriate to gender Jesus as a mother at this point, with the wounded side as both a lactating breast and a womb from which the Church is removed. The pain and suffering of the crucifixion is gendered in terms of the labour pains of birthing." Graham Ward, "The Displaced Body of Jesus Christ," in

Radical Orthodoxy: A New Theology, ed. John Milbank, Catherine Pickstock, and Graham Ward (London: Routledge, 1999), 170.

9. Leo Steinberg, famously, looked for instances of such phallic prominence. Leo Steinberg, *The Sexuality of Christ in Renaissance Art and in Modern Oblivion* (New York: Pantheon Books, 1983).

10. Jean-Luc Marion, *The Idol and Distance: Five Studies*, trans. Thomas A. Carlson (New York: Fordham University Press, 2001 [Fr. ed. 1977]), 215.

DESIGNER
Jessica Brawn
TEXT
10/15 Garamond
DISPLAY
Akzidenz Grotesk
COMPOSITOR
Integrated Composition Systems
PRINTER AND BINDER
Thomson-Shore